Writing Material Culture History

WRITING HISTORY

Published:

Writing History (second edition), Heiko Feldner, Kevin Passmore and Stefan Berger

Writing Medieval History, edited by Nancy F. Partner

Writing Early Modern History, edited by Garthine Walker

Writing Contemporary History, edited by Robert Gildea and Anne Simonin

Writing Gender History (second edition), Laura Lee Downs

Writing Postcolonial History, Rochona Majumdar

Writing the Holocaust, edited by Jean-Marc Dreyfus and Daniel Langton

Writing the History of Memory, edited by Stefan Berger and Bill Niven

Forthcoming:

Writing the History of Crime, Paul Knepper (2015)

Writing the History of Empire, Alexei Miller (2015)

Writing Material Culture History

EDITED BY ANNE GERRITSEN AND GIORGIO RIELLO

Bloomsbury Academic
An imprint of Bloomsbury Publishing Plc

B L O O M S B U R Y
LONDON · NEW DELHI · NEW YORK · SYDNEY

Bloomsbury Academic

An imprint of Bloomsbury Publishing Plc

50 Bedford Square	1385 Broadway
London	New York
WC1B 3DP	NY 10018
UK	USA

www.bloomsbury.com

BLOOMSBURY and the Diana logo are trademarks of Bloomsbury Publishing Plc

First published 2015

© Anne Gerritsen, Giorgio Riello and Contributors, 2015

Anne Gerritsen and Giorgio Riello have asserted their rights under
the Copyright, Designs and Patents Act, 1988, to be identified as
Editors of this work

British Library Cataloguing-in-Publication Data
A catalogue record for this book is available from the British Library.

ISBN: HB: 978-1-4725-1857-6
PB: 978-1-4725-1856-9
ePDF: 978-1-4725-1858-3
ePub: 978-1-4725-1859-0

Library of Congress Cataloging-in-Publication Data
A catalog record for this book is available from the Library of Congress.

Series: Writing History

Typeset by RefineCatch Limited, Bungay, Suffolk

CONTENTS

LIST OF FIGURES

LIST OF CONTRIBUTORS

Kathleen M. Adams, Professor, Department of Anthropology
Loyola University Chicago, USA

Glenn Adamson, Director
Museum of Art and Design (MAD), New York, USA

Sandra Cavallo, Professor, Department of History
Royal Holloway, University of London, UK

Manuel Charpy, Researcher, CNRS Institut de Recherches Historiques du
 Septentrion
Université de Lille 3, France

Kee Il Choi, Jr. Art Consultant and Historian
New York, USA

Viccy Coltman, Senior Lecturer, School of Art History
University of Edinburgh, UK

Flora Dennis, Senior Lecturer in Art History
University of Sussex, UK

Dinah Eastop, Curatorial Research Fellow, Collection Care Department
The National Archives, Kew, UK

Lesley Ellis Miller, Senior Curator, Furniture, Textiles and Fashion Department
Victoria and Albert Museum, London, UK

Suzanne Findlen Hood, Curator of Ceramics and Glass
The Colonial Williamsburg Foundation, Virginia, USA

David Gaimster, Director
Hunterian Museum, Glasgow, UK

Anne Gerritsen, Reader in Chinese History, Department of History
University of Warwick, UK

Hannah Greig, Lecturer, Department of History
University of York, UK

Jessica Hallett, Historian of Islamic Art and Researcher
Portuguese Centre for Global History (CHAM), Lisbon, Portugal

Christina Hellmich, Curator in Charge, Arts of Africa, Oceania and The Americas
 and the Jolika Collection of New Guinea Art
deYoung Museum, San Francisco, USA

Victoria Kelley, Reader and Senior Lecturer
University for the Creative Arts, Rochester, UK
Central Saint Martins College of Art and Design, University of the Arts
 London, UK

Ethan W. Lasser, Margaret S. Winthrop Associate Curator of American Art
Harvard Art Museums, USA

Ulrich Lehmann, Professor
University for the Creative Arts, Canterbury, UK

Dana Leibsohn, Priscilla Paine Van der Poel Professor of Art
Smith College, USA

John McAleer, Lecturer, Department of History
University of Southampton, UK

Ann Smart Martin, Stanley and Polly Stone Professor in Art History, Director of
 Material Culture Program
University of Wisconsin-Madison, USA

Kaori O'Connor, Senior Research Fellow, Department of Anthropology
University College London, UK

Catherine Richardson, Reader in Renaissance Studies, School of English
University of Kent, Canterbury, UK

Giorgio Riello, Professor of Global History, Department of History
University of Warwick, UK

Raquel Santos, PhD Student and Assistant Researcher
Portugnese Centre for Global History (CHAM), Lisbon, Portugal

Carolyn Sargentson, Honorary Senior Research Fellow
Victoria and Albert Museum, London, UK

John Styles, Research Professor in History, School of Humanties
University of Hertfordshire, UK

Claire Tang, PhD Student, Department of History
University of Warwick, UK

Writing Material Culture History

Anne Gerritsen and Giorgio Riello

Why things?

Just a few years ago, historians would have been sceptical about the value of engaging with 'objects' or 'artefacts'. The expression 'material culture' was equally alien to historical studies and mostly confined to the realm of the investigation of the remote past (pre-historical and ancient) or non-Western societies. Today we speak instead of a 'material turn' in history. On both sides of the Atlantic as well as in many parts of Australasia, historians seem to have experienced a Damascene conversion to material culture. And this is not just limited to historical research. At some institutions, students are now introduced to artefacts as readily as to manuscript and printed sources. History textbooks inevitably contain chapters dedicated to 'visual' and 'material' cultures.

This book is intended as a guide for students and teachers to understanding this new role played by material culture in history. We, as historians, are not the first to address this issue and we approach it with a particular view on how and why our field might benefit from an engagement with material objects.[1] In this volume, we have brought together not just historians, but also art historians, museum curators, archaeologists, anthropologists, design experts, television consultants and art consultants. Each brings a specific viewpoint on what material culture is and how material culture engages with history.

But what is material culture? The term material culture is defined in different ways depending on the disciplinary context within which the term is used. Historians have been using the label in a rather loose fashion, and sometimes simply take it to mean 'objects'. The 'material culture of domesticity', for instance, might refer to the material goods that turn a house into a home in the past or in the present. These might include soft furnishings and textiles, crockery and china, knick-knacks and children's toys. Even this simple list of material things or artefacts points to the fact that these might differ from similar objects that we find in a hotel room. Unlike hotel rooms, our houses are full of memories that are conveyed through the objects that fill them. Objects have meanings for the people who produce and own, purchase and gift, use and consume them. Material culture therefore consists not merely of 'things', but also of the meanings they hold for people.[2]

Meaning is a rather opaque concept. It emerges from the relationship between objects and people, but such relationships exist at the personal and individual level as much as they do at the public and collective level. For example, the children's toys scattered on the floor in the front lounge serve as a first indication that children live in the house. These might have very different meanings: for the children who play with them, the parents who bought them, the friends who gifted them, never mind the producers and sellers of the items. Such toys can then be seen as tokens of affection that bind parents and children in a specific time and place. For the child, however, they might be treasured for very different visual and tactile properties that are appealing to a child, which in turn create a different set of meanings and memories. The toys scattered on the floor are therefore not just material objects but they point at the affective, social, cultural and economic relationships that form our lives.

This present-day example is useful for us to ask more historical questions: were there toys in a similar household in the past? And, if we can trace them, did they have a similar or different function to today's toys? What do they tell us about childhood in the past and about the relationship between parents and children? Indeed historians are well aware that past households were not just different, but also that the meaning of childhood and of the affective bonds between parents and children were constructed differently throughout time and space. In this case the analysis of toys can become a powerful instrument to unearth a different world, one that might not be well recorded in written documents. However, we should be aware that 'material objects are not, and have not been, just caught up in an ever-shifting world but are actually creating, constructing, materializing and mobilizing history, contacts and entanglements'.[3] Objects themselves are not simple props of history, but are tools through which people shape their lives.

The simple acknowledgement that objects can serve as a way of understanding and appreciating the past, does not necessarily explain why and how historians should engage with them. There are many fine historical

accounts that do not consider either objects or material culture. The engagement and usefulness of material culture depends on the questions that we ask. A researcher interested in analysing the historical process of 'imitation', usually between people from different social and cultural classes, also referred to as 'emulation', might well benefit from including in his or her study the objects and materials that formed part of this process. A scholar interested in the philosophical thought of Hegel, however, might find little help in engaging with material culture methodologies.

There are, generally speaking, three ways in which material culture has enriched history. Firstly, by complementing other sources: the understanding of the written and visual sources of the past has been strengthened by including the material legacy of that same past. Secondly, by making historians ask new questions: by including objects, the study of emulation, for example, is no longer a mere concept, but is understood as a series of material practices based on the production and consumption of goods. Thirdly, by leading historians to new themes: by using objects, historians have begun to explore new areas of enquiry ranging from how people dressed in the past, their emotions, their taste and even the ways in which they related to the imagined and real world that surrounded them.

History's engagement with material culture

History has long been seen as the discipline in which its practitioners engaged in the analysis of textual documents and communicated by producing more texts.[4] The archive was the historian's second home. This maintained the traditional boundary between history and art history, the latter being interested in fine art, in particular two-dimensional artefacts such as paintings, prints and drawings.[5] Three-dimensional objects were 'dismissed' to the realms of archaeology and curatorship. Archaeology defined itself by the very act of unearthing its own source materials not from the depth of dusty archives, but from digs and excavations.[6] From the second half of the eighteenth century, the museum served as the 'palace of things', where armies of curators and restorers acquired, catalogued, preserved and displayed artefacts.

History's 'material turn' should not lead us to think that material culture has thereby become the preserve of history. History's engagement with material culture and its methodologies is relatively recent and what we here call 'material culture history' is a field of enquiry still in its infancy.[7] The above-mentioned disciplines of archaeology, anthropology, and museum studies did much to bring to the fore the importance of material artefacts as sources, and objects as agents and mediators between the present and the past. Archaeologists, museum specialists and anthropologists worked together to develop the field of 'material culture studies' by investigating the ways in which a material object relates to a meaning or a variety of meanings and is

therefore a prime source of information about cultures, their evolutions, their peculiarities and differences.[8]

The acceptance of material culture by history should also be explained by considering the changes that the discipline of history has undergone in the past fifty years. In the 1960s, historians first became interested in understanding the everyday lives of ordinary people who had lived in the past. This was a shift away from the idea of history as determined by the few at the top, to what has come to be known as 'history from below' in which agency is given to the lives of common people.[9] Yet, the people that replaced kings and queens, prime ministers and generals as the subjects of history did not necessarily leave substantial written records. One of the ways in which we can trace their lives is through the material goods they left behind. The buying, selling and using of goods, i.e. consumption, seems to have been common to poor and rich alike. In particular, the so-called 'consumer revolution' of the eighteenth century, when more goods were available to larger social groups than ever before, inspired a great deal of research in the 1980s and 1990s. This was followed by studies of consumption patterns in Renaissance Italy, early modern continental Europe, and also in the nineteenth- and twentieth-century Western world.[10] More recently consumption has entered historical research in areas as different as the Ottoman Empire, Tokugawa Japan, Ming and Qing China and Colonial Latin America as part of an engagement with global history.[11]

Beyond consumption, material culture has been a response to the growing interest in the everyday practices that shaped past lives. Material things have turned out again to be extremely useful to historians. Daniel Roche's book *Histoire des choses banales* (1997) captures the power of relatively 'banal' – translated into English as 'everyday' – objects for understanding a past that is made not just by wars, commercial treaties and courtly splendour, but also by the roasting heat of an open fire, the spread of the use of individual cutlery, or the surprise generated by seeing a pineapple for the first time.[12] In the United States, material culture has long been used to understand and display everyday life in colonial societies, thus merging archaeological investigation, museum curatorship, historical research and the heritage industry.[13] The innovative work carried out in places like Colonial Williamsburg and other major American museums, is complemented by an influential research agenda in the study of decorative arts, especially as part of the Winterthur-University of Delaware Masters programme that has trained generations of curators. History of design has been a great ally of material culture also in Britain and Continental Europe through graduate programmes, conferences and several academic journals.[14]

Interest in consuming practices and everyday life of past societies has been key to the success of material culture. In their attempt to understand people's desires and preferences, historians have re-evaluated the significance of material artefacts. This has led to the investigation of a series of themes ranging from the everyday to luxury, politics, trade and innovation;

modernization, gender, domesticity and comfort, fashion, architecture and the built environment, to name but a few. Collaborations between museums and academics have allowed scholars to go 'behind the scenes', into museum store-rooms, developing projects that draw on curatorial expertise.

This new engagement of history with material culture has had profound consequences for the writing of history. First, the primacy of the written account in the historical discipline has been destabilized: the world of 'the material' is no longer left to highly specialized fields such as the history of textiles, the history of costume, the history of furniture, etc. Historians now actively engage with a series of themes and areas of study that were previously left out of consideration. Second, the boundaries of history have changed: material culture has been one of the most fertile areas of collaboration between historians engaged in different branches of history, between historians and academics in the humanities, social sciences and more recently the sciences, and between historians and museum curators. And finally, the separation between different kinds of historians has been challenged, and professional historians employed within their discipline at universities work more closely with practitioners whose analyses and presentations of the past are produced in non-academic circles for exhibitions and exhibition catalogues, radio and TV programmes, and country house and heritage displays.

Writing material culture history

How do historians approach objects? How, practically speaking, do they engage with material culture and its methods? What are the inevitable challenges the historian encounters when integrating documentary, visual and material sources into their analyses? These are some of the questions that this volume wishes to address. A series of articles and books have been produced in recent years in an attempt to guide both professional historians and students. Our book differs in three main ways from other valuable contributions. First, we argue that there is no single way of engaging with material culture. One can see a tendency – partly exacerbated by students' demands – to pinpoint a method of analysis. Jules Prown famously suggested a practical guide to material analysis and divided academic and curatorial approaches. Prown's scholarship is very useful for critical reflection on the engagement with material culture, but should not be taken at face value.[15] The ways in which historians approach both artefacts and material culture can and should vary, depending on the available materials, the context and the aims of the research. A second important point, and a consequence of the previous, is the fact that there cannot be a unified and universal methodology because of the interdisciplinary nature of 'material culture history'. Inter- and multi-disciplinarity are always part of the study of objects as, to cite Burman and Turbin, 'the meanings of [an object] are multiple, many-layered, and overlapping, concerning, for example, individuals, aesthetics, sexuality,

cultures, economies, and ideologies'.[16] This book acknowledges not just the importance of multiple disciplines – anthropology, archaeology, art history and literary studies in particular – but also the specific contributions they make to the field of history. Finally this book wishes to shift the focus of material culture history away from its often uncritically assumed Western context (especially Europe and North America) towards wider geographies. We think it is a significant departure for historians to begin thinking about objects not just in the context of microhistory and history from below, but to reflect on the ways in which artefacts came to be powerful tools for the creation of global connections.

The book is divided into three parts. The first part, entitled 'The Disciplines of Material Culture' is dedicated to illustrating the ways in which different disciplines have dealt with and contributed to the study of material culture. The focus is on literary and archival studies, archaeology, anthropology and art history. We have decided to integrate longer methodological contributions with more 'practical' shorter pieces, balancing the need for methodological guidance with the importance of 'applied' case studies. One of the insights of this section is that documentary sources and objects should be seen not as distinct but as part of a continuum. Objects from the past appear to us both in their material form and in textual records where our imagination conjures their form, and what matters more for our historical understanding is how we 'read' both kinds of artefacts. Literary methodologies, legal theory and archaeology each have different ways of accounting for objects, as some of these chapters demonstrate, but they help us to narrow the space between the micro-level world of the individual objects, and the macro-level of historical concepts like the Reformation or the Renaissance. And literary scholars as much as archaeologists struggle with the problem of synchronicity vs. sequence of objects: individual sites might give a 'snapshot' in time but they are more often the result of complex material and temporal layering which can only be understood by triangulating archaeological, documentary and visual materials.[17]

The discipline of anthropology has been particularly important to shape historians' engagement with material culture.[18] We see this in a study of a single material (Lycra®) and in the study of the materiality of a single place (Indonesia). Anthropology offers the qualitative and quantitative methods of analysis that allow us to make sense of the spatial and chronological contexts within which materials take on meaning. A further three pieces in this first part explore art historical methodologies through a study of the relationship between two- and three-dimensional artefacts and the boundaries between art and material culture. When objects move, they establish connections across space. The examples explored here are porcelain produced in China to be carried to France in the eighteenth century and a basket and a silver coin in early nineteenth-century California. The very different political environments in which the movement of these objects occurred is an important backdrop, but it is the analysis of the objects

themselves that enables these scholars to reveal the subtle movements of power at work.

The second part of this book entitled 'The Histories of Material Culture' addresses the relationship between history and material culture. Where historians of material culture and artefacts once mostly worked on topics like consumption and everyday life, today material culture and object-based research covers a great variety of topics and issues ranging from gender to politics and race. This part aims to show how material culture has the potential to re-cast established historical narratives in new and exciting ways. Trade of porcelain and cotton textiles between Europe and Asia in the early modern period, for instance, shows how objects articulate exchange, taste, design and cultural understanding on a global scale. Here, too, objects shape and are shaped by power relations played out across vast distances, as the exchange of garments in the space of the Pacific Ocean illustrates.

A second important change that has prompted historians to consider material culture more seriously is a renewed interest in understanding experience, the senses and emotions in history. Material culture allows us to immerse ourselves in the intimate world of beds, in the social relationships embodied by the sound of a bell, in the sensorial experience of light before electricity or the emotional world of tokens used to identify abandoned children. A wide variety of objects passes review here, including beds, handbells, light bulbs, fragments of cloth and wallpaper. They all have the power to open up vistas onto the past in ways that documentary sources alone do not. None of these are stable objects: they take meaning in space and time, they change as human thoughts about them change, and it is in the human–object relationship that history is written.

The final part of this book entitled 'The Presentation of Material Culture' is dedicated to the study of the presentation as well as the preservation and representation of objects. Here, particularly, we see how historians' engagement with objects has blurred the very boundaries between 'professional' history and other types of historical enquiry. In what ways is the history presented in a museum, an exhibition or a film different from what we read in a scholarly article or book? Several of the contributions in this book deal with what has turned out to be a challenge to history as a discipline. The interpretation of the past (rather than history) involves historians, but also curators, freelance exhibition organizers, TV presenters and film makers. They all deal with what we loosely call 'material culture' and provide an interpretation of the past, but they do it in different ways. Even within a museum context, artefacts can be displayed differently in order to achieve different purposes or comply with different narratives, as several studies here illustrate. The complex process of creation of a major new set of galleries requires that objects are integrated into different stories. The case of empire, to give another example, shows how artefacts are used in rather specific ways to construct historical narratives.

Issues of interpretation are not just important in the presentation of objects but also in their preservation, as we see in the case of three Iranian

carpets highlighting how the process through which conservation and interpretation are interlinked and their helpfulness to scholars. Objects like carpets and desks do not belong to a specific time, as we are often led to believe by museum labels. They are, instead, the result of layers of use, interpretation and restoration across time. Cataloguing and comparing artefacts, in this case material objects and drawings that form part of an archive, similarly add layers of interpretation. Curators are not just in charge of the preservation of artefacts but also their interpretation especially in museum displays and exhibitions. In this sense, they are in the unenviable position to mediate between the care of rare and sometimes precious and fragile objects and their enjoyment by the public. The book concludes with a reflection that expands on the ways in which people – rather than scholars – engage with material culture and understand the past through objects. This is the case not just of museum experience but also of the 'material past' as is presented on the small and large screen.

All together, the contributions in this final part of the book adopt a distinctive perspective to both material culture and to artefacts. An indicator of this might be the fact that unlike contributions in other parts of this book, they address issues and problems in the first person, reporting and reflecting on direct experience. Whilst history books only disguise their author through the use of the impersonal and collective third person, contributors to the third part of this book show how the engagement with objects creates a different relationship between past and present.

The potential and limitations of material culture history

We have so far explored the various ways in which material culture can enrich history. We do, however, also have to recognize that material culture has innate complexities as well as limitations. These are, for example, *material limitations*. Some objects survive and offer us interpretive possibilities; far more objects have not survived, and their absence can feature in our stories only with difficulty.[19] We should, whenever possible, consider the objects we have in light of the objects we do not have and ask how representative existing objects are of the much larger number of similar objects that have not reached us. The problems affecting the study of material culture are not just about survival. Material culture is based on meaning as much as on materiality. A second material limitation derives from the fact that we might have the object but we have often lost the context that made the object meaningful. Even archaeologists, for whom the find context is crucial, have to accept that the objects encountered in excavations are not necessarily in their 'original' context. De-contextualization is part of the very life of objects and must be acknowledged in research. Museums, because of their collecting

practices and scientific methods of categorization (for instance they divide objects by typologies, storing them in different departments), have unwillingly exacerbated the problem of de-contextualization.

Beyond material limitations, there are also *conceptual limitations* to the use of objects for historical study. A first important issue is the fact that objects bridge time. Unlike people and ideas, artefacts survive sometimes centuries and millennia. A beautiful Chinese Ming vase, as can be seen in one of the essays in this book, is both a source for historians in the present and an object that existed 400 years ago when it was made. This complicates the easy separation between 'past vs. present' and 'historians vs. historical subject'. The example is fetching because it reveals an even more complex notion of time. The vase is an artefact that existed not just now or 400 years ago when it was made, but has existed since. It has a lifespan, or what have been also defined as 'career' and 'biography', that the present-day object bears physically (it might have lost one of its parts, been chipped or broken) and in its meaning (for instance: Who owned it? Where did it go over time? How was it used?). Artefacts are therefore complex entities whose nature and life story can only partially be understood and recovered. One of their conceptual challenges – rather than limitations – is the fact that they often raise a series of question marks for researchers about their origin, use, value in the past and in the present. This is another reason why material artefacts need to be integrated with other sources – visual and documentary – both to produce better historical scholarship and to better understand the very material artefacts. As a corollary of the previous points, material culture requires interpretative skills on the part of researchers that are not just historical or interdisciplinary, but also aesthetic, visual and haptic.

Finally, some considerations have to be made about the *practical limitations*. Access to artefacts is often restricted. Those objects that are in museums can be on display in galleries and therefore unavailable for close inspection by researchers. The vast majority of objects are instead in store-rooms and access to them is possible only in those cases in which curators believe that it will not endanger the object. Museums are increasingly well equipped to welcome researchers 'behind the scenes', so to speak, but this requires long waiting lists – sometimes months. There are also a number of objects that cannot be handled (think about a large piece of furniture or a statue). A second important point is that not all artefacts are in museums. Indeed material culture surrounds us and includes landscape, architecture, objects of everyday use, artefacts to be found in antique dealers, auction houses and flea markets, and a great deal of perishable material culture such as food. Many objects are to be found also in archives as considered in several contributions in this book. This makes research logistically complex and requires the ability on the part of scholars to trace specific artefacts often through the use of catalogues (of exhibitions, sales, or museum indexes), dictionaries and online databases and resources. The internet has profoundly changed material culture research allowing for the easier access

to information and the integration of such information with images of artefacts. Thanks to museum online catalogues (still very partial though) we can for instance bring together objects that are in collections in different parts of the world.[20] We decided to include a list of useful resources to guide students and researchers through the most extensive online and material collections in the world. This can only be partial as large-scale digitalization projects are currently underway. It should be observed, however, that online access to digital images is one of the tools available to researchers and cannot substitute the engagement with material artefacts.

Conclusion

This introduction serves the reader as a guide to the theoretical and practical analyses put forward by 25 contributors in this book. We have highlighted the role of history in the study of material culture as well as how material culture has shaped historical research and scholarship. We strongly believe that material culture has the potential to enrich history as a discipline and more widely the understanding of the past. This requires however the acknowledgement that other disciplines have a great deal to offer to history as to the ways in which to approach and interpret artefacts. We have therefore given great prominence to interdisciplinarity and highlighted the potential of material culture to approach themes as different as design, the senses, emotion etc. Finally, this book develops a distinctive line of research that focuses not just on Europe but uses material culture to study wider geographies and the connections between different areas of the world.

Notes

1 K. Harvey (ed.) (2009), *History and Material Culture: A Student's Guide to Approaching Alternative Sources*. London: Routledge; A. D. Hood (2008), 'Material culture: the object', in S. Barber and C. Peniston-Bird (eds), *History Beyond the Text: A Student's Guide to Approaching Alternative Sources*. New York and London: Routledge, pp. 176–98; P. Miller (ed.) (2013), *Cultural Histories of the Material World*. Ann Arbor: University of Michigan Press. On visual and material culture see: L. J. Jordanova (2012), *The Look of the Past: Visual and Material Evidence In Historical Practice*. Cambridge: Cambridge University Press.

2 P. Stallybrass (2002), 'The value of culture and the disavowal of things', in H. S. Turner (ed.), *The Culture of Capital: Property, Cities, and Knowledge in Early Modern England*. London: Routledge, pp. 275–95.

3 M. W. Conkey (2006), 'Style, design, and function', in C. Tilley, W. Keane, S. Küchler, M. Rowlands and P. Spyer (eds), *Handbook of Material Culture*. London: Sage, p. 364.

4 L. Auslander (2006), 'Beyond words', *American Historical Review* 110 (4), pp. 1015–44.

5 P. Burke (2001), *Eyewitnessing: The Uses of Images as Historical Evidence*. London: Reaktion.

6 D. Gaimster (1994), 'The archaeology of post-medieval society, c. 1450–1750: material culture studies in Britain since the war', in B. Vyner (ed.), *Building on the Past: Papers Celebrating 150 Years of the Royal Anthropological Institute*. London: Royal Anthropological Institute, pp. 283–310.

7 G. Riello (2009), 'Things that shape history: material culture and historical narratives', in Karen Harvey (ed.), *History and Material Culture*. London: Routledge, pp. 24–47; P. Findlen (2013), 'Introduction: early modern things', in P. Findlen (ed.), *Early Modern Things: Objects and their Histories, 1500–1800*. Basingstoke: Routledge, pp. 3–27.

8 A. Appadurai (ed.) (1986), *The Social Life of Things: Commodities in Cultural Perspective*. Cambridge: Cambridge University Press; D. Miller (1987), *Material Culture and Mass Consumption*. New York: Blackwell; H. Glassie (1999), *Material Culture*. Bloomington: Indiana University Press; C. Tilley, W. Keane, S. Küchler, M. Rowlands and P. Spyer (eds) (2006), *Handbook of Material Culture*. London: Sage; D. Hicks and M. C. Beaudry (eds) (2010), *The Oxford Handbook of Material Culture Studies*. Oxford: Oxford University Press.

9 E. P. Thompson (1963), *The Making of the English Working Class*. New York: Vintage; F. Braudel (1967–73), *Civilisation matérielle et capitalisme 15c–18c siècle*, 3 vols. Paris: Armand Colin.

10 J. Thirsk (1978), *Economic Policy and Projects: The Development of a Consumer Society in Early Modern England*. Oxford: Clarendon; N. McKendrick, J. Brewer and J.H. Plumb (1982), *The Birth of a Consumer Society: The Commercialisation of Eighteenth Century England*. London: Europa; S. Schama (1987), *The Embarrassment of Riches: An Interpretation of Dutch Culture in the Golden Age*. London: Random House; L. Weatherill (1988), *Consumer Behaviour and Material Culture in Britain, 1660–1760*. London: Routledge; J. Brewer and R. Porter (eds) (1993), *The World of Goods*. London and New York: Routledge; C. Shammas (1990), *The Pre-industrial Consumer in England and America*. Oxford: Clarendon; A. Pardailhé-Galabrun (1991), *The Birth of Intimacy: Private and Domestic Life in Early Modern Paris*. Cambridge: Polity; R. A. Goldthwaite (1995), *Wealth and the Demand for Art in Italy, 1300–1600*. Baltimore: Johns Hopkins University Press; D. Roche (1997), *Histoire des choses banales: Naissance de la consommation dans les sociétés traditionnelles (XVIIe–XVIIIe siècles)*. Paris: Fayard; R. Sarti (2002), *Europe at Home: Family and Material Culture, 1500–1800*. New Haven and London: Yale University Press; M. Berg (2005), *Luxury and Pleasure in Eighteenth-Century Britain*. Oxford: Oxford University Press; E. Welch (2005), *Shopping in the Renaissance: Consumer Cultures in Italy, 1400–1600*. New Haven and London: Yale University Press; R. Ago (2013), *Gusto for Things: A History of Objects in Seventeenth-Century Rome*. Chicago: University of Chicago Press.

11 C. Clunas (1991), *Superfluous Things: Material Culture and Social Status in Early Modern China*. Cambridge: Polity; S. B. Hanley (1997), *Everyday Things*

in Premodern Japan: The Hidden Legacy of Material Culture. Berkeley: University of California Press; S.A.M. Adshead (1997), *Material Culture in Europe and China, 1400–1800*. New York: St Martin's Press; T. Brook (1998), *The Confusions of Pleasure: Commerce and Culture in Ming China*. Berkeley: University of California Press; D. Quataert (ed.) (2000), *Consumption Studies and the History of the Ottoman Empire, 1550–1922: An Introduction*. Albany: CUNY Press; A. J. Bauer (2001), *Goods, Power, History: Latin America's Material Culture*. Cambridge: Cambridge University Press; C. Clunas (2007), *Empire of Great Brightness: Visual and Material Cultures of Ming China, 1368–1644*. London: Reaktion.

12 Roche, *Histoire*.

13 A. Smart Martin (1996), 'Material things and cultural meanings: notes on the study of early American material culture', *William and Mary Quarterly* 53 (1), pp. 5–12; T. H. Breen (2004), *The Marketplace of Revolution: How Consumer Politics Shaped American Independence*. New York: Oxford University Press.

14 G. Adamson (2013), 'Design histories and the decorative arts', in Miller (ed.), *Cultural Histories*, pp. 33–8.

15 J. D. Prown (1982) 'Mind in matter: an introduction to material culture theory and method', *Wintherthur Portfolio* 17 (1), pp. 1–19.

16 B. Burman and C. Turbin (2002), 'Introduction: material strategies engendered', *Gender & History* 14 (3), p. 374. See also A. Smart Martin (1997), 'Shaping the field: the multidisciplinary perspectives of material culture', in A. Smart Martin and J. Ritchie Garrison (eds), *American Material Culture: The Shape of the Field*. Winterthur, DE: Henry Francis du Pont Winterthur Museum.

17 On archaeology and material culture see: M. D. Cochran and M. C. Beaudry (2006), 'Material culture studies in historical archaeology', in D. Hicks and M. C. Beaudry (eds), *The Cambridge Companion to Historical Archaeology*. Cambridge: Cambridge University Press.

18 Appadurai (ed.), *Social Life of Things*; Miller, *Material Culture*.

19 G. Adamson (2009), 'The case of the missing footstool: reading the absent object', in Harvey (ed.), *History and Material Culture*, pp. 192–207.

20 An example is the recent exhibition 'The Interwoven Globe' at the MET in New York. The exhibition curators were able to bring together a man's gown and its matching waistcoat currently in different American museums. It was thanks to online catalogues that it was realized for the first time that these two items belonged to the same garment.

Further reading

Appadurai, A. (ed.) (1986), *The Social Life of Things: Commodities in Cultural Perspective*. Cambridge: Cambridge University Press.

Auslander, L. (2006), 'Beyond words', *American Historical Review* 110 (4), pp. 1015–44.

Berg, M. (2005), *Luxury and Pleasure in Eighteenth-Century Britain*. Oxford: Oxford University Press.

Brewer, J. and R. Porter (eds) (1993), *The World of Goods*. London and New York: Routledge.

Burke, P. (2001), *Eyewitnessing: The Uses of Images as Historical Evidence*. London: Reaktion.

Clunas, C. (1991), *Superfluous Things: Material Culture and Social Status in Early Modern China*. Cambridge: Polity.

Findlen, P. (ed.) (2013), *Early Modern Things: Objects and their Histories, 1500–1800*. Basingstoke: Routledge.

Glassie, H. (1999), *Material Culture*. Bloomington: Indiana University Press.

Goldthwaite, R. A. (1995), *Wealth and the Demand for Art in Italy, 1300–1600*. Baltimore: Johns Hopkins University Press.

Grassby, R. (2005), 'Material culture and cultural history', *Journal of Interdisciplinary History* 35 (4), pp. 591–603.

Harvey, K. (ed.) (2009), *History and Material Culture: A Student's Guide to Approaching Alternative Sources*. London: Routledge.

Hicks, D. and M. C. Beaudry (eds) (2010), *The Oxford Handbook of Material Culture Studies*. Oxford: Oxford University Press.

Jordanova, L. J. (2012), *The Look of the Past: Visual and Material Evidence In Historical Practice*. Cambridge: Cambridge University Press.

Kingery, D. W. (ed.) (1996), *Learning from Things: Method and Theory of Material Culture*. Washington DC: Smithsonian Institution Press.

McKendrick, N., J. Brewer and J. H. Plumb (1982), *The Birth of a Consumer Society: The Commercialisation of Eighteenth Century England*. London: Europa.

Martin, A. Smart (1996), 'Material things and cultural meanings: notes on the study of early American material culture', *William and Mary Quarterly* 53 (1), pp. 5–12.

Miller, D. (1987), *Material Culture and Mass Consumption*. New York: Blackwells.

Miller, P. (ed.) (2013), *Cultural Histories of the Material World*. Ann Arbor: University of Michigan Press.

Prown, J. D. (1982), 'Mind in matter: an introduction to material culture theory and method', *Wintherthur Portfolio* 17 (1), pp. 1–19.

The Disciplines of Material Culture

CHAPTER ONE

Material Culture and the History of Art(efacts)[1]

Viccy Coltman

Figure 1.1 is an oil on canvas portrait painted by the American artist John Singleton Copley of his fellow Bostonian, the silversmith Paul Revere. Measuring 89.22 × 72.39 cm and inscribed in the lower right with the date 1768, this portrait, now in the Museum of Fine Arts, Boston, opens our discussion of material culture and history of art for a number of pertinent reasons. In the first instance, because painted portraiture is one of the dominant genres of mainstream art historical enquiry; because the portrait is an example of an object of visual culture (flat art) that depicts three-dimensional 'fat' things, both human and inanimate, on its canvas.[2] Its sitter is himself a producer of luxury material objects, like the portrait painter he sat for.

Looking at the painted canvas, the art historian might begin with a careful visual analysis of the image. Copley depicts the Boston silversmith at half-length, seated ostensibly at work on one of his silver teapots, which he holds in the cupping grasp of his left hand. The thumb and first finger of his massive right hand are poised in a V-shape at his chin – in a hand gesture that is more indicative of a thinking philosopher than a working craftsman. The sitter looks straight out from the canvas, with the right hand side of his large square-shaped face foremost and the left side turned into shadow. Revere is dressed informally in a white linen open shirt and an unfastened waistcoat, which are reflected blurrily in the polished gleam of the wooden bench on which he rests his elbow and whereon lie examples of the tools of his trade.

Copley's portrait of Revere is said to be unprecedented in his oeuvre and in American colonial painting as being a completed likeness of a fellow

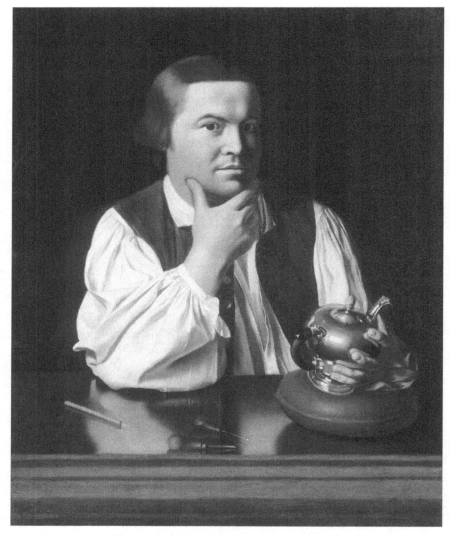

FIGURE 1.1 *John Singleton Copley,* Paul Revere, 1768. *Oil on canvas, 89.22 ×
72.39 cm. Museum of Fine Arts, Boston. Gift of Joseph W., William B. and Edward
H. R. Revere. Photograph © 2013, Museum of Fine Arts, Boston.*

craftsman. Who might have commissioned it is unknown. A recent cataloguer
suggests that teapots were among the most complex objects Revere made
and relates the inscribed date of the portrait to a decline in Revere's
production of teapots in the aftermath of the 1767 Townshend Act which
imposed duties on a variety of imported goods, including tea.[3] Positioning
the portrait in this political and economic context, makes it appear an act of

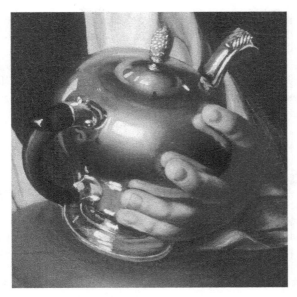

FIGURE 1.2 *Detail of Figure 1.1.*

nostalgic self-promotion, of technical virtuosity mastered but no longer patronized by the Boston elite and/or an intimate, idealizing portrait of a master craftsman 'at work' on a luxury object. Revere's great-grandsons gave the portrait to the Museum of Fine Arts in Boston in 1930, which gives it a secure family provenance at least among later generations. Figure 1.2 is a detail of the four fingers of Revere's left hand as they grasp the weight of the silver teapot. Notice how Copley paints the vertical steps of light bouncing off the curved silver surface of the painted teapot and how this contrasts with Revere's substantial fingers whose blackened, stumpy nails are almost engraved in paint at their tips.

The careful looking that prompts description is the art historian's preliminary mode of engagement. What has been identified as the 'descriptive techniques of art history', Jas Elsner goes further in suggesting that all art history is essentially ekphrasis – the literary representation of works of art.[4] Ekphrasis uses one medium of representation – words – to represent another, in this case, an object. Description is quickly followed by discussion of more abstracted forms of objecthood in which the art historian's gaze is directed ever outwards away from the artefact with as frequent as necessary recourse back to it. Copley's portrait of Revere might be recruited into a wide range of historical and art historical narratives, including, but not limited to, painted portraiture as a genre of representation; about the artist and his oeuvre; about representations of 'makers'; about silver; about materiality;

about tea as what Walvin has termed 'an accidental fruit of empire' in the world of goods, or about the consumption of a global commodity in part of Britain's empire; about the entangled relationships between consumable commodities and other kinds of traded goods, both natural and man-made.[5] Close scrutiny of the portrait makes it 'talkative' in the process described by Lorraine Daston: of 'mak[ing] things eloquent without resorting to ventriloquism or projection'.[6]

Mind in matter

Daston's comment rehearses that of the art historian, Jules Prown, who in a series of articles published from 1982 devised a 'method for piercing the mute carapace of objecthood to let the work speak'.[7] Prosopopoeia, the rhetorical technique of envoicing a silent object is, it seems, at the core of material encounters. Prown wrote extensively on Copley and refers to the Revere portrait in an essay entitled 'Style as Evidence'.[8] For him, the portrait 'celebrates worldly stuffs – polished wood, gleaming silver, soft flesh, fabric, hair'.[9] In 1760s colonial America, the image conveys 'a delight in sustainability, the corporeal reality, of things'. Prown devised an exploratory series of six 'broad' categories for the study of material culture: Art, Diversions, Adornment, Modifications of the Landscape, Applied Arts and Devices (Figure 1.3), which he organized sequentially from the more decorative or aesthetic to the more utilitarian, being unable to classify them by alternative categories like their physical materials or methods of fabrication. His later categories are arguably more applicable to what has since been designated design history. Entitled 'Mind in Matter', Prown's essay was the first to define material culture and the nature of the discipline in its relationship to history of art. His pioneering schema has yet to be superseded and as far as I can ascertain only one art historian, Michael Yonan, in an essay published in 2011 has suggested it may be time to revisit it.[10] Although Yonan rightly observes that Prown's influence has been primarily in American art and material culture studies a number of his foundational points in this essay are worth rehearsing here, as shown in Figure 1.3.

Mind in Matter
1. Art (paintings, drawings, prints, sculpture, photography)
2. Diversions (books, toys, games, meals, theatrical performances)
3. Adornment (jewelry, clothing, hairstyles, cosmetics, tattooing, other alterations of the body)
4. Modifications of the landscape (architecture, town planning, agriculture, mining)
5. Applied arts (furniture, furnishings, receptacles)
6. Devices (machines, vehicles, scientific instruments, musical instruments, implements)

FIGURE 1.3 *Prown's six broad categories for the study of material culture (1982).*

Prown finds the term material culture 'unsatisfactory, even self-contradictory' given the association of material with base things and culture with its antithesis – lofty, intellectual things.[11] In this respect, 'material culture' is not unlike Carlo Ginzburg's 'elastic rigour', and the emergence of material culture in tandem with microhistory might be a fertile area for further investigation.[12] Prown endorses that 'artifacts are primary data for the study of material culture'; that material culture is a discipline, rather than a field, unlike art history; that like art history, material culture studies culture through artefacts. Yonan's intervention is that material culture is a meta-methodology, a 'true transdiscipline' emerging out of the interdisciplinary congeries that is material culture studies. His essay explores the 'commonalities and divergences' between art history and broadly defined material culture studies. Similar positioning of disciplines characterizes existing discussions of the relationship between art history and visual culture, or visual studies, which emerged in the 1990s in English-speaking countries as another transdisciplinary and cross-methodological field. A plethora of books and articles have since appeared on the latter which has been said to constitute a 'range of tangibly "visual" cultural forms such as advertising, painting, photography, film, television, cinema, journalism and propaganda'.[13] Newer forms of 'new media' must be added to Chris Jenks' already out-dated (1995) inventory.

Are history of art and visual culture 'distinct, antagonistic, or complementary enterprises' asks Deborah Cherry. Cherry identifies the semantics of definition as part of the problem, asking can art history and visual culture enjoy a comfortable co-existence?[14] Or, one might add, at the opposite extreme, is visual culture what Derrida, quoting Rousseau, understands as a dangerous supplement to history of art: 'Compensatory and vicarious, the supplement is an adjunct, a subaltern instance which *takes-(the)-place*'.[15] What *is* dangerous are bald statements like the unfounded claim by anthropologists in 2006 that 'visual studies has displaced or enfolded art history'.[16] In an essay on 'Visual Culture: An end to the history of art' that deserves to be better known by art historians and visual culturalists alike, Matthew Rampley argues that visual studies and the notion of visual culture will not displace the history of art on account of its never being exclusively concerned with images alone.[17] The recurrent problem as he sees it with visual studies is in its restrictive self-definition – being primarily concerned with visual representations, it seems to exclude the entire domain of material artefacts which are intrinsic to the history of art. We might conceptualize this difference as follows: that while visual culture is concerned with 'the flat' in two dimensions, like Copley's portrait of Revere, material culture deals with 'the fat' in three. In this respect, visual culture does have a welcome disrupting effect on the ingrained hierarchies in history of 'fine' art in which certain of the 'flat' arts of Prown's first category Art, the paintings, drawings and prints, are divorced from the 'fat' art of sculpture. The issue remains how best to articulate the *ménage a trois* – if indeed it is such a configuration – between history of art, visual

culture and material culture without at one extreme, evangelizing pronouncements or, at the other, 'territorial grumpiness and defensiveness'.[18]

For Prown, writing a decade prior to the explosion of studies about and around the visual, the rationale for an emphasis on material culture appears to be a primarily cerebral one of finding mind in matter. As he confidently asserts in the essay of this title: 'Inasmuch as material culture is fundamentally a quest for mind, for belief, works of art are more direct sources of cultural evidence than are devices'.[19] Devices are Prown's sixth and final category (Figure 1.3) representing the history of technology, which like its implements, has made an innovative contribution to material culture studies. In a subsequent essay on 'The truth of material culture: history or fiction', first published in 1993 Prown revisits this theme: 'in addition to their intended function, [he explains, artefacts are] unconscious representations of hidden mind, of belief, like dreams. If so, then artifacts may reveal deeper cultural truth if interpreted as fictions rather than as history. I realize that an analogy between dreams and artifacts as expressions of subconscious mind is not self-evident; indeed it seems unlikely'.[20] Such a cognitive agenda may seem contrived and counter-intuitive to the physical object-ness of material culture study. But as Bill Brown articulates it in his discussion of thing theory: 'If thinking the thing, to borrow Heidegger's phrase, feels like an exercise in belatedness, the feeling is provoked by our very capacity to imagine that thinking and thingness are distinct'.[21] In 2005, the archaeologist Carl Knappett suggested that in order to expand material culture theory we need to review the relation between mind and matter.[22] 'Material thinking' becomes then a useful proposition in the in-between objectscape between material culture and history of art; the greyscale between mind and matter, or thinking and things.

Material thinking

In the final paragraph of the second and last part of *The History of the Art of Antiquity* (first published in German in 1764), Johann Joachim Winckelmann offers an extended reflection on what might be identified as the particularities and peculiarities of the art historical endeavour at the moment of its literary inception. Since Winckelmann is routinely recognized as the father of art history, this passage ostensibly recording his thoughts on the moment of the completion of his *History of the Art of Antiquity* is worth quoting as it appears in the most recent English translation published in 2006:

> . . . I could not keep myself from gazing after the fate of works of art as far as my eye could see . . . [we] have as it were only a shadowy outline of the subject of our desires remaining. But this arouses so much the greater longing for what is lost, and we examine the copies we have with greater

attention than we would if we were in full possession of the originals. In this, we are often like individuals who wish to converse with spirits and believe they can see something where nothing exists ... One always imagines that there is much to find, so one searches much to catch sight of something. Had the ancients been poorer, they would have written better about art; compared to them we are like badly portioned heirs; but we turn over every stone, and by drawing inferences from many tiny details, we at least arrive at a probable assertion[23]

Winckelmann describes a compulsion to gaze 'after the fate of works of art as far as my eye could see'. This emphasis on the eye as the apparatus of vision and the extended gaze as a particular mode of prolonged, contemplative viewing is fundamental to the art historical process as it is understood in Western culture. A subsequent reference to the 'glimpse' juxtaposes these two alternative modes of viewing, which is later accompanied by a more elusive, restless look in which 'one searches much to catch sight of something'.[24] While viewing is far from the exclusive domain of art history, what is characteristic of its practices is what is seen. Art historians almost always see objects in their material manifestations as they are among the primary data which they encounter – whether as in Winckelmann's case, as originals or copies, physically proximate or spatially distant. The intellectual territory of history of art is more accurately a history of artefacts, a crowded landscape of objects. Within this densely populated objectscape, art historians, like Winckelmann, look *hard* at the objects in our field of vision as what has already been considered a preliminary mode of engagement.

This is quickly followed by a second mode in which, like colleagues in other disciplines, we see the imprint of more abstracted forms of objecthood. According to Arjun Appaduari, 'No social analysis of things (whether the analyst is an economist, an art historian, or an anthropologist) can avoid a minimum level of what might be called methodological fetishism'.[25] If methodological fetishism is as in his account 'returning our attention to the things themselves', then art historians have long been incriminated, not so much in a return to things, as in an enduring embrace of them.

Towards the end of the passage at the culmination of his *History*, Winckelmann writes about what he sees as the lack of correlation between the surviving objects of the ancients and the relative poverty of their written record. This uneven historical provision between objects and texts has at least since the 1970s provided a rationale for material culture studies, in which the former are seen as being more socially representative and non-elitist than texts. As Henry Glassie wrote in his pioneering *Folk Housing in Middle Virginia* (1975), 'A method based on the document is prejudiced: fated to neglect the majority of people, for they were non-literate, and, within the boundaries of literacy, to neglect the majority of people, for they did not write. Even today, in societies of nearly universal literacy, it is a rare soul who bequeaths to future historians a written account of his

thought'.[26] Arguably Winckelmann fashions himself as one of those 'rare souls'. American folk and decorative arts have been especially well served by the democratizing impulse of material culture studies.[27] Yet how can we reconcile the inclusive nature of material culture studies with the exclusive temperament of history of art – a discipline that is exceptionally verbose and that relies as much (more?) on words as objects? Art historians are uncharacteristically reticent about their commitment to material culture – even books with material culture *in the title* rarely articulate their precise terminology, a working definition or their terms of engagement. So an obvious ensuing question must be: what is the stuff of material culture in its application to art history?

Striking in Winckelmann's account is his reference to an active form of looking that involves intimate handling of the object. We 'turn over every stone', he writes, in a phrase that is more metaphorical than literal: one of the most distinctive aspects of Winckelmann's art history is his extended, exhaustive descriptions of individual works of ancient art, like the *Apollo Belvedere*. This sphere of objects – from stone to marble masterpiece – embraces the vast domain of materials that constitute material culture studies. In *In Small Things Forgotten: The Archaeology of Early American Life* (1977), James Deetz offers a still useful definition of what constitutes the stuff of material culture. Material culture, he writes, 'is roughly synonymous with artifacts, the vast universe of objects used by mankind to cope with the physical world, to facilitate social intercourse, and to benefit our state of mind'.[28] Having established this premise, he proceeds to offer a more radical account in its spaciousness which embraces the entire physical environment, including solid matter, liquids and even gas: 'We can also consider cuts of meat as material culture, since there are many ways to dress an animal; plowed fields; even the horse that pulls the plow, since scientific breeding of livestock involves the conscious modification of an animal's form according to culturally derived ideals. Our body itself is a part of our physical environment, so that such things as parades, dancing, and all aspects of kinesics – human motion – fit within our definition. Nor is the definition limited only to matter in the solid state. Fountains are liquid examples, as are lily ponds, and material that is partly gas includes hot-air balloons and neon signs'.[29] Deetz's definition, which includes both animate and inanimate objects, may be too capacious (and capricious) for some.

As a proponent of historical archaeology, Deetz is interested in remembering 'small things' that survived above ground as well as those excavated from below.[30] With chapters devoted to ceramics, gravestones, houses and supplemented by discussion of grave-pits, refuse, cuts of meats, recipes, furniture, cutlery and musical instruments, Deetz's inclusive 'bits and pieces' (his phrase) seem rather too indiscriminating for art historians who have long delighted in the comforting parameters of their own self-serving taxonomies. 'Why not let things alone?' asks Brown, 'Let them rest somewhere else – in the balmy elsewhere beyond theory'.[31] The impact of

what Brown provocatively terms 'complicating things with theory' is beyond the scope of this chapter. At the risk of being unfashionably retrograde and anti-theoretical, Figure 1.4 offers a revised model of object analysis to those which proliferated in object studies in the 1980s, yet which have been conspicuous by their absence ever since in art history.[32] It is applicable to artefacts of material culture, whether they are works of art or not. As Prown reminds us in 'Mind in matter', 'all tangible works of art are part of material culture, but not all the material of material culture is art'.[33] Figure 1.4 is informed by earlier paradigms for object analysis. In 1961, C. F. Montgomery published a series of fourteen steps that he described as 'the prosaic homework of study' devised in order to determine the date and place of an object's manufacture and its authorship.[34] A decade later in 1974, McClung

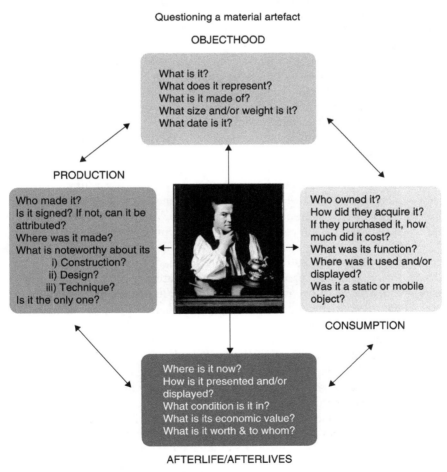

Questioning a material artefact

OBJECTHOOD

What is it?
What does it represent?
What is it made of?
What size and/or weight is it?
What date is it?

PRODUCTION

Who made it?
Is it signed? If not, can it be attributed?
Where was it made?
What is noteworthy about its
 i) Construction?
 ii) Design?
 iii) Technique?
Is it the only one?

Who owned it?
How did they acquire it?
If they purchased it, how much did it cost?
What was its function?
Where was it used and/or displayed?
Was it a static or mobile object?

CONSUMPTION

Where is it now?
How is it presented and/or displayed?
What condition is it in?
What is its economic value?
What is it worth & to whom?

AFTERLIFE/AFTERLIVES

FIGURE 1.4 *Questioning a work of art.*

Fleming suggested a model for artefact study which utilizes two conceptual tools – a five fold classification of the basic properties of an artefact and a set of four operations to be performed on these properties.[35] This is a 'how-to' model, the idea being the student will apply it him/herself subsequently to other examples of early American decorative arts.

Im-material culture

In the paragraph from the end of his *History of Art*, Winckelmann describes a longing for what is lost that results in scrutinizing Roman copies of Greek sculpture with more attention than the originals had they survived. 'In this [he writes], we are often like individuals who wish to converse with spirits and believe they can see something where nothing exists'. While discussing this episode 'mourning the death of art history', Whitney Davis makes the following observation: 'Strictly speaking, the history of art is the history of what has been lost in, and to, history'.[36] While I have no desire to cast the history of art as a 'pathological walking-of-the-dead', a 'pageant of corpses revivified by the historian' or 'a ghastly puppet show' (the quotes are all from Davis), the trope of conversing with spirits and seeing something where nothing exists enables an innovative notion of immaterial culture as it pertains to history of art.[37] Effectively, adding the immaterial to what Daniel Miller has termed the large compass of materiality, the ephemeral, the imaginary, the biological and the theoretical.[38] As with other aspects of material culture studies, the anthropologists have got there first.[39] Within their discipline, the immaterial has been invoked in terms of loss/absence/death, implicated in religious belief and practice and identified as things in dreams. In an article entitled 'Presencing the Im-material', for example, Victor Buchli recognizes its paradoxical nature: 'that in order to conceive the immaterial, one must always try to understand it in material terms'.[40] Beyond the anthropology of absence, in an essay published in 2009, 'The case of the missing footstool: Reading the absent object', Glenn Adamson conjures up the category of the 'absent object' using the deficiency of surviving British domestic footstools before 1800 as a case study.[41] For Adamson, one of the key obstacles in the study of material culture is the phenomenon of loss. He suggests we treat this not as a problem, but as a matter of historical interest in its own right, writing 'if we want the study of material culture to unlock the secrets of history, then surely we should be analysing what people of the past did *not* make, and what they did *not* do, with as much care as we examine their surviving material traces'. The supposition that material culture 'unlock[s] the secrets of history', is an uncritical one and seems as indebted to fictional detective Sherlock Holmes as the title of Adamson's article. Where Adamson pursues the absent object, an alternative to this negative imprint is in a concept of immaterial culture which pursues artefacts that are lost in their material incarnation in its definitive state, but that survive through their representation as phantom objects

(Winckelmann's 'shadowy traces'), or in other alternative, non-material forms of cultural expression. My contention would be that Adamson's project is too nihilistic, not to mention limitless, given the surfeit of material objects that do survive and the manifest traces of those that *do not*.

How the immaterial artefact came to disappear, whether by accident or design is relevant in so far as its recorded destruction relates to the biography of the object during its extended life cycle; the linear and non-linear temporality of things is a likely area of incipient research across material culture studies. The life cycle of objects must be necessarily extended in order to incorporate proleptic and retrospective iterations, not only phantom or retrospective objects like Winckelmann's Roman copies after Greek masterpieces, but where they exist, as incunabula, as artefacts that survive prematurely in preliminary designs or drawings for objects that are lost in their completed state, or that were abandoned or rejected prior to being executed. While Victor Buchli is 'interested in the prototype, because of its immateriality', art history is populated with examples of immaterial artefacts that are in his words 'materialized, stabilized physically or expressed in durable form'.[42] This mode of durable expression can be variously visual, material and/or textual. Work in the last two decades by literary scholars has celebrated the 'cavalcades of objects' among the pages of English Renaissance verse, eighteenth-century It-narratives and Victorian novels (to cite only a selection).[43] All of these textualized objects might propitiously be understood in relation to the 'vast heap of *things*' that constitute immaterial culture, the similarly densely populated objectscape in between history of art and material culture, where the notion of the objectscape becomes a means for describing art history as practice, rather than as theory, by relocating the discipline in its objecthood.[44]

Notes

1 I would like to thank the editors of this volume for inviting me to contribute to it; Chris Breward, Jas Elsner, Ruth Burgon and Rachel Travers for their assistance, also, my PhD students who teased me endlessly for my penchant for pictograms, including Freya Gowrley, who read an earlier draft. My friends and colleagues in the 'East India Company at Home, 1757–1857' project, Margot Finn, Helen Clifford, Kate Smith and Ellen Filor, forced me to revisit material culture studies when I was thoroughly preoccupied with administration and I am indebted to them for this and for all their invaluable input; for further information see http://blogs.ucl.ac.uk/eicah/.

2 I have 'borrowed' this flat/fat analogy from my colleague Evelyn Welch.

3 http://www.mfa.org/collections/object/paul-revere-32401. See E. W. Lasser (2012), 'Selling silver: the business of Copley's *Paul Revere*', *American Art* 26, pp. 26–43.

4 J. D. Prown (1982), 'Mind in matter: an introduction to material culture

theory and method', *Winterthur Portfolio* 17 (1), p. 7; J. Elsner (2010), 'Art history as ekphrasis', *Art History* 33 (1), pp. 10–27.

5 J. Walvin (1997), *Fruits of Empire: Exotic Produce and British Taste, 1660–1800*. Basingstoke: Macmillan, p. 12. I agree with J. de Groot (2006), 'Metropolitan desires and colonial connections: reflections on consumption and empire', in C. Hall and S. O. Ross (eds), *At Home with Empire: Metropolitan Culture and the Imperial World*. Cambridge: Cambridge University Press, pp. 177–78, that a detailed analysis of the 'consumption of empire' should approach it as a composite of material and cultural elements with combined, uneven and shifting interaction.

6 L. Daston (2004), 'Speechless', in L. Daston (ed.), *Things That Talk: Object Lessons from Art and Science*. New York: Zone Books, pp. 21 and 9.

7 J. D. Prown (2001), *Art as Evidence: Writings on Art and Material Culture*. New Haven and London: Yale University Press, p. 1.

8 J.D. Prown (1980), 'Style as Evidence', *Winterthur Portfolio* 15 (1), pp. 197–210. See also Prown's observation in the introduction to *Art as Evidence*, p. 10: 'although my work in art history and in material culture was expressed in separate graduate courses and separate essays, they were unified in my mind: they employed the same methodology for the most part and they worked towards achieving similar ends'.

9 Prown, *Art as Evidence*, p. 56.

10 M. Yonan (2011), 'Towards a fusion of art history and material culture studies', *West 86th* 18 (2): http://www.west86th.bgc.bard.edu/articles/yonan. html [accessed 27 July 2014].

11 Prown, 'Mind in matter', p. 2. This essay and all Prown's articles discussed in this chapter have been republished in various places. They were brought together in Prown, *Art as Evidence*, which includes an introduction by the author ('why I wrote what I wrote when I wrote it') and a bibliography of all Prown's published works, pp. 295–97.

12 Ginzburg is quoted and discussed in P. Glennie and N. Thrift (2002), 'The spaces of clock times', in P. Joyce (ed.), *The Social in Question: New Bearings in History and the Social Sciences*. London and New York: Routledge, pp. 151–74. See also B. S. Gregory (1999), 'Is small beautiful? microhistory and the history of everyday life'. *History and Theory* 38 (1), pp. 100–110.

13 C. Jenks (1995), 'The centrality of the eye in Western culture: an introduction', in C. Jenks (ed.), *Visual Culture*. London: Routledge, p. 16.

14 D. Cherry (2004), 'Art history visual culture'. *Art History* 27 (4), p. 479.

15 J. Derrida (1976), *Of Grammatology*. Baltimore and London: Johns Hopkins University Press, p. 145.

16 E. Edwards, C. Gosden and R. Philips (eds) (2006), *Sensible Objects: Colonialism, Museums and Material Culture*. Oxford and New York: Berg, p. 10.

17 M. Rampley (2005), 'Visual culture: an end to the history of art', *Ars* 38 (1), pp. 53–66.

18 The latter phrase is quoting W. J. T. Mitchell (2002), 'Showing seeing: a critique of visual culture', *Journal of Visual Culture* 1 (2), p. 166.

19 Prown, 'Mind in matter', p. 15.

20 J. D. Prown (2000 [1993]), 'The truth of material culture: history or fiction?', in J. D. Prown and K. Haltman, *American Artifacts: Essays in Material Culture*. East Lansing: Michigan State University Press, p. 13.

21 B. Brown (2001), 'Thing theory'. *Critical Inquiry* 28 (1), p. 16.

22 C. Knappett (2005), *Thinking through Material Culture: An Interdisciplinary Perspective*. Philadelphia: University of Pennsylvania Press, p. 3.

23 J. J. Winckelmann (2006), *History of the Art of Antiquity*, trans. H. F. Mallgrave. Los Angeles: Getty Research Institute, p. 351.

24 N. Bryson (1983), *Vision and Painting: The Logic of the Gaze*. London: Macmillan, pp. 87–131.

25 A. Appadurai (1986), *The Social Life of Things: Commodities in Cultural Perspective*. Cambridge: Cambridge University Press, p. 5; T. Dant (1999), *Material Culture in the Social World: Values, Activities, Lifestyles*. Buckingham: Open University Press, pp. 40–59, has a useful chapter on fetishism in relation to Marx, Freud and Baudrillard.

26 H. Glassie (1975), *Folk Housing in Middle Virginia: A Structural Analysis of Historic Artifacts*. Knoxville: University of Tennessee Press, p. 8. I would have to agree with E. B. Wood (1967), 'Pots and pans history: relating manuscripts and printed sources to the study of domestic art objects', *American Archivist* 30 (3), p. 441: 'Documents are *artifacts* in themselves. The paper, the ink, the handwriting, tell us as much as the words'.

27 A. Smart Martin and J. Ritchie Garrison (eds) (1997), *American Material Culture: The Shape of the Field*. Knoxville: University of Tennessee Press.

28 J. Deetz (1977), *In Small Things Forgotten: The Archaeology of Early American Life*. New York: Anchor Press, p. 24.

29 Deetz, *In Small Things Forgotten*, p. 24; T. Bickham (2008), 'Eating the empire: intersections of food, cookery and imperialism in eighteenth-century Britain', *Past & Present*, 198, pp. 71–109, makes some pertinent comments about food as a material object.

30 Deetz, *In Small Things Forgotten*, p. 5, distinguishes between historical archaeology and prehistoric archaeology, explaining that in America, historical archaeologists are concerned with the development of culture since the seventeenth century and the ways in which it compares and contrasts with its Old World antecedents and its impact on the Native American cultural tradition.

31 Brown, 'Thing theory', p. 1.

32 An exception is Marcia Pointon who in her inestimable student handbook to history of art first published in 1980 includes a circular pictogram captioned 'Interrogating a work of art' with a series of eighteen questions – nine moving clockwise, the other nine, anti-clockwise. M. Pointon (1997), *History of Art: A Student's Handbook*. London: Routledge, 4th edition, p. 63.

33 Prown, 'Mind in matter', p. 2.

34 C. F. Montgomery (1961), 'Some remarks on the practice and science of connoisseurship', *American Walpole Society Notebook*; republished in 1982 as 'The connoisseurship of artifacts', in T. J. Schlereth (ed.), *Material Culture Studies in America*. Nashville: AASLH Press, pp. 143–52.

35 E. McClung Fleming (1974), 'Artifact study: a proposed model', *Winterthur Portfolio 9*, pp. 153–73.

36 W. Davis (1994), 'Winckelmann divided: mourning the death of art history', in W. Davis (ed.), *Gay and Lesbian Studies in Art History*. New York: Haworth Press, p. 150.

37 Davis, 'Winckelmann divided', pp. 154–55.

38 D. Miller (ed.) (2005), *Materiality*. Durham and London: Duke University Press, p. 4.

39 H. Morphy (2010), 'Art as action, art as evidence', in D. Hicks and M. C. Beaudry (eds), *The Oxford Handbook of Material Culture Studies*. Oxford: Oxford University Press, p. 266, suggests that in recent years, anthropology has had a greater impact on art history than the other way round.

40 V. Buchli (2010), 'Presencing the im-material', in M. Bille, F. Hastrup and T. F. Sørensen (eds), *An Anthropology of Absence: Materialisations of Transcendence and Loss*. New York: Springer, p. 185.

41 G. Adamson (2009), 'The case of the missing footstool: reading the absent object', in K. Harvey (ed.), *History and Material Culture: A Student's Guide to Approaching Alternative Sources*. London and New York: Routledge, pp. 192–207.

42 Buchli, 'Presencing the im-material', p. 187.

43 P. S. Hammons (2010), *Gender, Sexuality, and Material Objects in English Renaissance Verse*. Ashgate: Farnham; M. Blackwell (ed.) (2007), *The Secret Life of Things: Animals, Objects and It-Narratives in Eighteenth-Century England*. Lewisburg: Bucknell University Press; E. Freedgood (2006), *The Ideas in Things: Fugitive Meanings in the Victorian Novel*. Chicago and London: Chicago University Press, p. 1.

44 C. S. Wall (2006), *The Prose of Things: Transformations of Description in the Eighteenth Century*. Chicago and London: Chicago University Press, p. 96.

Further reading

Brown, B. (2001), 'Thing theory', *Critical Inquiry* 28 (1), pp. 1–22.

Cherry, D. (2004), 'Art history visual culture', *Art History* 27 (4), pp. 479–493.

Deetz, J. (1977), *In Small Things Forgotten: The Archaeology of Early American Life*. New York: Anchor Press.

Prown, J. D. (1982), 'Mind in matter: an introduction to material culture theory and method', *Winterthur Portfolio* 17 (1), pp. 1–19.

Prown, J. D. (2000 [1993]), 'The truth of material culture: history or fiction?' in J. D. Prown and K. Haltman, *American Artifacts: Essays in Material Culture*. East Lansing: Michigan State University Press, pp. 11–27.

Prown, J. D. (2001), *Art as Evidence: Writings on Art and Material Culture*. New Haven and London: Yale University Press.

Rampley, M. (2005), 'Visual culture: an end to the history of art', *Ars* 38 (1), pp. 53–66.

Winckelmann, J. J. (2006), *History of the Art of Antiquity*, trans. H. F. Mallgrave. Los Angeles: Getty Research Institute.

CHAPTER TWO

Father Amiot's Cup:

A Qing Imperial Porcelain Sent to the Court of Louis XV[1]

Kee Il Choi Jr.

The history of material culture draws together scholars from different disciplines of the humanities and the social sciences. Thus, numerous methods and viewpoints are applied to questions of common interest, to reconstruct, as Simon Schama expressed it, 'the reality of lost worlds'. Simultaneously, Schama persuasively asserted that 'History without the eloquence of images is blind; art without the testimony of texts is deaf'.[2] This brief essay, then, attempts to link texts and objects in order to highlight a hitherto neglected connection between China and France in the eighteenth century, the essential concerns of which are poetry, porcelain and politics. Sophisticated actors carried out this interaction and, through established networks of trade and information, arrived at what Greg M. Thomas called 'a mutual appreciation of difference' between cultures, but also 'the recognition of similarity'.[3]

Henri-Léonard-Jean-Baptiste Bertin is mostly remembered as a key minister of state who served Louis XV (r. 1715–74) at a time of crisis following the conclusion of the Seven Years' War in 1763.[4] A creature of the French Enlightenment whose belief in reform was tempered by an abiding devotion to the monarchy, Bertin was born in 1720 into a wealthy family of the *noblesse de robe* from the Périgord. Originally schooled by the Jesuits and trained in law, he rose rapidly to become *lieutenant-général de police de Paris* in 1757, *contrôleur général des finances* in 1759, and *sécretaire d'État* from 1762–80. In this capacity, Bertin became responsible not only for the king's personal finances, but also for an influential assortment of departments,

including the *Compagnie des Indes*, canals, roads, mines, veterinary medicine and agriculture. In 1767, he was also appointed *commissaire du Roi* of the royal porcelain manufactory at Sèvres, a position he held until 1780. He died in exile in Spa, Belgium in 1792.

Bertin's role as a discerning collector of Chinese art and artefacts is not well known today. However, in his popular guidebook to Paris of 1787, Luc-Vincent Thiéry (1734–1815) not only celebrated Bertin in this respect, but also highlighted the 'continuous correspondence which M. Bertin maintained for more than twenty years with the French living in Peking'.[5] Comprised of hundreds of letters, this correspondence was mined liberally by French historians of the early twentieth century, who focused mainly on Bertin's patronage of the Jesuits following the suppression of the order in France in 1764. These same letters – which Bertin himself proudly proclaimed to be his *correspondence littéraire* – also document myriad artefacts and works of art sent to him from China between 1765 and 1786 by his principal correspondents. These included the great French sinologist Father Joseph Amiot, and the two native Chinese but French-educated Jesuit missionaries Aloys Ko (1732–95) and Etienne Yang (1733–93).[6] By virtue of their privileged entrée at the Qing court, these three men were able to procure extraordinary objects which were not otherwise available through commercial networks. These comprised printed books, paintings, lacquers, hard stones and several precious imperial porcelains. Until now, none of these porcelains has been identified or even specified in terms of type.

A close examination of the texts associated with Bertin has revealed a remarkable discovery. The *Porcelaines* section of the sale of *Le Cabinet Chinois de Feu M. Bertin* in 1815, includes the following description of lot 20: 'A cup with its cover; one sees in the well of the cup three trees, about which the Emperor Qianlong composed a poem which is inscribed on the cup and its cover. Father Amiot, missionary in China, translated the poem into French. The transcription and translation are found at the end of the Ode to Mukden' (Figure 2.1).[7]

This auction catalogue entry may be linked to two descriptions of porcelain cups and covers sent from China to Bertin in the 1760s. The first description, attached to a letter from Father Amiot to Henri-Léonard Bertin dated 23 September 1766, reads: '2 cups and their covers, on which are poems composed by the Emperor himself, in the 11th year of his reign, and which I have translated into French as best as I could'.[8] A second item from a list dated 1769 describes: 'two cups with poems by the Emperor TCHIEN-LONG'.[9] In aggregate, these texts from 1815 and the 1760s suggest that at least one of these cups had inscribed on it the *Sanqing cha* ('Three Purity Tea') poem, which was indeed composed by Qianlong in the winter of 1746, the eleventh year of his reign.[10] This poem praised the virtues of a tea brewed in the pristine water of melted snow from a blend of the essence or fruit of three trees – plum blossom, pine nut and finger citron – and hinted at the attributes of an upright character (Figures 2.2 and 2.3). The Qianlong

FIGURE 2.1 *Tea Bowl in overglaze iron-red inscribed with the imperial poem* Sanqing cha *(1746). Qing dynasty, Qianlong mark and of the period (1736–95). H: 5.6 cm; MD: 10.8 cm; BD: 4.8 cm. National Palace Museum (17581), Taiwan, Republic of China.*

FIGURE 2.2 *Tea Bowl. Detail of interior. The interior presents plum blossom, finger citron and pine nut, the ingredients of* Sanqing cha *or 'Three Purity Tea', the subject of the poem composed by the Qianlong emperor and inscribed on the exterior.*

FIGURE 2.3 *Tea Bowl. Detail of base. Six-character reign mark* (nianhao) *of the Qianlong emperor.*

emperor (r. 1736–95) is said to have composed over 40,000 poems, many of which were inscribed on officially commissioned works of art and ceramics.

Imperial 'character' porcelains of the Qing dynasty have survived in a variety of palettes – iron-red, underglaze blue and famille rose – and were inscribed with tea poems composed not only in 1746, but also in 1759, 1764 and 1791.[11] The Qianlong emperor is said to have awarded such tea-themed porcelains to guests who, by imperial behest, composed exemplary poems at his annual New Year's tea parties held in January at Chonghua Palace.[12] This event was staged 43 times during Qianlong's reign and attended by an elite group of courtiers numbering from 18 to 28.[13] The acts of drinking the fabled tea and composing poems to further extol its virtues at these ritualized occasions assumed a moral and political dimension. As the poem delineates, each of the three ingredients evokes an aspect of purity: the inviolate colour of the plum blossom, the clean fragrance of the finger citron and the refreshing taste of the pine nut, and hence is known as *Sanqing cha* or 'Three Purity Tea'. The relevant character for 'purity' (*qing*) is the same character used to denote the traditional image of the virtuous, incorruptible official (*qing guan*). While no evidence has yet surfaced which places him at any of these parties, I would like to suggest that, prior to 1765, Father Joseph Amiot may have received the gift of such a *Sanqing cha*

porcelain cup or cups, perhaps in recognition of imperial esteem for the
Jesuit's own literary attainments. Amiot then forwarded the cups on to
Henri Bertin in what might constitute the first documented instance of
authentic Qing imperial porcelain to reach Europe.

Jean-Joseph-Marie Amiot's early life represents an ordinary beginning to
what became an extraordinary career in China. Born in Toulon in 1718,
educated in theology and the classics, he was admitted to the Society of Jesus
in 1737, and ordained in 1746.[14] Three years later, Amiot departed for China
as a missionary, arriving in Canton in July of 1750. He was immediately
commanded by the emperor to attend the court at Peking, where he quickly
established himself, eventually becoming Qianlong's official translator of
Western languages. During the course of a China mission of over forty years'
duration – he died in Peking in 1793 – Amiot studied many aspects of
Chinese culture, especially languages. He mastered Manchu, the emperor's
native tongue, as well as Han Chinese, both necessary for service within the
Qing court. His translation of the poem 'Ode to Mukden' composed by
Qianlong in 1743, was published by Joseph de Guignes (1721–1800),
another Bertin protégé, in Paris in 1770.[15] This volume also offered a second
verse – 'a Poem on Tea, composed by the same Emperor'.

The 'Poem on Tea' is the wholly overlooked coda to the renowned
publication of the 'Ode to Mukden,' a paean to antiquity in which the Qianlong
emperor heralded what Mark C. Elliott has described as 'the mythical locus of
Manchu origins'.[16] This imperial celebration of Manchu ethnicity, as well as a
promotion of its national myth, achieved partially through the official
dissemination of this poem, helped both to further legitimize Qing antiquity
and thereby to bolster the Qing claim to the throne of heaven. In addition,
Amiot's publication of these combined texts in French illuminates his thinking
about Qianlong, and thereby the significance of the imperial porcelain cups
which he received from the emperor and sent to Bertin.

As the description of 1766 implies, Amiot transcribed the 'Sanqing cha'
poem from an imperial porcelain 'character' cup and then translated it.
Hence, his interest in the inscribed ceramic was literary and, as such, not
unprecedented. European awareness of inscribed Chinese export wares
began in the seventeenth century.[17] The invoices of 1623 and 1626 of two
Dutch merchantmen list 'character' cups in their cargos. Two still-life
paintings by the French artist Jacques Linard (1600–45), dated 1627 and
1638, depict blue and white bowls decorated with an abbreviated version of
the Northern Song dynasty prose poem 'Rhapsody on Red Cliff' composed
by Su Shi (1037–1101) in 1082. The bowls presented, although not imperial,
are of a type attributable to the Tianqi period (1620–27). The 1721 inventory
of Augustus II the Strong (1670–1733), Elector of Saxony records two
similar, extant examples of this Ming export type.

In the 1770 preface to the 'Three Purity Tea' poem, Amiot confirms that
Qianlong composed it while hunting at the imperial game reserve at Mulan,
located north of the Great Wall; and that it was inscribed by the emperor's

command on cups of 'exceptional porcelain' made at an imperial factory.[18] Amiot further observes that the emperor was accompanied by thousands of men who, like him, were dressed and bivouacked in the Tartar manner, evoking for the Manchu people a 'memory of their ancient origin'.[19] Amiot deftly contrasts this pursuit of the manly, martial arts of archery and horseback riding – skills central to the ancient Manchu hunter-warrior ethos – with the composition of the poem and the fashioning of the inscribed cup, essential components of the Han literati pursuit of the fine arts: poetry, calligraphy, painting and connoisseurship.

In addition, the preface to the 'Three Purity Tea' poem helps us to understand how Amiot – effectively a civil servant with two political masters – mediated his own relationships both to the Qianlong emperor and Henri Bertin. On the one hand, Amiot filially emphasizes the superiority of the emperor's erudition as a poet-warrior balancing both Han and Manchu traditions; and on the other, subtly recommends himself to the minister as an exceptional analyst of Chinese civilization. Thus, he states: 'One needs to master perfectly the Chinese language in order to be in tune with their poetry, to understand and to be able to express in our language all the subtlety of expression which the Emperor employed in his verse'. And he concludes: 'I offer it only as a copy of a picture by a Great Master; because the Emperor is one of the foremost literary lights of his Empire'. By casting the 'Poem on Tea' in this light, Amiot promoted the emperor before a European audience as a learned and great ruler of an ancient culture. The cup upon which it was inscribed and which Amiot sent to Bertin served as an authentic exemplar of the Qianlong emperor's greatness for the minister's admiration and reflection. A defining aspect of that greatness was the Emperor's role as both the possessor and guardian of China's antiquity as exemplified by its many cultural, religious and political traditions.

Amiot's cup, therefore, figures prominently as a paradigm of specific aesthetic and political values conveyed from one country and culture to another by what Maxine Berg has called 'knowledge communities'.[20] Jesuit missionaries had long comprised one such community of knowledge both of Christianity and European science at the Qing court. In addition, they not only supplied their European masters with unusual objects, but also with critical intelligence about China. While it has been largely ignored by art historians, especially with respect to Bertin, the significance of such intellectual and practical contributions cannot be overstated.

Bertin's career was distinguished by his diplomatic courtship of China and his promotion of the foreign land as an instructive model for France in the aftermath of the Seven Years' War.[21] His aggressive public policy advocacy would not have been as pervasive or effective were it not for the informed agency of Joseph Amiot and the two Chinese Jesuits, Ko and Yang. Bertin's innovative application of some of their information and analysis toward the reform of the Sèvres factory in the early 1770s, resulted in an appreciation of cultural differences between France and China, one attained

through a contemplation of a similar archetype of antiquity. Most relevant for us is the high value placed in his correspondence on obtaining 'authentic' information – useful, practical knowledge of the Enlightenment, but coming from very far away.

Notes

1 This essay was derived from a more extensive paper entitled 'Father Amiot's Cup, Henri-Léonard Bertin and Fashioning 'Antiquity' at Sèvres', which I presented at the conference 'Global Commodities: The Material Culture of Global Connections, 1400–1800', held at the University of Warwick in December 2012. Walter Liedtke of The Metropolitan Museum of Art, François Louis of the Bard Graduate Center and Kristel Smentek of the Massachusetts Institute of Technology generally offered support as well as much valued criticism of the text at various stages. The staffs of the library of the Institut de France, Paris, and the Thomas J. Watson Library at The Metropolitan Museum of Art, New York, could not have been more professional or agreeable in responding to my many requests for materials.

2 S. Schama (2013), 'The Rijksmuseum re-opens,' *Financial Times*, 29 March, http://www.ft.com/cms/s/2/6050ffc2–96cb-11e2-a77c-00144feabdc0. html#slide0, 2. [accessed 27 July 2014].

3 G. M. Thomas (2009), 'Yuanming Yuan/Versailles: intercultural interactions between Chinese and European palace cultures', *Art History* 32 (1), p. 117.

4 J. Silvestre de Sacy (1970), *Henri Bertin dans la sillage de la Chine*. Paris: Cathasia, is the standard biography. See also C-Y. Lee (2002), 'L'enjeu politique et religieux des modes de répresentation dans les *Mémoires concernant les Chinois* (1776–1791)', *Histoire de l'art* 51, pp. 87–99.

5 L-V. Thiéry (1787), *Guide des amateurs et des étrangers voyageurs à Paris*. Paris: Hardouin et Gattey, pp. 134–36.

6 See Lee, 'L'enjeu politique et religieux', pp. 88 and 98 (note 2) for biographical information on Ko and Yang.

7 '20 Une tasse avec son couvercle; on voit dans le fond de la tasse trois arbres, pour lesquels l'Empereur Kien-Long a fait des vers qui sont gravés sur la tasse, et le couvercle. Le père Amiot, missionnaire á la Chine, les a traduits en français. La transcription et la traduction se trouvent á la suite de l'éloge de Moukden'. H. Delaroche and Moreau (1815), *Notice des articles curieux composant le cabinet chinois de feu M. Bertin, ministre et sécretaire d'État sous Louis XV et Louis XVI*. Paris: Crapelet, p. 9.

8 '40 2 tasses avec leurs couvercles sur les quels sont des vers faits par l'Empereur lui même, la 11e année de son regne, et que j'ay traduits en français le moins mal que j'ay pû'. Institut de France, Ms. 1515, Amiot to Bertin, at the very end of the letter, an attached itemization of things sent, 23 September 1766. Folio 2–3 (verso). See also H. Bernard-Maître (1948), 'Catalogue des objets envoyées de Chine par les missionnaires de 1765 á 1786', *Bulletin de l'Université Aurore* 33–34, p. 125.

9 'Deux tasses avec des vers de l'Empereur TCHIEN-LONG'. Institut de France, Ms. 1524, from an itemization of things sent from China in 1769. Folio 133 (verso). See also Bernard-Maître, 'Catalogue', p. 132.

10 P.Y.K. Lam (1998–99), 'Tang Ying (1682–1756) the imperial factory superintendent at Jingdezhen', *Transactions of the Oriental Ceramics Society* 63, pp. 67–71.

11 See Museu de Arte de Macau (2002), *Huai bao gu jin: Qianlong huang di wen hua sheng huo yi shu / Aomen yi shu bo wu guan (The Life of the Emperor Qian Long / The Macao Museum of Art)*. Macao: Macao Museum of Art, for illustrations of bowls inscribed with tea poems composed chronologically: pp. 258–59 (1746); p. 262 (1759 and 1764); and pp. 266–7 (1791). For a famille rose bowl (Grandidier Collection) with the *Sanqing cha* poem of 1746, see Musée Guimet (2006), *Les Très riches heures de la cour de Chine: chefs d'oeuvre de la peinture impériale des Qing, 1662–1796*. Paris: Réunion des musées nationaux, p. 171, fig. 84. None of the *Sanqing cha* bowls and covers sent to Bertin has been located. For a pair of iron-red bowls and covers with *xiqing tang zhi* marks, see Christie's (2010), *Fine Chinese Works of Art and Ceramics including Property from the Arthur M. Sackler Collections*. New York: Christie's, 26 March, lot 1437.

12 See B. Liao (2013), *Ye ke yi qing xin: cha qi, cha shi, cha hua (Empty vessels, replenished minds: the culture, practice and art of tea)*, 5th ed. Taipei: National Palace Museum, pp. 152–53, catalog numbers 129 (Figure 1.1) and p. 130, for illustrations of two of the twenty cups said by the author to be original to the palace of the Qianlong era. See also B. Liao (2012), *Cha yun ming shi: Gu gong cha hua*, 4th ed. Taipei: National Palace Museum, pp. 93–6, for more on the gifting of bowls decorated with the *Sanqing cha* poem at the annual Lunar New Year tea parties.

13 I am grateful to Liao Baoxiu for confirming both the frequency of these celebrations during the Qianlong emperor's reign as well as the variable number of courtiers in attendance.

14 For biographical information on Jean-Joseph-Marie Amiot, see Lee, 'L'enjeu politique', pp. 88 and 98 (note 3); and F. Picard (2008), 'Amiot', in F. Pouillon (ed.), *Dictionnaire des orientalistes de langue française*, Paris: IISMM:Karthala, pp. 14–15.

15 Qianlong, Emperor of China (1770), *Éloge de la Ville de Moukden et de ses Environs*. Translated by P. Amiot. Paris: N.M. Tilliard.

16 M.C. Elliott (2009), *Emperor Qianlong – Son of Heaven, Man of the World*. New York: Longman, pp. 58–9; and idem (2004), 'Qianlong's Ode to Moukden', in C. Ho and B. Bronson, *Splendors of China's Forbidden City: The Glorious Reign of Emperor Qianlong*, London: Merrell, p. 32.

17 C.J.A. Jörg and J. van Campen (1997), *Chinese Ceramics in the Collection of the Rijksmuseum, Amsterdam: The Ming and Qing Dynasties*. London: Philip Wilson, p. 51, catalogue no. 33.

18 Qianlong, *Éloge*, pp. 329–30, for the complete preface referred to here and ensuite.

19 See also M.C. Elliott (2004), 'Manchus and Tigers and Bears', in C. Ho and B. Bronson, *Splendors of China's Forbidden City: The Glorious Reign of Emperor Qianlong*. London: Merrell, p. 110.

20 M. Berg (2004), 'In pursuit of luxury: global history and British consumer goods in the eighteenth century', *Past & Present* 182, p. 104.

21 G. Lewis (2004), 'Henri-Léonard Bertin and the fate of the Bourbon monarchy: the Chinese connection', in N. Hampson et al. (eds), *Enlightenment and Revolution: Essays in Honour of Norman Hampson*. Aldershot, Hampshire: Ashgate, pp. 69–90.

CHAPTER THREE

Written Texts and the Performance of Materiality

Catherine Richardson

Quantitative and qualitative methodologies

Unlike archaeologists, or art or architectural historians, historians of material culture tend to begin with written documents that describe objects rather than the objects themselves. Historians might be seen as starting from a position of absence then – the things on which they work are 'on the other side' of language, embodied and mediated by historical subjects' sense of the appropriate words in which to describe them. But whereas the object might be absent, the document writer's choices give access to contemporary processes of evaluation and interpretation. Historians may not have things, but they are able to access evidence of attitudes towards them, feelings about them and, therefore, their social and cultural meanings and functions. Such evidence is not easy to interpret. If historians are to do justice to linguistic subtleties, they need to be savvy about how language works and how it might relate to experience, of which materiality is such a crucial aspect. Some assistance might come from literary scholars, who often analyse how things work in a fictional context – how objects are deployed within narrative structures and what work they do there. Those ideas are useful as they draw attention to the crafted nature of all written documents, but historians need to extend that kind of analysis to investigate the point where language and the people who use it come together: at the moments when documents are written and read.

In broad and crude terms, historical study of material culture has been influenced by two central methods, the quantitative and the qualitative.

Social science offers a method for quantitative engagement with materiality. The 2004 book *Production and Consumption in English Households 1600–1750* by Mark Overton, Jane Whittle, Darron Dean and Andrew Hann, for instance, charts the development of consumption practices by 'approaching an old problem, the development of capitalism, through the economic activities of the household', analysing probate inventories with the aid of a sophisticated database. This allows them to give a framework for analysis of change over time and differences between geographical areas. They are able to demonstrate, for instance, that in Cornwall 'Less than 5 per cent of inventoried households in the county had specialised service rooms in the early eighteenth century, compared with more than 70 per cent in Kent'.[1] We get a clear sense from this kind of analysis of how individual choices and experiences might have fitted into a wider picture of the contemporary appreciation of material possibilities – of supply and demand, and of a comparative awareness of one's neighbours' consumption choices. What we do not get close to is material experience – to the actual choices individuals made and how they responded to them – or to consumption in terms of, as Sara Pennell has put it, 'what consumers did with the goods they consumed'.[2] We cannot understand individuals' interaction with their material environment, and it is into this gap that literary analysis can step.

A qualitative investigation has its roots in literary studies' micro-analysis of language. This kind of analysis usually takes place at the level of the individual document, as it aims to account for the choices that men and women made in respect of material culture. It begins by taking into consideration the purpose for which the document was written and the prescriptions and practices that shape and surround that purpose. It is only by understanding the role that the details of linguistic choice and their ordering might play in the aims of the writer that we will be able to evaluate the access language gives to material attitudes with any degree of accuracy.

The language of inventories

A probate inventory is a list of goods owned by the deceased at the time of their death. The appraisers who drew up the document were responsible for pricing the goods in relation to their value on the second hand market, and the descriptions they give of them are therefore intended to account for the price they have put on them, and also to some extent to distinguish between similar objects owned by the same person. We can use this detail to read backwards to the material qualities of the objects they describe. In high-status inventories it is fairly easy for us to see how descriptive language justifies value by helping the reader of the document to visualize the objects in question. The 1643 inventory of Warwick Castle, for instance (Figure 3.1), lists the magnificent goods of the recently-deceased 'right honorable Robert Lord Brooke'. Items include 'a large yellowe quilt of China satten stitch and

(a)

FIGURE 3.1 'An inventory taken at Warwick the twoe and twentith daye of January 1643 of all and singular the goodes chattels and credittes of the right honorable Robert Lord Brooke Baron Brooke of Beauchamps Courte in the Countie of Warwick', Warwick County Record Office CR 1886/ 2711, f. 1–1v.

(b)

FIGURE 3.1 *Continued*

bordered about with Crimson China satin lynd with golde colord sarcenett with an edging fringe about it red and yellow 8li', or 'foure peeces of fresh and lively hangings of the story of the Wooer belonging to the silver bedd chamber', valued at a staggering £80, and 'six large peeces of old hangings of the story of Meleager . . . belonging to the greate chamber' valued with other pieces at £40.[3] It is not only condition that determines price here: the imagery on the tapestry, the patterning of yellow and crimson satin on the quilt and its fringing, and the mention of fabrics from China, all bring pictures to the mind's eye that support the valuation.

Inventories offer the historian more than simply lists of individual items, however. Lord Brooke's Library contained £40 worth of books and the following objects:

A flat deske covered with greene blanckt velvet vs [5 shillings]
A Table of redwood with a standing frame xxs [20 shillings]
A fireshovell with brasses xviiid [13 pence]
A foote stoole of liver Collord velvet iis vid [2 shillings and 6 pence]
A lether cushion xiid and an old elbowe Chaire of red Cloth lacd and fringd vs [5 shillings]
A joynd stoole xiid [12 pence]

From the full description of objects in the same room, it is possible to begin to imagine how Lord Brooke might have used his library – an old red chair with arm rests, on which he might have sat at a redwood table with a green velvet-covered desk on it to read his books, with a joined stool next to him perhaps for his secretary. In other words, attending in detail to the language used in these documents advisedly, sensitive to the way their writers employed it to reconstruct their impression of the value of the objects, makes it possible to begin to reconstruct peoples' material environments – the connections between their things in space.

With lower-status inventories, this process of reconstructing the material nature of goods and spaces from their descriptions might appear less rewarding – things are often described in less detail and appear to be less visually striking. For instance, the following items were listed as being in the parlour next to the hall of William Rogers, Sergeant-at-Mace of Stratford-upon-Avon, on his death in 1597:

Item a table boorde and one stoole and a carpett	ijs [2 shillings]
Item a bench and ij coffers	xviijd [18 pence]
Item a presse, a cubbord & ij joynde boxes	xxs [20s]
Item a ioynde bedd with a trundle bedd	xijs [12s]
Item ij coverleddes with a rugg and a paire of sheetes	xs [10s]
Item a flockbedd, ij matteryses and iij bolsters	xs [10s]

Item a matteryce, a flockbedd, ij bolsters and ij white blanquettes	vjs viiid [6s 8d]
Item a paire of tables, a capcase & ij bottles	iis [2s]
Item aquavite, ballme water & rosa solis	vis viijd [6s 8d]
Item his wearinge apparrell	xls [40s]
Item a greate stone pott	ijs vjd [2s 6d]
Item ij peare of olde sheetes	iijs iiijd [3s 4d]
Item course lynnen	xiiijd [14d]
Item a pillowbyer and ij napkyns	xd [10d]
Item the glasse in the parlor wyndowe	xvjd [16d]
Item vij paire of sheetes	xxxs [30s]
Item iiij table clothes	viijs [8s]
Somma	vijli xviijs[4] [£7 18s]

How might we analyse a pragmatic, quotidian list like this? Attending carefully to linguistic hierarchies gives us a sense of the distinctions the appraisers thought significant. The adjectives used allow us to access the way the appraisers navigated around Rogers' room: the boxes and the bed are 'joined', the stone pot is a 'great' one, two of the pairs of sheets are 'old', and some of the linen is 'coarse'. They were interested in processes of manufacture – 'joining' wood with mortise and tenon joints was a superior form of making and goods produced in such a way were more durable, often more likely to be decorated and therefore worth more money. They were interested in the relative condition of goods, noting that some of them were old whereas others were not, and in their size, as a great stone pot would be worth more than a small one.

The language of the document, then, is the place to begin our understanding of contemporary perceptions of the relationships between different things as seen by the people who distinguished between them. But if our aim is to understand the full valence of both words and things, then we must consider going further and connecting linguistic analysis to surviving objects. For instance, let us consider what the 'greate stone pott' might have been like. The presence of a stone pot suggests that, in addition to apparently functioning as Rogers' bed chamber (with his bed and clothing in it), the room had a range of other functions. It held both playing tables for entertainment and his medicinal distillations. At this time aqua vitae had, according to the contemporary writer Gervase Markham 'infinite virtues', including efficacy 'against aches in the bones, the pox . . . all manner of cold sicknesses, and namely for the palsy or trembling joints, and stretching of the sinews; it is good against the cold gout; and it maketh an old man seem young'.[5] Balm water was an aromatic resin mixed with oils distilled in water, and rosa solis was made using aqua vitae, in which the plant (ros solis or sundew) was steeped 'in a glass or pewter pot of three or four pints' for three days and three nights.[6] So it is possible that the balm water and the rosa solis were kept in Rogers' two bottles, and the great stone pot contained the aqua

vitae, of which larger quantities were needed. Possession of these healing waters was a feature of elevated urban status; the greatness of this pot is linked to the quantity and significance of the goods it contains.

What might a great stone pot have looked like? Studying examples of stone pots helps us to understand how size, use and aesthetic qualities might combine in such a word as 'great'. First of all, language might be misleading. These pots were not made of stone, but 'stoneware', a robust type of earthenware common in the early modern period. Pots like the one in Figure 3.2 were imported from the region around Cologne in large numbers in the sixteenth and first half of the seventeenth centuries. At just under half a metre tall, this is a larger variety from Langerwehe, intended for storage as the stoneware reduces evaporation. They are sturdy and practical, but not without visual appeal, and although they are extremely familiar to archaeologists, for the majority of lower to middling status households they may well have been amongst the most visually remarkable objects owned. Rogers (a mercer who also kept an inn) had several other stoneware pots, but only three of his peers had such pots listed amongst their goods. Reading between language and objects allows us to refine our sense of the meaning of words. It suggests perhaps that 'great' here is not merely a description of size, but might mean distinguished, or pre-eminent – not only the opposite of 'small' but also of 'insignificant' and 'merely functional'.

This kind of careful attention to the detail of language which builds outwards from individual words can take us a long way towards understanding the dynamics of the objects and spaces of the past, especially when analysed in relation to other kinds of contemporary writing, quantitative analysis of runs of documents, and extant objects. Undertaking such work for groups of documents – for a whole village or an urban street perhaps – allows us to move beyond merely itemizing objects towards reconstructing wider ideas about the relationship between objects and status, perhaps even taste, not only for the elite but also amongst the middling to lower sorts.

The material culture of wills

If inventories give us access to the ways in which early modern appraisers assessed and categorized the goods of others, then wills give us some contact, however scribally mediated, with the language in which individuals described their own material environment: the 'will' as document had to represent the 'will' as intention of its author as precisely as possible, and that led to particular care in recording the dying person's words. As the writer of the testament of Simon Spatcherst says, the testator 'expressed his mynde to this deponent and desired this deponent to write the same'.[7] When the will was read, it was said to be read 'to the testator' in the presence of witnesses, the echo of their words ensuring its accurate repetition of their wishes.

FIGURE 3.2 *Large stoneware jug with incised and applied moulded decoration, Langerwehe, Germany, c. 1600. Height: 485 mm, Victoria and Albert Museum, C.132–1985 © Victoria and Albert Museum, London.*

The first significant aspect of this necessity to transcribe intention exactly is that we hear the words of those without writing skills, in an era before mass literacy. Particularly in the case of women and those of lower social status, these records of their testamentary decisions are often the primary contact they had with written culture. In these circumstances, the documents

themselves become significant objects, and an analysis of their physical forms, the 'materiality of the text', has been an important aspect of literary studies' approach to material culture.[8] For instance, the will and inventory which John Clerk of Sturry in Kent delivers to his overseer from his 'great purse', taken out of hiding for the occasion, are unreadable to both men, illegible because, as the court hears, neither were literate. As such they become symbols of Clerk's wishes, of his trust and the executive capacity he is passing on.[9] While both verbal self-consciousness and significant material wealth were often the preserve of the elite in such a society, Clerk's actions are resonant with perceived significance: his illiteracy renders the translation process between things and words a kind of encryption, making the literal into the symbolic. Taking account of both the significance of documents as objects and the physical forms that the writing of things takes within them helps us to understand our sources as part of their subjects' material environment.

It took time and cost money to make a will, so the number of bequests given and the detail in which they are recorded show how important the testator thought it was to ensure the smooth transfer of their goods. Describing goods is no trivial matter. Their identification has legal consequence, and objects so identified can therefore be taken as being singled out, made significant by their presence in the document. We need to read them with equal care, in a period which has been seen as characterized by a 'passion for specificity'.[10] For instance, Thomas Trott of St Stephen's parish in Hertfordshire, a yeoman, left to his son Roger 'the tabell in the hall with the frame where it standeth and all the hanginges in the same hall, with ij joyned formes . . . a great ioyned chest and a playne bedstede and the deepest saltinge trough'. To his son William he gave 'my ioyned beddstede, my great Chest that is bounde with iron, a pouldering trough which is in the old barne with a cover to it, one peare of flaxon sheetes & an other peare of towne.' To his son Thomas he left a 'playne bedsteed, the cubberd in the hall, a playne chest, the longe poulderinge trough, a peare of flaxon sheetes & a peare of towne sheetes, a bearinge sheete with a blacke seeme', to his daughter Margery 'ij peare of flaxon sheetes with a flaxon tabell cloth, a platter & a great candellstick', and to his daughter Elizabeth another two flaxen sheets and a flaxen tablecloth, platter and candlestick (not great), and finally to his daughter Ellen two pairs of flaxen sheets, a pewter basin and a candlestick.[11]

Trott's bequests show, like the lists of goods in inventories, subtle methods of discrimination between objects that include attention to their form and function, the processes by which they are made and the fabric of which they are constructed, their relative size and their location within the house. In addition, they indicate his sense of ownership and investment in them – 'my' joined bedstead, 'my great Chest'. In the connections Trott underlines between objects and spaces there is a clear sense that he is dividing up a functioning domestic unit, and that he is reordering the ownership of

different elements of it. In making this will, Trott is approaching his material environment as a store to be divided between his children. We can therefore think about his list of goods as a strategy, and analyse the relationship between the groups he gives to each of his children, noting, for instance, the way he seems to balance the joined bedstead to William with the plain bedstead to Thomas, or the deepest salting trough with the long pouldering trough. That strategy includes giving a range of objects practical for daily domestic and working life. As will be clear from the long lists of these goods I replicated above, studying such strategies means respecting the time and attention given by a document's original authors (reflected in the written 'space' they take up), and using this as a way of assessing their priorities and their sense of the significance of their own material culture. Ignoring this detail means discounting primary evidence for contemporary attitudes towards materiality.

Wills are actively engaged in negotiating the personal relationships between the testator and their recipients, and we might also use this evidence to talk about affective relationships with goods. We might want to talk about Trott's choices as indicative of his feelings towards his children – as symbolizing or embodying them – and the goods that he selects for each child as reflecting something more than his sense of their material needs. That is an argument that must be made solely from the patterns of his giving, as he does not directly comment on these matters. In some wills, the desire to make objects speak the language of affect is explicit. Joan Neale, for instance, transfers her possessions to a man called Nicholas Henden in language which, while it does not state the nature of their relationship, clearly demonstrates some kind of intimacy: 'I give unto you Nicholas Henden all my clothes and my gown cloth and I desire you to make you a cloak of it and weare it for my sake'.[12] The immediacy of her words seems to indicate passion and conviction (the will was orally delivered, and only written down after her death), but it is the conjunction of her use of the possessive and the injunction to use the object as a specific form of memorial that indicates the vital role objects could have in negotiating human relationships.

In an elite version of this tendency towards explicit testamentary expression of reciprocity, Katherine Scott, widow of Sir John Scott of Scotts Hall, leaves her 'best silver saltseller to the owner of Scottshall, and pray him in the Lord to take good care to fasten itt uppon his successors heires and owners of that howse with as much Care of mee, as I shew kindnesse to him, that itt maye be theire abidinge as testimony of my infinite affection thereunto (if it may bee) so longe as the world standeth'.[13] The length of the qualification – the logic and the reciprocity attendant upon her gift – and the language of affect (care, kindness, infinite affection and prayer) mediated through both the object of bequest and the house as a repository of family identity, are typical of elite material language. Attending to the language in which these bequests are expressed makes it possible to read them as

sophisticated testaments to a particular kind of early modern emotional engagement where the durability of objects is used symbolically. As Howell puts it, objects 'made social relationships concrete'.[14]

Such an approach is not without its dangers. In both cases quoted above, there is a specific reason for the explicitness of the language – one will repeats the patterns of speech as opposed to documentary form and the other articulates the concerns of elite status. But can we read such feelings back into less loquacious gifts such as those of Thomas Trott above? It appears that such sentiment does not naturally find a place within the generic constraints of the will. Lena Orlin cautions that 'so foreign is it for us *not* to sentimentalise objects – this is a Victorian legacy – that it may not occur to us to ask whether it would have been equally foreign for early moderns *to* sentimentalise them'.[15] Looking for evidence of the role of objects in early modern affect and interconnection is, however, a long way from seeing them as freighted with excessive, sentimentalized emotion around death. Relations need not be sentimental.

A combination of qualitative, linguistic analysis and quantitative assessment can help to guard against making immoderate assumptions. We can begin to assess how common bequeathal strategies are, both within and across communities: for instance, in a sample of 550 late-sixteenth-century wills, three types of objects are most commonly described with the possessive pronoun by testators: beds, rings and items of clothing, especially gowns. We can appreciate these objects as the ones to which individuals felt most personally attached, and note their close connections to the body.[16] They were all valuable objects, but whereas beds were only given within the family, jewellery and clothing were often also given outside the family and sometimes to executors or overseers of the will. This suggests a recognized strategy through which personal objects were given within the context of a patronage society that used a sophisticated material culture of allegiance. For instance Sheriff of Canterbury Leonard Bonner's executors were to purchase a ring with a death's head engraved upon it, and to meet together once a year, at an event where the rings could be formally worn – part of a ritual, public display of memory and association.[17] The role of objects in expressing allegiance after death is a long way from sentimentality. Through such a combined linguistic and quantitative analysis we can begin to understand the meanings of gifts in historical and geographical perspective.

Things in literary sources

As we have seen, will-making was a carefully scripted affair, the bequests given often intended to be displayed in public, in a show of relationship and allegiance, and this suggests the importance of notions of performance in early modern attitudes towards materiality. We have also seen how working

across documents produced at different levels of society and by individuals with varying levels of literacy reveals the challenges posed by the degree of explicitness with which attitudes towards things are discussed. For these reasons, studying the way objects are deployed in literary sources can be a useful addition to other forms of evidence available to historians. Here, objects are the explicit focus of attention as they are held up for the audience's scrutiny, self-consciously playing their part in the development of narrative and the exploration of character. Again, the meaning of things in such contexts is not straightforward, rather it is often debated by the speaking subjects.

Pamela Hammons analyses the way poets 'conceptualized relations among people and things, human and non-human subjects and objects', seeing how categories of object like love tokens and houses became implicated in the literary investigation of gender and property ownership. Her opening example is a poem written 'On Vollanties day this 14 ffeb: 1665' by a young London widow called Katherine Austen and addressed to an expensive jewel she had found near an old wall. Austen imagines herself talking to the stone:

Wellcome thou best of Vollanties
ffirmer to me then Lover's twines
Allas they vanish byt this tye
A pledge, a suertie Annually.[18]

Austen uses the object as a way of exploring religious meditation, seeing in its sparkle God's love for her: 'in its materiality, she encounters the divine', as Hammons puts it.[19] The rich meaning which early modern men and women found in their material culture – the way they used things as aids to thought – combined with their interest in writing imaginatively about them, makes literary works concentrated sources of meaning about early modern materiality. Drawing connections between documentary sources about objects and these more self-consciously expressive writings can help us to historicize the processes through which objects were cast in words – we can, for example, put this evidence alongside the bequests of rings explored above.

It is about the stage properties in early modern plays that the most coherent body of research has been produced, however.[20] Plays are deeply invested in the cant of contemporary meaning and the in-jokes about people and objects that appear so seldom in other types of evidence. They deal in the currency of the sharp social distinctions that can be drawn by the naming of things. In Middleton's *Women Beware Women*, for instance, Bianca, having been ravished by the Duke, finds her old life somewhat beneath her. She articulates the change of perspective brought about by her adultery through domestic objects, implicitly comparing her husband's house to the Duke's:

Why is there not a cushion-cloth of drawn-work,
Or some fair cut-work pinned up in my bedchamber,
A silver and gilt casting-bottle hung by't?[21]

These precisely described objects pinpoint clear contemporary distinctions between the households of the social elite and the upper-middling sort, and in so doing they re-animate the probate material with a sense of how status was mediated through objects. Understanding this process of discrimination gives a fuller picture of the significance of early modern materiality. It is a picture articulated through an attention to detail that is related to the distinctions of the inventories, and is based on the appreciation of the potential connections to the morality of goods on which archival sources are frequently silent.

Drama also has more conceptual things to tell us about the particular historicized relationship between material culture and language. The illusion of a material context for action in plays is formed from the interlocking, but also the explosive clash of things and language – a rich, sensory, electric connection between props, bodies and the spoken word. Perhaps the most famous prop on the early modern stage enters thus:

FIRST CLOWN: . . . Here's a skull, now. This skull has lain in the earth
 three-and-twenty years.
HAMLET: Whose was it?
FIRST CLOWN: A whoreson mad fellow's it was. Whose do you think
 it was?
HAMLET: Nay, I know not.
FIRST CLOWN: A pestilence on him for a mad rogue – a poured a
 flagon of Rhenish on my head once! This same skull, sir, was Yorick's
 skull, the King's jester.
HAMLET: This?
FIRST CLOWN: E'en that.
HAMLET: Let me see. [*He takes the skull*]
 Alas, poor Yorick. I knew him, Horatio – a fellow of infinite jest, of
 most excellent fancy. He hath borne me on his back a thousand
 times; and now, how abhorred my imagination is! My gorge rises at
 it. Here hung those lips that I have kissed I know not how oft. Where
 be your gibes now, your gambols, your songs, your flashes of
 merriment that were wont to set the table on a roar? Not one now to
 mock your own grinning? Quite chop-fallen? Now get you to my
 lady's chamber and tell her, let her paint an inch thick, to this favour
 she must come. Make her laugh at that.[22]

The scene combines early modern sensitivity to the meanings carried by objects with a metatheatricality that plays with how those things accrue meaning. Hamlet holds the skull in front of him, inviting the audience to

compare it to his youthful head and to imagine a conversation between equals – providing a lively image of the *memento mori*, the visual reminder of what we will all become. It is this image that was so often found on early modern mourning rings. The skull Hamlet holds was once the head of a living and breathing court jester whose job was to entertain with words. And yet, of course, it was not. It is a prop in a play, in which a gravedigger first gives it a potentially spurious context within the fictional world of the graveyard – can he really tell whose skull is whose in this raked up holy ground? – and then the actor playing a prince plays with the idea that he can re-enact a long-lost conversation with the jester. The audience are momentarily invited to wonder from whence this prop was dug, outside the illusion of the play – it was assuredly not from a courtly graveyard!

Conclusion

This chapter has tried to indicate the various ways that historians can analyse how language conjures things into being. It has shown that a detailed analysis of words can investigate the role played by language as the medium in which information about objects is communicated. It has been argued here that reading about things always involves some kind of call to the imagination of the reader – obviously on the stage, but also in the archive. Yorick's skull shows especially clearly that the imagination which is called upon is a sensory one – that material words always ask us to call to mind memories of sensory perception. We must do this if we are to appreciate the simultaneous lure and repulsion of the earthy skull, or the difference between a satin quilt and coarse linen sheets. In our perception of the significance of the relationship between words and things, reading is, it has been argued here, a kind of performance of objects in itself; a reanimation of the relationship between language, materiality and the imagination.

Notes

1 M. Overton, J. Whittle, D. Dean and A. Hann (2004), *Production and Consumption in English Households 1600–1750*. Abingdon and New York: Routledge, pp. 54–5 and 64.

2 S. Pennell (1998), ' "Pots and pans history": the material culture of the kitchen in early modern England'. *Journal of Design History* 11 (3), p. 202.

3 Warwickshire County Record Office, Probate Documents: WRO CR 1886/2711.

4 J. Jones (ed.) (2002–3), *Stratford-upon-Avon Inventories, Vols. I & II*. Stratford-upon-Avon: Dugdale Society Publications, p. 161.

5 G. Markham (1986), *The English Housewife*, M. R. Best (ed.). Toronto: McGill-Queen's University Press, p. 127.

6 Markham, *English Housewife*, p. 57.

7 Kent History and Library Centre Probate Documents: PRC 39/2 f125v.

8 See for instance A. Smyth (2010), *Autobiography in Early Modern England*. Cambridge: Cambridge University Press, a book that moves between different kinds of documentary and literary text with a respect for written form, and foundational work by Henry Woudhuysen and William Sherman on manuscript culture and marginal annotation. H. Woudhuysen (1996), *Sir Philip Sidney and the Circulation of Manuscripts, 1558–1640*. Oxford: Oxford University Press; W. Sherman (2007), *Used Books: Marking Readers in Renaissance England*. Philadelphia: University of Pennsylvania Press.

9 Kent History and Library Centre Probate Documents: PRC 39/5 f112v.

10 M. C. Howell (1996), 'Fixing movables: gifts by testament in late medieval Douai', *Past & Present* 150 (1), p. 36.

11 Hertfordshire Archives and Local Studies Centre Probate Documents: 33 AW 25; M. Parker (ed.) (2004), *All My Worldly Goods II: Wills and Probate Inventories of St Stephen's Parish, St Albans 1418–1700*. Hertfordshire: Bricket Wood Society, pp. 114–15.

12 Kent History and Library Centre Probate Documents: PRC 17/41, f337; for more on this will and the question of affect and memorialization more generally, see C. Richardson (2013), ' "Make you a cloak of it and weare it for my sake": material culture and commemoration in early modern English towns', in M. Penman (ed.) *Monuments and Monumentality Across Medieval and Early Modern Europe*. Donington: Shaun Tyas Ltd.

13 The National Archives: PCC 11/129/188.

14 Howell, 'Fixing movables', p. 44.

15 L. Orlin (2010), 'Empty vessels', in T. Hamling and C. Richardson (eds), *Everyday Objects: Medieval and Early Modern Material Culture and its Meanings*. Aldershot: Ashgate, p. 300.

16 The quantitative evidence underlying this analysis draws on just under 550 wills made for inhabitants of East Kent towns and villages between 1560 and 1600.

17 Kent History and Library Centre Probate Documents: PRC 17.51.1.

18 P. S. Hammons (2010), *Gender, Sexuality, and Material Objects in English Renaissance Verse*. Aldershot: Ashgate, p. 1.

19 Hammons, *Gender, Sexuality, and Material Objects*, p. 2.

20 See, as an introduction, J. G. Harris and N. Korda (eds) (2006), *Staged Properties in Early Modern English Drama*. Cambridge: Cambridge University Press.

21 Thomas Middleton, *Women Beware Women* 3.1.19–21, in T. Middleton (2007), *Thomas Middleton: The Collected Works and Companion*, G. Taylor and J. Lavagnino (eds). Oxford: Oxford University Press, pp. 1488–1541.

22 *Hamlet* 5.1.159–80 in W. Shakespeare (1997), *The Norton Shakespeare*, S. Greenblatt, A.G.W. Cohen, J. E. Howard and K.E. Maus (eds). New York: WW Norton and Co.

Further reading

Alcock, N.W. (1993), *People At Home, Living in a Warwickshire Village 1500–1800.* Chichester: Phillimore.

Arkell, T., N. Evans and N. Goose (eds) (2000), *When Death Do Us Part, Understanding and Interpreting the Probate Records of Early Modern England.* Oxford: Leopard's Head Press.

Fleming, J. (2001), *Graffiti and the Writing Arts of Early Modern England.* London: Reaktion Books.

French, H.R. (2007), *The Middle Sort of People in Provincial England 1600–1750.* Oxford: Oxford University Press.

Gaimster, D. (1997), *German Stoneware.* London: British Museum Press.

Hamling, T. and C. Richardson (eds) (2010), *Everyday Objects: Medieval and Early Modern Material Culture and its Meanings.* Aldershot: Ashgate.

Mirabella, B. (ed.) (2011), *Ornamentalism, the Art of Renaissance Accessories.* Ann Arbor: University of Michigan Press.

Richardson, C. (2006), *Domestic Life and Domestic Tragedy in Early Modern England.* Manchester: Manchester University Press.

Richardson, C. (2011), *Shakespeare and Material Culture.* Oxford: Oxford University Press.

Smith, H. (2012), *Grossly Material Things.* Oxford: Oxford University Press.

CHAPTER FOUR

Material Culture, Archaeology and Defining Modernity:

Case Studies in Ceramic Research

David Gaimster

Archaeology and the study of excavated material culture have the capacity not only to calibrate and amplify but also challenge the established documentary record of changing human experience. Over the past fifteen years or so, archaeological studies of key cultural trends in society over the late medieval to early modern transition have demonstrated the power of excavated artefacts to illuminate the lives of ordinary people.[1] The spread of a new secular artistic culture, the emergence of Protestantism and a more secularized everyday environment (with leisure time becoming an increasingly important category of culture for the many) are just some of the key material features of 'age of transition' that everyday objects can illuminate.

Ceramics hold a central position in the European archaeological record for the period between c. 1400 and 1700. By virtue of its utility at all levels of society, its relatively short lifespan and its durability in the ground, ceramics have proved to be one of the most sensitive and reliable archaeological indicators of social behaviour and mobility.[2] Traditionally, excavated ceramics of the period have been studied in the context of the technological and economic change in the reconstruction of daily life and in relation to interregional trade. However, ceramic tableware, tiles and

sculpture can also be observed to operate 'vertically' within the social hierarchy and 'horizontally' through cultural and ideological networks.

If the fifteenth to seventeenth centuries have a special significance, particularly for those studying the domestic environment in early modern Europe, it must lie in the emergence of a new demographic force for change, that of the 'middling sort' of consumer – the merchants, artisans and new professionals. These were based mainly in the towns and many of them had a level of disposable income comparable to their landed feudal contemporaries. In England and across the North Sea, intensifying intra-community competition amongst the socially ambitious urban mercantile classes may have been responsible for the growth of long-distance trade and in the manufacture and the consumption of domestic and personal goods. Not only that, these groups were instrumental in leading new design, in promoting more intensive modes of production and new decorative technologies, all of which created greater access to and desire for consumables. These trends are all key characteristics of what has been identified as a 'revolution' in the ceramic market that took place in England and the cross-Channel zone during the period.[3] This short paper will review a range of imported ceramic products circulating in late medieval to early modern England and assess their value for the study of social, cultural and ideological change in society.

The archaeological frequency of high-fired stoneware ceramics from the middle Rhineland provides a sensitive measure of an emerging table culture, particularly among urban mercantile communities.[4] Intensive workshop production, stimulated directly by growing demand on the urban markets of northern Europe, resulted in a relatively low cost to the consumer and the ability to reach a wide spectrum of the population. With its technologically superior body, which is impervious to liquids, stainless and odour free, stoneware revolutionized the spectrum of domestic activities from washing up to preserving food. Despite the plain, utilitarian body, the increasing variety of forms enabled stoneware to capture a niche in the popular tableware market of northern Europe from the fourteenth century onwards, enabling the aspiring middle classes to imitate aristocratic drinking and dining practices in a less expensive medium. Stoneware producers substituted fine metalware and drinking glass with a finely potted ceramic body that imitated their form, function and social role. The introduction of applied moulded ornament based on contemporary printed design sources during the early to mid-sixteenth century marked a further shift in the social value of stoneware, which became an increasingly important symbolic medium and prefigured the development of mass-produced printed ceramics of the eighteenth century.[5]

The fusion of graphical reproduction and moulded technology enabled producers of stoneware vessels to respond immediately to rapidly changing political and religious loyalties by introducing a completely new iconographic repertoire. Stoneware rapidly became a vehicle for promoting new political

affiliations and propaganda, drawing on printed armorials or portrait engravings. A Cologne stoneware tankard excavated in Bishopsgate, City of London, and now in the Museum of London, is applied with the moulded reliefs of two crowned monarchs (Figure 4.1).[6] The portraits are close in style and execution to contemporary printed images of the Habsburg Emperors Maximilian I (1459–1519), Charles V (1500–58) and Ferdinand I (1503–64). The identification of the portraits hinges on the likely production date of the vessel, which is secured to around 1535–40 on archaeological

FIGURE 4.1 *Salt-glazed stoneware tankard applied around the body with moulded caricature portraits of two Habsburg emperors, most probably Charles V (1500–58) and Ferdinand I (1503–64). Made in Cologne, c.1520–40, and found in Bishopsgate, City of London. By permission of the Museum of London (inv. 6559).*

comparative grounds. This date would suggest a dual portraiture of the bearded Charles V as Holy Roman Emperor and his younger brother Ferdinand I (who succeeded Charles as Emperor in 1558). Ferdinand's portrait would appear to be based on the engraving by Barthel Beham, published in 1531 on Ferdinand's election as King of the Romans.

The portraits are devised as satirical images of the two rulers, accentuating the pronounced malformation of the jaw in Habsburg family members. Cologne was a free city of the Empire and in constant tension with the Archbishopric, which was a separate state within the Empire. It is arguable that potters working in the city of Cologne were gently satirizing their Imperial overlords through the graphical manipulation of popular printed sources. A Cologne merchant, in the diasporic Hanseatic trading community of the City of London, may have owned the tankard. Political and religious satire was not unknown amongst the ornamental repertoire of traded Rhenish stoneware during the sixteenth century; the most well known in Siegburg production is the medallion moulded with the double-headed portrait representing the Pope wearing the papal tiara and, on the opposing portrait, the Devil's horns and satyr's ears.[7] Both heads share the same mouth and each nose serves as the chin of the mirror profile. Thus, on tipping the vessel to drink, the Pope becomes the Devil and the Devil becomes the Pope. This Lutheran image of the Pope as Antichrist derives from a satirical medal of the 1540s, which also appeared on propaganda broadsheets of the period.

The development of cheap wood block printing formed a significant factor in the symbolic transformation of domestic ceramics in Germany during the Lutheran Reformation. The smokeless ceramic stove made a dramatic intervention, both technologically and visually, into the English urban domestic interior between the mid-fifteenth and early seventeenth centuries, initially as a premium imported product and from the early sixteenth century manufactured in southern England close to the main marketplace of London.[8] The iconographic repertoire of the pre-Reformation period, characterized by the moulded representations of the Saints and the carved devotional scenes of contemporary wooden altarpieces, was superseded from the second quarter of the sixteenth century by woodcut-based representations of the leading protagonists of the Lutheran Reformation, the secular personality cults suiting the new Confessional and political affiliations of the North Sea and Baltic mercantile communities.[9] Out of the Hanseatic League's western orbit, the City of London produced a series of portrait tiles of Schmalkaldic League leaders, humanists and Old Testament warlords so beloved by Protestant sympathizers of the time. These finds place the English metropolis squarely within the cultural network of the Hanseatic League, which was instrumental in spreading Protestantism beyond northern Germany.[10]

Imported moulded pipeclay figurines are another medium, but in this case a portable one, for investigating how changing design and iconography

reflects the communication and reception of new religious, cultural and politically sectarian messages over the course of the fifteenth to seventeenth centuries. Archaeological mapping enables us also to observe their social topography, function and symbolic role.[11] Among the archaeological finds of imported devotional miniature pipeclay figurines on English sites, the most common personifications are those of the Virgin and Child, the virgin martyr saints, the crucified Christ and the Christ Child. The numerical dominance of the Virgin among surviving miniature devotional statuary reflects the high position of the Marian cult in the popular religion of late medieval England. Given the subjects and contexts of many of the finds, it is legitimate to speculate that they were produced primarily for a female audience. As in the case of imported pre-Reformation stove-tiles, the figures closely resemble ecclesiastical figural sculpture in stone, wood and terracotta. The domestic context associated with virtually all of these finds illustrates the transfer of the cult of the saints from the church altar into the secular sphere.

The replacement of the cult of the saints by temporal authority and humanist imagery in moulded stove-tile design is mirrored to an extent in the appearance of secular and profane forms in the range of pipeclay figurines circulating in England from the middle of the sixteenth century. The spectrum of post-medieval pipeclay figurines found in London and southern England is dominated by the figures of rulers and their consorts and by symbolic miniatures of humanist or secular armorial devices. Full-length figurines of Stuart monarchs and female consorts in the British Museum collections may be moulded after commemorative seventeenth-century engravings. London finds include a small equestrian figure of a female monarch holding the Sword of State, possibly Elizabeth or Anne of Denmark (Figure 4.2) and a full-length figure of a late Stuart monarch in full armour. Heraldic lions may commemorate the Glorious Revolution during which the new King William III placed the lion of Nassau in the centre of the royal arms of England.

What is crucial to the study of changes in taste, mentality and religious affiliation in Tudor and Stuart England, however, is the social context of these domestic ceramic finds. Apart from the number of royal palaces, military installations and aristocratic residences, the archaeological distribution of the ceramic imports discussed is dominated by urban secular findspots. In this sense the archaeology matches the historical picture which clearly indicates that the Reformation was an urban phenomenon, at least in its initial phases. It is no coincidence that the archaeological concentrations of imported symbolic ceramics of the period corresponds closely to the distribution of some of the largest diaspora communities of Low Countries and German merchants and artisans living in London and the South East. It is significant that these 'stranger' populations numbering some 5,000 individuals in London during the final years of Henry VIII's reign, particularly the Hanseatic merchant enclave, were instrumental to the introduction of

FIGURE 4.2 *Moulded equestrian figurine in white pipeclay of a female monarch or consort, probably Anne of Denmark, queen consort of King James VI (1574–1619). Found in the City of London and probably made there during the first quarter of the seventeenth century. Courtesy of the Trustees of the British Museum, PEE 1856,7–1,1657.*

Reformation ideology and the foundation of the first Protestant churches in the metropolis.

The value of examining archaeological ceramics as a historical source is illustrated in the above case studies and more widely in the historical archaeology literature.[12] However, some of the most productive research involves the study of ceramic finds within their excavated context and with reference to the identity and social profile of documented communities who occupied the site. Some of our most pressing questions concern the stratification of early modern society and the material characterization of rich and poor lifestyles. Excavations of sixteenth- to eighteenth-century tenements on Narrow Street, Limehouse, to the east of the City of London,

have produced an insight into the cosmopolitan lifestyle of the London merchant venturer community of the period.[13] The unprecedented quantities of pottery, glass and other goods from the Netherlands, Germany, France, Spain, Italy, Portugal, Turkey, Iran, China and the Caribbean are atypical of the contemporary central London domestic pottery market. The concentration of exotic imports to the east of the city marks a shift in the economic and social topography of the capital. Rather than the products of peaceful trade, the Spanish oil jars, Montelupo dishes, Portuguese tin-glaze plates, Chinese porcelain and Dutch glass derive from piracy and privateering expeditions in the North Sea, Mediterranean, Caribbean and Far East, mainly against the Dutch, Spanish and Portuguese, whose looted cargoes these assemblages represent. Archaeology of the marine waterfront communities downstream from the City of London reveal a distinctive microeconomy of luxury domestic goods, the globalized signature of which can be distinguished from the main London residential market. Meanwhile, less than two miles away, on the edge of the city at Aldgate, the archaeological record reveals a contrasting picture. The dominance of local lead-glazed red earthenware in the deposits, together with the recovery of bone- and wood-handled cutlery, is reflective of a materially impoverished community living on the periphery of the metropolis.[14] The discovery of clay pipe manufacture at the site, amongst the poorer trades of the city, reinforces the impression of social inequality. Whilst the comparative study of individual artefacts has much to offer the broader historical narrative, the archaeological survey of assemblages of material culture on the microscale of the household level – or say at the macroscale of the community level – enables us to more effectively connect material culture with real people. The *locus* and frequency of archaeological artefacts across towns and landscape makes a distinctive disciplinary contribution to mapping the social topography of material attributes of what we now regard as symptomatic of modernity and the foundation of the world we live in today.

Notes

1 D. Gaimster and P. Stamper (eds) (1997), *The Age of Transition. The Archaeology of English Culture 1400–1600*. Oxford: Oxbow; D. Gaimster and R. Gilchrist (eds) (2003), *The Archaeology of Reformation 1480–1580*. Leeds: Maney Publishing; D. Gaimster (2010), 'Archaeology of an age of print? Everyday objects in an age of transition', in T. Hamling and C. Richardson (eds), *Everyday Objects. Medieval to Early Modern Material Culture and its Meanings*. Aldershot: Ashgate, pp. 133–44.

2 D. Gaimster (1994), 'The archaeology of post-medieval society, c.1450–1750: material culture studies in Britain since the War', in B. Vyner (ed.), *Building on the Past. Papers Celebrating 150 Years of the Royal Archaeological Institute*. London: RAI, pp. 283–312.

3 D. Gaimster (1999), 'The post-medieval ceramic revolution in southern Britain, c. 1450–1650', in G. Egan and R.L. Michael (eds), *Old and New Worlds. Historical/Post-Medieval Archaeology Papers from the Societies' Joint Conferences at Williamsburg and London 1997 to Mark Thirty Years of Work and Achievement*. Oxford: Oxbow Books, pp. 214–25.

4 D. Gaimster (1997), *German Stoneware 1200–1900. Archaeology and Cultural History*. London: The British Museum Press, ch. 3.

5 Gaimster, *German Stoneware*, ch. 5.

6 Gaimster, *German Stoneware*, Cat.39 at p. 200.

7 Gaimster, *German Stoneware*, fig. 5.15.

8 D. Gaimster and B. Nenk (1997), 'English households in transition 1400–1600: the ceramic evidence', in Gaimster and Stamper (eds), *The Age of Transition*, pp. 171–96.

9 D. Gaimster (2003), 'Pots, prints and propaganda: changing mentalities in the domestic sphere 1480–1580', in D. Gaimster and R. Gilchrist (eds), *The Archaeology of Reformation 1480–1580*. Leeds: Maney, pp. 122–44.

10 D. Gaimster (2000), 'Saints and sinners. The changing iconography of imported ceramic stove-tiles in Reformation England', in D. Kicken et al. (eds), *Gevonden Voorwerpen. Lost and Found. Essays on Medieval Archaeology for H.J.E. Van Beuningen*. Rotterdam Papers 11, pp. 142–50.

11 Gaimster, *German Stoneware*, fig. 5.15; and D. Gaimster (2007), ' "Of idols and devils": devotional pipeclay figurines from southern Britain in their European context', in Carola Jäggi and Jörn Staecker (eds), *Archäologie der Reformation. Studien zu den Auswirkungen des Konfessionswechsels auf der matrerielle Kultur*. Arbeiten zur Kirchengeschichte, Bd.104. Berlin and New York: de Gruyter, pp. 259–83.

12 For instance F. Verhaeghe (1998), 'Medieval and later social networks: the contribution of archaeology', in H. Hundsbichler et al. (eds), *Die Vielvalt der Dinge. Neue Wege zur Analyse mittelalterlicher Sachkultur*. Forschungen des Instituts für Realienkunde des Mittelalters und der Frühen Neuzeit. Diskussionen und Materialien, Nr.3. Vienna: Österreichische Akademie der Wissenschaften, pp. 263–311.

13 D. Killock and F. Meddens (2005), 'Pottery as plunder: a 17th-century maritime site in Limehouse, London', *Post-Medieval Archaeology* 39 (1), pp. 1–91.

14 A. Thompson, F. Grew and J. Schofield (1984), 'Excavations at Aldgate, 1974', *Post-Medieval Archaeology* 18, pp. 1–148.

CHAPTER FIVE

Broken Objects:

Using Archaeological Ceramics in the Study of Material Culture

Suzanne Findlen Hood

The study of everyday people of the past can be challenging. Household inventories and public documents give historians some insights into their lives. Yet it is through objects recovered archaeologically from trash pits, privies, and wells that these people come alive again. A listing of 'twelve stone plates' on a probate inventory is revealed, through archaeology, to be more than a dozen simple plates but twelve English white salt-glazed stoneware plates made in Staffordshire and decorated with a portrait of the King of Prussia. In this case it is the blending of ceramics scholarship with archaeology that brings together as complete a picture of the people of the past as we are likely to get.

My short essay focuses on the experience of Colonial Williamsburg where decorative arts, archaeological and archival collections are brought together to give a more comprehensive view of the eighteenth century. Williamsburg, located in Tidewater Virginia, between the James and York Rivers, was the colonial capital of Virginia from 1699 until 1780. As capital of the largest and most populous of the American colonies, Williamsburg was an important and thriving city during the eighteenth century. Beginning in 1706, a grand Governor's Palace was erected giving the King's representative in Virginia an appropriate home from which to administer the colony.

Fast-forward to the early twentieth century and what had once been a thriving political, cultural and educational centre was now a quiet town. In

1926 the Reverend Dr W.A.R. Goodwin, rector of Bruton Parish Church, an eighteenth-century Episcopal church in the centre of Williamsburg, shared his dream of preserving the city's historic buildings with John D. Rockefeller Jr. and the restoration of Williamsburg began. The Colonial Williamsburg Foundation is a private, not-for-profit educational institution that preserves and interprets to the public the historic town of Williamsburg.[1] The Foundation has a large collection of seventeenth-, eighteenth- and early-nineteenth-century decorative arts, which are on display in the museums and are used to furnish the historic buildings. From the early days of the organization, Colonial Williamsburg was interested in recreating as much of the eighteenth-century streetscape as possible. This resulted in digging trenches on sites where eighteenth-century buildings were thought to have been in the hope of finding foundations. Ceramics, glass, metals and other artefacts recovered from these trenches were often preserved during this process, but it was not until the 1950s that a more formal and scientific archaeology programme was established.

One building footprint that the founders of Colonial Williamsburg were keen to find was the Governor's Palace. A large Georgian brick mansion, the Palace was the symbol of royal power in colonial Virginia. On 22 December 1781 the central portion of the building burned to the ground. At the time it was being used as a hospital to administer to wounded soldiers in the Continental Army. Archaeological exploration on the site began in 1930 and after almost two years of extensive digging the original footings, cellars, debris from the fire and a section of original wall had all been uncovered. While reconstruction of the building was the ultimate goal of the excavation, many of the artefacts recovered during the process were retained. Among these artefacts were numerous pieces of Chinese export porcelain including two teacups, which date to the late seventeenth or early eighteenth century (Figure 5.1). Given their date, these cups were likely owned by Lieutenant Governor Alexander Spotswood, who served in Virginia from 1710 until 1722. In 1716 he was the first to take up residence in the Governor's Palace. The connection between these teacups and Spotswood is particularly interesting in that Colonial Williamsburg has several objects in the decorative arts collection that descended in the Spotswood family or are identical to objects that did, thereby creating a case study of the choices made by at least three generations of one family.

In addition to their connection to a Lieutenant Governor and their recovery from the highest style home in Williamsburg, these teacups are important because of their decoration. Simple, handle-less cups, these bowls are ornamented in underglaze blue over the entire exterior surface with a simplified version of the Sanskrit character for *om*.[2] The design is arranged over the surface in three ranks of concentric circles. The interior decorated with two lines of underglaze blue, one just below the rim and the other two-thirds of the way down the side. On the more intact cup, the same character as on the exterior is written once on the bottom of the interior. Sanskrit is a

FIGURE 5.1 *Partially reconstructed teacups, Jingdezhen, China, 1685–1710. Excavated at the Governor's Palace, Williamsburg, Virginia. Height of cup on left: 1¾ inches. Colonial Williamsburg Foundation.*

liturgical language used in Hinduism and Buddhism. It appears on a number of Chinese porcelains in Southeast Asia and India. On wares decorated similarly, the organization of the design is meant to be read like a prayer wheel, as the bowl is rotated, the prayer is released.[3]

Porcelains decorated in this way were produced for over three hundred years and despite their apparent lack of connection to a Western audience, shards from a similar bowl were excavated at Santa Elena, on Parris Island, South Carolina from a sixteenth-century colonial Spanish settlement. Two almost identical teacups were recovered from the seventeenth-century sites, Jamestown Island and Bacon's Castle in Surrey, Virginia. Yet another cup was excavated at Johnson Hall, the site of an eighteenth-century home built by Sir William Johnson in Johnstown, New York.[4] It seems unlikely that the North American consumers of these porcelains were aware of the connection between the decoration on their teacups and Hindu and Buddhist religious practice, but it does raise questions about how these vessels made it to the eastern seaboard of what would become America.

The presence of these cups in Williamsburg forces us to think about trade networks. Were European merchants offered these cups along with all those wares more closely associated with European trade? The traditional market for vessels decorated in Sanskrit was India, Tibet, and Southeast Asia. The Dutch were the only European country trading directly with China in the eighteenth century whose base of operations was located in Southeast Asia at Batavia, what is now Jakarta, Indonesia.[5] Perhaps some of these Sanskrit-decorated wares were shipped to Indonesia for use there and instead made it onto Dutch ships bound for the West. There is at least one Dutch

earthenware plate known that is decorated with these same designs suggesting that enough of these wares made it to Europe to be copied by potters there.[6]

Also of curiosity are the differences between these two seemingly similar teacups (Figure 5.2). The less complete example has a wide foot with a small indentation in the centre. It was not trimmed back and refined as was the more intact piece. The archaeology that recovered these cups was not scientific in nature and therefore we do not know exactly from where they were recovered, nor when during the eighteenth century they were deposited. However as the only two cups in this pattern to come from the Governor's Palace site, it seems likely that they were in use together indicating that the differences in refinement between the two were not of note to the consumer. We know that wares of varying qualities were exported, but this is the only evidence at Colonial Williamsburg of vessels decorated in the same manner that were used in the same place and at the same time, and yet were of differing qualities.

By connecting archaeology, the study of decorative arts and material culture many questions are raised, which we may not be able to answer. When looking to furnish one of the eighteenth-century buildings in Colonial Williamsburg's collection sometimes there are probate inventories that help illuminate what was owned and used at that particular location, but more often than not we have no specific inventory for that property. In the absence of such documents the curator is faced with looking at records associated

FIGURE 5.2 *Detail of the bases of the partially reconstructed teacups, Jingdezhen, China, 1685–1710. Excavated at the Governor's Palace, Williamsburg, Virginia. Colonial Williamsburg Foundation.*

with another comparable site. However even when an inventory is available, it might not provide much detailed information. When Alexander Spotswood died in 1740 an inventory was taken of his worldly goods. By that time, Spotswood was living in Orange County, Virginia, more than one hundred and thirty miles northwest of Williamsburg. Eighteen years had passed since his residency in Williamsburg and while he did own blue and white porcelain at the time of his death, the inventory gives very little evidence as to what those pieces looked like. The inventory dated 26 January 1741 lists 'Ten China Dishes and 23 China Plates . . . One Burnt China bowl and 1 blue & white do . . . a parcel of China Tea Equipage'.[7] From this we know that he owned both dinner and tea wares made of Chinese porcelain. It is also clear that some of the wares were decorated with cobalt blue. However, we do not know what the patterns were, or the variety of patterns present. The only inventory of the Governor's Palace that we have belongs to Norborne Berkeley, 4th Baron Botetourt who died in 1770 while still in office. Blue and white Chinese porcelain tea wares were listed on his inventory, but given the date of his death, it is unlikely that any of these pieces relate to those illustrated here.[8]

Without the archaeological evidence we would not know that teacups decorated with Sanskrit script were in use at the Governor's Palace in eighteenth-century Williamsburg. In our effort to oversimplify our understanding of the past we may have missed completely that through the commodity of Chinese porcelain, China, Southeast Asia, Europe and Colonial America were all linked. This evidence brings to the fore the complex global connections between such far-flung places as China and the American colonies during the eighteenth century. Armed with this information, objects can be purchased for the decorative arts collection to reflect the ownership of these wares and – through label text – conversations can begin with the public about the wide variety of ceramics available to consumers in colonial Virginia. Objects like these teacups help push interpretation beyond norms and force scholars to ask questions, which can bring the people of the past alive to our twenty-first century museum audiences in a way that focusing solely on the aesthetics of an object may not.

Notes

1 The Foundation also operates the DeWitt Wallace Decorative Arts Museum and the Abby Aldrich Rockefeller Folk Art Museum: www.history.org

2 W. Willetts and L. Suan Poh (1981), *Nonya ware and Kitchen Ch'ing*. Selangor, Malaysia: The Southeast Asian Ceramic Society, pp. 6 and 54–7.

3 The British Museum, Object file, Franks.759.

4 L. R. Pomper, J. Legg and C. B. DePratter (2011), 'Chinese porcelain from the site of the Spanish settlement of Santa Elena, 1566–1587', *Vormen uit Vuur*

212–213, p. 37; J. B. Curtis (1988–89), '17th- and 18th-century Chinese export ware in Southeastern Virginia', *Transactions of the Oriental Ceramic Society* 53, pp. 47–64; D. S. Howard (1984), *New York and the China Trade*. New York: The New York Historical Society, pp. 62–3.

5 R. Kerr and L. E. Mengoni (2011), *Chinese Export Ceramics*. London: V&A Publishing, pp. 6–7.

6 Willetts and Poh (1981), *Nonya Ware*, p. 6.

7 Library of Virginia, Richmond, Va.: Inventory of Alexander Spotswood, 28 January 1741, Orange County Will Book No. 1, 1735–1743, p. 182.

8 Inventory of Lord Botetourt, 24 October 1770, in *An Inventory of the Contents of the Governor's Palace Taken after the Death of Lord Botetourt* (1981). Williamsburg, VA: Colonial Williamsburg Foundation, pp. 5–6.

Anthropology, Archaeology, History and the Material Culture of Lycra®

Kaori O'Connor

Just as England and America are two countries separated by a common language, so history and anthropology are separated by the world of 'things'. In the view of Marshall Sahlins, an anthropologist long associated with the relationship between the two disciplines, their estrangement can only be resolved through the development of an 'anthropology of history' which he defines as an integrated history in which culture is history and vice versa,[1] a project to which material things are central. This chapter is presented in three parts: a general introduction that traces the changing involvement of anthropology, archaeology and history with each other and with material culture; a brief review of key sources and methods that have been influential in interdisciplinary work; and then a case study of the textile fibre Lycra® in which anthropology, history and material culture are combined.

Anthropology and history: The back story

Arguably, history began as anthropology. The first text that established the name, field and form of narrative written history in the West was *The Histories* by the Greek writer Herodotus (c. 485–425 BCE). Epic in scope, it was intended, in his words to 'prevent the traces of human events being erased by time', and to 'preserve the remarkable achievements of Greeks and non-Greeks'.[2] *The Histories* can be seen as the first example of what the anthropologist Clifford Geertz[3] later called 'thick description' – a

culturally-informed materially-conscious account in which gods, omens, religious beliefs, dynastic relations, animate landscapes, different voices, strange customs and costumes, foreign and Greek thought ways, sacred and significant objects and much more were interwoven with an examination of the causes of the hostilities between the Greeks and the Persians and other non-Greeks, in which politics were only one factor. On the basis of this magnum opus, Cicero acclaimed Herodotus as the Father of History, and because of his 'ethnographic sensibilities', anthropologists consider Herodotus the first anthropologist as well.

Since Herodotus presented non-Greek values, objects and achievements in their own terms instead of solely from a Greek point of view, offering a culturally-nuanced interpretation of events and behaviour instead of insisting on Greek supremacy, he was vilified by Plutarch and other later historians who called him *philobarbaros* – 'lover of barbarians' – a label that has stuck to anthropologists ever since. They preferred the Greek writer Thucydides (c. 460–395 BCE), whose *History of the Peloponnesian War* was the antithesis of Herodotus's *Histories*. Seen entirely from the Greek perspective, it aimed to present what Thucydides called 'an exact knowledge of the past', focusing on pragmatic political decisions and the detailed movements of soldiers on the battlefield, and portraying the victory over the Persians as the inevitable result of the superiority of Greek civilization and strategy. There were no nuances, no multiplicity of voices, no sense of dynamic encounters. Historical thought now became *logos* (logical, universalistic and objective), while everything else was dismissed as *mythos* (mythic, particularistic and subjective) – fable or the stuff of literature and poetry. Material things retreated before text. As Sahlins put it, history became 'cultureless'.[4]

Written history and anthropology diverged, the former becoming ever more specialized, ideological and text-based, imbued with the notions of unilinear progress and the superiority of the 'civilized', while the latter was marginalized as travel and exploration literature until the era of European empires, when a systematic knowledge of the 'other' became imperative. Anthropology then re-emerged in alterity to history, as the study of peoples without writing and apparently without a past that was any different to their present, seemingly inferior on an evolutionary scale to 'advanced' societies, both socially and technologically. Initially, the anthropological mission was to advance the colonial project of knowing the primitive the better to civilize it, with the material culture of subject peoples providing the basis for the construction of developmental typologies that were displayed in ethnographic museums. Soon, however, the *philobarbaros* tendency reasserted itself in anthropological analyses that were predominantly small-scale, single-site studies that aimed to convey the *emic* or 'native' point of view. Apparently simple societies were now seen to be complex – even sophisticated – in their own right, albeit framed in a timeless 'ethnographic present' into which history, social change and developmental comparisons did not intrude.

In the absence of text, material culture was of central importance in providing insights into society beyond the technological. In the words of the fieldwork manual *Notes and Queries on Anthropology*[5] 'it is important that the study of the artefacts and material culture of a people should not be viewed solely from their material aspects . . . amongst all peoples . . . even among the higher cultures . . . we find an organic connection of ritual practices with the arts and crafts of daily life . . . the attitude of people towards these psychical effects should be noted and recorded'.[6] The 'ethnographic method' – intensive participant-observation in/of another culture on a single site – now emerged. With the development of academic anthropology, disciplinary polarization increased. As Geertz put it, historians accused anthropologists of 'wallowing in the details of the obscure and unimportant', while anthropologists accused political historians of 'being out of touch with the immediacies and intricacies of actual life'.[7] Archaeology was caught between history and anthropology. Although it had long been considered 'the anthropology of the past' by anthropologists,[8] during the colonial era archaeology had primarily served in a supporting role as political history's handmaid, with archaeological artefacts arranged in typologies used to validate text, or in series that sought to establish chronologies in the absence of text.[9]

Then, in the 1970s and 1980s, academic anthropology was swept by the revisionist postmodern movement that critiqued the discipline's fundamental assumptions and practices, ultimately transforming the field.[10] Under the influence of academic Marxism, critical theory was introduced, and all aspects of society were politicized and problematized. Because of their colonial associations, ethnographic artefacts initially aroused disciplinary discomfort, but with the rise of new forms of analysis involving structuralism and symbolic systems, the old 'psychic' aspect of things was recast in new terms. Now material objects were seen as not merely constituted by society, but constitutive of it, freighted with nuanced meanings that gave voice to social difference, providing insights into the dynamics of society as a whole. Materiality itself was questioned. Objects were no longer considered solid or stable; colour, smell, sound and images were now also perceived as 'material': 'things' could 'speak'.

Archaeology underwent a parallel transformation in two stages. First, the evolutionary and determinist elements implicit in early archaeology were rejected, and what became known in America as the 'new' or 'processual' archaeology developed, while in Britain social archaeology emerged.[11] A key concept was social process. While the 'old' archaeology had supported unilinear historical explanations, the new archaeology was concerned with how and why changes in social and economic systems took place in interactive terms, and how these processes were materialized in 'things' in their social context. One can think of all the cultural 'dirt' that was once carefully cleaned off artefacts used in historical displays, now being put back on.

Espousing logical positivism, the scientific method and objectivity, the early new archaeology was soon challenged by a radical group who came to be called post-processualists, led initially by Ian Hodder, Christopher Tilley, Daniel Miller and others at University College London (UCL) which became and remains a centre of material culture studies.[12] In different ways they rejected positivism in favour of 'symbolic, structural, and structural Marxist perspectives',[13] coming increasingly like many anthropologists to emphasize the subjective and the interpretive in their work, focusing on agency, metaphor, multiple voices, memory and ambiguity, and on objects or 'things' as vehicles for or materializations of these. Instead of isolation, connections, networks, encounters and exchanges were highlighted. The old distinction between humans and things dissolved – they were now seen as inextricably entangled.[14] Between anthropology and archaeology, *mythos* was restored, and the handmaid could now tell her own tales.

At the same time, academic history was undergoing its own critique. Traditional political history was challenged by the new social historians who advocated a bottom-up, non-elitist approach to the study of everyday life, often involving people who were not represented in official histories and left no written records of their own. Having as the historian Giorgio Riello put it 'survived and even thrived for centuries with little or no engagement with objects',[15] historians were now obliged to engage with material culture as an alternative to texts, even as anthropologists were having to interest themselves in history. 'Myth and record, legend and documents became blurred genres'.[16] How could anthropological methodologies be used in the historical study of material culture and how could historical materials be used in anthropological analysis of 'things'? To this we now turn.

Methodologies

In retrospect, postmodernism and the revisionism to which it gave rise resulted in a discourse that was sometimes enlightened, sometimes flawed.[17] On the positive side, it revitalized the disciplines, widening and enriching the fields of study, though with a tendency towards fragmentation and discontinuity. However, the extreme politicization ultimately became analytically limiting, and the free play of signifiers vertiginous.[18] Anthropology became too philosophical, relativistic and self-reflexive; it retreated from its empirical roots and did not address the larger social processes and problems that history, anthropology and archaeology aim to illuminate. There is now a growing impatience with scholarship that is concerned with how the subject fits into these conceptual frameworks, rather than with advancing the subject itself. Instead, there is a discernible new 'material turn': rather than theorizing materiality there is a 'return to the object', a reining in of interpretation and a renewed focus on contexts and the systematic use of material evidence within them.[19]

In the early 1990s, many feared that history would be swallowed by anthropology or vice versa, while others thought a fully amalgamated new field might arise. As Geertz predicted, neither of these happened, and the way forward for history and anthropology has proved to be one of 'redefining them in terms of one another by managing their relations within the bounds of a particular study'.[20] This is the approach taken here, although the limitations of space dictate the use of a single case study to show how history, anthropology and material culture can be combined in an analysis.

First, we need to consider how historical materials can be used in the anthropological analysis of 'things'. For anthropologists, this has meant venturing into the archives, long the exclusive preserve of historians. Initially, archives were considered antithetical to the direct experience of ethnography. Anthropologists were disinclined to accept what they saw as the narrow and ideological focus of text, particularly in the colonial archives which dealt with the regions in which anthropologists abroad had long worked. Here, the differences between the 'official' view and what anthropologists had observed 'on the ground' further discredited archives in their eyes. However, those anthropologists receptive to history began to see that 'Ethnography surely extends beyond the range of the empirical eye; its inquisitive spirit calls upon us to ground subjective, culturally configured action in society and history – and vice versa – wherever the task may take us ... one can "do" ethnography in the archives'.[21] It was realized that the dissonance between the 'official' view of text and direct experience was exactly what the ethnographer in the field encountered – different voices and perspectives, things revealed and things hidden. Indeed, it was these tensions, collisions, disruptions and contradictions that drove the dialectic of process and captured the nuances that are at the heart of all good ethnographies. It was also realized that the written word was just one sort of 'text', others being material things such as bodies, buildings and textiles, that anthropologists are accustomed to 'reading' on the ground. Doing ethnography in the archives therefore involves doing what the anthropologist does in the field – taking the official view or dominant voice as one of many, and building a larger context drawing on other voices and sources, things being prime among them.

Anthropologists have also constructed new kinds of archives, moving into another field of 'things' – public culture – the 'images, claims and representations created to speak to and about ... people; all of the products of art and entertainment (film, television, books and so on) as well as all of the text of information and analysis (all forms of journalism and academic production) ... and all the products of what is commonly called "the media," '[22] which can be stored and circulated by digital means. It is by studying these images *in social and historical context*, not merely deconstructing the images in their own terms, that anthropologists seek to understand the 'larger theoretical frames that both shape such work and are revised by it'.[23] The study of representations was pioneered by Geertz, who

argued that culture was embodied in public symbols which communicated a society's worldview, values and ethos.[24] Studies of representations also allow anthropologists to break away from the small-scale, and to interrogate large cultural formations such as 'class' and 'cohort', as well as to analyse classes of objects – types of things – rather than single objects.

Apart from the use of archives, anthropologists have gained new ways of thinking about history, the most useful for material culture studies being seeing the past not as a single 'essentialist' or 'realist' narrative, but as a multiplicity of them. The objective of this kind of historical anthropology is to show over time 'how realities become real, how essences become essential, how materialities materialize . . . "symbolic realism" captures well the spirit of the matter'.[25] One thing anthropology has not taken up is the scale of traditional longitudinal history. Anthropologists have so far tended to work in the relatively recent past, leaving the material culture of antiquity to the archaeologists. Ironically, as history and anthropology reached an accommodation, there were problems elsewhere. As David Shankland put it: 'social anthropology and archaeology in the United Kingdom divorced'.[26] This may be an overstatement and is certainly a decree nisi, not an absolute. While differences have arisen because of ways of working; different approaches to the recording of physical evidence; and the emergence of new technologies that have transformed what can be known about the past and the present, the inevitable reconciliation of the two disciplines promises progress in the future development of material culture studies.

As for the ways in which anthropological methodologies are used in the historical study of material culture, the influences are clear to see in the ever-increasing number of historical and interdisciplinary works that, in different ways, use objects to introduce dynamism, tension, contradiction and nuance, and to explore issues of identity, class, gender, power and difference.[27] The very materiality of the object – its smell, shape, sound and colour – is used to animate the past. In a pioneering study, the historian John Demos used material culture in an anthropological way to show how the shadowy house interiors and claustrophobic configuration of early American colonial hearths around which people clustered during long spells of bad weather contributed to the mentalities that gave rise to the Salem witch mania and trials.[28] Because invented traditions[29] require visible symbols, material culture has been central to studies of this cultural phenomenon, one case among many being Welsh 'national dress' for women, supposedly worn in a distant Cymric past, but actually designed by Lady Llanover in the 1830s, to give substance to Welsh national identity, a construct of the nineteenth century. A paradigm of articulation between disciplines is David Cannadine's study of the Colchester Oyster Feast, a private banquet that became a public ritual which meant different things to different people. His analysis of these differences demonstrated that 'what the Oyster Feast meant at any one time requires "thick description"; what it meant over time requires historical perspective.'[30]

Moreover, there has been a flow of single-object analyses whose methodology is redolent of archaeology. But with gains can come losses, and many of the single-object microhistories that are a common format of interdisciplinary material culture studies are open to the same kind of criticisms levelled at the old anthropological and archaeological single-site monographs. From the perspective of the new anthropology and archaeology, they can seem internally inert and externally isolated, more object-centred than object-driven, although anthropologists treat the two as inseparable. Three anthropological works have been particularly helpful in addressing these tendencies. The first, *The Social Life of Things* (1986) edited by Arjun Appadurai, focused on a particular kind of thing – commodities, or objects of economic value – and on their circulation, which materialized the politics that underlie exchange and value. As he put it, 'we have to follow the things themselves, for the meanings are inscribed in their forms, their uses and their trajectories . . . even though from a *theoretical* point of view human actions encode things with significance, from a *methodological* point of view, it is things-in-motion that illuminate the human and social context.'[31] A seminal paper in the volume is Igor Kopytoff's 'The cultural biography of things: commoditization as process' in which the object is envisioned as having a biography. This is not a simple physical trajectory in which an object goes from new to old through progressive stages of deterioration. Instead, this is the biography of the object as a socialized commodity, as a 'culturally constructed entity, endowed with culturally specific meanings and classified and reclassified into culturally constituted categories'.[32] Sometimes an object is valued for cultural reasons and considered a commodity, sometimes it is not valued and is seen as just a 'thing'. These shifts reveal what Kopytoff called the moral economy at work behind the objective economy of visible transactions.

An invaluable aid has been the emergence of multi-sited ethnography that cuts across the dichotomies of global/local and lifeworld/system. Interdisciplinary in nature, involving doing ethnography in several sites and from different viewpoints in each site, it seeks chains, threads, paths, conjunctions and juxtapositions, using a number of tracking strategies. The most common is 'follow the thing' – 'tracing the circulation through different contexts of a manifestly material object of study such as a commodity, gifts, money, works of art, and intellectual property . . . (thus revealing) process in the world system.'[33] These works have been highly influential in social and economic history, and especially in the rapidly expanding field of global history, which focuses on the global flow of goods, peoples and ideas. There is a growing body of 'commodities of empire' studies that are adding nuance and dynamism to previous postcolonial interpretations which tended to treat material goods as an unexamined category, by showing how the meanings and values attached to commodities change as they cross time, space and cultures.[34]

Commodities lead to consumption, the domain in which anthropology, history and material culture converged in the 1980s and 1990s. Many new

case studies refer to two classic anthropological works that remain key to the interdisciplinary study of material culture – Mary Douglas's *The World of Goods* (1979) and Marshall Sahlins's *Culture and Practical Reason* (1976), both of which combine structuralism and symbolic anthropology. During the critique of anthropology, the disciplinary focus on the faraway, the marginal and the powerless was questioned. Laura Nader persistently asked why anthropologists always studied 'down' instead of studying 'up'.[35] As she put it, 'what if anthropologists were able to study the colonizers rather than the colonized, the culture of power rather than the culture of powerlessness, and culture of affluence rather than the culture of poverty? . . . the consequences of not studying up as well as down are serious in terms of developing adequate theory and description'. Others argued that it was time to bring anthropology home, and apply it to the problems and processes of western life, a call to which Douglas and Sahlins responded.[36] Their direct engagement with the social object in mainstream contexts relevant to contemporary life made them accessible to non-anthropologists, and although these works are not new – *neophilia* is a besetting sin of the academy – they accommodate the new material turn referred to above, while inviting reinterpretation.

The context in which the works appeared was the rise of academic Marxism, in which 'commodification was seen as the embodiment of evil'.[37] As Douglas put it – 'there is obloquy for merchandising and guilt in ownership . . . [and] a growing swell of protest against the consumer society'.[38] In Marxist studies, the emphasis was on production-as-exploitation rather than on the goods themselves, with consumption – meaning purchase only – figuring as the end of a linear production–consumption trajectory. There was no interest in goods once they got into the hands of the purchaser and goods were assumed to be merely for utility, or for 'competitive display'. Even in non-Marxist circles, conventional economics were seen as a wholly rational system of production driven by profit and manipulative of consumers.

Writing against this, Douglas argued that far from being peripheral to social and political life, 'Consumption is the very arena in which culture is fought over and licked into shape', its centrality to everyday life underlined by her insistence that what happened to goods after purchase should be included in the consumption trajectory.[39] To Douglas, goods were social values in material form, 'making visible and stable the categories of culture', communicating social meaning and drawing the lines of social relationships, excluding and including.[40] This, not utility, gave goods their value. Culture was not free-floating, but embedded in organizations that made and circulated the goods, and instead of being passive, consumption should be seen as an active process in which all the social categories are being continually redefined.[41] The processes were familiar to anthropologists in the field, but Douglas applied them to mainstream economic life at home.

Similarly, Sahlins aimed to show that the capitalist economy was *au fond* a cultural system, that capitalist production is a cultural process, and that

the 'so-called logic of capitalism is no sheer rationality (but) a definite form of cultural order; or a cultural order acting in a particular form'.[42] Goods reflect and create the social order and are changed by it in return, in a continuous dialectical process. As he put it, 'The product that reaches its destined market constitutes an objectification of a social category and so helps to constitute the latter in society, as in turn the differentiation of the category develops further declensions in the goods system'.[43] As an example drawn from the American clothing system, Sahlins gives the emergence of denim blue jeans in the 1960s as the signifying uniform of the new social category of 'youth'. Both producers and consumers are complicit in the process, although not consciously. As Sahlins says, because it appears to the producers as a quest for pecuniary gain and to the consumers as an acquisition of useful goods, the basic symbolic character of the process is not recognized by the participants.

The correlation between categories of people and of goods is not static. Sometimes both are present, sometimes only one and sometimes neither, and this is where the interest lies. Taken together, Douglas and Sahlins provide an approach that is particularly well suited for analyses that combine history, anthropology and material culture because a key part of their method is to see how the correspondences between objects and social categories change over time. While some considered their analyses too structural, dynamism is introduced in the specificities of each case, and in the juxtaposition of studies of the same case longitudinally. Ideally, a corpus of studies of this kind would provide a comparative basis for further development but the full potential of their approach was not realized on publication. Instead, consumption studies as they envisaged them were swamped by a rising tide of constructionism, the idea that people were wholly free to construct themselves through things, very much part of the postmodern perspective.[44] Constructionism resulted in a plethora of 'lifestyle' studies which were fundamentally flawed because self-construction did not and cannot involve the set of *all* possible goods, but only those presented by culture, 'customization' being statistically inconsequential in a world of mass production and consumption. Also, constructionism was very literal, only dealing with the material, things that are present, not the immaterial – things that are absent or excluded. The following summarized case study based on my ongoing work on new materials, applied Douglas and Sahlins, history and anthropology, and Kopytoff's biography of the object to the material and immaterial culture of Lycra®.[45]

Lycra®: Material and immaterial culture

Textiles are a favourite material object for interdisciplinary study, and they have a special place in anthropology where it has long been recognized that cloth communicates 'the ideological values or claims of the wearer. Complex

moral and ethical issues of dominance and autonomy, opulence and poverty, continence and sexuality, find ready expression through cloth'.[46] However, anthropological studies have focused on traditional, handmade, natural fibre textiles like cotton, a bias that reflects the sites anthropologists tend to work in, as well as an embedded view that only artisanal handiwork and small-scale production can imbue or reflect social values and meanings. It also bespeaks a disdain,[47] shared by other disciplines, for synthetic, mass-produced modern fabrics as a subject for academic study – despite the fact that the significant textile development of the early part of the twentieth century was the displacement of natural by man-made fibres in the mass market, first in America and Europe, then further afield. The opportunity to break through this interdisciplinary denial came when anthropological observation threw up the puzzling absence of a particular textile object.

One of the defining demographic features of life today is the 'aging of the population' – the fact that there are more people over the age of sixty than ever before. This is the direct result of two factors: increased longevity and the post-Second World War 'baby boom' – the babies born in the developed world between 1945 and 1965 – the largest birth cohort in Western history. Improved standards of living and medical treatment mean that those born during the baby boom – popularly known as 'boomers' – are living longer than previous birth cohorts. To maintain quality of life, boomers are increasingly encouraged to exercise as they age, and as women live longer than men, regular physical activity is especially important for them. Doctors' waiting rooms, health clinics, gyms and spas are full of advice leaflets to this effect, yet in around 2000 I became aware of boomer women who complained that they could not find clothes to exercise in. Intrigued, I was able to establish ethnographically that the complaint was a common one, and that boomer women were remarkably consistent in what they wanted – 'Lycra leggings, like Jane Fonda used to wear', often in large sizes. The reference to Jane Fonda was significant. In the 1970s and 1980s, Lycra® leggings had been the signifying garment of the young boomer women who participated in the aerobic movement in which Fonda was a prime mover. Leggings were everywhere, in the gym and on the street as part of the new body conscious fashions of the time.

Compared to other birth cohorts, boomers have a high level of disposable income, making them significant potential consumers. The numerical size of the cohort, their financial resources and the demonstrable 'need' for exercise clothes – as well as the fact that leggings were technologically easy to manufacture – suggested that Lycra® leggings should be widely available, but they were nowhere to be found. This was a case of immaterial culture – a social category without a desired signifying object. It was also a sure source of potential profit that manufacturers seemed to be ignoring, indicating that something cultural was getting in the way of the purely rational pursuit of financial gain. I set out to investigate this dissonance, knowing that I would have to use a combination of anthropology and history.

The analysis demanded working on a large scale – the boomer cohort as a generational representation, and Lycra® leggings as a class of objects. The technique of generational representation in anthropology was pioneered by Sherry Ortner in her 2003 study of the Generation X birth cohort, which combined demography, aggregate data, historical materials, public culture and ethnography. In my study material objects would be used as well. This approach fixes the analysis on a broad canvas from the start, essential for studies which seek to address large social processes and groups. Fortuitously, this approach was supported by the material itself. The legging was only the form – the important element proved to be Lycra®, the stretch fibre of which the leggings were made.

'Following the thing' revealed that *all* Lycra® was made by a single transnational American company – E.I. du Pont de Nemours (DuPont) – who had invented it and subsequently controlled all aspects of its production and circulation, and also worked on an immense mass market scale.[48] DuPont was a paradigm organization of the sort mentioned by Douglas, in which culture was embedded and circulated as goods. In a capitalist society, this was an example of studying up, setting the analysis at the centre of power. It also provided the opportunity to work with man-made high-tech fibres, ubiquitous in everyday life but overlooked in academic studies. Historical materials were accessed through the DuPont archive held at the Hagley Museum and Library in Wilmington, Delaware. DuPont began as a family company, and the archive embraces both the history of the family and the history of its many products, going back to the founding of the company in 1802. Very few anthropologists have explored family business archives, and those who have find them even more discomforting than the usual sort. George Marcus, who worked on a study of American dynastic families, referred to the danger of ethnography in these circumstances becoming a repetition of 'the mythic narrative of the family in the guise of scholarly production'.[49] However, this is little different to the dominant voices anthropologists encounter in the field. And in the case of DuPont, what some might see as ideological constraint is amply compensated for by unique insights into the processes of production and consumption on a mass scale, seen through the corporate eye. It remains the case that, in a society defined by mass consumption, relatively little attention is paid, by historians or anthropologists, to material goods from the producers' point of view.[50] The historical work was carried out in tandem with ethnography on the boomers, the retail arena, and DuPont's textile activities.

In brief, DuPont began in the nineteenth century as a family company, focusing on a single product, gunpowder, developing an extremely strong company culture based on chemical expertise and constant research and development. Forced by monopoly regulations to diversify from their original powder business, DuPont moved into fields such as paints, plastics and textile fibres that were based on their long-established mastery of chemistry. In order to avoid monopoly problems in future, DuPont

abandoned vertical integration. Instead of working through all the stages of a product from raw materials to sales and distribution, it cut out all but the first two stages, while remaining indirectly involved in the total trajectory. DuPont would take raw materials and transform them into technologically advanced materials or processes. These they would sell on to independent manufacturers or fabricators, who made them into final and end-use products that were sold on to consumers.

All along the chain, DuPont enhanced the chances for success of products that incorporated DuPont materials. In the case of textile fibres, they worked closely with spinners, dyers and manufacturers and in order to create end-use demand, DuPont advertised direct to consumers, supported client advertising and ran promotions. In their laboratories, they constantly refined and improved their fibres and processes. DuPont made extensive use of the emerging field of market research in order to discover what consumers wanted, information they used to inform their technical, research, development and sales departments to facilitate the development of better products, and shared information with their clients to give them a competitive edge. Clients were tied to DuPont, not by restrictive contracts, but by the quality of the innovative fibres invented by the company as well as the promotional benefits that association with DuPont would bring. This unique way of working gave DuPont an unrivalled knowledge of the consumer market in which they were heavily invested. DuPont was only interested in mass market high-volume products, their outlook encapsulated by a company saying – 'to serve a market, fill a need'. In the market research documents, you see broad social formations – categories in search of goods – which DuPont aimed to supply.

With their eye on the mass market, DuPont were well aware of shifts in buying patterns, particularly the rise of women consumers in the 1920s. Increasingly, their textile invention and production were aimed at women, both as purchasers for the home and as direct consumers. For DuPont, 'need' in clothing terms meant something all women had to wear every day, and in the 1930s every woman wore stockings. Market research had established the need for stockings that were sheer and durable enough to compete with silk, but stable in price and certain of supply. After thirteen years of research and development, DuPont's nylon, launched in 1939, was an immediate commercial success. The search then began for the 'new nylon', a fibre that also filled a fundamental need. Another garment that all women 'had' to wear was a girdle; the confining 'modern' corset that was a taken-for-granted mark of social respectability. Girdles were worn by women of all classes, across all income groups, and women put their daughters into girdles when they were still at school. A woman would not leave the house without one, and the girdle was seen as a necessary corrective for fat, sag and jiggle. Here can be detected anthropological notions of propriety and bodily control as part of a pervasive moral system in which clothing, grooming and other bodily practices signify participation in a patriarchal culture and its values,

in which a woman was seen as 'controlled', both bodily and socially. 'Women' were a huge social category, objectified by girdles.

DuPont's market research had established the need for a more comfortable girdle, and the company spent more than twenty years developing a new stretch fibre. As the research and development work proceeded, a new social category emerged in the DuPont market reports – the infant boomers, whose cots, toys, clothes and much more were made of DuPont materials. The archive presents an unrivalled opportunity to see the young boomers, although they were not yet called that, through their objectifying goods. In those days, it was assumed that little girls would grow up to be just like their mothers, and in the corporate eye, the time and expense spent on developing a new girdle fibre was justified by the prospect of a birth cohort of unprecedented size entering the girdle-wearing market in due course, but that is not what happened.

DuPont launched its new elastane fibre, now called Lycra®, on 28 October 1959, revolutionizing the girdle market and achieving immediate commercial success. Lycra® girdles were strong yet supple and comfortable. As one advertisement put it – 'At last, a girdle that lets you breathe – even after shrimp, steak, French fries, salad, parfait and coffee!' (Figures 6.1 and 6.2).[51] So ubiquitous were girdles that the popular Barbie dolls, introduced in 1959 and the first dolls with a wardrobe of grown-up clothes, came equipped with miniature girdles. But after less than ten years, sales of girdles began to decline. DuPont's market research revealed that it was young boomer women, then entering the market as consumers, who were abandoning the girdle. In the larger social context of the 1960s, young women were rejecting the traditional women's role, and with it the objectifying girdle. Worse, their mothers soon followed them, embracing the liberation of the time.

Ethnography revealed the extent to which boomers remembered the heady liberation of abandoning the girdle. Bra-burning turned out to be an urban myth; bra sales actually rose during the period, because many of the jettisoned girdles had had built-in brassieres. Retailers remembered the foundation departments, once the most profitable in the store, closing down seemingly overnight. DuPont spent much time and money trying to save Lycra® girdles, working closely with its clients the lingerie and hosiery makers, but in the end the battle was lost, and rolls of Lycra® fabric intended for foundations languished unused in warehouses. Women embraced the new physical and social freedom, expressed through rule-breaking practices like aerobics, in which strenuous, sweaty gym-based exercise for women became socially acceptable for the first time. Gym personnel remembered the rise of aerobics, taken up so widely that it was called a 'craze'. The Lycra® fabric no longer needed for girdles was bought by enterprising small manufacturers who used it to make the leggings which became the objectifying garment of the young female boomer aerobics cohort – whether they worked out or just wore it as a fashion statement. The fabric that had once been seen as restrictive was now perceived as enabling. Boomers

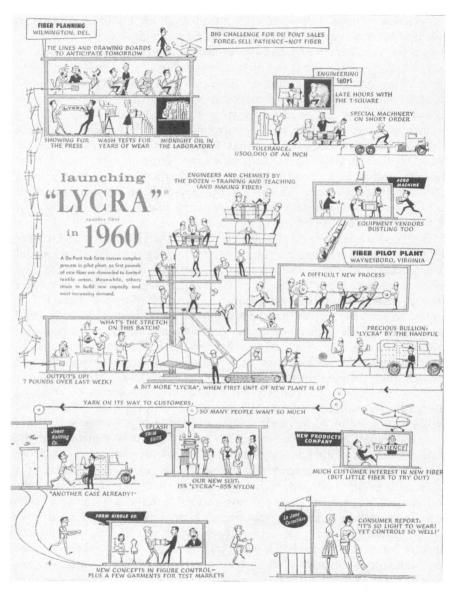

FIGURE 6.1 *From the* DuPont Magazine, *February 1960, showing the many stages involved in creating, developing and bringing Lycra® to the market. Courtesy of Hagley Museum and Library.*

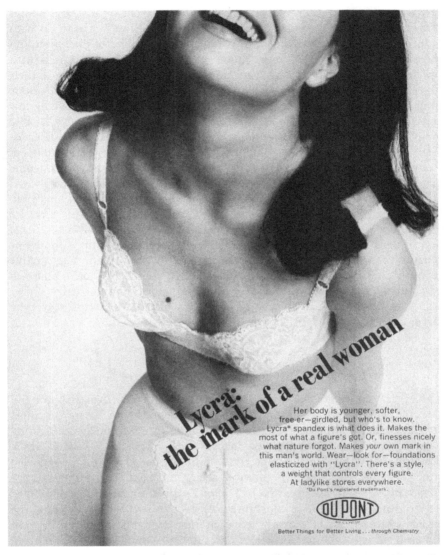

Lycra: the mark of a real woman

Her body is younger, softer, free-er—girdled, but who's to know. Lycra* spandex is what does it. Makes the most of what a figure's got. Or, finesses nicely what nature forgot. Makes *your* own mark in this man's world. Wear—look for—foundations elasticized with "Lycra". There's a style, a weight that controls every figure. At ladylike stores everywhere.
*Du Pont's registered trademark.

DU PONT

Better Things for Better Living . . . through Chemistry

FIGURE 6.2 *Invented for use in traditional foundation garments, Lycra® initially fell victim to changing social definitions of what a 'real woman' was. Courtesy of Hagley Museum and Library.*

considered Lycra® a liberating fabric, not a confining one – never realizing that the legging had grown out of the girdle they so hated. Leggings were so ubiquitous that they became a symbol of the young female boomer cohort, at a particular point in time.

My combined ethnographic and archival work went on to show why it was that midlife boomers could not find leggings to buy. It had to do with cultural constructs of age, and with the linked biographies of the object and the cohort. Originally, the young boomers associated Lycra® leggings with youth, activity and fitness. Most gave up regular exercise and leggings in their middle years, in the face of work and family demands, but the associations remained, re-emerging when they were told to resume exercise. But by this time, they were no longer young – and now the boomers and leggings became victims of the youth culture they had created. Their children – the members of Generation X – saw them as old, and leggings as something old-fashioned, 'something my mother used to wear'. No one wanted to produce or consume goods associated with being 'old'. 'Older women' became socially and culturally invisible, and leggings disappeared. Yet after the initial fieldwork ended, leggings reappeared, as did Jane Fonda with a later-life exercise programme aimed at boomers. Older women began to appear in advertisements and in the media. Boomers were finally being objectified again, although it remains the case that 'older woman' is a troubled category, still unattractive to both consumers and producers, as reflected in the restricted range of objectifying goods for boomers despite the large demographic market they constitute, which in turn gives insights into social attitudes to ageing, in the larger context of an ageing society still obsessed with youth.

Conclusion

The Lycra® study showed how, over time, categories and objects slip in and out of value and visibility in correspondence with social change, substantiating the work of Douglas, Sahlins and Kopytoff, and demonstrating how history and anthropology, macro- and micro-analysis and thick description and historical perspective can be combined in and through the study of material culture. In addition, seeing material culture through the corporate eye – in this case that of DuPont – gives a new understanding of how our material world is constituted. As regards textiles in particular, the Lycra® study revealed the extent to which our understanding of this form of material culture is limited if we take it as a 'given'– which we do with natural fibres and fabrics, studying modifications but never origins. With contemporary synthetic fibres, it is possible to follow precisely how things come into being, both on the level of scientific innovation and the culture that surrounds it, and also in terms of the social values that may drive or obstruct new textiles in the mass market. In its approach, the study intentionally turned away from philosophy and ideology, returning to the material, and to the practices of history and anthropology, but with a twist. The ultimate lesson of the Lycra® study was that immaterial culture has as much to say as material culture and things that are absent speak as eloquently as things that are there.

Notes

1 M. Sahlins (2004), *Apologies to Thucydides*. Chicago and London: University of Chicago Press.

2 Herodotus (1998), *The Histories*, trans. R. Waterfield. Oxford: Oxford University Press, p. 3.

3 C. Geertz (1973), *Interpretation of Cultures*. New York: Basic Books.

4 Sahlins, *Apologies to Thucydides*.

5 Anon (1929), *Notes and Queries on Anthropology*. London: The Royal Anthropological Institute, p. 187.

6 Anon, *Notes and Queries*, pp. 176–77.

7 C. Geertz (1990), 'History and anthropology', *New Literary History* 21 (2), pp. 322–23.

8 Anon, *Notes and Queries*, p. 363.

9 J. Moreland (2006), 'Archaeology and text: subservience or Enlightenment?' *Annual Review of Anthropology* 24, pp. 135–51.

10 S. Ortner (1984), 'Theory in anthropology since the sixties', *Comparative Studies in Society and History* 26 (1), 126–66; J. Clifford and G. E. Marcus (eds) (1986), *Writing Culture*. Berkeley and London: University of California Press; J. Clifford (1988), *Predicament of Culture*. Cambridge, MA: Harvard University Press; A. Grimshaw and K. Hart (1989–90), 'Anthropology and the crisis of the intellectuals', *Critique of Anthropology* 14 (3), pp. 227–61.

11 L. Meskell and R. W. Preucel (eds) (2007), *A Companion to Social Archaeology*. Oxford: Blackwell Publishing; C. Renfrew and P. Bahn (1991), *Archaeology: Theories, Methods and Practice*. London: Thames and Hudson.

12 V. Buchli (2002), 'Introduction', in V. Buchli (ed.), *The Material Culture Reader*. Oxford: Berg, pp. 1–22; D. Hicks (2010), 'The material-cultural turn: event and effect', in C. Hicks and M. E. Baudry (eds), *The Oxford Book of Material Culture Studies*. Oxford: Oxford University Press, pp. 25–98.

13 T. K. Earle and R. W. Preucel (1987), 'Processual archaeology and the radical critique', *Current Anthropology* 28 (4), p. 501.

14 I. Hodder (2011), 'Human-thing entanglement: towards an integrated archaeological perspective', *Journal of the Royal Anthropological Institute* 17 (1), pp. 154–77.

15 G. Riello (2009), 'Things that shape history: material culture and historical narratives', in K. Harvey (ed.), *History and Material Culture*. London: Routledge, p. 25.

16 J. Faubion (1993), 'History and anthropology', *Annual Review of Anthropology* 22, p. 36.

17 L. Nader (1997), 'Controlling processes: tracing the dynamic components of power', *Current Anthropology* 18 (5), pp. 711–37.

18 S. Ortner (1998), 'Generation X: doing anthropology in a media-saturated world', *Cultural Anthropology* 13 (3), p. 416.

19 See J. Bintliff and M. Pearce (eds) (2011), *The Death of Archaeological Theory?* Oxford: Oxbow Books; M. Edgeworth (2012), 'Follow the cut, follow the rhythm, follow the material', *Norwegian Archaeological Review* 45 (1), pp. 76–92.

20 Geertz, 'History and anthropology', pp. 324 and 329.

21 J. Comaroff and J. Comaroff (1992), *Ethnography and the Historical Imagination.* Boulder, CO: Westview Press, p. 11.

22 Ortner, 'Generation X', p. 414.

23 Ortner, 'Generation X', p. 415.

24 Geertz, *Interpretation of Cultures.*

25 Comaroff and Comaroff, *Ethnography*, p. 20.

26 D. Shankland (2012), 'Introduction', in D. Shankland (ed.), *Archaeology and Anthropology: Past, Present and Future.* London and New York: Berg, p. 1.

27 See C. Tilley with W. Keane, S. Kuechler-Fogden, M. Rowlands and P. Spyer (eds) (2006), *Handbook of Material Culture.* London: Sage; K. Harvey (ed.), *History and Material Culture.*

28 J. Demos (1999), *A Little Commonwealth.* Oxford: Oxford University Press.

29 E. J. Hobsbawm and T. O. Ranger (eds) (1983), *The Invention of Tradition.* Cambridge: Cambridge University Press.

30 D. Cannadine (1982), 'Transformation of civil ritual in modern Britain: the Colchester Oyster Feast', *Past & Present* 94, p. 130.

31 A. Appadurai (1986), 'Introduction: commodities and the politics of value', in A. Appadurai (ed.), *The Social Life of Things.* Cambridge: Cambridge University Press, p. 5.

32 I. Kopytoff (1986), 'The cultural biography of things: commoditization as process', in A. Appadurai (ed.), *Social Life of Things*, p. 68.

33 G. Marcus (1995), 'Ethnography in/of the world system, the emergence of multi-sited ethnography', *Annual Review of Anthropology* 24, pp. 106–7.

34 See J. Curry-Machado (ed.) (2013), *Global Histories, Imperial Commodities, Local Interactions.* London: Macmillan. See also Commodities of Empire project 2013 http://www.open.ac.uk/Arts/ferguson-centre/commodities-of-empire/index.shtml [accessed 27 July 2014].

35 L. Nader (1972), 'Up the anthropologist', in D. Hymes (ed.), *Reinventing Anthropology.* New York: Pantheon Books, pp. 289 and 290. See also Nader, 'Controlling processes'.

36 Hymes (ed.), *Reinventing Anthropology.* And see S. Forman (ed.) (1995), *Diagnosing America: Linking Levels of Analysis.* Ann Arbor, MI: University of Michigan Press.

37 D. Miller (1995), 'Consumption and commodities', *Annual Review of Anthropology* 24, p. 146.

38 M. Douglas (1979), *The World of Goods.* London: Routledge, p. vii.

39 Douglas, *World of Goods*, p. 37.

40 Douglas, *World of Goods*, p. 38.

41 Douglas, *World of Goods*, p. 45.

42 M. Sahlins (1976), *Culture and Practical Reason*. Chicago: University of Chicago Press, p. 185.

43 Sahlins, *Culture and Practical Reason*, p. 185.

44 J. Faubion and G. E. Marcus (2008), 'Constructionism in anthropology', in J. A. Holstein and J. F. Gubrium (eds), *Handbook of Constructionist Research*. New York: Guilford Press, pp. 67–84.

45 See K. O'Connor (2011), *Lycra: How A Fiber Shaped America*. London and New York: Routledge.

46 J. Schneider and A.B. Wiener (1989), 'Introduction', in A.B. Weiner and J. Schneider (eds), *Cloth and Human Experience*. Washington DC: Smithsonian Institution Press, pp. 12–13.

47 J. Schneider (1994), 'In and out of polyester: desire, disdain and global fiber competitions', *Anthropology Today* 10 (4), pp. 2–10.

48 E. I. du Pont de Nemours Inc sold Lycra® to Koch Industries in 2003.

49 G. E. Marcus and P. D. Hall (1992), *Lives in Trust*. Boulder, CO: Westview Press, p. 54.

50 R. Blaszczyk (2000), *Imagining Consumers: Design and Innovation from Wedgwood to Corning*. Baltimore: Johns Hopkins Press, p. ix.

51 DuPont's 'At last' advertising campaign, created to launch Lycra®.

Further reading

Blaszczyk, R.L (2012), *The Colour Revolution*. Boston and London: MIT Press.

Clafin, K.W., and P. Scholliers (eds) (2012), *Writing Food History: A Global Perspective*. London and New York: Berg.

O'Connor, K. (2011), 'The ladybird and the dressing gown: cultural icons of the "Golden Age" of British childhood', *Textile History* 42 (1), pp. 22–49.

O'Connor, K. (2013), 'Beyond "exotic groceries": tapioca/cassava/manioc, a hidden commodity of empires and globalisation', in J. Curry-Machado (ed.), *Global Histories, Imperial Commodities, Local Interactions*. Basingstoke and New York: Palgrave Macmillan, pp. 224–47.

O'Connor, K. (2013), *The English Breakfast: The Biography of a National Meal with Recipes*. London and New York: Bloomsbury.

O'Connor, K. (forthcoming 2015), *The Never-Ending Feast: The Archaeology and Anthropology of Feasting*. London and New York: Bloomsbury.

Riello, G. (2013), *Cotton: The Fibre that Made the Modern World*. Cambridge: Cambridge University Press.

CHAPTER SEVEN

Identity, Heritage and Memorialization:

The Toraja *Tongkonan* of Indonesia

Kathleen M. Adams

All nations draw on an array of symbols and images culled from specific, selectively-chosen pasts to present visions of national identity and national heritage to both their citizenry and to the broader world. In multi-ethnic or multi-religious nations the task of selecting symbols for national memorialization is particularly challenging, as national monuments, material symbols deemed sacred by the state, and public architecture must resonate with multiple groups if they are to be effective, emotionally charged vehicles for imagining the nation. This chapter addresses these themes via a brief, general discussion of the interplay between heritage objects and nation building, followed by a more detailed illustrative case study of the carved ancestral house (*tongkonan*) of the Toraja people of Indonesia.

Some nations adopt and elevate artefacts associated with the past glories of indigenous minority groups to advance their legitimation projects. For instance, the Mexican government strategically appropriated majestic images of the Aztec past (archaeological monuments and artefacts) to advance its nationalist legitimation project.[1] Likewise, the Australian government has used aboriginal art and totemic imagery on its postage stamps, currency and institutional seals: these aboriginal motifs have become entwined in recent constructions of Australian national identity, the objects

have come to represent 'something essential outside and before the nation that lies also at its heart, central to its identity'.[2] Other multi-ethnic countries invent new (sometimes touristically inspired) icons that allude to mythic pasts, thereby circumventing allusions to internal ethnic or religious divisions. The city-state of Singapore embraced the Merlion (a mythical lion-headed fish) as a symbol of its 'founding legend': today Merlion statues, monuments, and shops hawking Merlion T-shirts and chocolates adorn the cityscape, inspiring not only poetry, but also debate and ridicule from Singapore's citizenry.[3] Still other nations draw on assemblages of material symbols associated with different eras and groups residing within their borders. For instance, Papua New Guinea's Parliament House was designed to embody a collage of architectural and iconic motifs associated with the various regions and indigenous cultures that comprise the nation.[4] While embraced by many as a memorial to the nation, the design of this symbolic structure was not free from domestic and international criticism.[5]

In cases such as these, we gain glimpses into the ways in which heritage objects of particular groups can become entwined in the crafting of sensibilities about history, as well as about broader regional and national identities. But, as some studies have illustrated, these are far from seamless processes.[6] What role might heritage objects play in building not only inter-group bridges but also boundaries in multi-ethnic states? How do these sensibilities concerning the relationships between objects and group identities shift over time? And what happens when these heritage objects are paraded on the global stage?

I turn now to examine the nuances of these sorts of regional and national identity-building projects by drawing on the example of the tongkonan, an elaborately-carved traditional Toraja house structure that has been both miniaturized and monumentalized in various Indonesian locales. Through tracing the tongkonan's past and present associations with varied identities (rank, ethnic and regional), and by examining the ramifications of the touristic and governmental appropriation of the tongkonan, I highlight the ways in which material objects can serve not only to construct a 'unity and diversity' image of national identity, but can also simultaneously challenge (for some groups) that unity. In cases such as these, it pays to note that these ironies are enabled precisely because of the multivocal quality of symbolic objects.[7]

The Sa'dan Toraja are a small minority group in the predominantly Muslim nation of Indonesia. In a nation of over 242 million people, approximately 750,000 Torajans reside in their homeland of upland Sulawesi. Surrounded by lowland Muslim groups such as the Buginese and Makassarese, the Toraja have a strong sense of their unique ethnic identity and of their potential vulnerability in a nation that has experienced periodic outbreaks of inter-religious and inter-ethnic conflicts in recent years. Since the 1980s, the Toraja have attracted both domestic and international tourists. Tourists are drawn by their elaborate mortuary rituals and graves,

and by their spectacularly carved ancestral houses with sweeping bamboo roofs. In fact, since the 1970s a combination of factors including tourism, Indonesian governmental actions, and UNESCO lobbying have transformed these carved ancestral houses from symbols of elite familial status into icons of Toraja ethnic identity for both insiders and outsiders (Figure 7.1).

Known as tongkonans, these Toraja houses-of-origin are both physical structures and memorials to one's ancestral heritage. Today, as in the past, Torajans use houses as reference points in tracing their ancestry. Waterson convincingly argued that Toraja can be productively understood as what Claude Levi-Strauss called a 'house society'.[8] Levi-Strauss developed this term to describe societies in which kinship organization is tethered to named houses founded by ancestors, where houses own property, and serve as the locus of ritual activities: all are the case with the tongkonan. Each Toraja tongkonan has a unique name and history and 'belongs' to all the descendants of its founding ancestor.[9] These 'house histories' tracing the deeds of familial

FIGURE 7.1 *A carved Toraja* tongkonan. *Photo by the author.*

ancestors are recounted at certain tongkonan rituals, further underscoring the tongkonan's memorializing dimension.

Not all tongkonans are equal. Older tongkonans founded by offspring of celestial ancestors are more prestigious than more recently established ones. As the kin group associated with a tongkonan grows with each generation, it splinters into smaller groups that erect new satellite tongkonans. Thus each Torajan can count membership in multiple greater and lesser tongkonans, provided they maintain their ritual obligations to these structures.[10] Extended family members associated with a named, carved tongkonan periodically organize large pageantry-filled consecration rituals for their tongkonan, thereby reinforcing the glory and prestige of the house and those affiliated with it.

Toraja tongkonans not only memorialize extended familial identities and histories, but they also index rank identities. Tongkonans adorned with elaborately-chiselled motifs were traditionally associated with the nobility.[11] Commoners could only carve specific sections of their tongkonan facades and, in the pre-colonial era (before the abolishment of slavery), slaves were barred from using carved embellishments. Thus, the elaborately-carved tongkonan was a material symbol of noble identity.

For much of the twentieth century, Dutch missionaries and subsequently Indonesian government officials viewed the tongkonan with ambivalence and even antipathy. For these outsiders, the tongkonan was often a symbol of 'backwardness' and in the 1960s the Indonesian government mounted a campaign to encourage Torajans to abandon their tongkonans in favour of modern housing. However, in the 1970s and 1980s the tongkonan began to accrue additional new meanings for both outsiders and insiders. During this period, a number of churches designed with tongkonan flourishes appeared in the Toraja landscape. Likewise, Protestant Torajans began calling the Toraja Church the 'Big Tongkonan', reflecting both the endurance of the tongkonan as a key identity motif and the desire to integrate Torajan and Christian identities. This shift was partially linked to changes in Toraja Church leadership during this period. By the early 1980s, non-noble Torajan pastors had assumed church leadership positions: many embraced ideals of equality before God and hoped to eradicate Toraja practices that reinforced rank hierarchies. In clothing the church in the carved imagery and rhetoric of the tongkonan, these non-noble pastors were effectively loosening the carved tongkonan from its close association with the elite.

Likewise, as growing numbers of non-elites who made their fortunes away from the homeland returned to the highlands, some families sought to display their new-found economic status via traditional material symbols. Some non-noble families erected carved tongkonans while others incorporated carved tongkonan-derived motifs into their modern homes. While doing my initial research in the 1980s, on more than one occasion I heard elites grumbling about non-nobles who erected tongkonans.

Another set of developments with ramifications for the tongkonan began in the 1970s, when the Indonesian government gained a newfound appreciation of the touristic value of traditional architecture. Indonesian tourism promotional materials spotlighted the carved Toraja tongkonan and what was once exclusively a marker of noble familial status was held up to outsiders as a general symbol of Toraja ethnic identity. Thus began the proliferation of tongkonan imagery: tongkonan T-shirts and postcards were available for purchase, tongkonan statues and tongkonan topiary appeared at major intersections, and Indonesian schoolbooks illustrated chapters on the Toraja with sketches of carved tongkonans. The marriage of carved tongkonans with Toraja ethnic identity was firmly established for the next generation of Torajans, who were reared on this touristic imagery. The proliferation of the carved tongkonan as an icon of Toraja ethnicity prompted new identity dialogues on the provincial stage. By the mid-1980s carved tongkonan-inspired architectural motifs were being incorporated into some hotels, banks and other edifices in the lowland provincial capital of Makassar, nine hours away from the Toraja highlands (in the homeland of Torajans' historic rivals, the Makassarese and Bugis) (Figure 7.2).

When it became time to redesign Makassar's airport in the mid-1980s, it was lavishly decorated with carved tongkonan motifs and a carved tongkonan structure was implanted adjacent to the main landing strip, visible to tourists arriving from Bali. The outcropping of Toraja tongkonan motifs in the homeland of their age-old ethnic rivals was taken by some Torajans as a sign of a shift in the historic ethnic hierarchy on the island. However, by 1995 the airport was remodelled once again, this time echoing the shape of an enormous Bugis platform house. In a sense, with these successive reconstructions, we see an architectural battle being waged for ethnic symbolic predominance in South Sulawesi. The most recent airport remodel in 2008 offers an apparent truce in the symbolic architectural warfare: its soaring glass and steel roofline is a vague amalgam of Bugis and Toraja rooftops.

Finally the Indonesian government has embraced the tongkonan for its own nation-building aims. By the 1970s Suharto's New Order government was celebrating regional diversity as a cornerstone of Indonesian national identity. As many observed, the process of Indonesian nation-building leaned heavily on aestheticization of the potentially divisive visions of the indigenous societies within Indonesia's borders.[12] In traditional dances, costumes and architectural differences, the state found 'exemplary token[s] of safe ethnic difference'.[13] Thus, by the 1980s, the Indonesian government had issued carved tongkonan embellished postage stamps and currency. For some Torajans, this represented a new level of ethnic legitimacy and respect, but ironically the government's appropriation of their architectural symbols also serves to subsume them into the nation.

As Benedict Anderson observed, monuments and memorials look both backwards and forwards in time. Normally these structures 'commemorate

FIGURE 7.2 *Carved* tongkonan-*topped police post at Makassar Airport entrance road in 2012. Photo by the author.*

events or experiences in the past, but at the same time they are intended, in their all-weather durability, for posterity'.[14] As we have seen, for Toraja elite families, the tongkonan looks backwards in time memorializing founding ancestors and earlier generations, thereby serving as an icon of familial heritage and identity. Yet, tongkonans carry the expectation that future generations of kin will renew and celebrate them and with each successive generation their pedigree will become still more glorious. Likewise, as we have seen, in tandem with historical developments, colonialism, tourism development, return migration and nation-building, the tongkonan has accrued new meanings and come to be associated with newer, broader identities. Embraced by some and rejected by others, these newer sensibilities about whose heritage the tongkonan signals are not uncontested. Thanks to

their multivocality, heritage objects such as the tongkonan are likely to continue to be potent icons for multiple visions of identity.

Notes

1 D. Brading (1985), *The Origins of Mexican Nationalism*. Cambridge: Centre of Latin American Studies; D. Brading (2001), 'Monuments and nationalism in modern Mexico', *Nations and Nationalism* 7 (4), pp. 521–31; T. Tenorio (1996), *Mexico at the Worlds' Fairs: Crafting a Modern Nation*. Berkeley and Los Angeles: University of California Press.

2 F. Myers (1995), 'Representing culture: the production of discourse(s) for aboriginal acrylic paintings', in G. Marcus and F. Myers (eds), *The Traffic in Culture: Refiguring Art and Anthropology*. Berkeley and Los Angeles: University of California Press, p. 84.

3 B. Yeoh and T. Chang (2003), ' "The rise of the Merlion": monument and myth in the making of the Singapore story', in R. Goh and B. Yeoh (eds), *Theorizing the Southeast Asian City as Text: Urban Landscapes, Cultural Documents and Interpretative Experiences*. Singapore and London: World Scientific Publishing Co., pp. 29–50; L. Kong and B. Yeoh (2003), *The Politics of Landscapes in Singapore: Constructions of Nation*. Syracuse: Syracuse University Press.

4 P. Rosi (1991), 'Papua New Guinea's new Parliament House: a contested national symbol', *The Contemporary Pacific* 3 (2), pp. 289–324.

5 Rosi, 'Papua New Guinea's new Parliament House'.

6 Cf. L. Smith (2006), *Uses of Heritage*. Abingdon and New York: Routledge; K. Adams (2006), *Art as Politics: Re-crafting Identities, Tourism, and Power in Tana Toraja, Indonesia*. Honolulu: University of Hawai'i Press.

7 As Turner observed, multivocality is one of several properties of symbols that are connected to their dynamic quality and their ability to serve as 'triggers of social action and of personal action in the public arena . . . Their multivocality enables a wide range of groups and individuals to relate to the same signifier-vehicle in a variety of ways'. V. Turner (1975), 'Symbolic studies', *Annual Review of Anthropology* 4, p. 155.

8 R. Waterson (1990), *The Living House: An Anthropology of Architecture in Southeast Asia*. Singapore: Oxford University Press, pp. 47–8. In recent years there has been much discussion of the idea of the house as a specific form of social organization. This proposition has captured the attention of many Austronesianists, as it appears to have a great deal of explaining power for many dimensions of kinship practices and orientations. See C. Levi-Strauss (1983), *The Way of the Masks*. London: Cape; (1987), *Anthropology and Myth: Lectures 1951–1982*. Oxford: Blackwell; Waterson, *Living House*; J. Fox (1987), 'The house as a type of social organization on the island of Roti, Indonesia', in C. Macdonald and members of IECASE (eds), *De La Hutte au Palais: Societes, "A Maison", en Asie du Sud-Est Insulaire*. Paris: CNRS, pp. 215–24; J. Fox (ed.) (1993), *Inside Austronesian Houses: Perspectives on*

Domestic Designs for Living. Canberra: Comparative Austronesian Project, Research School of Pacific Studies, Australian National University; J. Carsten and S. Hugh-Jones (eds) (1995), *About the House: Lévi-Strauss and Beyond*. Cambridge: Cambridge University Press; and M. Erb (1999), *The Manggaraians: A Guide to Traditional Lifestyles*. Singapore: Times Editions, for further explorations of this concept.

9 A given tongkonan is only occupied by one nuclear family, with members of the broader group gathering at the tongkonan for extended family meetings and rituals.

10 Torajans' sense of broader familial identity is so strongly tethered to these houses that Torajans encountering one another for the first time when far from the homeland will frequently enquire as to each other's house affiliations.

11 L. Tangdilintin (1983), *Tongkonan Dengan Arsitektur dan Ragam Hias Toraja*. Ujung Pandang: Yayasan Lepongan Bulan, p. 59.

12 E. Bruner (1979), 'Comments: modern? Indonesia? culture?', in G. Davis (ed.), *What is Modern Indonesian Culture?* Athens: Ohio University Center for International Studies; G. Acciaioli (1985), 'Culture as art: from practice to spectacle in Indonesia', *Canberra Anthropology* 8 (1–2), pp. 148–72.

13 W. Keane (1995), 'The spoken house: text, act and object in Eastern Indonesia', *American Ethnologist* 22, p. 109.

14 B. Anderson (1990), 'Cartoons and monuments: the evolution of political communication under the New Order', in B. Anderson (ed.), *Language and Power: Exploring Political Cultures in Indonesia*. Ithaca: Cornell University Press, p. 174.

CHAPTER EIGHT

Exchange and Value: The Material Culture of a Chumash Basket[1]

Dana Leibsohn

Baskets are fragile things. Their fibres degrade with use, their colours fade in bright light. Yet the basket in Figure 8.1 – created in the early 1820s by a Chumash woman living on a mission in California – is largely intact. This is a basket that has been treated with care. Today it resides in a museum of anthropology, testimony to the craftsmanship of the Chumash, indigenous people that have long inhabited western California.[2]

The basket design includes alphabetic writing and images that would have been familiar to many living in Spanish America in the early nineteenth century.[3] The preference for such texts and imagery suggests an object embedded in networks of cross-cultural circulation and linked to histories of colonization and its economics. Baskets are traditionally made to hold and carry other objects; they can be transported with ease. During the first hundred years of this basket's existence, it travelled an extraordinary distance: more than 2,000 miles, from the mission to Mexico City and onto New York City, and then west into California again.[4] Beyond these basic facts, though, how does a basket register patterns of exchange and speak to the disparate meanings of value?

We can start with the basket's physical form. It measures 41 cm in diameter and 16 cm in height, which is neither very large nor very small by Chumash standards. The basket takes an open form, with sloped sides. The coiled structure is composed of rushes (*juncus textiles*), a material that was

FIGURE 8.1 *María Marta, presentation basket, c. 1822. Phoebe A. Hearst Museum of Anthropology, Berkeley, California, USA.*

locally tended, honoured and harvested both before and after the arrival of Spaniards. Compared to other baskets, the stitches that bind the coils here, and create the dark-upon-light design, are exceptionally even and tight. From this we know that the basket represents the work of a skilled basketmaker – one highly trained in the handling of fibres and awl, and who had time to create very fine work.

The Spanish words woven into a circle of text near the basket's rim register the name of a person, María Marta, and the place where she worked, San Buenaventura. Translated into English, the full text reads: 'María Marta, neophyte in the mission of the Seraphic doctor [in] San Buenaventura made me in the year. . . .'.[5] The words seem to stop short (before recording the year of the basket's creation), yet they clearly situate the basket geographically and culturally. San Buenaventura was one of several Franciscan missions founded in California in the late eighteenth century and devoted to the conversion and education of Chumash people. María Marta was a baptismal name,[6] and 'neophyte' was her status near the bottom of a church-determined hierarchy at whose head sat the 'Doctor'. And so this basket speaks directly of evangelization practices in the Americas – a primary filament in the cross-cultural web that bound Franciscans and Chumash together in this period. For in Spanish America, evangelization did not mean simply conversion to Christianity; it also required that indigenous people adhere to patterns of

daily life that friars and colonists sanctioned as proper and 'civilized'. It also meant for many contributions of time and labour to build and sustain churches and mission complexes.

Across three hundred years of Spanish rule in the Americas, very few handmade objects were signed. This basket represents a rare (if not unique) example of an object with a woman's signature. This implies that indigenous biographies – while often not well documented – contributed to the meanings invested in objects. Who made an object could matter greatly, and gender (along with individual subjectivities) was fundamental.[7] Yet the basket does not merely record its maker's name. Its text says María Marta 'made me', suggesting this basket was an object with presence and a voice in the world. The phrasing is that of a 'speaking object'. The basket's woven inscription also implicates habits of Western literacy. María Marta may well have learned to read and write Spanish letters at the mission, but we cannot be sure. Her woven words may have been copied from a text set out for her by a friar or other literate person.

Indeed, how much of a role María Marta had in designing this basket remains unclear. The patterned designs may have been her idea, although we should hold open the possibility that she was, at least in part, following a friar's directions. For Chumash people living at San Buenaventura in the early 1800s, autonomy was a complicated prospect. People came to the mission for many reasons, and we do not know why María Marta chose to move there. At the mission, people could count on food, although once baptized and living within the Franciscan fold, they were not at liberty to leave. Indians were 'spiritual children'.[8] Daily habits were subject to Franciscan rules of behaviour and religious practice, and indigenous labour was organized to support the mission, its residents and Franciscan ambitions. Products from the mission – including agricultural goods and baskets – were used locally, but they were also sold. Funds would have sometimes been spent to enrich the church, which had bells (that still exist today) and paintings imported from Mexico City. San Buenaventura may have been another world in comparison to the cosmopolitan cities of the early-nineteenth century, but it formed part of a network composed of other missions in California, religious colleagues in the capital of New Spain, painters and craftsmen thousands of miles away, and traders willing to make the journey from distant Mexico City.

How María Marta perceived her own situation at San Buenaventura is difficult to say, but her move to the mission, and the likely fact that she would stay forever, contrast pointedly with the mobility experienced by her basket. Of all the objects made for sale and trade on the California missions, baskets were among the most coveted. Chumash basketry had a long and illustrious history, and well before the arrival of the Franciscans, baskets were made for daily use, ritual occasions and exchange with other indigenous people. By the time María Marta wove her basket, nearly forty years after San Buenaventura was founded, baskets had been circulating outside

Chumash communities for many years. One European who travelled through California in the 1790s describes 'curious wrought baskets which were much admird [sic] & eagerly purchasd [sic] as articles of curiosity'.[9] Others write of so many baskets having been purchased or given as gifts that some villages in California had no more to offer. Given this history of commodity exchange and gifting, we might reasonably expect that María Marta knew her exquisite basket would be taken from the mission.

The pattern woven into the basket's side panels certainly points to the outside world. Certain portions of the basket's design emphasize geometric patterning. Others owe their inspiration to silver coins, of a type minted under Spanish auspices in Mexico. For this reason, this kind of basket is today sometimes called a 'silver basket'.[10] The specific coin that served as María Marta's model no longer exists (at least it is not known), although it was likely similar to the one in Figure 8.2. This coin was worth 8 reales; in English it would be known as a 'Piece of Eight'.

In Spanish America, the minting of such coins was to comply with official weights and measures, and symbolically, these coins evoked the wealth and imperial reach of the Spanish crown. We sense this from the coin's design. The pattern appears on pesos minted from the 1770s through to the 1820s. One side of the coin bears a profile of the Spanish king, with his name and year set into the text around the rim ('Charles IV by the grace of God, 1806'). The other side also displays text at its perimeter. Through abbreviations, the Latin lettering identifies Charles as King of Spain and the Indies; it registers the site of the mint (with an 'M' for Mexico City) and the coin's value (8 reales).[11] At the centre is the coat-of-arms of the Spanish monarchs, with the shield of Castile and Leon flanked by the Pillars of Hercules and a crown at the top.

Pieces of Eight of this type were used across the Americas. They may have been made (and used) in Spanish America, but they were also shipped to

FIGURE 8.2 *Eight-real coin, Mexico City, 1806. Photo by the author.*

Spain and France, India and China, serving as one of the world's main currencies. Spanish silver coins were, in fact, among the most mobile and fluid objects known at the time. As a form of money, coins make us think about wealth and desire, and economies of exchange. Coins were valued because of the silver they contained, but then, as now, coins were objects with complicated lives. Apart from being handed over to a merchant or trader to buy something, coins were pierced and strung together to make jewellery, hoarded in locked chests, and buried as offerings for the dead. Silver coins were also melted down and turned into other things: ingots, candlesticks, buttons. Given how convertible silver coins could be – how easily they can be turned into other things, through both physical manipulation and commodity exchange – how do we interpret the coin design of María Marta's basket?

Visual analysis makes it clear that only certain parts of Spanish coinage appear in the basket: while there is no portrait, the wording at the basket's rim parallels the text of the coin's perimeter (the words are of course different); and the crown, Pillars of Hercules and coat-of-arms have been excerpted from the coin and repeated four times along the basket's sides. At a basic level, a shift of design or imagery from one medium to another is a familiar gesture in the history of art and design. Today, for instance, it is not surprising to see frames from a comic book transferred to T-shirts or recast into movies (sometimes even in shot-to-shot remakes). In the early modern period, prints often inspired tapestry weavings and costumes for ritual processions; ceramics prompted new kinds of design work in glass and metal. Yet as a hand-worked technique, the 'translation' of pictorial elements from silver coin to reed basket was no simple matter, it required sophisticated thinking and a well-honed sense of design.

We sense something of this from the coat-of-arms and Pillars of Hercules, which appear as 'negative images'. That is, the forms are not a dark colour set onto light fibre; rather they have been outlined with dark stitches and are actually part of the light background of the basket. In addition, elements from the coin had to be translated from flat (or nearly flat) images on a circular object into stitched forms that would still be legible along the sloped angle of the basket's side. A practiced hand might create such translations out of habit, but we should not underestimate the technical expertise this involved.

Seen from this perspective, the basket – an object made of humble, fragile materials – is a virtuoso creation. No small part of its value comes from the labour, knowledge and skill implied in its final structure and form. The basket also offers a commentary on silver coins. It is not the physical weight of silver that matters here, nor the glint of the precious metal. Instead, the basket calls attention to the design of the coin, turning the silver token into an object of visual rather than strictly monetary value. In freezing the image of a coin in reed fibre, the silver object takes on meaning for its patterned appearance, not for what it can buy, not for its shiny surfaces. Unfortunately,

we cannot know precisely what María Marta was thinking when she made this basket: did she intend to comment on, and expand the symbolic meaning of silver coinage, or were the technical challenges of turning a coin into basketry foremost in her mind?

Of course a maker's intentions never dictates the meaning of an object or artwork, nor do the intentions of owners. Even so, it is tempting to try to trace the path of this basket after it left San Buenaventura. From what is known about baskets given as gifts to visiting officials, it would be reasonable to presume this one was taken to Mexico City by those who first owned it, or perhaps by their heirs. Even if the basket was never highly valued and spent much of its life in a dark closet, its state of preservation suggests it led a relatively privileged life. Just about one hundred years after it left the mission, in 1919 or 1920, Zelia Nuttall found the basket in a shop in Mexico City that specialized in antiquities. A well-known archaeologist and scholar of indigenous histories in the Americas, Nuttall purchased the basket, sent it to New York City and soon thereafter donated it to a museum in California, a museum now named in honour of her good friend, a wealthy philanthropist and collector named Phoebe Hearst.

As it became drawn into a cycle of gifting and collecting, the basket's status shifted from antique to indigenous artefact. The primary figures in this part of the basket's life were women of means who shared interests in objects created by indigenous people, creating new value for such objects through their preservation and study in museum settings. In the late nineteenth and early twentieth centuries in the United States, thousands of handmade, indigenous objects entered the world of Euro-American collecting and scholarship. This part of the basket's story, then, is hardly unique – and this, too, lends the object significance.

María Marta's basket travels little these days and it holds nothing more than air. It has become a quiet, still object. Even so, her basket demonstrates the eloquence of material forms, showing us how woven fibres can create and sustain multiple kinds of value. Trade and silver money, missions and artefacts, the weight of metal and ephemeral labour of coiling words and images into basketry: María Marta's handiwork bears witness, even today, to the complex relationships that objects could create in, and for a colonial world.

Notes

1 This chapter owes much to collaborative research and writing with Barbara E. Mundy, who helped me develop a deeper understanding of this basket; I also thank Byron Hamann and Jeffrey Moro for sharing their perspectives on colonial and contemporary cultural practices.

2 The basket is held by the Phoebe A. Hearst Museum of Anthropology, Berkeley, California (1–22478).

3 California was part of New Spain, and subject to the Spanish Crown until

Mexico won its independence in 1821. Alta California, as the region was known, then became part of Mexico. In 1848, after the Treaty of Guadalupe-Hidalgo, it became part of the United States.

4 The collection history of the basket is summarized by L. Smith (1982), 'Three inscribed Chumash baskets with designs from Spanish colonial coins', *American Indian Art Magazine*, pp. 62–68.

5 In Spanish: 'María Marta, neofita de la mision de el Serafico Doctor San Buenaventura me hizo en . . .' Zelia Nuttall gives a slightly different translation of the inscription, attributing it to Ana Marta. See Z. Nuttall (1924), 'Two remarkable California baskets', *California Historical Society Quarterly* 2 (4), pp. 341–3.

6 Smith has argued that María Marta's indigenous name was Lapulimeu. Smith, 'Three inscribed Chumash Baskets', p. 67.

7 Male signatures, especially on paintings, are more common, although the number of indigenous craftsmen whose names have survived are few indeed. María Marta's basket may therefore be seen as doubly rare because of its signature. Yet the production of objects by women in hierarchical institutions led by men (such as missions) represents a well-known aspect of colonial practice in this region and period.

8 S. W. Hackel (2005), *Children of Coyote, Missionaries of Saint Francis: Indian-Spanish Relations in Colonial California, 1769–1850*. Chapel Hill, N.C.: University of North Carolina Press, p. 3. On conditions at the Chumash missions, including discussion of religious and labour expectations, as well overt and subtle acts of resistance, see: Hackel, *Children of Coyote*; and J. Sandos (2004), *Converting California: Indians and Franciscans in the Missions*. New Haven: Yale University Press.

9 A. Menzies (1924), 'Archibald Menzies' journal of the Vancouver expedition', *California Historical Society Quarterly* 2 (4), p. 315.

10 Other 'silver baskets' are housed in the National Museum of the American Indian and the Santa Barbara Museum of Natural History. None of these other baskets bear María Marta's name – making this particular basket unique – although she is clearly not the only woman to have created works of this type. Indeed, Menzies mentions baskets with the Spanish coat of arms and texts woven into their patterned decor in his 1790s journal. Menzies, 'Archibald Menzies' journal', p. 326.

11 The texts are composed in Latin, and include abbreviations: 'Carolus IIII Dei Gratia 1806' (obverse), and 'Hispan[iarum] et Ind[iarum] Rex mo 8K T.H.' (reverse).

The Histories of Material Culture

CHAPTER NINE

Spaces of Global Interactions: The Material Landscapes of Global History[1]

Anne Gerritsen and Giorgio Riello

The past decade has seen an increasing interest in material culture outside traditional national boundaries. As Western societies are producing less and less of the commodities that are consumed on a daily basis, historians have discovered that already in the early modern period (c. 1400–1800) a wide range of goods circulated across continents and global markets. Some historians have called this an era of 'proto-globalisation' or 'the first global age' to signal that some of the features that we commonly attribute to recent globalization are not necessarily new.[2] Chinese blue and white porcelain (sometimes still called 'China') was manufactured in China and exported to other parts of Asia, Africa and Europe and reached North America practically with the first European settlers at the beginning of the seventeenth century.[3] Indian cotton textiles (in French *indiennes*), printed and painted with colourful motifs, were equally successful global commodities as can be seen in numerous archaeological sources, paintings, and surviving artefacts preserved in museum collections.[4]

What singles out commodities such as porcelain and cotton is that already during the early modern period, they became part of the daily lives of millions of people. Unlike the precious rarities that adorned the cabinets of wealthy collectors, over the course of the seventeenth and eighteenth centuries porcelain and cottons were traded in their millions, especially by European chartered companies such as the English, the Dutch and the

French East India companies.[5] In Europe, such commodities came to embellish the interiors of rich and poor households alike. An examination of European inventories shows how next to local earthenware and other ceramics, porcelains manufactured in China were quite common.[6] Similarly cotton textiles – before they became fashionable items of dress in the eighteenth century – adorned the walls of bourgeois interiors as they were cheaper alternatives to expensive hand-woven tapestries.[7]

Porcelain and cotton – together with other imported commodities such as lacquer, small ivories, caskets and other so-called 'exotic' goods – reshaped domestic interiors not just in Europe but across vast parts of the world.[8] This is the case for areas of European settlement such as North and Latin America, but also for strategic trading posts such as the Cape of Good Hope, Goa, Batavia and Canton. Elsewhere too, Chinese porcelain was used for everyday decoration, dining and elite display. The sultans of the Ottoman Empire collected vast quantities of Chinese porcelains for the kitchens of the Topkapi Palace in Istanbul; the Mughal emperor Shah Jahan (r. 1627–58), famous for building the Taj Mahal, was a great patron of the arts and an avid collector of Chinese ceramics, and the Safavid rulers of Iran, too, built up substantial collections of Chinese porcelains.[9] Similarly, beautiful Indian cotton textiles were used to decorate princely and imperial interiors in South Asia, as we see in numerous Mughal miniatures. Already by the fifteenth century, textiles were also traded across the Indian Ocean and were used in religious rituals in Southeast Asia, as apparel in places as far apart as West Africa and Japan and as items of domestic decoration in the Middle East.[10]

We argue here that it would be a mistake to interpret artefacts such as cotton textiles or porcelain simply within a matrix of trade or as part of a history of expanding consumer choices. That is one of the pitfalls of the study of material culture: all too easily it can become a display case for the consuming habits of past societies, in particular those of the increasingly rich and supposedly 'modern' West.[11] The value of artefacts and commodities from afar was not just located in their ownership or consumption, but in the new imaginary spaces they created. A teacup made in China created its own world of ideas, its own associations with the drinking of another Asian commodity such as tea, its own pleasure in the translucent nature of the material, in the beauty of light blue design on a glossy white surface. An Indian cotton fabric was not just an alternative to woollens or linens; it created a series of associations and ideas about its provenance. It was a fabric that was light, brightly coloured, often decorated with strange flowers and beautiful birds. It was also a fabric that at least in Europe became both popular and fashionable.

Paula Findlen has recently argued that we should see the early modern period as an 'expansive landscape of interconnected people and things'.[12] Such interconnections can be mapped onto the large canvas of global trading routes but also onto the small spaces of early modern European parlours and chambers replete with objects from Asia. We argue that these early modern commodities created new spaces, reconfigured geographies and

TABLE 9.1 Spaces of global interaction

The type of space. . .	The processes that shape the object:	Objects	Key variables
. . . where objects are created	– Working the material – Customization – Trade	– Mounted porcelain (Fig. 9.1) – Customized palampores (Fig. 9.2)	Taste and value
. . . imagined in objects	– The visualization of distant spaces	– 'Tea-scene' porcelain (Fig. 9.3) – China-Japan-India palampore (Fig. 9.4)	Meaning and understanding
. . . produced in negotiations between producers and consumers	– Hybridization – European presence in Asia	– Petticoat with Europeans (Fig. 9.5) – 'Red-hair' *famille rose* porcelain (Fig. 9.6)	Contact and exchange
. . . situated at a distance from Asia	– Import substitution – Fusion between Asian and European processes	– Delftware pot (Fig. 9.7) – 'Emperor' tapestry (9.8) – Toile (Fig. 9.9) – 'Palampore' plate (Fig. 9.10)	Consumer demand and cost

brought into contact societies living at vast distances from each other at a time when it took more than two years to go from Europe to China and back. The table inserted here highlights the variety of spaces and processes that created the material landscapes of global history, and the key variables at work (Table 9.1).

Material culture and the global spaces of creation

The material interconnectedness of the early modern world can first and foremost be mapped onto individual objects. The mounted bowl in Figure 9.1

FIGURE 9.1 *Green-glazed porcelain bowl decorated with thin gold in flower patterns, made between 1522 and 1567 in Jingdezhen, China. The mount is made in engraved silver-gilt, probably in Germany around 1550. A narrow band encircles the edge of the bowl, and is connected with the base by four hinged ribs.* © *British Museum, AF.3130.*

traces a trajectory that brings China, Japan, Germany and eventually Britain (where it now forms part of the British Museum collections) into contact with each other. The bowl of green-glazed porcelain was made in the second quarter of the sixteenth century in Jingdezhen in Jiangxi province, China, where at the time the finest porcelain of the world was produced. The decoration in thin gold on the bowl is referred to as *kinrande*, a Japanese term meaning 'gold brocade'.[13] The use of a Japanese term for the decorative style of this Chinese porcelain points to the market for which such wares were usually made, except that this green *kinrande* was not exported to Japan but to Germany, where it received these very finely worked gilded silver mounts.

This green *kinrande* is not a unique object, but it dates from a time when such objects were exotic and highly sought after luxurious possessions, before the European trading companies began delivering large quantities of Chinese ceramics to European markets in the seventeenth century. In the sixteenth century, only royal households and aristocratic families could have afforded Chinese porcelains. This is why their owners emphasized their importance and value by adding richly decorated and exquisitely made silver mounts. By adding a mount, the Chinese object acquired greater significance not only in value but arguably also in space.[14] The travels of the object are layered onto the material: the green-glazed porcelain first gains a layer of thin gold decoration for an imagined Japanese consumer, and a layer of silver when the German owner claimed the object. The silver-gilt mount and the porcelain bowl together form an entirely new object that encompasses travels across long distances and different cultural zones. The reconfiguration of the object symbolizes the reconfiguration of the early modern landscape of global connections.

If solid porcelain was physically changed whilst moving from hand to hand, the apparently more malleable Indian cottons were not necessarily subjected to similar processes of material reconfiguration. In the seventeenth and eighteenth centuries, Europeans were keen to acquire large pieces of Indian cotton cloth to be used as wall- and bed-hangings. These were produced on the Coromandel Coast of India and called *palampores*. As extant examples such as that in Figure 9.2 show, they gave consumers the pleasure of intensely colourful scenes with luxuriant flora and fauna.[15] They could be several metres large and were cut to form a set, for instance a set of curtains and valances for a bed, thus entailing some material reshaping to suit European uses and needs.

Palampores are often used as examples of 'exotic' commodities whose success on European markets depended on their 'foreignness'. For a long time the tree of life – the most common motif on palampores sold to Europe – was thought to be a quintessentially Asian design going back to ancient Persian and Egyptian mythology. Yet, the exoticism of the tree of life has been questioned and textile experts now argue that it was most likely to have originated in Europe (possibly borrowed from Scandinavian myths)

FIGURE 9.2 *Painted and dyed cotton bed curtain (palampore), made on the Coromandel Coast of India, c. 1700 for the European market.* © *Victoria and Albert Museum, Given by G. P. Baker IS.121-1950. This artefact is currently on display at the V&A's British Galleries, room 56c, case 1.*

and 'exported' to India where thousands of palampores came to reproduce the tree in every shape and form.[16] Neither European nor Asian, the tree of life was embedded on a rockery and laid out in a triangular shape that is distinctively Indian and completed with beautiful but out-of-scale flowers that in the case of Figure 9.2 are clearly Indian although they show some understanding of European botanical taste.

Palampores show how design was neither totally determined by producers nor by consumers. It was created through processes of customization negotiated over long distances through the sending of samples and letters.[17] The English, for instance, were very fond of acquiring Indian quilted palampores (quilts), even if these cost an astonishing £5½ to £6 in the mid-seventeenth century – the equivalent of £5,000–£10,000 in today's money.[18] This might explain why the English East India Company in London was so precise in giving instructions to its employees in Agra in India to acquire quilts that could be used on both sides with borders of different colours around nine inches wide, so that they could be spread across the bed. Even the stitching had to be stronger, as it was thought to make the object last longer.[19]

We might interpret these requests as a sound understanding of the English market, but they also show the complexity of the creation of global commodities such as palampores, Indian quilts or mounted Chinese porcelains. Their manufacture and design were as globally connected as was their trade. Far from being passive props of global exchange, their making, their physical attributes and arguably their overall success among consumers depended on a dynamic process that entailed the communication of ideas, preferences and sound marketing advice between remote parts of the world.

The spatial dimension of the so-called 'first global age', however, should not be solely interpreted through the categories of physical geography. If during this time the world became more connected ('shrunk' we would say today) it was not just because people and goods moved with increasing ease from one point to another on the world map. It was also because people had the capacity to imagine and make sense of worlds beyond their own, something we call a 'global imaginary'.[20] Artefacts and especially popular commodities had a significant role to play in the creation of this global imaginary. Far from being simply 'items of consumption', they represented both in fictionalized and in concrete form (i.e. they 'materialized') far away spaces, people and environments.

Material culture and the global spaces of imagination

Objects created 'imagined spaces' – views of faraway places where they were produced or where they were thought to have come from. We have to

remember that the average European adult man or woman would have spent most of his or her life within a radius of just a few miles. The rich and literate became increasingly conscious of the expanding world that surrounded them via the printed media – both books and prints – and the richest of them prided themselves by collecting expensive artefacts from Asia, Africa and the New World.[21] The majority of people, however, were far more likely to encounter a Chinese figure on the surface of a cheap porcelain plate than on the pages of a book or, for sure, in the flesh.

This is the case of the porcelain plate depicted in Figure 9.3 which is part of the fine collection of Export Art in the Peabody Essex Museum in Salem, Massachusetts. It was made around 1740 in Jingdezhen. By then, the method of producing porcelain, i.e. plates and vessels made of clay, decorated with colour (cobalt blue in this case) under a transparent glaze and fired at extremely high temperatures, was no longer exclusive to China. The court-sponsored potters working in Meissen for Augustus the Strong had discovered the method about thirty years earlier, and were producing very fine porcelains. Nonetheless, most of the porcelain in Europe during this time had still been made in China.

FIGURE 9.3 *Porcelain 'tea production' plate, made in Jingdezhen, China. Held in the Peabody Essex Museum.*

The scene in the middle of the plate depicts one of the stages in the cultivation of tea. A number written in cobalt under the glaze on the back of the plate confirms that this is number 11 in what would have been a series of 24 scenes. The Peabody Essex Museum owns a second plate with the number 12 on the back, depicting two men in a natural landscape shouldering poles and a third man on horseback, as well as a large tureen, numbered 19, showing two men on rafts laden with parcels of tea travelling on a river. Scene 11 illustrated above shows one man working with a hoe in a field, and a second man approaching him with a hoe over his shoulder. Rocks and a tree frame the field in the foreground, while the straight lines of a building fill the top right-hand quarter of the plate. To the left of the building, two men sit on the ground with a plate of food between them and a pot of tea next to them. The men are all barefoot, wearing simple cotton clothing, with the two men in the field wearing what look like straw hats. The men carrying the poles with parcels of tea in the plate numbered 12 and the men on the rafts in illustration 19 on the tureen are similarly dressed in the garb of men labouring in the fields, while the man on horseback is wearing the long robes of a scholar or official. The border on the cavetto surrounding the rural scene is decorated with a pattern of cornucopias and large shells. It is not a very common pattern, although the various plates and tureens that belong to the series of tea cultivation images all have this border.[22]

There is much we do not know. For whom was this series of tea production plates produced? And if there was a single owner, did he or she display the set as a narrative series depicting the complete process of producing tea, or just as individual items? Either way, the scene in the centre of this plate conjures up a remote world; to a European diner, the details in the illustration – the dress style of the labourers, the vegetation, the practice of eating with chopsticks in the field – would all have seemed unfamiliar. Of course, he or she might well have tasted the fruits of the depicted labour as by the middle of the eighteenth century tea drinking had become popular and commonplace in Europe.[23]

The point is that porcelain objects such as this plate and the numerous other depictions of Chinese landscapes that found their way onto the cups, saucers, vases and plates that graced eighteenth-century European interiors, allowed for the possibility of visualizing other worlds. With that we do not wish to suggest that the user of this plate will have gained an insight of what the various processes in the tea production in China will have looked like – far from it! Both the stylized nature of the decorations produced for export and the absence of concrete knowledge of the wider world amongst ordinary Europeans will have hampered such insight. Instead, the plate facilitated the imagination of other worlds. Both consumer and producer will have known nothing of each other, yet in viewing the same plate they briefly shared a vision. Each will have interpreted what they saw depicted in his or her own way, and extrapolated a different imagined space from it. The object is what creates the connection, and what makes this a 'global imaginary'.

If few Europeans visited Asia, Asia would visit Europeans at home in the shape of scenes like the ones to be found on the large palampore in Figure 9.4 now preserved at the British Museum in London. Measuring five metres by five, this enormous and expensive piece of furnishing fabric was woven and printed on the Coromandel Coast of India, possibly soon before 1772 when it was traded to Saint Petersburg. Seated Chinese beauties arranging their hair occupy the main field of the textile and are surrounded by an 'Indian tree'

FIGURE 9.4 *A glazed cotton chintz hanging (palampore). Painted and dyed and made on the Coromandel Coast of India for export. The seal impression on the reverse is in Cyrillic script and includes in Arabic numerals the date 1772, thus suggesting that it was sold to Russia. © The Trustees of the British Museum 1998,0505,0.1.*

design, bamboos and peonies filled with exotic songbirds. The Indian theme continues in the inner register (border) filled with marching sepoys (soldiers at the service of European powers in India) whilst the outer border represents scenes of daily life in Japan probably copied from Japanese printed books.[24]

Here different parts of Asia are to be found in scenes that range from daily life in Japan, to military marching in India, to intimate female practices in China. None of these were real spaces and none of these spaces had particular connections with each other, but one might wonder what a rich consumer in late-eighteenth-century St. Petersburg might have made of them. Beyond their beauty, what sort of imagination would they create? Today we are able to distinguish between the Chinese, the Japanese and the Indian parts of the overall representation, but would an eighteenth-century person have identified them easily? It might be even more puzzling for us to think that a very similar textile was found in Palu in Sulawesi Island, Southeast Asia.[25] Its owner in Southeast Asia might have used it in a completely different way from his or her Russian counterpart. Similarly the Southeast Asian owner might also have conceived the different spaces here represented in a very different way, possibly finding the Chinese central motif much more familiar, especially considering the cultural and economic connections between this part of the world and China.[26]

Material culture and the global spaces of negotiation

The ability to imagine other spaces was integral to the structuring of world trade. Economists and economic historians explain the intensification of world mercantile networks in the period between 1400 and 1800 as the result of new and more direct maritime routes and the fact that cheaper Asian wares found easy markets in Europe and over time also in the New World. This interpretation, however, has been challenged in recent years by showing how early modern consumers were neither satisfied by unadulterated Asian commodities nor by simple customization. As we have seen, the commodities themselves bore in their forms, materials and design if not the knowledge, at least the appreciation of wider geographies. But the 'imagined worlds' that commodities such as cottons and porcelain presented were not unmediated ones. They were the result of what we call a 'negotiation' in which those imagined spaces emerged from a dialogue between producers and consumers across vast geographies.

Religious art, for instance, shows how some of the key symbols of Christianity were reinterpreted according to categories that made sense to Asian artists unaccustomed with the Christian faith. The potters at the ceramic centre of Dehua in Fujian specialized in statuettes and figurines made of glossy white porcelain, known in Europe as *Blanc-de-Chine*. Dehua

Buddhist figures, for example of the goddess of mercy Guanyin depicted in a seated position with a child on her lap, could easily be adopted to look like Maria with the baby Jesus. Such porcelain pieces came to be known as 'Blessed Virgin Goddesses of Mercy', popular not only in Europe, but in Japan, where Christianity was banned after 1639, and the blend of Christian and Buddhist symbols became part of the 'hidden Christian' culture of Tokugawa Japan. Europeans were also keen to locate themselves in the wider world geographies that Asian commodities represented or hinted at. Already in the second half of the sixteenth century, Portuguese traders in Satgaon in Bengal were keen to acquire beautiful cotton coverlets embroidered with tussar silk thread. These were prized both in Portugal and in Tudor England. They did not just include the commissioner's coat of arms (as in the case of porcelain), but they often represented scenes with Portuguese men hunting among the lush Indian vegetation.[27]

An example of this spatial negotiation is the eighteenth-century petticoat in Figure 9.5.[28] Worn under an open skirt by a European woman, this petticoat is both quintessentially European and Indian at the same time. The upper part is decorated very much in European style, but it was painted, and thus undoubtedly produced in India. The more intriguing lower border, the part of the skirt that would have touched the floor confirms its provenance. Here we find a busy scene representing European men and women engaged in different activities: some are taking tea or other beverages; some are playing European instruments; some are hunting with European weapons; and others are having a stroll in a garden. We recognize them as Europeans because they are dressed in what looks like European attire; the man playing the instrument is sitting on a chair, a form of seating still relatively alien in Indian interiors in the mid-eighteenth century when this petticoat was painted.

It is evident that the Indian craftsmen who created this cloth must have had access to a repertoire of European images, possibly prints, which were not simply copied, but filtered through their eyes and hands. The result is a 'hybrid' product that conforms to European uses and aesthetic sensibility, whilst retaining an Indian identity. One might ask what the appeal was for Europeans, seeing themselves represented in what they wore, and finding themselves transposed into a different world, one in which horses are wonderfully patterned with flowers, and in which they are surrounded by strange animals. In fact an object like this raises the question of identity: would early modern Europeans have recognized themselves in these figures? Or would they have perceived them as sufficiently distant from their idea of self to be classified as 'other'?[29]

Numerous goods found in Europe but made in Asia depict Europeans, suggesting their popularity amongst consumers. The central image in Figure 9.6 reveals a seated gentleman with reddish curly hair in European clothing, attended by a servant with similar hair colour. Two dogs are playing at their feet, and both men gaze lovingly upon the two creatures. The space in which they are seated, partly indoors with a vase with flowers

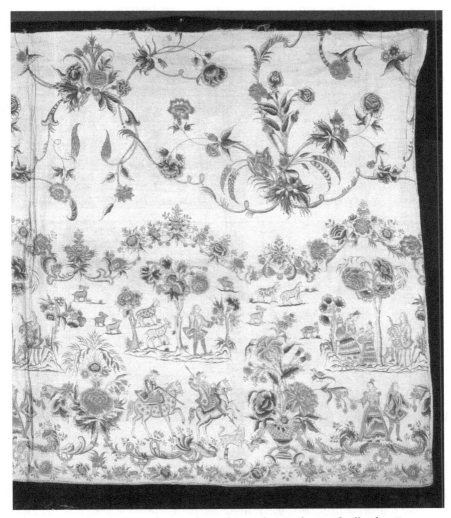

FIGURE 9.5 *Fragment of an Indian chintz designed specifically for European petticoats. The mordant-dyed and resist-dyed cotton cloth was produced on the Coromandel Coast of India, c. 1750. © Victoria and Albert Museum IS.14-1976.*

on a table, and partly outdoors with flowers and plants growing over a low wall, is decorated in Chinese style. So whose space is depicted here? Whose imagined world have we entered?

By the time this object was manufactured in Qing China (1644–1911), Europeans had been ordering porcelain to their own specifications for well over two hundred years. Initially only the Portuguese ordered specific designs and images to be displayed under the glaze by the Chinese potters, but they

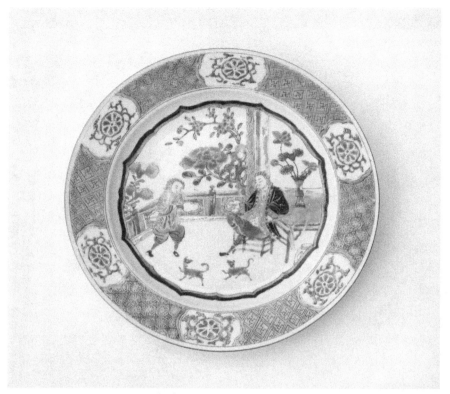

FIGURE 9.6 Famille rose *porcelain plate. Made in China during the reign of Qianlong (1736–95). H 2.7cm, D 24.2cm. Collection Gemeentemuseum Den Haag Nr. 0324059.*

were swiftly followed by Spanish, Dutch, French and English merchants. Because of the nature of porcelain manufacture, the blue decorations on blue-and-white porcelains have to be applied before the vessel is placed in the kiln for high-temperature firing. That meant instructions for designs had to be conveyed to the potters based in the city of Jingdezhen, far from European factories in Canton. The plate in Figure 9.6, however, was enamelled, meaning that the colour decorations will have been applied after the first firing, and then fired again at a much lower temperature. This process could be completed in places more conveniently located for communication with overseas consumers, such as in Canton. With this shift, Europeans suddenly were able to enter the Chinese landscape, quite literally as we see in this plate.

The range of themes depicted on porcelain produced in China expanded dramatically over the course of the eighteenth century. Ideas were delivered in the form of prints, or (reverse) copies of prints, and faithfully reproduced by the Chinese potters. We see the appearance of ships and churches, harlequins

and prostitutes, learned doctors and elegant Chinese ladies with parasols as envisioned by the great Cornelis Pronk (1691–1754), and of course very large quantities of so-called armorial ware. These depicted the crest or armour of the family who had ordered the items, usually in large dinner sets to grace stately homes. When in the first half of the sixteenth century the Portuguese king had placed a request for his crest to be placed under the glaze of a porcelain cup, he was ordering an item with the greatest possible exclusivity. By the late eighteenth century, even families of middling means could afford to place an order in China. Europeans had truly entered the Chinese landscape: as demanding customers but also as personages featuring in the envisioned landscape. We will never know what the makers of these porcelains will have thought of the red-haired, dog-loving European, sprawled in his chair, but the likelihood is the painter will have known he was not depicting a Chinese figure. Nor will we know whether the same painter would have realized that Pronk's lady with the parasol that became such a characteristic of this so-called *Chine-de-commande* was intended to be 'Chinese'. The Europeans had succeeded in creating a vision of space that might have looked 'Chinese' to their eyes, but had probably lost its 'Chineseness' to its makers.

Spaces of reinterpretation and distancing

We have claimed that the capacity of manipulating the physical but also the symbolic value and meaning of Asian objects was integral in the reconfiguration of the geographical and imaginary spaces of early modernity. Yet the examples provided so far take for granted that what Europeans did was to transform, translate and recompose existing geographies: those of Asia (of China and India in particular) but also those of Europe. In fact, over time, one can observe more complex processes in which the associations between product and place are questioned and in some cases challenged and even discarded.

When the potters in Delft made the object represented in Figure 9.7, they were producing 'China' in Delft. By the 1670s, Chinese wares had become commonplace in Dutch homes, and the potters in Delft had mastered the skills required to produce 'China': they copied Chinese decorative themes to perfection, including the stylized design elements from the natural world such as the clouds and plants framing the individual scenes, the lobed symmetrical patterns on the neck and base of the pot, and the seated Chinese immortals in cross-legged positions, attended by servants. The material is unmistakably 'Delft', the design is unmistakably Chinese; the combination, however, is something entirely new.

Material culture allowed for the reinterpretation of an imagined space, which may have at one stage referred to a set of meanings located in China, but came to constitute an entirely new world. Once it had been the productive process of manufacturing porcelain that captured the imagination, precisely

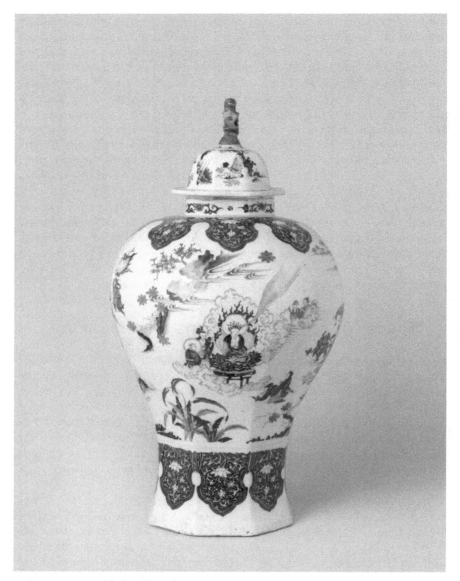

FIGURE 9.7 *Lidded eight-sided pot, made in faience in Delft, c. 1670–c. 1685. H 83.5cm, D 45cm. Rijksmuseum, BK-NM-12400-445.*

because the process could not be known. The remote space of China was imagined through its representation on the imported object. But once the processes of production were mastered in Europe, the spaces of production no longer mattered, and the representations of space on objects came to refer to something entirely new. The depiction of the emperor of China on this

tapestry made in Beauvais, France (Figure 9.8), is not intended to conjure up an image of China. The rich decoration, complete with fantastic flora and fauna, armed guards, prostrate visitors and a lady on a gilded chariot under a parasol, only obliquely refer to something that may have at one stage looked like China. It is a fictional world that completely reinterprets Asia through highly skilled use of materials, designs and the imagination of space.

In the case of cotton textiles one can see a profound transformation in the second half of the eighteenth century. Once the productive process of printing on cotton or linen was mastered by European calico printers in the first half of the eighteenth century, the productive legacy of India was quickly forgotten. New technologies of copper-plate printing allowed for the substitution of Indian floral and fauna patterns with detailed narrative scenes, often referring not to other places but to the past. The copper-plate printed cottons produced in Europe (often called *toiles*) represent scenes from Aesop's fables, ruins of ancient monuments and bucolic vignettes with shepherds and their herds.

Even more than for porcelain, in the case of cotton textiles one can see a concept and design distancing from Asia that over time grows into an active repudiation. With the exception of stereotyped chinoiserie motifs, the majority of European *toiles* that came to replace previously imported Asian cottons, concentrated on European subjects and topics. An exception might be a series of popular *toiles* produced in different versions by several

FIGURE 9.8 *'The Audience of the Emperor (or The Chinese Prince's Audience)'. Wool and silk tapestry weave produced in Beauvais, France, 1722–23. Dimensions 125 × 198 inches. Fine Arts Museums of San Francisco, Roscoe and Margaret Oakes Collection. 59.49.*

European calico printers between the very end of the eighteenth century and the 1840s (Figure 9.9). However, the world they represent is not real but fictional. Rather than constructing and materializing spaces that they knew existed, cotton textiles became the medium of narration of invented spaces. But these spaces were not Indian or Chinese; they were instead those of European characters living in a Rousseauian idyll. An example is the series of *toiles* inspired by a tremendously successful book by Jacques-Henri Bernardin de Saint-Pierre entitled *Paul et Virginie*, first published in Paris in 1788. Upon publication, the book was an instant hit. Recounting the story of Paul and Virginie, two children raised in relative seclusion on the island of Mauritius and who fall in love, several of the key scenes from the book were reproduced as prints as well as on a variety of objects including Sevres porcelain and furnishing *toiles*.

What is important for us is that by the second half of the eighteenth century medium and meaning were no longer inextricably connected; they no longer formed a unit of semantic coherence. Design – as many Victorian design reformers would soon complain – was left to roam freely, producing commodities that both in the case of cotton textiles and porcelain had neither bearing on the 'original' product nor any connection to the real and invented geographies that they previously had.

FIGURE 9.9 *Roller-printed cotton furnishing fabric, produced in France, c. 1815– 20 depicting scenes from Jacques-Henri Bernardin de Saint-Pierre's novel* Paul et Virginie *first published in Paris in 1788. Victoria and Albert Museum 1681–1899.*

Moving in time to the early nineteenth century, one is confronted with an object like the tin-glazed earthenware plate produced by the Rockingham Ceramic Factory in Swindon, England in the 1830s (Figure 9.10).[30] Although it is earthenware, it attempts to imitate the key material properties of

FIGURE 9.10 *Lead-glazed earthenware plate produced by the Rockingham Ceramic Factory in Swindon, England, c. 1830–40. Victoria and Albert Museum, given by J. G. Evans, Esq., C.24-1970. This plate is currently exhibited in the V&A's Ceramics Study Galleries, Britain & Europe, room 139, case 29, shelf 2.*

porcelain. Its transfer-printed decoration represents the tree of life motif that for over two hundred years was so popular on Indian textiles rather than on porcelain and ceramics.

How did the tree of life end up on a plate? And how was it possible that design migrated from one material to another? These are complex questions that are not new among design historians, who have observed how transfer printing on porcelain and copper-plate printing on cotton came to share many similarities, leading to a design 'convergence' between what used to be very different types of objects and decorative motifs.[31] For historians of material culture, an object like this 'palampore plate' raises issues both of use and meaning. One might imagine that a plate like this was displayed on a sideboard and therefore might have acted as a 'miniaturised' background just as palampores had done on a larger scale.

The reading of this plate, however, becomes more complex once we start considering its meaning both per se and in the long history of porcelain and cotton that we have attempted to capture in this essay. This 'palampore plate', whilst being an example of sophisticated workmanship and even product innovation, is also the materialization of how much the mental and imagined spaces that Asian objects had once produced had come to be 'flattened out'. One might interpret this object as an example of 'fusion' or the triumph of global connections; others might see it instead as pure and meaningless decoration, lacking both context and knowledge.

Conclusion

We have argued here that the spaces of global interactions that objects came to form were both material and imagined and were generated by the interaction between producers, consumers and trading intermediaries. Through the use of specific examples, we have attempted a classification of the different ways in which global spaces were generated through the trade and exchange of commodities, ranging from the material creation of products in space; to the imagination of space through objects; to the negotiation over hybrid spaces; to a distancing of Europe from the wider spaces of Asia (Table 9.1). The different strategies should not be taken as mutually exclusive or positioned on a chronological line of evolution. Although we have positioned 'reinterpretation at a distance' as a late phase in Europe's material engagement with Asia, the creation, the imagination and the negotiation of global spaces were all processes that formed part of the global reconfiguration of the early modern period.

Notes

1 We would like to thank Rosemary Crill, Lesley E. Miller, Clare Browne and Hilary Young at the Victoria and Albert Museum and Karina Corrigan at the

Peabody Essex Museum for their help and advice. Much of the analysis in this paper would have not been possible without the help of curators and access to the artefacts and to their online images. The research and writing of this paper has been possible thanks to the support of the AHRC International Network 'Global Commodities: The Material Culture of Global Connections' led by Gerritsen and Riello and by the Philip Leverhulme Prize held by Riello. Earlier versions of this paper were presented at the CHAM conference 'Colonial (Mis)understandings: Portugal and Europe in Global Perspective, 1450–1900' held in Lisbon on 17–20 July 2013 and at Royal Holloway's Centre for the Study of the Body and Material Culture Seminar held in London on 23 October 2013.

2 C. A. Bayly (2000), ' "Archaic" and "Modern" globalization in the Eurasian and African Arena, c. 1750–1850', in A. G. Hopkins (ed.), *Globalization in World History*. London: Palgrave.

3 R. Finlay (2010), *The Pilgrim Art: Cultures of Porcelain in World History*. Berkeley: University of California Press.

4 G. Riello (2013), *Cotton: The Fibre that Made the Modern World*. Cambridge: Cambridge University Press, pp. 17–27.

5 A. Farrington (2002), *Trading Places: The East India Company and Asia 1600–1834*. London: The British Library.

6 A. E. C. McCants (2007), 'Exotic goods, popular consumption, and the standard of living: thinking about globalization in the early modern world', *Journal of World History* 18 (4), pp. 433–62.

7 G. Riello (2010), 'Fabricating the domestic: the material culture of textiles and social life of the home in early modern Europe', in B. Lemire (ed.), *The Force of Fashion in Politics and Society: Global Perspectives from Early Modern to Modern Times*. Aldershot: Ashgate, pp. 41–65.

8 See in particular M. Berg (1998), 'Manufacturing the Orient. Asian commodities and European Industry 1500–1800', in S. Cavaciocchi (ed.), *Prodotti e tecniche d'oltremare nelle economie europee. Secc. XIII–XVIII. Atti della ventinovesima settimana di studi, 14–19 aprile 1997*. Florence: Le Monnier, pp. 385–419.

9 J. Carswell (2000), *Blue and White: Chinese Porcelain around the World*. London: British Museum Press; J. A. Pope (1956), *Chinese Porcelains from the Ardebil Shrine*. Washington: Smithsonian Institute.

10 For an overview see J. Guy (1998), *Woven Cargoes: Indian Textiles in the East*. London: Thames & Hudson.

11 For a critique of 'consumption' and the 'consumer revolution' as an explanatory model see C. Clunas (1999), 'Modernity global and local: consumption and the rise of the West', *American Historical Review* 104 (5), pp. 1497–1511.

12 P. Findlen (2013), 'Introduction: early modern things', in P. Findlen (ed.), *Early Modern Things*. Basingstoke: Routledge, p. 5.

13 K. Fujio (1967), *Selection of Outstanding Kinrande Porcelains*. Kyoto: Unsodo Pub. Co.

14 S. Pierson (2012), 'The movement of Chinese ceramics: appropriation in global history', *Journal of World History* 23 (1), pp. 9–39.

15 For an in-depth analysis of a palampore and its restoration see S. Ellis (2009), 'A passage in the life of a Palampore: conservation', *Journal of the Canadian Association for Conservation* 34, pp. 21–30.

16 A. Morall and M. Watt (2008), *English Embroidery from the Metropolitan Museum of Art, 1580–1700*. New Haven: Yale University Press; M. Bellezza Rosina (1988), 'Tra oriente e occidente', in M. Cataldi Gallo (ed.), *I mezzari: tra oriente e occidente*. Genoa: SAGEP Editrice, pp. 20–1; M. Gittinger (1982), *Master Dyers to the World: Technique and Trade in Early Indian Dyed Cotton Textiles*. Washington DC: The Textile Museum, p. 186; R. Maxwell (1990), *Textiles of Southeast Asia: Tradition, Trade and Transformation*. Melbourne: Australian National Gallery and Oxford University Press, p. 27.

17 For an illustration of the processes of customization of Asian goods on the part of Europeans in the seventeenth century, see J. Styles (2000), 'Product innovation in early modern London', *Past & Present* 168, pp. 124–169.

18 W. Foster (ed.) (1912), *English Factories in India, Vol. 6, 1637–41*. Oxford: Oxford University Press, p. 312.

19 About quilts: 'some, all of on[e] kinde of chinte, the lyninge and upper parte of one and the same; some of differinte chintes, yet such as eather side may be used; and some to have borders only of different cullers [colours], aboute a covide deepe [9 inches], to hange by the bed side on all sides alike, and the inner parte of the quilte allso to bee both sides alike. This last is most used in India, and wee thinke will be most pleasinge in England. They must be a little thicker and stronger sticht then ordinary, for there better lastinge'. W. Foster (ed.) (1906), *English Factories in India, Vol. 1: 1618–21*. Oxford: Oxford University Press, p. 84 (16 March 1619).

20 For the twentieth century see M. B. Steger (2009), *The Rise of the Global Imaginary: Political Ideologies from the French Revolution to the Global War on Terror*. Oxford: Oxford University Press.

21 For exploring different aspects of European collecting of rarities, but also flora and fauna, see P. H. Smith and P. Findlen (eds) (2002), *Merchants and Marvels: Commerce, Science, and Art in Early Modern Europe*. London and New York: Routledge.

22 It is also found on an earlier armorial service for the Guillot family in Amsterdam, an example of which is held in the Metropolitan Museum of Art in New York (51.86.100). William Sargent has suggested that the pattern may have its origins in the 'décor à la corne' seen on eighteenth-century faience from northern France. W. R. Sargent (2012), *Treasures of Chinese Export Ceramics: From the Peabody Essex Museum*. New Haven: Yale University Press, pp. 137–8.

23 M. Berg (2005), *Luxury and Pleasure in Eighteenth-Century Britain*. Oxford: Oxford University Press.

24 For more information see: http://www.britishmuseum.org/research/collection_online/collection_object_details.aspx?objectId=178804&partId=1&searchText=palampore&images=true&page=1 [accessed 27 July 2014].

25 The fragment is 348 x 80 cm and is now at the Tapi Collection in Mumbai, Acc. No. 02.43. It is reproduced in D. Shah (2005), *Masters of the Cloth: Indian Textiles Traded to Distant Shores*. New Delhi: TAPI Collection, p. 47. There is also a palampore at the Victoria and Albert Museum in London representing one of the two Chinese seated ladies. See V&A IS.43-1950 (Given by G.P. Baker): http://collections.vam.ac.uk/item/O481959/palampore-unknown/ [accessed 27 July 2014]. The individuation of this motif is now possible thanks to access to online catalogues such as the British Museum and V&A online catalogue. Although only a fraction of the millions of objects in these museums' collections are available online – and even a smaller number have images – they provide a unique tool for researchers.

26 On the consumption of Indian cloth in Southeast Asia see: K. R. Hall (1996), 'The Textile Industry in Southeast Asia, 1400–1800', *Journal of the Economic and Social History of the Orient* 39 (2), pp. 87–135.

27 J. C. Boyajian (1993), *Portuguese Trade in Asia under the Habsburgs, 1580–1640*. Baltimore and London: The Johns Hopkins University Press, pp. 140–2.

28 R. Crill (2008), *Chintz: Indian Textiles for the West*. London: V&A Publications, Cat. No. 66, p. 31, illus. p. 113.

29 These issues are discussed by Giorgio Riello in a podcast with Rosemary Crill of the V&A to be found at the University of Warwick's Knowledge Centre: http://www2.warwick.ac.uk/knowledge/culture/globalcommoditiesnetwork/ [accessed 27 July 2014].

30 This pattern, called 'India' is 'perhaps the most commonly encountered of all the Brameld [Rockingham] transfer-printed patterns'. A. Cox and A. Cox (2001), *Rockingham, 1745–1842*. Woodbridge: Antique Collectors' Club, p.155. We thank Hilary Young for helping us with this reference.

31 There are several Ironstone patterns with a flowering tree motif. See G. A. Godden (1999), *Godden's Guide to Ironstone: Stone & Granite Wares*. Woodbridge: Antique Collectors' Club.

Further reading

Berg, M. (2004), 'In pursuit of luxury: global history and British consumer goods in the eighteenth century', *Past & Present* 182, pp. 85–142.
Bleichman, D. and P. C. Mancall (eds) (2002), *Collecting across Cultures: Material Exchanges in the Early Modern Atlantic World*. Philadelphia: University of Pennsylvania Press.
Gerritsen, A. and S. McDowall (eds.) (2012), 'Global China: material culture and connections in world history', *Journal of World History* 23 (1), pp. 3–8.
Krahl, R., N. Erbahar and J. Ayers (1986), *Chinese Ceramics in the Topkapi Saray Museum, Istanbul*. London: Philip Wilson Publishers.
North, M. (ed.) (2010), *Artistic and Cultural Exchanges between Europe and Asia, 1400–1900: Rethinking Markets, Workshops and Collections*. Aldershot: Ashgate.
Sheriff, M. D (ed.) (2010), *Cultural Contact and the Making of European Art since the Age of Exploration*. Chapel Hill: University of North Carolina Press.

CHAPTER TEN

Cosmopolitan Relationships in the Crossroads of the Pacific Ocean[1]

Christina Hellmich

A set of unique handmade Unangan garments extant in the collection of the Peabody Essex Museum in Salem, Massachusetts, forms the focus of this short chapter. Specialized garments made from sea mammal and bear intestines have provided the Unangan people physical protection from the harsh Arctic environment for generations.[2] These outer garments, often referred to as *gut parkas* or by their Russian name of *kamleika*, were historically worn over other clothing made of bird skin or fur. Though transparent, paper thin and weighing just ounces, processed gut is very tough and waterproof due to the physical qualities of intestinal tissue (Figure 10.1).[3]

The style of the Unangan parka is characterized by its simple cut and horizontal strips of gut. The variation in the structure of sea lion gut tissue results in visible white areas in the centre of strips that are employed as a design element.[4] In contrast to its simple form, the parka may have extremely elaborate ornamentation.[5] The intricate embellishments added to seams, cuffs and collars were personalized for the wearer using materials gathered locally or through trade.[6] The Peabody Essex parka has bird-skin edging on the collar and sleeves. Bright bands of dyed oesophagus on the collar and cuffs required thousands of minuscule stitches. Small pieces of dyed hair have been incorporated into the seams.

During the European Age of Exploration, the islands and surrounding waters of the Unangan people in the Bering Sea were rich with marine mammals and fish, and these formed the centre of this culture's material and

FIGURE 10.1 *Parka. By courtesy of the Peabody Essex Museum, Salem, Massachusetts, E3662.*

spiritual life. In the late eighteenth century, these resources were claimed as part of a fast-growing global trade network and as part of the imperial goals of Russia. Slavery, forced labour and resettlement of the Unangan on their own islands swiftly impacted their material culture. The Unangan garments of the Peabody Essex Museum collection enable us to explore the cultural meaning of clothing items as commodities and gifts during the expansion of global trade at the end of the early modern period. The garments can be viewed as products and cultural fragments from a moment in time, but they also played a key role in fostering the socio political connections that facilitated the trade in furs and sandalwood. They were gifted several times

and directly conveyed personal and political favour. Their value, meaning and significance shifted with their physical transference between parties and expressed the larger and very complex social, political and economic milieu of the time.

The quality of Unangan women's handiwork was acknowledged regionally and 'the waterproof decorated garments they produced were traded by their men to the mainland in exchange for caribou skins, caribou hair, iron, and copper'.[7] As Jane Schneider and Annette B. Weiner expressed in *Cloth and Human Experience*, 'cloth is a repository for prized fibers and dyes, dedicated human labor, and the virtuoso artistry of competitive aesthetic development'.[8] As soon as European explorers encountered these gut garments, they acquired them because they functioned superbly. English Captain James Cook bought parkas for his crew during his stay in the area in 1778.[9]

The hooded parka in the Peabody Essex Museum collection came to the museum with two other Unangan gut garments: a cape and a pair of pants. They were included in a special exhibition in 1920 entitled, 'The Hawaiian Portion of the Polynesian Collections in the Peabody Museum of Salem'.[10] The clothing ensemble was originally catalogued by the founding organization of the museum, the East India Marine Society, as 'the Royal Robe of Tamahama, King of the Sandwich Islands, made of the intestines of the Ursine Seal, received of the old king by the donor, Captain Thomas Meek of Marblehead'.[11] Tamahama was the man we know today as Kamehameha, King and unifier of the Hawaiian Islands in the late eighteenth century.[12] The catalogue entry proffers that the garments were 'probably exchanged for sandalwood, and then presented to Captain Meek by Kamehameha as being of more value than anything Hawaiian'.[13] Meek gifted them to the Society before 1821.

After one hundred years in the museum's collection, the provenance of the garments, particularly their connection to King Kamehameha, still defined their importance.[14] Their connection to their place of origin in the Unangan community and the story of the Unangan women who expertly crafted and embellished the clothing was never chronicled or perhaps never revealed during their journey to Salem. Ernest Dodge, who joined the staff of Peabody Museum of Salem in 1931 and later became Director, celebrated the work of the East India Marine Society for 'their good sense to catalogue their material', recording the collector and the date of accession.[15] He remarked that 'if enough dated pieces are available, the progress of white and native acculturation can be definitely traced'.[16] However, the 'native' or indigenous data about works collected during this period, like these gut garments, is most often absent. Museum documentation provides an incomplete narrative of these pieces, but we can analyse the fine materials and techniques used in their creation with the help of indigenous and conservation specialists to learn more about the possible conditions of their creation and about the women who made them (Figure 10.2).

FIGURE 10.2 *Front of cape. By courtesy of the Peabody Essex Museum, Salem, Massachusetts, E3662.*

The Peabody Essex Museum cape follows the style of a Russian naval officer's cape. Unangan seamstresses applied the techniques and materials used for parkas to these elegant and richly adorned capes. This one is unusual for its vertical panels with red and blue embellishments. The

appliquéd bands of geometric motifs of dyed oesophagus are exquisitely finished. Hundreds of these beautiful and functional garments were created. These were hybrid costumes used by Russians and visitors for celebrations, souvenirs, trade or as gifts. They were created and conveyed in the space between the violence and alliances between Unangans and Russians that marked this period of colonization. The local significance of gut garments was subverted as they shifted in form and function to objects that might never be worn – only gifted and exchanged. When brought home to Europe or America, they celebrated exploration and colonization of far away lands.

But who made these garments? Was this fine work a condition of the seamstress' servitude? Were her material and colour choices impacted by her economic situation or other factors? Human hair fibre is generally used on parkas; however, in this garment it has been incorporated just into the upper cape. All of the materials would have taken considerable time to gather and prepare. Some might have been local, others such as caribou hairs, would have been articles of trade. In the absence of documentation at this time, we can only speculate how the Peabody Essex garments made their way from the Aleutian Islands to the Hawaiian Islands and into the collection of King Kamehameha. An historic encounter between crewmembers of a Russian ship and King Kamehameha shows how garments and cloth from all over the world functioned as gifts during this period. It is possible that the gut cape and garments were conveyed in this manner.

Ukranian artist Louis Choris arrived in Hawaii on the Russian vessel *Ruirik* on the 24 November 1816.[17] He was sent onshore to Hawaii island with a small contingent of other men including a botanist Adelbert de Chamisso who recorded that, 'On the shore, countless people were under arms. The old king (Kamehameha), in front of whose house we landed, was sitting upon a raised terrace, surrounded by his wives, and dressed in his native costume, the red malo and the black tapa, the wide beautiful folded cape of black cloth'.[18] During their time on shore, Choris asked to paint Kamehameha's portrait. He recorded that, 'I asked Tammeamea permission to do his portrait; this prospect seemed to please him very much, but he asked me to leave him alone an instant, so he could dress. Imagine my surprise on seeing this monarch display himself in the costume of a sailor; he wore blue trousers, a red waistcoat, a clean white shirt and a necktie of yellow silk. I begged him to change his dress; he refused absolutely and insisted on being painted as he was'.[19] The portraits and studies by Choris are the only known paintings of Kamehameha created during his lifetime.[20] They became very popular in Hawaii and the distinctive painting of Kamehameha in European dress made its way to America even before Choris arrived back in Saint Petersburg in 1818.[21] The king's choice of European clothing, rather than Hawaiian garments, might have functioned as a sign of his political equality with the Emperor of Russia for whom the portrait was being painted. Marshall Sahlins suggests that his ability to acquire European clothing and other luxury goods as gifts or commodities

and to consume, or to wear, them was clear by his clothing choice, and would have been seen as a sign of his power to his rivals on Oahu.[22] The colours of the garments Kamehameha selected for his seating – the 'red waistcoat' and 'yellow necktie' – expressed his royal status, and the adoption of cloth and different styles of dress by King Kamehameha and the chiefly classes in Hawaii did not change their role as a signifier of status.[23]

Kamehameha was born on the island of Hawaii and he did not travel beyond the island chain in his lifetime. However, the world arrived at his doorstep. Captains sought sandalwood for the China trade and provisions for their long Pacific Ocean journeys. Kamehameha supported trade and received ships from around the globe. He was also a collector of European material culture beginning in 1778, stockpiling European silverware, porcelain, shoes and brocade.[24] One purchase in 1812 included furniture, fireworks, 'velvets, satins, silks, 50 paper parasols, 50 silk hats, 135 pounds of large glass beads, and the like'.[25] By the end of his reign, Kamehameha controlled the supply of European goods coming into the kingdom by forcing trade on only certain islands under the direction of his European or Hawaiian agents who implemented contracts he executed with the captains.[26] In 1779, upon his visit to the Hawaiian Islands, Kamehameha gave Captain James Cook the cloak he was wearing. Cook departed Hawaii with over thirty cloaks that he described as having the textural quality of velvet. They are now in collections around the globe including six in Saint Petersburg, although fewer than one hundred feather cloaks have survived worldwide. Many of these were gifted to non-Hawaiians by Kamehameha and subsequent Hawaiian monarchs.

Global commodities such as sandalwood, guns and iron were central to the relationships of Europeans and King Kamehameha in the late eighteenth and early nineteenth century. However, these relationships were predicated on diplomatic and political exchanges between the parties involving what anthropologist Annette Weiner has termed 'soft' valuables: cloth and textiles such as sacred and culturally important feather cloaks and bark cloth as well as European clothing items.[27] Cloth was used as a currency of prestige by traders abroad and also when they returned home. The brothers Thomas and John Meek of Marblehead who donated the garments to the museum came from a family of seamen. They were both engaged in the China trade. Both men were major figures in Honolulu and their experiences are well documented in the journal of Stephen Reynolds.[28] Gail Pike Herscher, who has researched the Meek brothers extensively indicates that 'they had easy access to Kamehameha in business and leisure and they mediated for missionaries and other merchants'.[29] Thomas would convey ten works to the East India Marine Society museum including the gut garments. For Meek, the garments were textile 'treasures' for their ability to 'facilitate claims to the past – its names, legends, and events – that justify the transactions and extend the power of living actors'.[30] It was their connection to Kamehameha that was most important, illustrative of a personal relationship with the

king. The garments were 'received of the old king' and their distinction as a gift rather than a simple commodity was important to Meek.[31]

Each work presents a challenge to reconnect the points of its past to discover its many lives as an object. By amplifying and expanding the voices, histories, and meanings associated with the work, some histories are liberated and some are repressed; others remain unknown and lost – at least for now. Multiple intentions and cultural misunderstandings have been imbedded in these hybridized objects. While it seems doubtful that King Kamehameha would consider the gut garments as 'being of more value than anything Hawaiian', his gift of the parka, cape and pants to Meek points to their multifaceted personal relationship and shows the symbolic importance of textiles in global exchange.

Notes

1 With thanks to Karina Corrigan, Karen Kramer, Dan Finamore, Gail Pike Herscher, William Fitzhugh, David Dearinger, Mary Malloy, Pat Boulos, Carol Ivory and Robin Wright.

2 P. Hickman (1987), *Innerskins and Outerskins: Gut and Fishskin*. San Francisco: San Francisco Craft and Folk Art Museum, p. 4. See also: Kamleika, AOA 1842,12-10.46, The British Museum, London.

3 Hickman, *Innerskins and Outerskins*, p. 8.

4 Interview with Mimi Leveque by Christina Hellmich, February 2012. See also Hickman, *Innerskins and Outerskins*, p. 6.

5 W. W. Fitzhugh and A. Crowell (1998), *Crossroads of the Continents: Cultures of Siberia and Alaska*. Washington: Smithsonian Institution Press, p. 219.

6 F. Reed (2008), 'Embellishments of the Alaska native gut parka', in *Textile Society of America Symposium Proceedings*. Textile Society of America, pp. 1–2.

7 Fitzhugh and Crowell, *Crossroads*, p. 56.

8 J. Schneider and A. B. Weiner (1989), 'Introduction', in J. Schneider and A. B. Weiner (eds), *Cloth and Human Experience*. Washington, DC: Smithsonian Institution Press, p. 2.

9 Hickman, *Innerskins and Outerskins*, p. 5.

10 Peabody Museum (1920), *The Hawaiian Portion of the Polynesian Collections in the Peabody Museum of Salem*. Lynn: Thos. P. Nichols & Son Co, p. 50.

11 Peabody Museum, *Hawaiian Portion*, p. 50.

12 Christian missionaries standardized the Hawaiian language after their arrival and eliminated 't's in favour of 'k's.

13 Peabody Museum, *Hawaiian Portion*, p. 50.

14 The parka and cape travelled back to Hawaii in 2002 for inclusion in a temporary exhibition at the Bishop Museum, 'Hoʻi Pūʻolo ~ Returning Gifts',

that featured Hawaiian items from Salem, Massachusetts that were given as gifts by Hawaiian *ali'i* or chiefs including Kamehameha.

15 E. S. Dodge (1945), 'Captain collectors: the influence of New England shipping on the study of Polynesian material culture', *Essex Institute Historical Collections* 81, p. 31.

16 Dodge, 'Captain collectors', p. 31.

17 J. Charlot (1958), *Choris and Kamehameha*. Honolulu: Bishop Museum Press, p. 15.

18 Charlot, *Choris and Kamehameha*, p. 20. Tapa, also known in Hawai'i as 'kapa', is a paper-like cloth made from the inner bark of trees.

19 Charlot, *Choris and Kamehameha*, p. 21.

20 Charlot, *Choris and Kamehameha*, p. 27. See anonymous copy, Chinese, after Louis Choris (1795–1828), *Tamm ahammaha* [King Kamehameha I], c. 1816, oil on canvas, 24.9 × 20.3 cm. Boston Athenaeum collection. A small copy after the work in the Boston Athenaeum now in the Peabody Essex Museum was gifted to the Essex Institute in 1897. See 'Tammahammaha' [King Kamehameha I] engraving, 10.3 × 7.2 cm. Peabody Essex Museum collection. For a copy made in China, see *King Kamehameha I in a Red Vest*, anonymous Chinese oil on canvas painting after original by Louis Choris, c. 1820, Honolulu Academy of Arts now Honolulu Museum of Art.

21 R. E. A. Hackler (1969), *The Voice of Commerce*. Honolulu: Hawai'ian Historical Society.

22 M. Sahlins (1990), 'The political economy of grandeur in Hawaii from 1810 to 1830', in E. Ohnuki-Tierney (ed.), *Culture Through Time: Anthropological Approaches*. Stanford: Stanford University Press, p. 40ff.

23 L. B. Arthur (1998), 'Fossilized fashion in Hawai'i', *Paideusis: Journal for Interdisciplinary and Cross-Cultural Studies* 1, pp. 4–7.

24 M. Malloy (1986), '30 Souvenirs of the fur trade, 1799–1832: the Northwest Coast Indian collection of the Salem East India Marine Society', *American Indian Art Magazine* Autumn, p. 251.

25 Sahlins, 'Political economy', p. 38.

26 M. Sahlins (1981), 'Historical metaphors and mythical realities: structure in the early history of the Hawaiian kingdom', in *ASAO Special Publication No. 1*. Ann Arbor: University of Michigan Press, p. 44.

27 Schneider and Weiner, 'Introduction'.

28 Phone conversation with Gail Pike Herscher, 14 March 2012.

29 Phone conversation with Gail Pike Herscher, 14 March 2012.

30 Schneider and Weiner, 'Introduction', p. 6.

31 Email from Mary Malloy, 27 November 2012.

CHAPTER ELEVEN

Invisible Beds:

Health and the Material Culture of Sleep

Sandra Cavallo

Can we trace the history of sleeping from the object itself? A close comparison between two beds, both Tuscan and from the fifteenth and sixteenth century respectively, offers an interesting contrast and points to significant changes in sleeping habits during this period. The first is the monumental 'Davanzati bed' held at The Metropolitan Museum in New York (Figure 11.1). Long believed to be authentic and a unique example of Renaissance furniture, this structure has recently been declared a fake by furniture experts. A modern copy, inspired by beds frequently represented in the visual sources of the period, this artefact should be seen as a product of the market dynamics stimulated by the revival of the Renaissance style at the turn of the nineteenth century.[1] This case exemplifies the caution that needs to be used when dealing with objects supposedly surviving from a remote past. However, the correspondence between this artefact and the descriptions emerging from 'hard' archival evidence, such as carpenters' contracts, suggests that the Davanzati bed can still be taken as representative of a typology common in central Italy in the fifteenth century – as a 'genuine fake' which closely reproduces, if not the materials and productive techniques used in the Renaissance, at least the proportions, composition and ornamental features of the original object.

First, the Davanzati bed is very large and yet not in the dimensions (up to 3.5 metres in width) that contemporary descriptions attribute to Renaissance beds.[2] Second, it is surrounded all along its perimeter by chests with opening

FIGURE 11.1 *Bed known as Davanzati Bed, The Metropolitan Museum of Art, New York. Walnut. H. (bed and dais) 144.1 cm; W. (dais) 217.2 cm; L. (dais) 261.3 cm; H. (dais) 40.3 cm; H. (bed at headboard) 103.8 cm; W. (bed at headboard) 148.6 cm; L. (bed) 224.8 cm. Gift of George R. Hann, 1965 (65.221.1). Black and white photo. © 2013. Image copyright The Metropolitan Museum of Art/Art Resource/ Scala, Florence.*

lids that served the multiple purpose of providing a surface to lay clothes and objects of common use (vessels, towels and articles for washing), containers for storing goods and also sitting space for visitors. Indeed, the animated scenes represented in endless depictions of Nativities (for example Benedetto da Maiano's 'The birth of the Virgin' or Ghirlandaio's 'Birth of St John the Baptist') present the bed as a focus of sociability in a period in which, as suggested by many testimonies of the time, bedrooms were used as a space to entertain, eat, dance and make music, not just as a place to rest and sleep.[3] Overall the design of the fifteenth-century bed underlines 'openness' rather than seclusion. Though the iconographic evidence suggests that the bedframe was occasionally hidden from the eye by curtains, these were not part of its structure but were sliding on independent rods at the sides of the bed, protruding from the wall thus providing privacy when needed.

 The second bed (Figure 11.2), deemed to be authentic by furniture analysts, is from the second half of the sixteenth century and is much

FIGURE 11.2 *Bed, central Italy, sixteenth century; Palazzo Davanzati, Florence (inv. 204). Please note that the curtains are spurious. By kind permission of the Ministero dei beni e delle attività culturali e del turismo, Florence.*

narrower, measuring 163.5 cm in width. No longer fitted with surrounding chests, like its fifteenth-century predecessor, it is a simple, independent structure that appears to have lost its multifunctional character and be made exclusively for the purpose of lying and resting in a well-protected environment. The bedframe presents in fact an important new feature: it includes pillars supporting a canopy from which curtains hang creating a completely enclosed space for resting.

Object-based comparative analysis reveals therefore that the re-shaping of the bedframe in the sixteenth century did indeed entail the disappearance of the protruding platform on which the bed rested, as suggested by other scholars, and hence a decline in the social function of the bedroom.[4] However, further elements point to a much deeper transformation of sleeping habits. First, the diminished size of the bed might hint at the growing

tendency for spouses from the most prosperous ranks to sleep separately, in personal bedrooms. Though already recommended by architect Leon Battista Alberti in the mid-fifteenth century, this custom only became generalized among elite groups in the following century, when the consolidation of a gendered organization of space in the noble palace led to the creation of separate female and male quarters.[5] Second, the fact that curtains and canopies became an integral component of the bedframe is evidence of a growing preference for sleeping in a hermetically closed environment. Often defined as *camera* (room) by contemporaries, precisely to stress this enclosing effect, this space has indeed become 'a room within a room'. Unexpectedly, an explanation for the dissemination of this new custom can be found in contemporary medical literature. Following the growing attention that people pay to healthy living and the prevention – rather than treatment – of disease, the period witnessed a sort of medicalization of everyday life.[6] Sleep was one of the quotidian practices discussed by physicians in the health advice literature (*regimens*) directed to a wide audience, a genre that flourished in sixteenth- and early-seventeenth-century Italy.[7] In 1602, for example, Doctor Fonseca indicated the ideal dimensions of a bed (he said that it had to be 1.5 metres wide) while a few decades earlier, Doctor Rangoni had recommended that 'the bed should never be without a canopy'.[8]

Regimens also offer helpful insights into the medical rationale underpinning this advice. Most of their recommendations followed from the fundamental role that sleep was supposed to play in digestion: as this could occur only when body and mind were inactive, it was paramount for the sleeper to be protected from cold temperature, light and noise – all disturbances that would upset the vital digestive process. Clearly, heavy bed curtains and canopies provided a shelter from these harmful agents. They also shielded the body from the pernicious effects of moonlight, another natural element which was supposed to generate serious ailments, especially if it shone directly on the head. Medical advice was also informed by additional anxieties about the impact of cold temperature upon the body: feeling cold was supposed to close the pores and prevent the regular elimination of internal residues through the skin that guaranteed the health of the body. More generally, the air of the night was reputedly particularly noxious by medical thought, to the extent that physicians recommended sleeping with the windows closed even in summer.[9] These anxieties also account for the peculiar positioning of beds in bedrooms.[10] In architectural plans, beds regularly featured in a corner of the room, shielded from draughts from windows and doors – a preoccupation that often even led to the displacement of the fireplace from the ideal central position it was expected to occupy.

The popularization of these health concerns, facilitated by the development of print, offers a new key to understand the changes that were taking place in the construction of the ideal sleeping environment. Surely other elements also played a part. Historians have seen the growing culture of comfort, the

increased use of textiles in domestic furnishing and the rising ethos of privacy as the main factors responsible for the transformations that affected the material culture of the late-Renaissance home.[11] Ideas of comfort however are not immutable: in order to grasp why sleeping in what appears to us a suffocating, oppressive environment was regarded as 'comfortable' by our predecessors, we need to be aware of the health benefits that, as explained above, they attributed to such arrangements.

Other characteristics of the late-sixteenth-century bedframe deserve attention, for example its lightness and simplicity. The wooden structure and its textiles are easy to dismantle and store, and to carry from one room to another or from the city to a country villa. The portability of the canopied bed suited the increasingly mobile early modern society, where the development of means of transport, namely the carriage, made travelling and unexpected visitors a much more common occurrence. Indeed the new bed allowed a much greater flexibility in sleeping facilities than the immovable, cumbersome fifteenth-century bedframe. As suggested by contracts with carpenters, this was often part of a matching wooden ensemble that included not just the surrounding chests and wall panelling (as illustrated in the above mentioned Benedetto da Maiano's image) but the so called *lettuccio* (small bed), and therefore was usually assembled by carpenters *in situ*.[12]

The story of the *lettuccio* – for which some genuine examples survive – is similar to that of the night bed.[13] Its presence in the Italian bedroom is documented from the mid-fifteenth to the beginning of the sixteenth century and confirms the social functions played by this space in this period. Indeed depictions of these wide benches with arms at the sides and a tall *spalliera* at the back, suggest that they provided extra seats for visitors (as in Andrea Del Sarto's 1513 fresco *The Birth of the Virgin*). This function is also confirmed by the definition 'letto da sedere' (bed to sit) found in Boccaccio and other authors.[14] These objects, however, were also frequently equipped with a thin mattress and a pillow.[15] They were therefore also used to recline, especially by convalescents and those afflicted by minor ailments, as hinted by the Tuscan saying 'stare tra letto e lettuccio' (move between the bed and the small bed).[16]

Interestingly, the *lettuccio* or *lettuccio da sedere* disappears from the record in the first half of the sixteenth century. In its place, *letti da riposo* (resting beds) are listed among household possessions later in the century. This shift in terminology – an important source in its own right, to which scarce attention is normally paid in studies of material culture – may be suggestive of a change in function. No surviving examples of the *letto da riposo* are found in Italy but reclining daybeds are sometimes represented in the frescoes and paintings of artists such as Giulio Romano and Lambert Sustris, both active in Italy in the first and second half of the sixteenth century respectively. Even if clearly inspired by classical examples, they bear close resemblance to the descriptions of *letti da riposo* found in the inventories and letters of the Roman nobility a few decades later.[17] It is

plausible therefore that these images had an impact on the actual production of late-Renaissance daybeds.[18]

By comparison with the *lettuccio da sedere*, the *letto da riposo* has dropped arms and *spalliera* and has become a miniature bed, with three edges. Ideal for laying and short-period rests, it is designed exclusively for individual use and reclining, and no longer for sitting and facilitating sociability. Moreover it is a self-standing and potentially portable object: in Rome 'beds for day rest' can be found not just in bedrooms but in *camerini* (small adjoining rooms), *tinelli* (dining rooms for domestic servants) and even in the outdoor space of the villa garden, where the summer heat invites post-prandial naps. Medical advice, however, dictated that in order to be healthy daytime sleep should be short and hence less pleasurable than night sleep, and lay people seem to have taken this injunction seriously given that hard leather pillows and horsehair mattresses are preferred for daybeds.[19] Once again health concerns appear a neglected but powerful force in the redefinition of the material culture of sleep.

A close, comparative focus on the characteristics of the object – be it a surviving example or a by now invisible material presence, come alive through a combination of contemporary accounts and textual and visual representations – gives new insights into the transformations that affected the look of artefacts of everyday use such as the night and the day bed over more than a century. However, the study of the cultural processes underpinning such transformations – in this case the changing meanings that contemporaries attributed to sleep – represents an essential complement to object-based analysis, capable not only of increasing our understanding of the changing functions of beds but of enhancing the perception of the material qualities of these artefacts. For example, the awareness of the medical significance of sleeping practices has allowed us to grasp aspects of the evolution of the bed that had so far escaped the attention of material culture experts.

More in general, the health perspective represents an important addition to the dominant narratives of change affecting the Renaissance home, reminding us that the repertory of explanations we normally employ to make sense of the transformations taking place in the domestic world can still be enriched by new sets of paradigms.

Notes

1 M. Ajmar-Wollheim and F. Dennis (2006), 'Introduction', in M. Ajmar-Wollheim and F. Dennis (eds), *At Home in Renaissance Italy*. London: V&A Publications, pp. 20–1.

2 For example, C. Paolini (2004), *I luoghi dell'intimità. La camera da letto nella casa fiorentina del Rinascimento*. Florence: Edizioni Polistampa, p. 29; and B. Preyer, 'The Florentine *casa*', in Ajmar-Wollheim and Dennis (eds), *At Home*, p. 41.

3 See the accounts cited in P. Fortini-Brown, 'The Venetian *casa*', in Ajmar-Wollheim and Dennis (eds), *At Home*, p. 59; and B. Preyer, 'The Florentine *casa*', in Ajmar-Wollheim and Dennis (eds), *At Home*, p. 40.

4 Fortini-Brown, 'Venetian *casa*', p. 59; and Preyer, 'Florentine *casa*', p. 41.

5 Paolini, *I luoghi dell'intimità*, p. 16; P. Waddy (1990), *Seventeenth-Century Roman Palaces: Use and the Art of the Plan*. Cambridge, MA: The MIT Press.

6 This is the thesis developed in S. Cavallo and T. Storey (2013), *Healthy Living in Late Renaissance Italy*. Oxford: Oxford University Press.

7 R. Fonseca (1603), *Del conservare la sanità*. Florence: Semartelli, ch. 1.

8 Fonseca, *Del conservare la sanità*, p. 80; T. Rangoni (1556), *Consiglio del magnifico cavaliere . . . come i venetiani possano vivere sempre sani. . . .* Venice: F. de' Patriani, p. 11.

9 Fonseca, *Del conservare la sanità*, p. 80.

10 On the position of beds H. Burns (2001), 'Letti visibili e invisibili nei progetti architettonici del Rinascimento', in A. Scotti-Tosini (ed.), *Aspetti dell'Abitare in Italia tra XV e XVI Secolo. Distribuzione, Funzioni, Impianti*. Milan: Unicopli, pp. 131–42. Direct exposure to a source of heat was also considered unhealthy, hence the bed could not face the fireplace.

11 For a discussion of these interpretive paradigms see Cavallo and Storey, *Healthy Living*, pp. 18, 136, 144.

12 See the contract for a bed frame and *lettuccio* commissioned in Pistoia in 1488, cited in Paolini, *I Luoghi dell'intimità*, p. 29. For a Sienese example, dated 1508, see F. Calderai and S. Chiarugi, 'The lettuccio (daybed) and *cappellinaio* (hat rack)', in Ajmar-Wollheim and Dennis (eds), *At Home*, p. 375, n.2.

13 See the *lettuccio* held by the Monte dei Paschi in Siena, reproduced in image 7.21 in Calderai and Chiarugi, 'Lettuccio' p. 122.

14 Novel of friar Rinaldo, day seven, novel three, cited in Paolini, *I Luoghi dell'intimità*, p. 29.

15 This is suggested by domestic inventories (Paolini, *I Luoghi dell'intimità*, p. 31), iconographic evidence (for example Sandro Botticelli's *Annunciazione*, c. 1490; Biagio D'Antonio's *Storie of Lucrezia*, 1450–75), and the Sienese exemplar, which includes a wooden 'pillow' in its structure.

16 Paolini, *I Luoghi dell'intimità*, p. 31.

17 See Cavallo and Storey, *Healthy Living*, pp. 122–26.

18 On daybed drawings Burns, 'Letti visibili', pp. 132 and 141, n. 7.

19 Cavallo and Storey, *Healthy Living*, pp. 121 and 123.

CHAPTER TWELVE

Material Culture and Sound:

A Sixteenth-Century Handbell

Flora Dennis

The sixteenth-century bronze handbell in Figure 12.1 is 9.8 cm high, weighs 417 grams and was made to create sound.[1] Although its clapper has been replaced at some point in the bell's history, the noise produced when it strikes the lower portion of the bell's body will be exactly the same today as it was five hundred years ago. Unlike musical instruments from the same period, which have usually been significantly modified in such a way as to affect the nature of the sound they produce, the handbell allows us to access directly the sound of the past. But while the ring created by picking up and shaking this bell today may not have changed, the significance of that sound cannot be the same. How can someone from the twenty-first century begin to reconstruct the sixteenth-century connotations, associations and messages that this object was originally conceived to produce? We can think not only about this handbell as a material object which looks the way it does and was made in a certain way to carry out a particular purpose, but can also, by carefully considering its appearance and materiality, begin to understand the relationships between the people who heard it, the places in which it was rung and resonated, and the meaning that its sound conveyed.

How much can we deduce from the object itself? Can we be certain it was made to produce sound and was not just for decoration? Looking at the bell, certain physical aspects which dictate its function are immediately apparent. Its shape follows an established and instantly recognizable form of a truncated cone with a flared rim, the hollow body creating a resonating chamber.[2] The sound bow, where the brass ball of the clapper strikes the bell, is the most vulnerable element. This is the thickest part of the bell,

FIGURE 12.1 *Handbell with the arms of the Lippomani family, probably Veneto, 1530–70. Bell-metal, H 9.8cm (with handle), D 9.4 cm,* © *Victoria and Albert Museum, London.*

protecting it from damage when struck, and is also the widest, allowing the clapper room to gain momentum as it swings.[3] Two large chips to the rim of the bell might suggest that it was well-used. It is made of bronze, a robust and durable material, composed of copper and tin. Compared to the alloys used to make bronze sculpture in this period, however, the metal here has a much higher tin content, which makes it more sonorous.[4] Known as bell-metal, this type of bronze was developed purely for its resonant properties. In determining the composition of the alloy, the effect on sound quality had to be balanced against the metal's workability: increasing the amount of tin made the bell sound better, but also made it more brittle.

The top of the object has been modified: it may originally have had a handle or a peg similar to its current one. We know from portraits such as Raphael's well-known *Pope Leo X with Cardinals Giulio de' Medici and Luigi de' Rossi* (1517–18), now at the Uffizi in Florence, that it was customary to attach a large tassel to these pegs, creating a sensory contrast between the cold, hard metal of the bell and the soft, giving qualities of silk. The surface of the bell is covered in bands of relief decoration that draw heavily on the vocabulary of classical ornament: egg and dart patterning, acanthus leaves,

grotesque masks, swags and bundles of fruit and foliage, and profile heads. In addition this bell has a coat of arms and an inscription referring to its original owner, both in relief. The arms and inscription have been cast into the bell (rather than incised after casting) and reveal the object as having belonged to, and probably been specially commissioned by, a member of the Venetian patrician Lippomano family: 'PVLSV MEO SERV[O]S VOCO LIPO MANO TVOS' ([with] my ring I call your servants, o Lippomano).

Speaking in the voice of the bell, the inscription forms a declaration of its function and its position as an intermediary between master – Lippomano – and servants. This immediately tells us that the original owner had servants to call, and therefore that he (most likely to have been a man) occupied an elevated social status.[5] The handbell is servant to the master, by carrying out his wishes when picked up and rung, but by instructing the servants to come when they hear its ring, the bell takes on its master's authority. The profile heads of the classical hero Hercules and an unidentified emperor that appear on either side of the Lippomano arms further emphasize this authority.

The fact that servants needed to be called implies a physical distance between Lippomano and those who attended to him. This makes us think about the physical disposition of rooms within the house in which the bell was used, and the ways in which social divisions within the household might have been expressed spatially.[6] By communicating the master's needs, the bell also reminds us of the tension between autonomy and dependence inherent in master–servant relationships. It suggests that at particular times, Lippomano wished to occupy a separate space removed from the activities of his servants, but needed them sufficiently near to be able to answer the bell's summons. This is confirmed in contemporary writings about the configuration and use of domestic space, in which sound is revealed to be an important concern in the physical organization of the household. Leon Battista Alberti, in *De re aedificatoria* (c. 1445–52, published 1485) suggests that 'the prattling and noisy hordes of children and housemaids should be kept well away from the men', while also specifying that 'the maids and valets should be stationed close enough to their areas of responsibility to enable them to hear commands immediately and be at hand to carry them out'.[7]

What can we understand from the bell about how it functioned in practice? The bell's weight is substantial enough to make lifting and ringing it a conscious and deliberate act. Rather than calling for assistance, Lippomano preferred to use a handbell as a proxy for his voice to overcome the distance between the space he occupied and that of his servants. When picked up by Lippomano and rung, the bell became its master's voice and an extension of his body, saving him the physical exertion of shouting. This was partly motivated by practical concerns: the bell's ring was clearer and more penetrating than a shout, its message instantly read, and it was generated by a dignified and easily controlled physical movement. However, the use of the bell in place of the master's shout also makes us consider contemporary ideas about ideals of behaviour, decorum and the appropriateness of raising the voice in the home.

The bell enabled a physical distance between master and servants to be maintained and managed. The need for this distance was motivated by perceptions of the activities of servants, in spaces such as kitchens particularly, as cacophonous and disturbing. While the bell is an object designed to create occasional noise, it suggests the importance of silence. This was a quality most valued in the study, a room to which wealthy noblemen and merchants retreated to read, write letters and accounts, and cherish carefully-assembled collections of objects which constituted explicit links to the cultures of antiquity.[8] Evidence from archival documents, contemporary paintings and other objects associated with the study confirms that bells were most commonly found in this room. Like the decorative inkwells, candlesticks and pounce pots also found in studies, the bell's expensive bronze material and classically inspired ornament combined to bolster its owner's status, while performing a useful function. Inventories from this period refer to 'study bells' or list bronze bells within the panoply of objects found in the study.[9] Sixteenth-century portraits of popes, cardinals, noblemen and other male figures depicted in study-like settings increasingly included handbells resting on tables, alongside books, papers and the paraphernalia of writing.[10] Symbolizing the power of these sitters over the rest of an implied, substantial household, these bells were attributes of status.

The handbell exemplifies the idea of an object with agency. When stationary on a table, it performed a decorative role within the study, forming part of the visual landscape of classically inflected, functional objects occupying that space. When picked up and shaken, however, its primary identity as a sounding object came to the fore and had the power to compel others to act upon its command. The bell reminds us not only of the importance of considering the often forgotten sensory dimensions of objects, but also reveals the complex dynamics of human relationships within a busy and important sixteenth-century household.

Notes

1 P. Motture (2001), *Bells and Mortars. Catalogue of Italian Bronzes in the Victoria and Albert Museum*. London: V&A Publications, pp. 144–5. This bell is also discussed in F. Dennis (2010), 'Resurrecting forgotten sound: fans and handbells in early modern Italy', in C. Richardson and T. Hamling (eds), *Everyday Objects: Medieval and Early Modern Material Culture and its Meanings*. Aldershot: Ashgate, pp. 191–209.

2 See P. Price (1983), *Bells and Man* . Oxford: Oxford University Press, pp. x–xi for the most typical profiles of bells.

3 Motture, *Bells and Mortars*, p. 25.

4 Motture, *Bells and Mortars*, pp. 18–20.

5 Most handbells are recorded in the possession of men (they appear regularly in the inventories) in Archivio di Stato, Venice, Cancelleria inferiore, Miscellanea

notai diversi, Inventari bb. 36–44 (covering 1534–98). For a handbell belonging to a courtesan, see C. Santore (1988), 'Julia Lombardo, "somtusoa meretrize": a portrait by property', *Renaissance Quarterly* 41, p. 70.

6 See F. Dennis (2008–9), 'Sound and domestic boundaries in fifteenth- and sixteenth-century Italy', *Studies in the Decorative Arts* 16 (1), pp. 7–19.

7 L. B. Alberti (1988), *De re aedificatoria. On the Art of Building in Ten Books*, trans. J. Rykwert, N. Leach and R. Tavernor. Cambridge, MA: MIT Press, pp. 120 and 149–50.

8 On the development, use and contents of this room, see: D. Thornton (1997), *The Scholar in his Study. Ownership and Experience in Renaissance Italy*. New Haven and London: Yale University Press.

9 See Archivio di Stato, Venice, Cancelleria inferiore, Miscellanea notai diversi, Inventari b. 36, n.55 (1536), b.38, n.25 (1548) and b.44, n.3 (1596) for *Campanelle da Studio*; *Campanelle da Bronzo* are referred to in studies in b.37, nos.10 (1543), 43 (1544), 49 (1545) and b.39, n.31 (1557).

10 See Dennis, 'Resurrecting forgotten sound', pp. 203–5.

Lustrous Things:

Luminosity and Reflection before the Light Bulb

Ann Smart Martin

Born in 1791, Lydia Huntley Sigourney remembered her childhood home many years later. Arrayed inside the parlour closet was a 'wealth of silver cans, tankards, and flagons'. Her excitement came at night when there were 'brief glimpses of that parlor, lighted by two stately candlesticks, and an antique candelabra'. To the young girl, it seemed as magical as 'the hall of Aladdin'. In her *Sketch of Connecticut, Forty Years Since* (1854), she described a farmer's home where 'the masterpiece of finery was a tea table'. The table was 'fine' because it was stored in the perpendicular – as a disk in air – where its 'surface displayed a commendable luster'. It was 'for show and not for use'. Children's fingerprints were banned 'by penal statute', but the 'polished orb' attracted a kitten's claws when the animal saw a rival in its mirror-like reflection (Figure 13.1).[1]

Sigourney describes two effects of the juxtaposition of light and man-made things: reflection (the action of surfaces to throw back light, sometimes with a perfect doubling) and lustre (an effect where light moves into an object and radiates out, with pleasurable, often colourful effects). Physics explains some of these properties. Material culture – in this case attesting to the relationships of human and object, trained brain and skilled hand, all with attuned senses – explains others.

This essay investigates how the relationships of people and objects are mediated by human sensory experience: it asks how different domestic environments of lighting changed people's uses, actions and appreciation of

FIGURE 13.1 *Tea table, Philadelphia, 1765–75. Mahogany. H 28½ in. Diameter of top: 36¼ in. © Courtesy Chipstone Foundation. Photo Gavin Ashworth.*

everyday things. The larger historical project from which it draws examines domestic practices of lighting and their effects on daily life from the middle of the seventeenth century until successful innovations of electricity near the end of the nineteenth century. Artificial lighting became increasingly common in the early modern period. An expensive commodity that many could not afford, most people continued to guide their lives by the sun and moon. But that slowly changed in the two hundred years before electricity. Whether grouping around pockets of illumination like a lamp, moving through darkness with a taper in hand, or sitting by small burning rushes or fires,

wealthy and poor people had differing access to lit spaces. Nonetheless, more and better lighting changed social practice as economic conditions led to night-time entertaining. With artificial lighting, suppertime dining was no longer a leftover snack but an evening occasion that ritualized the end of the day. Eating late was always an index of low social position for the poor, but the elite recast the later evening as an illuminated theatre of dining as a sign of prestige. The elongated evening could transform afternoon social tea drinking of women to mixed-gender evening parties. Card games, formal dances and the like became even more popular when artificial domestic and public lighting extended and policed the night.[2]

Even as augmented artificial light changed people's everyday behaviours, different lighting conditions transformed materials and surfaces of household furniture and furnishings. That is, the choice of particular materials to construct objects has a relationship to the environment of their visual experience. Scholars most commonly explain such changes through time as a parade of design types or stylistic changes based on larger cultural patterns of trade, influence and prestige. But perhaps there is more: in an evolutionary sense, objects that were the most pleasing when experienced in certain light conditions ultimately succeeded in the marketplace of ideas.

The eighteenth-century mahogany tea table was a remarkable thing.[3] Perfect site for an artisan to display both the enhanced natural beauty of wood on its surface and his prodigious carving skill, it took centre stage for a significant eighteenth-century ritual. The table served as an approved proxy for wealth and leisure that could be metaphorically transformed into a disapproved place for women's gossip and wasted time. Contemporary pundits found a symbolic opposition: tea tables (bad wives) and spinning wheels (good wives).[4]

Lydia Sigourney's details drew upon her reader's cultural association of tea tables with their owners' economic success. But her appreciation was for the effect of the wood. Figure 13.1 shows the possibilities when an expert artisan worked with an impressive piece of wood. This mahogany timber, at mid-century probably prized in shipping and handling and purchased at a premium, produced a board of at least a full three foot width. Its surface displayed warm rolling effects: mottled and coloured, and creamy and shadow. Its splendour resulted from light particles that bounced from sub-surface cellular disturbances and the fancy woods used.

Those woods to marvel were found in the forests of the tropical regions of the vastly expanded imperial holdings of Britain and had many uses in a continent that had depleted a good part of their own natural timber supply. Merchants quickly evaluated these new *botanica* from the West Indies, North and South America, India and Africa for their ability to turn a profit. Contemporaries prized them for novelty, density, ease of working with tools and luxury consumer demand. That demand drove and followed their evolution from nature to culture, tropical commodity to esteemed household luxury. But such huge timbers often grew in nearly inaccessible British

colonial places, and, as historian Jennifer Anderson rightly reminds us, such beautiful woods came from the enslaved labour of thousands.[5]

Dramatic aesthetic qualities of a category of goods denoted as 'fancy' or 'good' particularly materialized that sense of exoticism and luxury. Striking contrasts of heart and sapwood in cocus wood (*Brya ebenus*), rich in colour in cedar (*cedrela spp.*), or those with marvellous grain patterning like mahogany (*swietenia mahogani*) were especially well-suited to add 'to the elegance of modern furniture, the veneering and ornamenting'.[6] The aesthetic experience of all kinds of wood differed; the distinctive look of wood is most marked when grain patterns are unusual, like semi-circular shades of colour, alternately light and dark, occasioned by the different angles at which the light falls upon it.

The authors of *The Library of Entertaining Knowledge* (1830) explained the structural genesis of the aura of fancy woods as arising from 'being cross-grained, or presenting the fibres endways or obliquely to the surface'.[7] As light reflects from different angles of the wood when finished, the surface may produce a fine shimmer: 'the more contorted, interwoven, and at the same time, regular in their distribution of fibrous masses ... the greater the beauty and richness of expression'.[8] Modern woodworkers struggle to achieve that effect called 'chatoyance'. Like velvet, when the surface is seen from multiple directions the colour seems to change. The *Cabinet-Maker's Assistant* of 1853 pointed out that it is the viewer's position and the actions of movement that made the wood's beauty 'the lights and shades dissolving into and alternating with each other'. He marvelled, 'this allusion of change defies the imitation of the painter, and is unconsciously one of the chief attractions which mahogany furniture presents'.[9]

Native woods continued to be used and were admired for their beautiful figure and finished effect. Birch, if finished without any colour, could create a figure of 'rare beauty', difficult to convey by mere description for 'when [they are] finished in French polish, they possess a transparent appearance, suggestive of coloured crystals or precious stones'.[10] But only the rosy tone of the yew could match the finest tropical imports in 'deep and warm tints'. The most common veneering timber was walnut and its lack of figured curling certainly made it 'rather deficient in beauty' opined the authors of the anonymous *Library*.[11] Naturally beautiful trees carefully sawn to create the widest boards and the best patterns still needed a final step to create true lustre. A resin finish could form a solid yet transparent film capable of accentuating the natural matter of dried wood. The lacquer protected the wood's surfaces and helped create enhanced specular reflection.

It was however the shifting, shaping and dancing of candle and firelight that brought such pieces to life. The measured candlelight worked in several ways: just like in mirrors, the most perfectly smooth surface reflected and doubled its light. In addition, the most complicated grained surfaces reflected

and refracted, scattering tinted light in unexpected and differing directions. Reflection, and these difficult anisotropic surfaces, still challenge a programmer's ability to render wood and its experience for many kinds of digital media, such as film and video games.[12]

The wax candle, oil lamp – and later gas jets – were all lighting technologies that would change the quality and quantity of light, particularly for the more well-to-do in urban areas in the two centuries before the light bulb. The stylistic look of household furniture and furnishings changed as well. In the late seventeenth and early eighteenth century, households were sparsely furnished. Native woods like walnut were the most common wood, small grained and generally unfinished with lacquer. Craftsmen might combine them with the more colourful and dramatic global woods used in arresting ways or use flashy, inlay of mirror bits and minerals to catch the flickers of firelight and task lighting. Most likely seen in overall darker conditions, heavily sculptural and carved pieces painted with bright colours receded and emerged, enlarged with shadowing and shading.

By the middle of the eighteenth century, multiple candles were more common. Fanciful asymmetrical design elements might ornament furniture and an array of objects for home, but overall, furniture surfaces were flat and finished in high gloss and numerous mirrors increased lighting power. Artisans treated silk fibres with chemical action to add to its sheen and rustle. They might add metallic fibres to create a slight twinkling effect in textiles and wallpaper. Polished silver gleamed and reflected from multiple source points of light. Hence, Lydia Sigourney, peering from the dark hallway into a room lit by candlesticks and candelabra reflecting on a darkened cupboard of silver might imagine the glittering cave of Aladdin. Modern high lighting levels from above diminished that power and helped make matte – not shiny – finishes more appealing.

By 1830, many in the middling ranks expected an artificially lit domestic space and evenings were open to entertainment and study. New and better sources for fuels – whale oil was far brighter and kerosene better again – and hundreds of patented improvements in lighting technology. Light is still most often based on a single source – a lamp on a table, for example – but that flame is far brighter and more uniform and increasingly suffused from multiple source points for private or family use.

Much high-end furniture gleamed with highly finished lustrous services and reflective brass fittings, like bail pulls with oversized escutcheons. The glamour of other parts of the world continued with mahogany and now rosewood, but with less admirable effects, as mahogany came from less optimal sources and in smaller logs. Soon the neoclassical style of furniture itself demanded a design including a series of collages, with flat surfaces enlivened with multiple kaleidoscopic effects of veneer patterns. As the stripping of the surfaces of woods and recasting as veneer became increasingly mechanized with the invention of cutting machines, new possibilities at new prices changed furnishings yet again. The industrialization of wood is well

underway. With the coming of gas lighting, then electricity, the domestic interior would move closer to what we might call a modern place.

Material culture teaches how human/object interaction continually shaped everyday experiences. Actions might be habitual, trimming a candle to minimize its stench and smoke; or optimizing, like dragging a chair to a light or making a table from the best figured and polished mahogany. Such actions might perhaps be unconscious like breathing and the ever so slow shifting of eyes or bodies to enhance the splendour of mahogany.

Both of these material things – a mahogany table and a light source – has a biography that links consumers to enslavement, animal slaughter, migration and global trade. So too they tell tales of masterful artisanship (skill, repetitive practice and talent), human pleasure (women claiming their rights by claiming a table) and dramatic surfaces in a changing night.

Notes

1 L. H. Sigourney (1868), *Letters of Life*. New York: D. Appleton, p. 46; and (1854), *Sketch of Connecticut, Forty Years Since*. Hartford: Oliver D. Cooke and Sons, pp. 143–44.

2 W. O'Dea (1958), *The Social History of Lighting*. New York: Macmillan; W. Schivelbusch (1995), *Disenchanted Night: the Industrialization of Light in the Nineteenth Century*. Berkeley: University of California Press; B. Bowers (1998), *Lengthening the Day: A History of Lighting Technology*. New York: Oxford University Press; M. Dillon (2002), *Artificial Sunshine: A Social History of Domestic Lighting*. London: National Trust Enterprises; A. R. Ekirch (2005), *At Night's Close: Night in Times Past*. New York: W.W. Norton; D. Koslofsky (2011), *Evening's Empire: a History of the Night in Early Modern Europe*. Cambridge: Cambridge University Press.

3 For two sources that focus specifically on the tea table itself, see: A. Smart Martin (2006), 'Tea tables overturned: rituals of power and place in Colonial America', in Deena Goodman and Kathryn Norberg, *Furnishing the Eighteenth Century*. London: Routledge; S. Fayen (2003), 'Tilt-top tables and eighteenth-century consumerism', in *American Furniture*. Hanover, NH: Chipstone Foundation, pp. 95–137.

4 Benjamin Franklin conveyed this concern to his sister Jane Mecom, 6 January 1726–27, in C. Van Doren (ed.) (1950), *The Letters of Benjamin Franklin and Jane Mecom*. Princeton: Princeton University Press, p. 35.

5 J. L. Anderson (2012), *Mahogany: The Costs of Luxury in Early America*. Cambridge, MA: Harvard University Press. For imported tropical woods, see: A. Bowett (2002), *English Furniture 1660–1714: From Charles II to Queen Anne*. New York: Antique Collectors' Club.

6 Anon (1830), *The Library of Entertaining Knowledge: A Description and History of Vegetable Substances, Used in the Arts and in Domestic Economy*: Vol. 3. *Timber Trees, Fruits*. Illustrated with Wood Engravings, 2nd ed. London: Charles Knight, p. 168.

7 *Library of Entertaining Knowledge*, Vol. 3, p. 168.

8 P. Thomson (1853), *The Cabinet-Maker's Assistant: A Series of Original Designs for Modern Furniture with Descriptions and Details of Construction.* Glasgow: Blackie and Son, p. 33.

9 Thomson, *Cabinet-Maker's Assistant*, p. 33 .

10 Thomson, *Cabinet-Maker's Assistant*, p. 7.

11 *The Library of Entertaining Knowledge*, Vol. 3, p. 168.

12 S.R. Marschner, S.H. Westin, A. Arbree and J.T. Moon (2005), 'Measuring and Modeling the Appearance of Finished Wood', *Cornell University ACM Transactions on Graphics*, SIGGRAPH 2005 Proceedings, pp. 727–34.

Objects of Emotion:
The London Foundling Hospital Tokens, 1741–60

John Styles

Marcel Proust, in the first volume of his novel *A la Recherche du Temps Perdu*, famously invokes a small cake – a madeleine – to express the unique capacity of objects to evoke emotions and memories.[1] Yet Proust immediately offers a qualification. It is not the sight, nor even the touch of the cake that overwhelms his narrator with exquisite pleasure rooted in memories of childhood, but its taste. Proust's madeleine carries great emotional power, but a power exercised at a particular moment in a very specific manner. The fictional story exemplifies both the opportunities and the limitations of historical study of the relationship between objects and emotions. Objects can transmit emotional messages, carry emotional associations and evoke emotional responses, but frequently they do so in such a personal way as to defy broader appreciation. Even when objects are emotionally charged in ways that command wide recognition, that recognition is often restricted to very specific circumstances. Things that exhibit emotional power in one setting can lack it in another. Moreover, even when an object's emotional charge was widely recognized at some period in history, there is no guarantee it can be recaptured by the historian.

It is not wholly surprising, therefore, that recent scholarship on the history of the emotions has focused on texts and paid little attention to objects. Starting from the assumption that human emotions are less biological constants than cultural constructs, it is through the changing use

of words that historians of emotion have endeavoured to understand the ways people in the past articulated and understood their feelings.[2] It is, of course, also possible to approach objects as a system of signs to be read, a material language. But if objects represent a kind of text, then it is one that is (and was) exceptionally unstable, elusive, and ambiguous, easy to manipulate and almost impossible to read consistently.[3]

So what can objects tell us about the history of the emotions? The records of London's Foundling Hospital, the first English orphanage for abandoned infants, in the middle decades of the eighteenth century provide an unmatched opportunity to explore the possibilities and pitfalls of studying the history of the emotions through objects. More than five thousand objects dating from 1741 to 1760 survive in the orphanage's archive. Each one accompanied an individual, documented infant admitted to the Hospital. The presence of these objects in the archive arises from one of the most profound experiences of separation and loss known to human beings – the rupture of the foundational emotional bond between mother and baby.[4]

The official name of the Foundling Hospital was 'The Hospital for the Maintenance and Education of Exposed and Deserted Young Children'. It admitted its first infants in 1741. During the years from 1741 to 1760, the process of giving over an infant to the Hospital was an anonymous one. It was a form of adoption, whereby the Hospital became the infant's parent. Its previous identity was effaced. Initially no questions at all were asked of those who brought the children to the Hospital, in order to avoid the shame which might otherwise encourage mothers to abandon their babies in the street, or even kill them. No record of the mother's name was kept by the Hospital's clerks.

Admission to the Hospital before 1760 was anonymous, but the mother retained the right to reclaim the child if her circumstances changed. Ensuring mothers were able to retrieve their children was an important priority for the Hospital, although the number of children actually reclaimed was tiny. Each baby left in its care was registered with a number, accompanied by information designed to assist future identification. On the printed registration forms, there were headings for entering the sex of the child, the clothes it was wearing on admission (which were then replaced with Hospital issue), and any special distinguishing marks on its body. In addition, the Hospital encouraged mothers to supply a token, which might be a note, a letter, or a small object, to be kept with the registration form as an identifier. Small objects were especially suitable when the mother concerned was illiterate, as so many of the Foundling mothers must have been in the mid-eighteenth century. Mothers were well aware of this. A letter left at the Hospital with a child in 1756 reported 'it is wrote over the Door to have a token sent with the Children for distinction'.[5]

Between 1741 and 1760, 16,318 babies were admitted to the Hospital. They were all less than one year old on admission. Despite the Hospital's instructions, two-thirds arrived without a material token and half without a

letter. Did their mothers simply relinquish any hope of reclaiming their children? Were they heartless, troubled or disorganized? We cannot know. Undoubtedly many Foundling babies were simply dumped at the Hospital, uncared for and unloved. A baby admitted in 1759 was reported to have been 'exposed and deserted by the parents of the sd [said] child or persons unknown and left to the mercy of the world'.[6]

Nevertheless, for about 5,000 of these babies a small material object survives as an identifier. Some are small, everyday items such as metal watch seals, coral necklaces, coins, brooches, rings, padlocks, keys and buttons. Yet these trinkets are unrepresentative of the generality of objects attached to the registration forms. The overwhelming majority are swatches of textiles. Sometimes, especially during the period from 1741 to 1756 when only selected children were admitted, these pieces of fabric were supplied as a token by whoever left the child, often with an accompanying letter or statement. Sometimes, especially during the period from 1756 to 1760 when the Hospital took all-comers and was overwhelmed with babies, they were cut from one of the items of clothing the baby wore when it arrived, presumably by officials looking for some material means of future identification.

Does the predominance of fabrics prove that during the eighteenth century textiles were the most potent vehicle for fixing emotion and memory? For a mother, whose hands had sewn or washed the fabric, and whose baby had touched, worn and soiled it, perhaps. But for the generality of people, probably not. After all, the bulk of the Foundling textiles were supplied not as tokens, but were cut from the babies' clothes by the Hospital staff. Identification was the priority here. It was usually the most distinctive, colourful fabric worn by the child that was chosen, most often a print or a check.

However, textiles are also prominent among the items intentionally supplied as tokens by the mother, or whoever else brought the child, particularly coloured silk ribbons. Once again identification was a priority. A yard of multi-coloured figured ribbon in bright, lustrous tints could be purchased for a few pence. Plain ribbons were cheaper still. The variety of colours and patterns on sale was enormous. Cheap, colourful, patterned and diverse: these characteristics made ribbons a perfect way for poor mothers to fulfil the Hospital's instructions to provide 'a token . . . for distinction'. Yet there was more to the link between ribbons and the Foundling babies than vibrant colours and varied patterns. Ribbons were universally recognized symbols of love, especially in circumstances of separation and loss. They were the very currency of romance, love and courtship, especially in their role as fairings, the gifts exchanged between lovers at fairs and holidays. Their emotional significance was especially strong when the beloved was absent. The emotion could be rendered more intense by tying the ribbon in knots, known as loveknots. The effect could be intensified yet further by attaching other love tokens, such as coins or rings, to the ribbon,

hanging it round the neck or tying it to an item of clothing for greater intimacy. All these emotional enhancements can be observed among the Foundling tokens.

Even more emotionally explicit is a subset of emblematic items among the objects supplied as tokens. The most expressive include carefully contrived textile images, sometimes hand-sewn, sometimes obtained by customizing the natural imagery commonly employed in commercial designs printed on linens and cottons. An acorn or a bud might suggest germination and new growth, a butterfly the chance to fly free, a flower the capacity to blossom and fruit (Figure 14.1). The most direct expressions of raw maternal emotion are those that use the heart, an established symbol of love in the eighteenth century. The heart was literally believed to be the seat of the emotions. Foundling mothers left embroidered hearts, hearts cut out in fabric, hearts drawn on paper, metal hearts, and suit of hearts playing cards. One heart-shaped metal pendant left as a token carried the lines 'you have my Heart, Tho' we must Part', but the words seem almost redundant, such was the familiarity of the heart as an emblem of love.[7]

These objects demonstrate how mundane things could be deliberately made, elaborated, or customized to express emotion. They also show that the emotional charge attached to objects was contextual and impermanent. A suit of hearts playing card, signifying intense maternal emotion in its role as a Foundling token, is unlikely to have had the same emotional resonance in a game of All Fours or Cribbage. More problematically, these objects raise the issue of authenticity. Do they tell us how poor mothers felt about giving up their babies, or do they tell us how poor women thought a wealthy institution would expect them to express emotions about separation and loss? After all, mothers may well have believed that fulfilling the Hospital's expectations would help secure admission and preferential treatment for their child.

The one form of emotional expression among the tokens that defied institutional expectations was the attempt by numerous mothers to name their babies. Although it must have been common knowledge that the Hospital gave every baby a new name, mothers constantly asserted their own choice of name. Some employed paper letters and notes, but others sewed names, initials, birth dates and birthplaces on fabric, or even wrote them on ribbons (Figure 14.2). In this defiance of the Hospital's policy, we find potent evidence of authentic maternal attachment. Yet it is available to us only because it is in the form of a text, even if the words are crudely sewn on fabric in worsted yarn.

Disappointing though this dependence on words may be for those in search of a more object-orientated history of emotion, it demonstrates the great strength of the Foundling archive as a historical source: words and things in combination. The materiality of the Foundling tokens remains emotionally important. Many of the mothers, probably most, were illiterate. They could only express themselves in writing if their words were inscribed

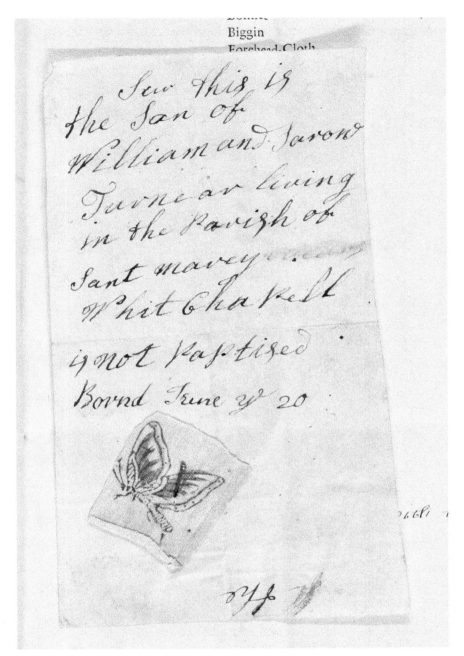

FIGURE 14.1 *Cotton or linen printed with a butterfly, Foundling 9018, a boy admitted 23 June 1758. The note reads: 'Sar this is the Son of William and Sarow Turnear living in the Parish of Sant Marey Whitchapell is not paptised Bornd June ye 20'. © Coram. Image © London Metropolitan Archives, Foundling Hospital Billet Books, A/FH/A/9/1/102.*

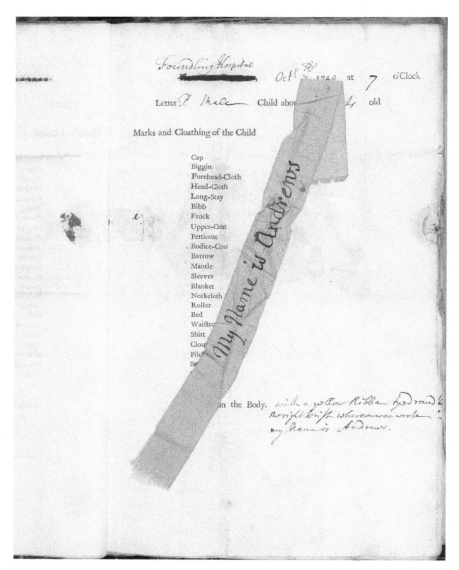

FIGURE 14.2 *A yellow silk ribbon with the words 'My Name is Andrews' written in ink, Foundling 453, a boy admitted 7 October 1748. The text at the bottom right of the form reads 'A yellow Ribban tyed round the right Wrist whereon was wrote my Name is Andrews'.* © Coram. Image © London Metropolitan Archives, Foundling Hospital Billet Books, A/FH/A/9/1/006.

for them by others. The language of ribbons and hearts, by contrast, was accessible to all. But the mothers' recourse to textiles as a vehicle for self-expression was not just a second-best substitute for writing. Theirs was a world where the use of certain objects to mark events, forge relationships and express emotions was familiar, and the meaning of those objects widely shared. It was a world in which verbal literacy existed in conjunction with a material literacy which, though not entirely lost to us, has become elusive.

Notes

1 M. Proust (1946), *A la Recherche du Temps Perdu. 1: du Côté de Chez Swann.* Paris: Gallimard, p. 68.

2 See, for example, P.N. Stearns and C.Z. Stearns (1985), 'Emotionology: clarifying the history of the emotions and emotional standards', *American Historical Review* 90 (5), pp. 813–36; B. Rosenwein (2002), 'Worrying about emotions in history', *American Historical Review* 107 (5), pp. 821–45. For an overview that offers an object-orientated alternative, see: S. Tarlow (2012), 'The archaeology of emotion and affect', *Annual Review of Anthropology* 41, pp. 169–85.

3 For a recent critique of this approach in the study of fashion, see: C. Campbell (2012), 'The modern Western fashion pattern, its functions and relationship to identity', in A.M. González and L. Bovone (eds), *Identities through Fashion: A Multidisciplinary Approach.* London: Bloomsbury, pp. 9–22, and E. Tseëlon (2012), 'How successful is communication via clothing? Thoughts and evidence on an unexamined paradigm', in González and Bovone (eds), *Identities through Fashion*, pp. 109–37.

4 J. Styles (2010), *Threads of Feeling: The London Foundling Hospital's Textile Tokens, 1740–1770.* London: The Foundling Museum.

5 London Metropolitan Archives, A/FH/A/9/1/034: Foundling Hospital Billet Book, 1756, Foundling number 2810.

6 London Metropolitan Archives, A/FH/A/9/1/137: Foundling Hospital Billet Book, 1759, Foundling number 12279.

7 Token on display at the Foundling Museum, London, bearing the initials IW and the date 6 September 1759.

Material Culture and Materialism:

The French Revolution in Wallpaper

Ulrich Lehmann

Introduction

In the stores of the wallpaper museum in Rixheim in the Alsace region of France survive two almost identical pieces of paper, dating back to the early 1790s: one is a *maquette*, a design in gouache made by a commercial artist for a Parisian manufacturer of wallpaper, the other is a printed piece, ready to be mounted on the walls of a public or private space (Figures 15.1 and 15.2). They share the same format and nearly all their material and visual features, but mark different stages both within a process of production and, significantly, within the history of the French people. They form thus significant examples for a history of material culture that resides in the effective combination of analysing the making of objects together with using a materialist approach to historical research – an understanding of the past through social classes, their labour conditions and the forms of production they engage in.

A new way of printing papered pieces for walls was introduced in the second half of the eighteenth century in France. They were called *papiers de tentures* (tinted or dyed papers) or *papiers peints* (painted papers) – referring in their nomenclature to their respective forms of making. Both of the pieces

FIGURE 15.1 *Manufacture Réveillon, wallpaper for the 'Fête de la Fédération', 1790, gouache (template) on paper, 103.5 × 53.5 cm, Rixheim, © Musée du Papier Peint.*

FIGURE 15.2 *Manufacture Jacquemart et Bénard, wallpaper for the 'Fête de la Constitution', 1793, 103.5 × 53.5 cm, Rixheim, © Musée du Papier Peint.*

of paper[1] that are discussed here originate from the period of the French Revolution, a time of radical political and economic change. Their design and production, respectively, separates the pieces by almost three years, and by looking at their motifs together with their forms of making, we can analyse concrete interaction between political, social, economic and cultural factors.

The aim of this paper is to explore the relationship between the production, distribution and consumption of objects and a particular perception of history or the relationship between material culture and materialism. The way I intend to use this term differs from the contemporary research in the humanities and social sciences that inquires into objects allied to the rituals and belief systems of particular communities across time – although my present approach shares some theoretical concerns with recent archaeological and anthropological methodologies, most notably with the notion of a 'social life of things'. Yet I am interested in looking at the material autonomy of an object, which moves away from its function as cultural sign or from its symbolic value. For me the term material culture denotes types of material production which are to some degree structurally self-reflexive – of social and economic systems as much as of aesthetic ideas – and which position an object within a conceptual space that is shared by creative work and the production of commodities.

The term materialism is discussed here in both its historical and its philosophical expressions, which denote that historical development is grounded in concrete economic structures with inherent political potential as well as representing a philosophical tradition that finds empirical and material bases for thinking and rejects an idealist position – the latter one often found in the discussion of aesthetics or culture in general. The leading early proponent of materialism in this combined historical and philosophical coinage is Karl Marx, who put it very succinctly in 1859: 'It is not the consciousness of men that determines their existence, but, on the contrary, their social existence that determines their consciousness'.[2]

Papered walls: Réveillon's story

Let us return to the two pieces of wallpaper. I mentioned above that they could be placed either in a public or private space; this is important for their initial assessment as a commodity. If one, or indeed both, were commissioned by a government department to decorate a public interior, the production had to adapt to such demand, for instance in terms of size of the motif, colour, etc. If, in contrast, the piece was intended to decorate the wall of a private home, its quality of manufacture, for example the number of colours used, the expert labour involved to realize a complex motif, and the multi-layered printing process to ensure depth of visual field, etc. would be different. Therefore one can say that consumption determined production.

But, conversely, the production determined the consumption, too, as the social and political position of the manufacturer, especially during the French Revolution, played a crucial role in the way in which its products were acquired and displayed.

The pieces of wallpaper in question were produced on the same premises, using the same technique and – a significant point to be discussed below – with almost the same set of materials, yet the name of the actual manufacturer changed in the time that separates the two designs. The first piece, completed in 1790, was produced by the *manufacture royale* (supplier to the French court) of Jean-Baptise Réveillon; in 1793 the second piece was produced by the manufacture of Jacquemart et Bénard. Their succession was as much part of the contemporary political landscape as it was a reflection of the reorganization of French manufacture at the time.

Up to 1789 Réveillon had advanced to becoming the most innovative, exclusive, but also prolific manufacturer of this new type of wall hangings called *papiers peints*. In April 1789, a few months before the fall of the Bastille, Réveillon, who had been dabbling quite amateurishly in politics, was attacked by a crowd from his own district to the east of Paris, the Faubourg Saint-Antoine. The people there were angered by the manufacturer's apparent opposition to a minimum wage and by his rather ostentatious display of wealth in his royal manufacture, with his large park and townhouse. The ransacking of his mansion and manufacture and, subsequently, the bloody reprisal by government troops, who killed and injured hundreds of demonstrators, marked the first violent protest of the French Revolution. Réveillon sought refuge in the Bastille prison (bad move), then in London (better one), before finally handing over the business in 1791 to two of his erstwhile employees, Pierre Jacquemart and Eugène Bénard. These two workmen-cum-entrepreneurs expressively supported not only the new French Republic but its radical Jacobin wing,[3] donated collective funds during the war, and supplied the government as well as private customers with an extensive selection of republican and revolutionary motifs.[4]

What does an intimate connection between manufacture of artefacts and radical politics reveal? To reply to this question it is necessary to move away from a history of artefacts that is constructed through the appearance of things, their forms and surface qualities, as well as their symbolic value and usage. Merely looking at things from the past in such a way does not allow for a concrete understanding of objects that were made through particular means of production, under specific social and labour conditions, and by using a defined range of materials and techniques.

The tendency of material culture as a discrete field of inquiry to view the forms of objects and their function through archaeological or socio-anthropological lenses is still prevalent in Western academia.[5] This has its epistemological origin in the need to distinguish it from classic archaeology and art history on one side, which was concerned with movements, styles

and the iconography of things, and to separate it on the other side from classical anthropology and sociology, which look at systems of interaction and internal relations in which objects were seen as symbolic markers and operational for the communication between social groups. For neither of these fields the aspect of production was regarded as essential – this was left to a largely descriptive history of technology in which procedures, processes as well as tools and techniques were studied as part of a developmental and implicitly positivist history of technological advancement.

So, looking at our example, what does the production method reveal about the meaning of the pieces that were decorating bourgeois homes, noble mansions as well as official residences? Wallpaper was a thoroughly modern medium in the latter half of the eighteenth century. There had been printed papers used for the decoration of furniture before (lining drawers, wrapped around boxes, etc.), but it took until the 1770s for a materially 'cheaper' alternative to embossed leather or printed silks on walls to become popular. This was due to social changes as much as to changing fashion: new, bourgeois consumers, who wanted to see themselves as 'mobile' in the societal and aesthetic sense, embraced a form of wall hanging that could be changed easily, economically and repeatedly. The nineteenth-century historian of decorative art Charles Blanc declared in his essay on wallpaper that 'it is entirely logical that the advent of democracy coincided with the almost universal desire to augment the wellbeing of the most numerous of classes, and inventing for it, if not a direct equivalent of luxury, at least something that suggests it to them. Thus on the eve and on the day after the French Revolution, in 1785 and 1792, a Parisian fabricant, Réveillon, and an industrialist from Mulhouse, Züber, brought a new impulse and considerable development to the manufacture of wallpaper'.[6]

From consumption to production

But if such an argument appears to be based initially around consumption, it is its dialectical relationship with production that first and foremost established the appeal of wallpaper beyond its novelty aspect. In *Grundrisse* (1857–58), which would lay the foundations for his extended work on political economy, *Capital* (1867), Marx established this relationship between production and consumption not only within a materialist view of historical developments but, more specifically, to show how objects and subjects interact with each other in a modern, capitalist economy and culture dominated by commodities:

> Consumption produces production in a double way, (1) because a product becomes a real product only by being consumed. For example, a garment becomes a real garment only in the act of being worn; a house that is not lived in is in fact not a real house. Only by disintegrating the product does

consumption give the product the finishing stroke;[7] for the product is production not as objectified activity, but rather only as object for the active subject; (2) because consumption creates the need for *new* production, that is it creates the ideal, internally impelling cause for production, which is its presupposition. Consumption creates the motive for the production; it also creates the object which is active in production as determinant aim.[8]

The notion of the object of material culture as product of labour is crucial here for the understanding of materialist history. Furthermore, it is the relationship of the object to the subject that fuses cultural history with political economy: through the term 'commodity fetishism' Marx posited an analogy between the relation of things and the interaction of people at the core of modernity. In one of his earlier, explicitly philosophical books, Marx wrote:

The production of ideas, of conceptions, of consciousness, is at first directly interwoven with the material activity and the material intercourse of men, the language of real life. [. . .] But life involves before everything else eating and drinking, a habitation, clothing and many other things. The first historical act is thus the production of the means to satisfy these needs, the production of material life itself. And indeed this is an historical act, a fundamental condition of all history.[9]

There is no distinction to be drawn between a socio-economic assessment of historical development and any of its material expressions. More specifically, objects of culture, assessed through the contemplation of artisanal or artistic production in which the realization of 'beauty' as well as 'use value' remains implicit to varying degrees, must indeed be related to their contemporary economic and political structures in order to produce veritable social consciousness – thus comprehending thought as historical praxis.

History as material life means material culture history as history of production. And while the material value of paper appeared more economical than silk, and thus more suited to a changing society, it was the very form of making the *papiers peints* which signalled to consumers that they were buying into the very idea of a contemporary object. Wallpaper manufacture brought together processes from textile printing, paper making, book- and map-printing in order to implement one of the first serial manufactures in pre-industrial France.

In April 1789, on the eve of the violent demonstration against him, Réveillon divided his 300-strong workforce into '4 classes' and listed their profession in descending order of remuneration. This list also provides a neat overview of the procedural steps that had to be taken to make wallpaper. First came the draughtsmen and engravers (paid at 50–100 sols[10]), then printers – *fonceurs* (who applied colours as base layers) – and carpenters

(30–50 sols), porters, *broyeurs* (who ground pigments), packers and sweepers (25–30 sols), colourists, in three groups of 8–10 labourers (no pay given), each headed by a foreman, and finally children, aged between 12 and 15 years (8, 10, 12 and 15 sols) for manual labour.[11]

From preparing the paper – indeed Réveillon had secured supply of consistent quality through the acquisition of a paper mill as early as 1772 – to its colouring, printing and finish, as well as packing, shipping and retailing, each phase was arranged within an economical, vertically integrated manufacture, thus reversing the traditional, holistic approach of the artisan, who kept his entire production within one workshop floor with employees performing varying tasks. Ironically, despite the proto-industrialized working process, Réveillon's final products remained very exclusive in terms of quality and were seen very much as an artisanal, even 'artistic' product.[12]

There exists a watercolour of 1788 that shows how the division of labour within wallpaper production was spatially arranged across the manufacture. Each step in the making of the *papiers peints* is allocated its discrete floor, restricting the contact and communication between productive phases, as an echo of the alienating 'factory system' that had come into effect within contemporary textile weaving and spinning in Manchester and which would characterize the industrialization of Europe.

Materialist culture: From Russia back to France

Wallpaper is for us a way into a materialist understanding of the history of material culture in which production, its organization and the political and social circumstances in which it took place are key to understanding history. We need, however, to jump more than a century forward for the very term 'material culture' to be invented when in 1919 the Russian Academy for the History of Material Culture was founded in Petrograd (today Saint Petersburg). Subsequently renamed the State Academy for the History of Material Culture (GAIMK), its history exemplifies the move from an archaeological or ethnographic investigation of artefacts to an analysis of culture and society through its productive forces and labour relations. The Academy's principal communication occurred through its journal *Material Culture*, published in more than 130 issues between 1921 and 1935.[13]

Alongside this new perception of material culture, but independently from it, emerged another definition, put forward by the progressive artist and educator Vladimir Tatlin. This definition went back to a more 'mechanical' meaning of materialism as the concrete production of objects and of their function in relation to the subject through labour. The term material culture emerged here from an aesthetic formalism of revolutionary art, which approximated industrial processes to the production of objects of structural engineering, and it became extended to a general perception of

cultural work. As head of the 'Section for Material Culture' at the Petrograd GINKhUK (State Institute for Artistic Culture) between 1923 and 1925 Tatlin put forward the following definition for material culture:

> 1) Research into material as the shaping principle of culture; 2) research into everyday life as a certain form of material culture; and 3) the synthetic forming of new material and, as a result of such formation, the construction of standards for new experience.[14]

The lived, everyday experience of the subject emerged from the development of new modes of production which, implicitly, replaced within a revolutionary society the erstwhile exploitation and alienation of labour. New ways of making raised the consciousness of the producer, and his action – not the desirous or symbolic consumer – determined cultural progress. This progress did appear as positivist and teleological (goal directed) within the orthodoxy of scientific socialism of the 1920s and 1930s. So much so that the wider history of material culture was regarded as one of qualitative as well as quantitative change – but it is important to recognize that progress and change were not simply equated with technological or scientific advancement but with social and political emancipation.

Tatlin's definition of material culture and its immersion into a history of progress had been prefigured, I would argue, in the wallpaper manufacture during the French Revolution. The *papiers peints* operated as illustrations of political change and of a process of social emancipation. It generated a perception of change as communicable, as read through outcomes and products and as eventual manifestation. As demonstrative of *social* change the motifs and patterns on the papered wall pointed at a structural (socio-political) change beyond any visual style or movement that they displayed on its surface with revolutionary insignia or *tricolore* colours. Although they were symbolic, their application in everyday life was governed also significantly by a fashion for changing commodities – in 1791 the slogan 'Liberté ou la mort' was as trendy on the walls of the bourgeois as was sporting baggy trousers (*sans-culottes*).

The basis for the consumption of new wallpapers runs counter to their production in nationalized or re-distributed manufactures. Therefore their use in many public and some private interiors was read as reflection of changed ownership of production and labour conditions rather than a mere indication of political sympathies. The novelty of a new form of wall decoration was combined with a related support for a novel form of governing the people.

The designs for the two wallpapers from the manufactures Réveillon and Jacquemart et Bénard (Figures 15.1 and 15.2) incorporated novelty in a complex fashion. One part is the continuing but rather ephemeral fashion of floral motifs and arabesques on wallpaper, going back to the historical origin of silk wall hangings in the middle of the eighteenth century. The

other part is the motifs with more or less overt political symbolism, which are fused with the flower arrangements and garlands. A new stylistic trend is mixed with signs of political change – but in this case, ironically perhaps for an emerging consumer culture, it was the ephemeral style that outlasted the politics of the day. Réveillon used for his *papier peint* of 1790 a motif by Jean-Baptiste Huet, a prolific painter in the Rococo-style who produced many compositions for the textile printworks in Jouy, and whose work was transposed into decorative patterns that became fashionable and influential for a number of fields in the applied arts.[15] This flower still life, as can be seen from the fragment in the Album Billot (swatch no.1053), had been produced as far back as 1789 by the *manufacture royale* of Réveillon (Figure 15.3). It was common for wallpaper manufacture to acquire the rights for patterns in textile printing in order to be able to apply them to paper. What was much less common was their integration into a concretely political context, which continued over the next five years or so.

The other elements of this wallpaper design, its figures and symbols, had been designed in the manufacture itself, and in the gouache of 1790 they reference directly the *Fête de la Fédération*, which was established as an

FIGURE 15.3 *Manufacture Réveillon, Swatch no.1053 from the 'Album Billot', 1794–97, water-based paint on paper, c. 15 × 11 cm, Rixheim, Musée du Papier Peint.*

annual public event on 14 July 1790 to commemorate the fall of the Bastille fort and the subsequent establishing of the new French constitution.

The second version, the printed wallpaper, was linked to a later celebration, the *Fête de la Constitution*, that was the culmination of a number of national celebrations as grand public manifestations on 10 August 1793 in Paris and part of the provinces.[16] While the first was a festivity generated by the districts of Paris and was guided by an inclusive spirit, the second was more a political demonstration, which served as a call to arms for not letting die away the radical spirit of the revolution.

Across the three years that separate them, the festivities thus embody, respectively, what many materialist historians have called the 'two revolutions': the first by the bourgeoisie, the second by the working class.[17] The same revolution, but at two different stages, at two different points within its history – how did this become manifest in two near identical papers, which, furthermore, were dominated by floral decorative schemes? Material culture was singularly capable here of showing history. The specific form of production of wallpaper allowed for the ready adaptation to changing social environments and for the aforementioned integration of aesthetic ideas into political economy.

Papered walls: A revolutionary story

Wallpaper was printed from a selection of woodblocks into which motifs were cut and which often were floated on beds of water to allow for moistened paper to be pressed into it. More frequently, the paper, with its base colour already applied, would be pressed into the woodblock with the aid of a lead mallet or, in more industrialized manufactures (especially in Britain), through a cylinder drum that rolled across the sheet.[18] In the context of the relationship between wallpaper and other printing of engravings or books, it is important to note that wallpaper, in order to carefully align different blocks for the successive stages in printing complex motifs, could not be placed underneath the press; it had to go on top, similar to the technique used for printing cotton textiles.[19]

Henri Clouzot, in one of the earliest essays on wallpaper in the context of art-historical research, situated the connection between the *métiers* of wallpaper and engraving within the latter innovating the 'rentrure': the careful aligning of successive, differently coloured printing blocks of the same motif in order to position precisely the colouration of the design.[20] This had to be done individually by skilled hands at each stage during the printing process. Only relatively simple patterns that required the imprint of one or two motif(s) on a single base colour could be put through a letterpress-type procedure. Depending on the complexity of its motif, the paper that had been pressed into one woodblock would be passed along to a succession of other printers in the line to imprint it with a subsequent shade or motif

until the desired design was fully realized in all its colours and details; the addition of highlights and some retouching by hand of the printed colours was used only for very expensive designs.

The vast amount of variation that could be drawn from this often serialized combinations of base colours, repeat patterns and motifs allowed the manufacturers to produce large quantities of *papiers peints* to accommodate even small changes in fashion for a new colour or a different design into their ready-made decorative schemes. The ambiguity, ephemerality and transitoriness in French society in the years before the Revolution thus found its material equivalent in the shifting decoration and insignia on their walls.

Through the production process wallpaper emerged as being related on the one side to the manufacturing process of patterns in textile printing, and on the other hand, in its design process and in the way in which individual motifs could be framed into borders and friezes on a wall, to engravings. This structural duality, taking the design process from one field, and the printing technique from another, accounted for the ambiguous position of wallpaper, which on the one hand held a haptic relationship to the human figure-like textiles; while on the other hand were in line with the traditional aesthetic contemplation of pictures and thus distanced it from the subjectivity of the viewer.

One can observe across our two examples between 1790 and 1793 the degree to which republican political demands had shifted. While the earlier wallpaper (Figure 15.1) retained the centrality of general notions of fatherland and liberty, the latter radicalized ideas through the display of the Phrygian caps, which as *bonnet de la révolte* had inspired contemporary milliners back in 1789. In the earlier *Fête de la Fédération* two Roman pennants are mounted on the left[21] by a dolphin (read: 'dauphin', i.e. crown prince) and an eagle on the opposite side, with two related inscriptions simply stating 'Patrie' (standing for the royal subject) and 'Liberté' (for the nation). The two standards above bore parallel inscriptions: on the left 'Fédération National, À Le [*sic*] 14 Juillet 1790', on the right 'Constitution', thus commemorating the brief period when royals were still envisaged to be paired with a National Assembly within a combined governance for the good of the nation. The subsequent wallpaper for the festivities of 1793 (Figure 15.2) dispensed with these inscriptions, and substituted dolphin and eagle with republican bonnets as the abstract and universal symbol for the new social and political state and, more specifically, as reference to the dominance of montagnards/Jacobins in the government of the time – the liberal, Girondist *convention*, literally, had to be erased.

The script and established symbolism of the earlier design were scraped and cut out, and two new woodblocks were placed into the printing process that now displayed the novel index for a more radical republicanism.[22] Here, the analogy between material and political process was at its most graphic: the old was cut out (or rather cut off – think of the overworked executioners during the *Terreur*) and replaced by the new. But this 'new' was not a novel

autonomous design but one that was inserted into an existing discourse. There existed a continuous *progress* that is dialectically rephrased by a *revolutionary* element, which emphatically relied on the established basis in order to radically implement change.

Structurally speaking, the insertion did not change the semantics of the 'text' but it introduced a motif that fundamentally altered the reading of the discourse by virtue of preserving its overall structure. A further significant analogy introduced itself by looking at the historical instances of the irruption of the working class dialectically from the continuous progress of the bourgeoisie since the 1780s. The *quatrième ordre*, the fourth estate with a working class conscience ruptured at certain neuralgic points in the course of the Revolution the continuity of bourgeois emancipation (the third estate (*tiers état*) in parliamentary representation), correcting and radically re-assessing it through a generation of new material cultures – without ever being able to fully implement a radical change in the societal structure.

Objectification and subjectification

The emphasis given to production and the materiality of the object leads to an assessment of an artefact within the historical development and the praxis of its making. In historical materialism, labour determines the self-consciousness and freedom of the subject through the appropriation of the object (of nature). Marx wrote: 'The person objectifies himself in production, the thing subjectifies itself in the person . . .'[23] In its first instance production can be regarded as a historical factor, which through particular forms and through structural implementations within capitalism turns into an alienating process when labour and its products become estranged from the worker/maker. Conversely, subjectivity can arise when the process of production becomes self-generative for developing historical consciousness, which in turn changes society through political and social action – as, for example, when a proto-industrialized workforce within a wallpaper manufacture forms part of the vanguard in demanding social change and political representation.

This argument underscores the dialectics within material culture through a focus on usage – either in the form of commodity fetishism (objectification) or in the form of raising consciousness (subjectification for political praxis). These two conflicting but mutually dependent tendencies exist within both consumption and production. In material culture the subject's social relations are reified through commodification, but the thing (object, commodity) is subjectified under certain conditions as part of a ritual or action. The object (as well as the objective) of studying material culture therefore appears within certain historical events as an objectifying force and a necessary element for political praxis. But it must appear as dialectical

since the objectification and subjectification negate each other as part of historical progression.

As I have detailed in the two wallpaper samples, the specific production technique of an object can become the site for social emancipation or political revolt, while at the same time perpetuating existing commodity fetishism (following fashions, constantly buying into new trends), which impacts on labour structures and thus on the workers' social relations. Dialectically, this commodity fetishism can be undermined, subverted and turned around towards subjectivity and street protest when objects of material culture become exposed through their productive processes as indicative of economic and political power structures – in my examples as official propaganda for the Jacobin cause.

Marx had conceived historical materialism simultaneously as a method of assessing concrete historical processes and as a generic structural device for history itself.[24] The resulting problematic of analysing a structure via the notion that particular modes of productive labour (and the objects resulting from such labour) have to be understood in their context of a particular socio-economic system, which in turn is seen a priori as having been established by the labour structure, gave rise to the dialectic of labour itself. Labour is to be regarded simultaneously as action and as structure; it is a mobile process that can, and should, generate constant social movement, and, equally, operates according to a fixed societal structure that contextualizes human action at a particular point in time. Accordingly, objects of material culture can be understood dialectically, both as results of labour processes and, through analyses of their modes of production, equally as origins for specific social and economic patterns in history.

Emphasizing the relationship between political development as historical self-renewal and material production constitutes not only a historical method but it generates in itself a force of production. This contains the potential of men who, in their self-articulation, become the objects as well as subjects of history by obtaining the means of production and by taking charge of their own material culture (as was demonstrated in the Soviet Revolution in Petrograd). In doing so, however, men were developing productive structures that denied them such emancipation, as a commodity culture was cemented where the relationships between objects mirrored in a determinist fashion economic and social relations between people.

Conclusion

The radicalization of the dialectic in demanding concrete social and political action is fundamental to the emancipation of material culture in the late-eighteenth and first half of the nineteenth century as the developing ground for productive conflicts. It is my contention that in order to understand this history of material culture the use of historical materialism as a

methodological tool is important. During the time of the French Revolution when new parameters for assessing historical progress were laid down in Europe so that technological or economic advancement became allied for a few years with avowed concerns about equality and social emancipation, material culture had to be understood more inclusively. It implied concentrating on the production of things, which, in turn, has to be regarded as historical patterns within materialism, in order to show the meaning proper of objects within an economic, social and political setting.

The radical fervour of the French Revolution was replaced by revisionism and eventual monarchism at the turn of the nineteenth century, and the use of wallpaper as an explicit form of propaganda with its own distinct decorative idioms fell away. Their pioneering function as part of a contemporary and ephemeral material culture bore too many risks; they were all too easily rendered obsolete by political changes.

Before cutting and pasting new political motifs into existing decorative patterns, Jacquemart et Bénard in 1792 had been commissioned by the Comité des Inspecteurs de la Convention Nationale to produce wallpaper for the newly nationalized Tuileries palace. The manufacturers submitted 'eight or ten republican designs in ink to be subsequently engraved, printed, and displayed on the walls'. When the completed wallpapers left the workshop a few weeks later the committee refused to accept them, as in the short interval 'ideas about the look and function of wallpaper have become far too variable'.[25] The designs for these *papiers peints* were overtaken not simply by fashion but by social and political events.

Material culture history was shown, within the dialectical relationship between the production and consumption of commodities, as creating new structures for receiving objects of artistic and artisanal labour, and within these structures changing taste would eventually replace political engagement and partisanship. The disregarding of production, which today is apparent in the 'consumption theories' of social anthropology and design history, is thus not simply a reflection of the neo-liberal economization of society and culture that surrounds us; it had been a fateful part of the origins of materialism itself.

Notes

1 The term 'pieces' is chosen, as the printing of wallpaper on rolls was patented in France only in 1831. See B. Jacqué (2006), 'Pour une histoire des techniques de production du papier peint en France à la fin du XVIIIe siècle', *Support/ tracé* 6, p. 14.

2 K. Marx (1977 [1859]), *A Contribution to the Critique of Political Economy.* Moscow: Progress Publishers, p. 3.

3 The connection between the manufacture of wallpaper and Jacobin politics in France during the 1790s is remarkable. No other branch of the industry had

such a distinct political affiliation at this time. Major manufacturers of *papiers peints* like Jacquemart, Bénard, Jean-Jacques Arthur, Réne Grenard, Nicolas-Louis Robert and Nicolas Guerrin were all members of the radical Commune and directly involved in local and national politics (both reformist and radical). Indeed, Arthur and Grenard became close friends with Maximilien de Robespierre and would pay with their lives for this friendship in 1794.

4 A sample book of a travelling salesman for the manufacture of Réveillon/ Jacquemart et Bénard, dubbed 'Album Billot' shows for the period between 1789 and 1797 how much such politically symbolic designs (some 22 motifs) had also filtered down to domestic consumption. Previously kept at the Musée du Papier Peint in Rixheim (Alsace), the volumes of the Album Billot have vanished recently into the hands of an unknown private collector.

5 Recent examples with critical historiographies include W. D. Kingery (ed.) (1996), *Learning from Things: Method and Theory of Material Culture Studies*. Washington and London: Smithsonian Institution Press; and J. D. Prown (2001), *Art as Evidence: Writings on Art and Material Culture*. New Haven and London: Yale University Press.

6 C. Blanc (1897 [1882]), *Grammaire des Arts Décoratifs, Décoration Intérieure de la Maison*. Paris: Renouard/Laurens, p. 69.

7 In English in the original text.

8 K. Marx (1974 [1857–58], *Grundrisse der Kritik der Politschen Ökonomie (Rohentwurf), 1857–1858*. Berlin: Dietz, p. 13; translated by M. Nicolaus as (1973) *Grundrisse: Foundations of the Critique of Political Economy (Rough Draft)*. London: Allen Lane, p. 91 [translation modified].

9 K. Marx and F. Engels (1953 [1844–45]), *Die Deutsche Ideologie*. Berlin: Dietz, p. 24. Trans. by W. Lough in K. Marx and F. Engels (1938), *The German Ideology, Parts I & III*. London: Lawrence & Wishart, p. 16.

10 Before 1795 the French currency was divided in *denier, sol* or *sou* (12 deniers) and *livre* (20 sols).

11 *EXPOSÉ JUSTIFICATIF POUR Le sieur RÉVEILLON, Entrepreneur de la Manufacture Royale de Papiers Peints, Fauxbourg Saint-Antoine* (1789), pp. 15–17. The 'four classes' did not include the children who were listed as an auxiliary workforce only. A decade later Réveillon's successors Jacquemart and Bénard provided an almost identically structured list, indicating that once modern wallpaper manufacture had been established, it did not change essentially, even when political and economic circumstances adapted to the progressive industrialization of France at the beginning of the nineteenth century; see Archives Nationales, Paris, document F^{12} 2285, 'Tableau de l'intérieur de la Manufacture de Papier Peint seize rue de Montreuil Faubourg Antoine Ciderant Exploité par le M. Réveillon Aujourd'hui Apportenant aux Citoyens Jacquemart et Bénard de Successeurs'.

12 This is underscored by Réveillon's separate listing of artists who were paid up to 10,000 *livres* per year to provide original designs for the manufacture. See *EXPOSÉ JUSTIFICATIF POUR Le sieur RÉVEILLON*, pp. 15–17.

13 For a reference to the founding of this institution in its historical context see, for example, G. Childe (1942), 'The significance of Soviet archaeology', *Labour Monthly* 24 (11), pp. 341–43.

14 V. Tatlin (1988), 'Report of the Section for Material Culture's Research Work for 1924' (Petrograd, 11 October 1924), cited in Larissa Alekseevna Zhadova, *Tatlin* (1988), New York: Rizzoli, p. 256.

15 H. Clouzot and C. Follot (1935), in their book *Histoire du Papier Peint en France*, Paris: Moreau, plate XVI, credit the flower still life to Huet without, however, furnishing any proof for his attribution. Jacqué deemed the motif unlikely to have been designed by the painter as 'the design and its execution is very different in spirit'. B. Jacqué (ed.) (1989), *Papier Peint & Révolution.* Rixheim: Musée du Papier Peint, p. 27.

16 See M. Ozouf (1976), *La Fête Révolutionnaire 1789–1799*. Paris: Gallimard, pp. 44–74 (on the original *Fête de la Fédération*) and pp. 99–124 (on the festivities in the summer of 1793 and 1794); for a structurally and conceptually more inclusive view, see C. Mazauric (1984), *Jacobinisme et Révolution*. Paris: Messidor/Editions sociales, pp. 149–206 and 222–25; and for comments on the revolutionary documents concerning art and festivities see K. Scheinfuss (1973), *Von Brutus zu Marat: Kunst im Nationalkonvent 1789–1795*. Dresden: Verlag der Kunst, pp. 90–116. An earlier important work on the revolutionary festivities comes from A. Mathiez (1904), *Les Origines des Cultes Révolutionnaires, 1789–1792*. Paris: Bellais.

17 Originally, Louis Blanc postulated the theory of the 'two revolutions' in his *Histoire de la Révolution Française* (1847–62), 12 vols. Paris: Pagnerre/Furne, Jouvet et Cie., 1868–70 (second edition), vol.1 (1870), book 3, chs. 1–3, pp. 338–552; he picked up this notion in his chapter on 'philosophie' in vol. 6 (1864), book 7, ch. 9, pp. 310–36, esp. p. 311. Albert Soboul took up this theory in his 1981 essay 'Qu'est-ce que la Révolution', *La Pensée* 217/218, reprinted in *La Révolution Française* (1982). Paris: Terrains/Editions Sociales, p. 591; and Kurt Holzapfel, in his introduction to a historiography of the Lyon silk workers' revolts of 1831 and 1834 ascribed a similar pattern to the two revolutions there; see K. Holzapfel (ed.) (1984), *Louis Blanc/Louis Auguste Blanqui/Ludwig Börne/Jewgeni Tarlé: Die Lyoner Arbeiteraufstände 1831 und 1834*. Berlin: Dietz, pp. 33–9.

18 The use of the cylinder drum is first credited to the manufacture Leroy in 1842. See B. Jacqué (1987), *Le Papier Peint, Décor d'illusion*. Barembach: Gyss, p. 31 – in this volume Odile Nouvel-Kammerer also provides a concise overview of the technical aspects of wallpaper manufacture, pp. 27–35.

19 The wallpaper manufacturer Jean-Baptiste-Michel Papillon produced a series of illustrations that were intended for d'Alembert's and Diderot's *Encyclopédie* (1749–72). They detailed the entire process of producing *dominos* (early form of wallpaper in small sheets), and plate II shows this 'reversal' of the printing process, complemented by the use of a letterpress in one corner of the workshop. See H. Clouzot and C. Follot (1935), *Histoire du Papier Peint*. Paris: Moreau, which features reproductions of Papillon's illustrations.

20 H. Clouzot (1912), 'La Tradition du papier peint en France au XVIIe au
 XVIIIe siècle', *Gazette des Beaux-Arts* 54 (656), pp. 138–39.

21 Or rather on the right, as it is a *maquette* whose imagery was to be reversed
 by its engraving into the woodblock.

22 Jacqué, *Le Papier peint*, p. 27, has doubted whether the earlier, 'girondist'
 wallpaper of the *Fête de la Fédération Nationale* was ever produced, but the
 surviving sample in the Album Billot of 1789–90 indicates the existence of this
 first design in print.

23 Marx (1974 [1857–58]), *Grundrisse*, p. 11. Trans. p. 89.

24 Marx emphasized in a letter to Ferdinand Lassalle of 22 February 1858, that
 the *Grundrisse* are 'zugleich Darstellung des Systems und durch die
 Darstellung Kritik desselben' – how the systematic presentation of the
 bourgeois economy establishes its critique. G. Mayer (ed.) (1921), *Ferdinand
 Lasalle, Nachgelassene Briefe und Schriften, vol. III*. Stuttgart/Berlin: Deutsche
 Verlagsanstalt, p. 116.

25 Archives Nationales, Paris, F^{12} 2285, 'Requête reçue le 23 brumaire an VI
 (13th of November 1798)'. See Clouzot and Follot, *Histoire du Papier Peint en
 France*, pp. 122–24; and C. Velut (2001), *Décors de Papier: Production,
 Commercialisation et Usages de Papiers Peints à Paris, 1750–1820*, 2 vols.
 Paris: Université Paris I – Panthéon-Sorbonne, p. 715.

Further reading

Blanc, C. (1897 [1882]), *Grammaire des Arts Décoratifs, Décoration Intérieure de la
 Maison*. Paris: Renouard et Laurens.

Clouzot, H. and Follot, C. (1935), *Histoire du Papier Peint en France*. Paris: Moreau.

Jacqué, B. (2006), 'Pour une histoire des techniques de production du papier peint en
 France à la fin du XVIIIe siècle'. *Support/tracé* 6, pp. 12–22.

Lehmann, U. (2010), 'Performance matérielle: Dufour et le matérialisme', in Bernard
 Jacqué and Georgette Pastiaux-Thiriat (ed.), *Joseph Dufour: Manufacturier de
 Papier Peint*. Rennes: Presses Universitaires de Rennes, pp. 237–49.

Marx, K. (1974 [1857–58]), *Grundrisse der Kritik der Politschen Ökonomie
 (Rohentwurf), 1857–1858*. Berlin: Dietz. Trans. by M. Nicolaus as (1973)
 Grundrisse: Foundations of the Critique of Political Economy (Rough Draft).
 London: Allen Lane.

Mazauric, C. (1984), *Jacobinisme et Révolution: Autour du Bicentenaire de Quatre-
 Vingt-Neuf*. Paris: Editions sociales.

Velut, C. (2001), *Décors de Papier: Production, Commercialisation et Usages de
 Papiers Peints à Paris, 1750–1820*, 2 vols. Paris: Université Paris I – Panthéon-
 Sorbonne.

CHAPTER SIXTEEN

Time, Wear and Maintenance: The Afterlife of Things

Victoria Kelley

To the extent that the study of material culture is concerned with 'afterlife', it often concentrates on decay and destruction, or on deconstruction. If material objects are looked at beyond the phases of design, production, circulation and acquisition, they are usually considered as bearers of trace, scarred with the marks of time and use. So, for instance, in architectural critique, there is a fascination with ruins – romantic, industrial or postmodern palimpsest.[1] This paper will focus predominantly on fashion, clothing and textile examples in order to consider the issue of afterlife in material culture history. Here, too, there is a considerable body of literature on decay and dissolution, textiles and trace. Kitty Hauser has written about the way that denim jeans develop patterns of creasing and fading that become as unique as the fingerprints of their wearers.[2] And Tim Dant, in considering how material objects 'are physically formed within a culture but are also socially constructed in the ways that they are fitted into routine, everyday practices and ways of life' has also analysed wear and tear in denim jeans.[3]

Because textiles often function in intimate contact with the human body – garments, coverings, bandages, shrouds – they are exemplary 'biographical' objects, telling the story of people, events and passing time in their physical dissolution. In a museum context, textiles that tell stories become poignant relics. The clothes in which Vice-Admiral Horatio Nelson died, stained with blood, ripped by the fatal musket ball, crudely cut open by a naval surgeon, form a point of pilgrimage in the National Maritime Museum in Greenwich. Even when they do not signal heroism or martyrdom, the marks of use and time on textiles and clothing can be socially eloquent. In the late nineteenth

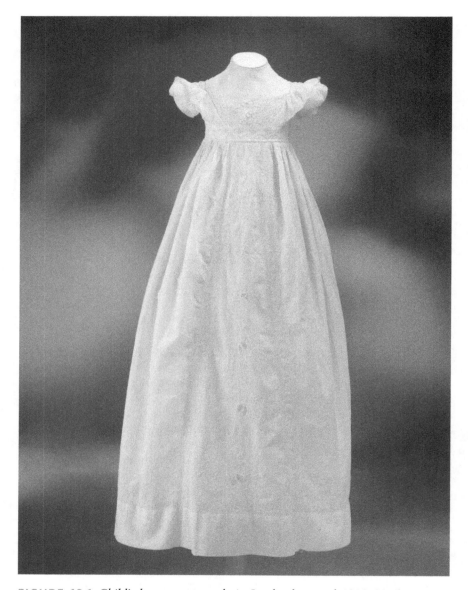

FIGURE 16.1 *Child's long gown, made in Scotland around 1820–30,* © *Victoria and Albert Museum, London.*

and early twentieth centuries social observers and journalists, preoccupied with the problem of poverty, went undercover to investigate life on the margins. The process always commenced with adopting appropriately aged and derelict garments. Jack London, setting out into the East End of London at the start of his journey to find 'the people of the abyss', describes how he purchased 'a frayed jacket with one remaining button' as his disguise.[4]

Dirt, dereliction and decay are important, one aspect of the afterlife of things to be considered in the writing of material culture history. However, we should also think about another issue – not decay and ruin, but rather maintenance, the often hidden and frequently overlooked assiduous habits of upkeep that were and are used to counter dereliction and to stave off ruin. These processes range from simple tasks of cleanliness to the surface strategies of ironing, starching and pressing, to the careful restitution techniques that make good wear and tear through darning, patching and mending. These textile practices have their equivalents in many other fields of material culture. If the afterlife of objects is in part about the ways in which time and use cause dereliction and decay, we should remember too the strenuous efforts to postpone these processes that are also part of the relationship between people and things over time.

The Victoria and Albert Museum has in its collection a child's dress from the early nineteenth century (Figure 16.1). Like many museum objects, this one looks perfect. It is certainly not obviously dirtied or stained or frayed. Unlike a relic such as Nelson's uniform, this object does not carry visible traces of time or history. However, close inspection reveals that it has been carefully mended around the waistband, and a layer of embroidery has been added that hides the mend, yet reveals a complex afterlife. This was and is a valued garment in which the time and skill of maintenance have been invested, both by unknown historical figures, and by museum conservators who continue the tradition of upkeep of 'old things'.

Here are old things:
Fraying edges,
Ravelling threads;
And here are scraps of new goods,
Needles and thread,
An expectant thimble,
A pair of silver-toothed scissors.

Thimble on a finger,
New thread through an eye;
Needle, do not linger,
Hurry as you ply.
If you ever would be through
Hurry, scurry, fly!

Here are patches,
Felled edges,
Darned threads,
Strengthening old utility,
Pending the coming of the new.

Yes, I have been mending . . .
But also,
I have been enacting
A little travesty on life.

Hazel Hall's poem 'Mending' was published in 1921.[5] Hall was a seamstress
living in Portland, Oregon who made her living by her needle and published
several well-received collections of poetry before her early death in 1924.[6]
As well as expressing the intense subjectivity of an individual literary voice,
Hall's poem is an autobiographical record of her trade as a professional
maker, mender and maintainer of clothing and textiles. Her words capture
several important themes. There are the textiles themselves, old, soft, worn,
'fraying' and 'ravelling'. Yet Hall moves on quickly to describe the 'new
things' that will mend these old clothes. Her tools – needles, scissors and
thimble – are anthropomorphized as 'expectant' and 'silver-toothed', eager
and active, suggesting the skill and satisfaction of mending, 'strengthening
old utility' and keeping valued objects in good repair.

The second verse captures the speed and insistence of Hall's work ('do
not linger'; 'hurry, scurry, fly'). Mending and maintaining clothing has
traditionally been a routine task, one of the many that fill everyday life. Hall
did it for a living, but for many people (mostly women), it has been among
the many activities that comprised unwaged labour in the home, part of the
domestic round, and often performed under considerable time pressure.
Although it has its satisfactions, mending is not a task that has any heroic or
final outcome, as Hall suggests in the line 'if you ever would be through',
which hints at the possibility that the task will never be completed. Like
cleaning, laundry and other tasks of maintenance, mending is cyclical, it is
an ongoing project that, once done, must simply be done again. The poem's
ultimate effect turns on the final lines: 'I have been enacting/ a little travesty
on life'. Enacting suggests performance, a gendered role, and 'travesty'
signals the way in which everyday routines like mending could become,
especially for women, a block to subjectivity and selfhood, a poor substitute
for personal ambition in the public world. This effect was amplified for Hall
by the fact that she was wheelchair-bound and unable to escape from the
upstairs room in which she worked.

Hall's poem captures the complexity and contradiction of historical tasks
of maintenance. As analysis of traditional domestic routines and housework
has shown, the carrying out of such labour was cyclical, routinized, often
invisible and frequently frustrating. Yet it could also be a means by which
social status was achieved and maintained, family relationships articulated,
even love demonstrated (it is tempting to speculate that the V&A's dress was
mended and altered with love, although there is no evidence to support this
contention, and a whole range of other motivations may have been involved).
I have explored elsewhere the complex meanings of the work of cleanliness,
and how the demands of maintaining clothes and homes could manifest

ideas of both *anxiety* and *delight*, in particular places and periods.[7] In the remainder of this paper I will concentrate firstly on ways to consider some of the symbolic meanings and historically specific values associated with maintenance in the afterlife of objects, and secondly on the categories of source material that may be useful in writing the history of this particular aspect of material culture.

Why do we maintain clothes? As Joanne Entwistle has pointed out, fashion is an embodied practice, with clothing as an extension and external representation of the self.[8] Therefore maintaining clothing is about bodily maintenance and bodily control. Michel Foucault, discussing the wearing of uniform, posits military routines of cleanliness and self-presentation as a disciplining device.[9] Such activities are not just a representation of or metaphor for discipline, but are also, in Foucault's view, instrumental in fostering it. Foucault's analysis concerns how the power of modern state institutions is exercised through normalizing disciplinary practices, leaving little room (at least in his earlier work) for the agency of the individual. Anthropologist Mary Douglas, on the other hand, analyses cleanliness and the rituals around it (we can extend her interpretation to the wider tasks of maintenance) not as a means of external control, but as socially useful ways of ordering and classifying the world, suggesting considerable scope for individual agency and creativity in such tasks.[10] We might posit Foucault and Douglas at opposite ends of a scale of interpretation, with the work of many anthropologists, sociologists and historians in between, all offering some insight into the motivations behind the work of maintenance. Sociologist Tim Dant has examined the on-going interactions involved in the 'cultural appropriation of material things',[11] and, from the same discipline, Elizabeth Shove has explored the particular routines intrinsic in modern practices of cleanliness.[12]

Yet such approaches only go so far in interpreting historical material and specific instances. As early as 1989 design historian Judy Attfield, in her study of British new-town housewives in the 1950s, showed how for many of her female subjects the more expressive results of cleanliness, including highly polished furniture, could be indicative of pride and identity, a socially and temporally precise linkage between material qualities and immaterial values.[13] The practices of maintenance are not isolated, but shaped by many historical currents. So, for instance, in the late nineteenth century new scientific understanding of the causes of disease brought the idea of the germ into everyday discourse, adding new urgency to domestic hygiene. And sometime in the latter years of the twentieth century the social meanings of worn and frayed clothing changed, so that instead of signalling destitution and abjection (like Jack London's jacket) tattered garments became instead a symbol of informality, associated with street and youth fashion (as in worn jeans) or the deconstructive strategies of avant-garde designers (Rei Kawakubo, Martin Margiela and others). This change was consequent on affluence and the ready supply of cheap mass-produced clothing – it is only

in a society in which nobody needs to be ragged that raggedness can be detached from shame, and used instead as an aesthetic strategy.

How can we write the material culture history of the afterlife of objects, and specifically, the afterlife implicated in maintenance? Because it is everyday, routine and repetitive, maintenance often lies beneath the historical radar. Like many cyclical practices, it is invisible in narratives that stress exceptional events, change and progress. More open modes of history writing in recent decades have done much to reclaim 'history from below', yet maintenance is still perhaps neglected. Concentrating on material culture is one way we can redress this neglect. Some strands within material culture (as distinct from material culture *history*) have paid quite a lot of attention to maintenance, upkeep and the habits and routines of everyday life. But what is the difference between writing about these things in the present, and in the past? In the present, subjects are available to question and observe, however, as Frank Trentmann has noted, 'historians do not have the privilege of retroactive ethnography'.[14] What, then, are our sources for writing about the history of the routine and overlooked habits of maintenance? Firstly, there are objects: the V&A dress is as eloquent as any written source, evidencing the care, time and skill devoted to the maintenance of valued objects. Advice literature – prescriptive writings on many aspects of everyday life – also frequently give an insight into the regimes of maintenance, the expected normative standards of a given place or time. The extent to which such didactic norms are complied with in reality is something that advice literature cannot reveal, but here biographical or autobiographical accounts can suggest the space between ideal and reality. Memoirs of working-class subjects, and particularly of women and children (as listed in Burnett, Vincent and Mayall's *The Autobiography of the Working Class*).[15] often capture the rhythms of daily life more completely than those of known historical figures with heroic events to describe. Hazel Hall's poem can be read as a type of autobiography, and it captures the contradictions and emotional entanglements of the processes of upkeep, as well as the values associated with it. Objects have many afterlives, complex histories that impact upon their physical state beyond the point of production and acquisition. They are subjected to use, to wear and tear, to dissolution, decay and deconstruction, but these processes are met with resistance in the form of reuse, repair and the routines of maintenance.

Notes

1 T. Edensor (2005), *Industrial Ruins: Space, Aesthetics and Materiality*. Oxford: Berg; A. Huyssen (2003), *Present Pasts: Urban Palimpsests and the Politics of Memory*. Stanford: Stanford University Press.

2 K. Hauser (2005), 'The fingerprint of the second skin', in C. Breward and C. Evans (eds), *Fashion and Modernity*. Oxford: Berg.

3 T. Dant (2005), *Materiality and Society*. Buckingham: Open University Press.

4 J. London (1903), *The People of the Abyss*. London: Isbister, pp. 9–11.

5 H. Hall (1921), *Curtains*. New York: John Lane, p. 76.

6 J. Witte (2000), 'Introduction', in H. Hall, *The Collected Poems of Hazel Hall*. Corvallis: Oregon State University Press.

7 V. Kelley (2010), *Soap and Water: Cleanliness, Dirt and the Working Classes in Victorian and Edwardian Britain*. London: I.B. Tauris; V. Kelley (2015), 'Housekeeping: surface strategies in the domestic interior, c.1870–1914', in D. McMahon and J. Myers (eds), *The Objects and Textures of Everyday Life in Imperial Britain*. Aldershot: Ashgate.

8 J. Entwistle (2000), *The Fashioned Body: Fashion, Dress and Modern Social Theory*. Cambridge: Polity, p. 4.

9 M. Foucault (1991 [1975]), *Discipline and Punish: The Birth of the Prison*. London: Penguin, pp. 135–56.

10 M. Douglas (1991 [1966]), *Purity and Danger: An Analysis of the Concepts of Purity and Taboo*. London: Routledge.

11 Dant, *Materiality and Society*, p. 14.

12 E. Shove (2003), *Comfort, Cleanliness and Convenience: the Social Organisation of Reality*. Oxford: Berg.

13 J. Attfield (1988), 'Inside pram town: a case study of Harlow house interiors, 1951–1961,' in J. Attfield and P. Kirkham (eds), *A View from the Interior: Women, Feminism and Design*. London: The Women's Press.

14 F. Trentmann (2009), 'Materiality in the future of history: things, practices, and politics', *Journal of British Studies* 28 (2), p. 290.

15 J. Burnett, D. Vincent and D. Mayall (1984), *The Autobiography of the Working Class: An Annotated Critical Bibliography, vol. 1: 1790–1900*. Brighton: Harvester Press.

How Things Shape Us:
Material Culture and Identity in the Industrial Age

Manuel Charpy

From cufflinks and corsets with electric alarms, to collectibles and gifts, since the nineteenth century the world of goods has become a playing field for developing social identities. Reflecting on how material culture changes individual and social identities encourages us to appreciate the connection between objects and everyday life. In particular, it is the ordinary, the quotidian object that needs to be considered.[1] This type of object reveals the gestures, the sensibilities, the relationships with the self and with others – in other words, the anthropological structures of society. From this point of view, objects are not mere witnesses of social and anthropological phenomena or arbitrary social indicators, they are instruments and tools through which individuals and groups define themselves on a daily basis.[2] Unlike Michel Foucault who saw objects as micro-devices of power imposed from higher orders, I consider how groups and individuals use objects to model their lives and define their social identities.

This chapter focuses on nineteenth-century urban societies and aims to understand how the bourgeoisie of the new industrial age appropriated the material world to construct a new identity for itself. More than objects of public consumption such as transport and communication networks or machines, office devices, etc., it is personal objects such as clothes or furniture that allow us to understand the processes at work. These were objects that redefined the relationship between people, space and time. They created communal identities within social and family groups who often shared

similar behaviours through objects. They were tools that imposed identity but were at the same time used to resist homologation.

Objects and the structures of daily life

The history of technology has only recently abandoned the epic story of great inventions and has fostered new links with the history of material culture. Such a convergence between technology and material culture is to be found in the way in which technologies – even relatively modest ones – constantly are seen as key to changing social practices and our daily lives.[3] A history of the ways in which objects shape our lives is in the first instance a history of the temporal framework that is inherent to everyday life.[4] In this regard, the nineteenth century was quite a turning point: a series of novel objects contributed to the creation of a new relationship with time. Clocks and pocket watches were emblematic of this mutation: between the very end of the eighteenth century and the 1830s, people learnt to think about time in an abstract way. In public spaces, the middle and later popular classes learnt to refer abstractly to time through the use of pocket watches. Transport timetables were devised to the minute. Cheaper costs of production and better internal mechanisms meant that mantelpiece clocks appeared in most domestic interiors, especially in urban dwellings.[5] And this relationship with time was further honed with the discovery of the second.[6] The perception of day and night – which led to a proliferation of patents of invention for tactile or lighting systems to read time at night – was built on abstract time appended to every moment of everyday life. Concepts of sleep management, appointments as part of work time, and leisure time for hobbies also appeared.

From the very beginning of the nineteenth century, the vibrant sensation of accelerating social change sprang from this new relationship with time. It was accompanied by the delaying of night-time and by the reorganizing of the rhythms of everyday life through technical objects. From the 1840s onwards oil and gas lamp lighting made the night retreat in urban spaces and from the 1880s electricity expanded this trend.[7] This 'subjugated night' of Western cities became a time for evening strolls, entertainment, shopping and commerce.

Although often neglected, changes in the private space were just as profound. First the oil or petrol Carcel lamp spread throughout the Western world because its spring-based system allowed for the flame to no longer flicker. It became possible to read and write into the night. Soon afterwards battery-powered electric lights (well before the advent of electricity) changed the night. Between 1850 and 1890, a myriad of hybrid technical objects allowed for instant lighting. Two such devices, available at the same time in New York, London and Paris were remotely controlled lighters that used a light switch to spark a petrol lamp to life, and a portable battery-run electric Carcel lamp that lit up as soon as it was picked up. These devices changed

the intimacy of night-time, and with it, undoubtedly, the relationship with sexuality, dreams and nightmares.

New technologies as applied to artefacts changed not just time but also space. They produced an increase in mechanical speed – particularly through steamboats and trains – that shrunk physical space and changed the perception of distance as in the case of the near-instantaneous speed of communication of the telegraph in the 1850s.[8] This was the case not just for larger equipment but also for the devices that formed part of private life like the fastening systems developed in the first half of the nineteenth century.[9] The locksmiths Fichet in Paris and Chubb in London developed 'unpickable' locks and alarm systems with music boxes, detonations and bells. With these safety systems came a new sense of space that pushed the street further away. In the 1860s, another important development was the invention of a battery-based electric intercom system, making it possible to remotely open and close doors in bourgeois buildings using switches and acoustic tubes (Figure 17.1). These redefined the relationship between space and social interaction. Thus an entire series of technical objects changed the way in which everyday life was lived.[10]

Mechanical orthopaedics and daily discipline

Technological objects were not alone in transforming everyday life. Sometimes simple objects changed the body and established gestures and behaviours. They changed the ways in which people stood, how they moved and encouraged new repetitive orthopaedics. The idea that things shaped people and their bodies was not new in the nineteenth century. Walking and posture were not considered natural in the least but were seen as shaped in large part by clothes and accessories.[11] Mechanist conceptions of the body held that objects fixed behaviour. The clothing reform across the industrialized world at the end of the eighteenth century was accompanied by a mutation of gestures and postures (Figures 17.2a and b).

The development of folding hats, umbrellas, suspenders with springs were all means of fixing gestures. As Veblen noted, for the high society of the nineteenth century clothes had to be impracticable and had to proclaim idleness and intellectual work.[12] All clothes aimed at marking distinction – for example, men's top hats required an arrogant posture of the head. Similarly, crinoline determined the manner in which one sat and moved about. The success of the corset throughout the nineteenth century indicates this orthopaedic need. It imposed gestures and also inhibited a person from bending down or undressing alone. It is not surprising at all that corset-makers in London, New York and Paris were also medical orthopaedic instrument makers who produced girdles, waist belts and posture braces.[13] The rejection of practical clothes, such as rubber garments, was based on the obvious but absurd point that they were simply not inhibiting enough.[14]

Fig. 65. — Maison éclairée au moyen de l'allumeur-extincteur Radiguet.

FIGURE 17.1 *Electrified building with Radiguet switches ('allumeur-extincteur'), Paris, 1880s. Engraving from Philibert Delahaye,* L'Éclairage dans la ville et dans la maison, *Paris: Masson, 1888. Author's collection.*

(a)

(b)

FIGURE 17.2 (a) 'Le Khiva', corset-bras, Paris, c. 1870. (b) Orthopaedic braces for men, 'Orthomorphes', with patent, Paris, 1907. Author's collection.

The advent of ready-to-wear clothing for men around 1850 corresponds to new body postures. Fixed sizes – based on fixed measures from the statistical findings on average sizes of conscripts – were derived from the uniforms of military personnel and office employees.[15] From then on, clothes did not fit the body but the body had to adjust more or less painfully to the clothes.[16]

This manner of shaping behaviour through objects extended to furniture. The new bourgeoisie required its furniture to be an integral part of its lifestyle. The philosopher Emile Alain, a man of his times, noted that 'furniture of attractive style [. . .], even more so than clothes, regulates attitudes, and therefore thought and passions'. He concluded that 'society needs to be supported by furniture, as women by their corsets'.[17] In fact, every piece of furniture fixed society's gestures. Heavy armchairs and chairs inhibited slouching; other pieces of furniture such as meridiennes or rocking chairs catered instead specifically to those needs.[18] There was also a proliferation of gesture-fixing furniture such as footrests, love seats, etc. New professions invented by machines both in factories and offices also prompted a fresh scrutiny in the importance of gestures based on the belief that habit could shape bodies.[19] It is in this way that one must interpret the desire of the bourgeoisie to use the furniture of past centuries as a way to absorb the noble manners of a previous age.[20] Similarly, the modern movement conformed to the same logic, this time embracing the present by adopting furniture inspired from office and school spaces.

Objects also imposed a daily discipline through their surfaces. The history of material culture does not often consider surfaces, and yet surfaces are the interface between the objects and consumers.[21] Far from being inert in everyday life, surfaces materially expressed the licit and illicit activities of their users.[22] In the age of photography and patinas – which were simply surfaces that recorded people's actions – surfaces became the way through which people were controlled and through which people controlled themselves. Whether in the form of painted, polished or glass-fitted furniture, waxed floors, or pile fabrics, the disorder of gestures left its mark on surfaces.[23]

Control was materially negotiated. Creases, for instance, were decisive in body discipline. In the bourgeois closet, creases – ruffled or puckered – were not the fruit of repeated wear but were decided in advance. It was understood that a body that had mastered its gestures and practised self-control did not create creases. The same could be said of cleanliness. White was established as the colour of cleanliness (for instance for underwear) because it could be maintained by simple bleaching but also because it got dirty easily.[24] The smallest marks were the visible proof of suspect morality. Outward appearance was as important – collars and cuffs exhibited personal hygiene to the outside world – which explains the failure of disposable paper and waterproof celluloid collars and cuffs to garner support among the upper classes. Contrary to what one might think, the fragility of materials and the complexity of their upkeep were the reasons for their success.

The order of things

The order of all objects had three dimensions: an aesthetic one (layout); a social one (distinction); and an orthopaedic one. There was nothing natural about it – organizing and arranging objects in an apartment or in an international exhibition was a re-enactment of cultural and social order.[25] And this explains why by the mid-nineteenth century catalogues – themselves a tool for arranging things – were full of storage furniture such as cupboards, chests, sideboards, china cabinets, bookshelves, umbrella-stands, hat-stands and coat-stands.[26] A profusion of boxes contained the hundreds of pieces of cutlery sets, and other boxes with neatly named tags contained 'gloves', 'fans', and even 'money' and 'souvenirs': everyday life was based on a taxonomic order.

This system of orderliness extended to entire houses and apartments as the placement of objects created boundaries between spaces – between intimate and social, between masculine and feminine and between upstairs and downstairs. Furnishing books and decoration magazines developed principles and models to organize the interiors for their bourgeois readers, and decorators promoted apartment design that showed furniture carefully and tastefully arranged. Everything had to be in order. For example, handbooks spent several pages on the best way of making a bed. Order was proof of a family's self-control.

From the 1870s, however, manuals started to underline the need for order to appear 'natural'. The capacity to create a tasteful disorder became in turn distinctive. While disorderliness was suspect, too much petit bourgeois order was also frowned upon. Controlled disorder was to mimic life – chairs were to be slightly out of place, and some newspapers, photos and music sheets could lie about on tables and side tables (Figure 17.3).[27] Large quantities of industrially produced fake still-life objects in rubber, wax and pasteboard lent an air of lived but immobile disorderliness on tables. This controlled disorder was evidence of self-control, and simultaneously proof of a personal touch.

This culture of control was also imparted to future generations. Mini-kitchen sets comprising over fifty items were used to teach little girls the names of all cooking tools and to maintain them in order. Doll's houses, popular even in bourgeois households, were used for girls to learn the meaning of order and how to take care of a home.

The modern man did not abandon this order of things even when he stepped out of his house. Each object had its place, right down to his clothes. While commoners' clothes had large pockets deformed by the carrying of all sorts of objects, bourgeois men's clothing had a multitude of compartments and special pockets for objects carried on one's person. By adopting vests and redingotes with numerous drawer-like pockets, the bourgeois man travelled with a complete luggage-set that maintained his belongings in order in the four corners of the world (Figure 17.4).

L'ART DE SOIGNER LES ŒUVRES D'ART 135

Photo E. Couronneau. — Coll. E.-B.

FIG. 22. — Coin d'un atelier d'artiste.

FIGURE 17.3 *A corner of a studio as model of 'elegant disorder'. Photograph from Émile Bayard,* L'art de soigner les œuvres, *Paris, 1928 [written before 1918]. Author's collection.*

FIGURE 17.4 *Travel trousseau, 'travel goods' in catalogue of department store Les Trois Quartiers, Paris, 1890s. Author's collection.*

Objects and self-fashioning

The multiplication of personal objects allowed for the affirmation of the individual and acted as ways to acquire consciousness of the self.[28] This is visible in the proliferation of writing desks starting from the end of the eighteenth century. They were an invitation to write correspondence and manage one's finances, but also to write about oneself.[29] The many locks on desks, boxes, albums and personal diaries are proof of the desire for and an instigation to secrecy. From the 1830s women's desks included mirrors that prompted self-observation (Figure 17.5). Dressing gowns for both men and women allowed them to sit down and examine themselves. In a century when the practice of writing autobiographies and keeping personal diaries filtered down the social classes, it was this accumulation of new tools that encouraged a new objectification of the self.[30]

This encouragement to observe the self was also manifested in the collection of objects of social ritual. Bouquets, photographs, ribbons and other wedding objects, for instance, came to be displayed in 'wedding glass-cases', transparent spaces that staged personal memorabilia in one's apartment and where private, family and collective memories intermingled. In this world

FIGURE 17.5 *Secretaire with mirror and table for fancy works with mirror, from* Le Garde-Meuble, ancien et moderne, *albums of chromolithographs published by Désiré Guilmard, c. 1855–60. Author's collection.*

of objects dedicated to the construction of a new perception of the self, imprints and images of oneself had a special place. The nineteenth century incessantly promoted the culture of material imprints and simultaneously developed techniques to record the body. This was the case of the immensely popular hair work – jewellery and artwork made with hair – created in the early nineteenth century using one's hair or that belonging to a beloved, dead or alive (Figure 17.6).

The demand for material souvenirs of oneself and loved ones led to the development of portrait machines: at the dawn of the nineteenth century the mechanical physionotrace, and from the 1860s onwards photography.[31] Their immediate success was due to the fact that they allowed personal images to be reproduced in multiples. These new portraits were also

FIGURE 17.6 'A. M. Souvenirs', picture made with hair on ivory, Champclaux, Clermont-Ferrand, 1840s. Author's collection.

accompanied by a renewed attention to presentation. Thick frames in wood, metal or marble, clip frames, leather-bound albums with bronze clasps, glass paperweights, etc., were some of the many ways in which these such personal images were displayed and transformed into memorabilia. Face moulds of living or dead persons were also successful as they could be produced in multiples out of heavy and sometimes expensive materials. This desire to give a material form to remembrance explains the long-lasting success of the painted miniature portrait and of the Daguerreotype – a unique image on metal. Remembrance portraits were portable and by the second half of the century they were miniaturized as portraits on pendants, on cufflinks and as charms.[32]

These images were not just representations, but were also real tools. The frequent visits to the photographer from a very young age led individuals to an intimate experience of self-discovery. Photography was like a second mirror, and even more so as it was a learning tool – posing in a studio with the photographer's help and with celebrity portraits as models, was instrumental in the development of a new body language (Figure 17.7). These collections of traces of oneself and of the loved ones took on a new dimension at the end of the century with amateur cameras and photographs. These memories also created a new relationship with one's own past: faces of ancestors whom one had never met now became familiar.

Collecting objects was an ideal activity of self-fashioning.[33] This was the case for wealthy collectors of ancient art and for the rich travellers who surrounded themselves with artefacts that served as both memorabilia and documentation of their past exploits. But in the nineteenth century, collections spread to the petite bourgeoisie and by mid-century even the smallest material evidence of the past could become a collectible item. Showcases, invented in the 1830s, permitted an orderly arrangement of the world as if it were an album. Collecting objects implied using one's knowledge but also reorganizing the world around oneself. While this order mimicked a scientific one, by the second half of the nineteenth century it had become an affirmation of taste and the expression of one's personal order.

This was all the more evident with knick-knack collections of industrially produced, shop-bought ceramic cats and local dolls that had no monetary worth but were given value through individual meaning.[34] These collections were material autobiographies to be seen as forms of possessive individualism. Private spaces were invaded by a whole gamut of objects that acted as material devices to collect and rearrange traces of oneself.[35] Glass played a central role as glass supports, globes and showcases, all contributed to protecting and magnifying the mementos and autobiographical objects that they held. Glass brought the past into the present. This was a past that was kept at a distance but was constantly reorganized through memorabilia, memories and the world that surrounded a person.

FIGURE 17.7 *Photographs for the album '500 célébrités contemporaines', department store Félix Potin, c. 1900. Author's collection.*

Give substance/body to social identities

Since the turn of the century, sociologists have regarded processes like imitation and distinction through material culture as important means for groups to distinguish themselves from others.[36] What could convey more distinction than the ability to appreciate the finish or distressed state of an antique? What could convey more distinction than impeccable table manners? The study of material culture, however, allows us also to consider

how objects create social groups. Instead of creating distinction, collectively chosen objects also help forge the forms, practices and the shared identities of members of a social group.

Clothes are emblematic for the creation of collective identities.[37] The bourgeois wardrobe, as we saw, marked its difference through price, form and material, and even more so by the gestures it allowed and prohibited. This was equally true of bohemians, labourers and marginal groups. Bohemians displayed their aloofness from the bourgeois wardrobe through their unkempt hair and whimsical baggy clothing.[38] Beyond this anti-bourgeois stance, roomy clothes also permitted sweeping and theatrical gestures, and the near-absence of layers of clothing facilitated a physical sensitivity to the world. The same goes for the working classes. While they wore their Sunday best for photographs and special outings, after work they were most likely to be seen in clean, good quality blue overalls. Sale records of second-hand clothing adverts show that labourers refused to buy a redingote even when it was cheaper than overalls, because they could demonstrate one's belonging to a group by adopting the shared silhouette produced by wearing overalls.[39] Even though they worked without shirts, neckerchiefs and caps facilitated free movement while marking an identity built around work.

From clothes to furniture, the objects shared by a group served not just as signs, but also as communal identity. The exchange of objects, especially non-commercial exchanges, also helped to create a sense of belonging. Exchanging gifts was seen as essential to building social ties and creating shared identities. One might consider, for instance, all rituals that involve the exchange of gifts: weddings with wedding lists, birthdays, religious ceremonies, or Christmas and New Year gifts that in this period became true commercial events.[40] Family archives often preserve carefully drawn-up lists of gifts received. The business of gift-giving was intended to cement ties. Objects were rarely arbitrary; in families, for example, parents gifted old lace that symbolized the feminine culture of textiles.[41] Within families it was common to exchange works of art, sets of tableware or even antiques, all transmitting a collective heritage. Young girls were encouraged to exchange gifts that had been made with love – painted objects, dried flowers, etc. – to be kept as souvenirs or keepsakes. The object served to render tangible the history of a relationship. In an age of merchandizing, these non-commercial exchanges were proof of a desire to share a sensibility and build a common memory.

The exchange of portraits also appeared as a means to bolster social and family relations. This was obvious in families where copies of engraved physionotraces, moulded busts and paper photographs were widely shared. In this way, every nuclear family could possess a picture of the entire family. Pictures and photo albums were also a means to make social relations concrete. Since the very beginning of the century, it became commonplace to distribute one's portraits.[42] This preoccupation with creating social relations

led to the adoption of the photo-visiting card in the mid-1850s. Cheap portraits on Bristol paper were exchanged freely; at home, an album was a measure of one's social reach.[43]

Collections were another example of these non-commercial exchanges in the second half of the century. Collecting meant exchanging, either via the post or in person, and inventing and reifying new social relations through the objects. This led to the widespread success of collections of apparently insignificant objects.

This belief that objects could constitute social and family relations found its apex in wills and testaments. Throughout the century, and across all social strata, objects occupied an increasingly important place. 'Ethical wills' were replaced by 'material wills' that became longer in order to list objects and recount their stories when they were bequeathed to friends and family.[44] An ordinary coffeepot could be bestowed with guidance and stories as easily as valuable antiques. Portraits and busts, keepsakes and toys were also handed down. These practices demonstrated a concern for posterity, but also the trust in the ability of these objects to pass on family culture and devotion.

Ascendancy and the empire of objects

Groups and individuals use objects to establish normative practices and to build identity. But the world of goods also serves as a stage for power struggles in the private sphere as much as at the realm of politics. In places of authority such as prisons, barracks and schools, this material relation of power defines groups and individuals.

One might consider, for example, the bourgeois world of objects and the exertion of power over its domestic staff. The imposition of professional uniforms on servants meant that bodies were obscured by the paraphernalia of occupational function. White collars, bonnets and aprons allowed visual control over the hygiene and behaviours of servants. This assertion of control manifested itself not just in the use of speaking tubes, semaphores and bells (electric after 1860), but also in the daily management of specific objects and surfaces. The inspection of stains was a major concern for all servants. In the age of ruolz (a silver-plated metal), electrotyping and aluminium, silver cutlery and utensils remained the norm. Silverware oxidized without even being used, and every week the servants had to polish it; in a well-kept house, the objects demanded the constant care of the domestic staff.

Fragile and easily stained surfaces demanded permanent care. The need to polish silver, clean and iron clothes, and polish furniture on a daily, weekly or seasonal basis demonstrates the power objects exerted over both domestic staff and the mistresses of the houses. It created a world of unending toil. The fear of spare time – and the perversions that a lack of meaningful

activity could encourage – led to the emergence of bourgeois activities whose chief purpose was to occupy time: needlework, embroidering tablecloths, decorating knick-knacks, and so on.[45]

This concern with order and discipline was also visible in clothing. Besides the rubber chastity belts for young girls, women wore orthopaedic corsets and were expected to change their dress numerous times a day. This served as a means of limiting movement from one space to another and especially from the private to the public sphere. Even among the working classes, free movement was the prerogative of prostitutes. In contrast, the eroticism imposed on prostitutes by men was a reversal of this norm.[46] Unsurprisingly, one of the first issues raised by the feminist movement related to the wearing of items of (functional) clothing.[47]

I argue that the care that clothing and furniture entailed should be seen as a means through which the power of the mistress of the house was asserted over the domestic space and the domestic staff. Yet, the boundaries of power were not just internal to households. Power was also taking material shape through the action of the state. For example, in Paris, women were prohibited from wearing trousers without a dispensation from the Préfecture de Police, and cap-wearers were forbidden from entering museums. These prohibitions defined personal and collective identities. Yet the action of the Western bourgeois state stopped at the entrance of the private domestic space even though social studies show that the state remained concerned with the material life of the popular classes.

An even more important arena in which power was played through material relations in the course of the nineteenth century was the international and colonial exchanges that shaped identities and practices through objects (Figure 17.8). The political and economic dominance of Western states over the rest of the world was particularly evident in Western interiors. From the 1830s onwards, interiors were decked in exotic objects: primitive objects from Oceania and Africa; antiques from Asia and pre-Colombian America; rustic objects from rural Kent, Long Island, or Normandy. These objects demonstrated dominance through their commodification and decontextualization as, in entering bourgeois interiors, they totally lost their connection to the past of their own communities.

This power over things and via things emerged also directly within the colonial context. Clothes played a key part in this, because they controlled the appearance of colonized populations. Clothes also gave form to bodies that conformed to specific ideas of work, organization, appropriateness, and even eroticism.[48] Needless to say, the material resistance of colonized populations served to prove the importance of objects in colonial relations. In India, for instance, resistance to British rule during the Swadeshi movement came in the form of a boycott of British goods, and by burning European western suits in spectacular bonfires in the streets.[49] The rejection of the colonial system was manifest not only in the destruction of objects, but in their subversion. For example, in Congolese cities, the rejection of

恒寶綿

FIGURE 17.8 *French settler in Cochinchina. Picture engraved on mother-of-pearl from photograph with a frame in curved wood, Chinese handicraft, c. 1890. Author's collection.*

colonization mirrored the ways in which young people dressed in top hats and layer upon layer of redingotes, donning elegant, polished shoes, pretending to be zealous, model students whilst effectively showing their refusal to work in the service of the colonizers. In 1835, the Mullicks, an Indian family, created the first museum of European goods and *objets d'art* in Calcutta; it was a means of political contestation but also a way of consolidating social status.[50]

Objects were subject to resistance because, besides their economic significance, they raised questions of identity. In Japan, for instance, the adoption of Western clothing by the social elite in the nineteenth century was a way of belonging to the Western world but also of preserving and consolidating hierarchies and power within society. This appropriation can be even more complex as was the case in nineteenth-century China. Here watches were prized not for telling time but as jewellery for the higher ranks; rubber shoes became a sign of urbanity whereas in the West they were symbols of the rural world; and Western mirrors were used to frighten away bad spirits from the front door rather than look at oneself.[51]

Much remains to be done in exploring the collections and movements of exotic objects by non-European collectors in the colonial space, as is the case for the influence of imported goods on Western identities. The domination of Europe on the rest of the world did not exempt the West from the influence of imported objects. A case in point was the import and adoption of the divan and slippers or the kimono and face powder combinations – the gestures and postures that they created were adopted because of the objects themselves. This was not just a fashionable aesthetic; to be able to lounge on a sofa or a divan or be able to spend time indoors in a kimono allowed a new relationship with the self – one of repose and of eroticism. In other words, all importations were an appropriation and a reinvention that gave rise to new gestures and new visions.

Conclusion

I have argued here that ordinary practices can be examined to understand how objects create bodies, gestures, memories, perceptions of the self and cohesive social identities. Public spaces – and the city in particular – also need to be analysed in this perspective. One might ask, for example, how the appearance of pavements in the 1830s changed the ways in which one moved around the city; or how machines in the workplace changed human gestures, the organization of space, and impacted on time, noise and pain. In the same way, all the forms of resistance to the norms imposed by objects remain a vast field of study: from the aristocratic refusal to use the telephone and photography, to working-class resistance to machines, all social groups tinker and negotiate with the material world.[52]

The nineteenth century was certainly a turning point that shaped many social practices of the twentieth century. Much remains to be explored on the production of identity for different social groups through the mobilization, appropriation and rejection of material objects. A study of these objects and their effects on individuals and groups leads to the core questions of identity in the modern era. In the end, what this essay has sought to demonstrate is that social groups attempt to reify their social and personal identities through material culture. In return, anthropological analysis of these material cultures allows the historian to deconstruct these categories, or rather, to reconstruct their implication in the material world.

Notes

1 M. De Certeau (1980), *L'invention du Quotidien*, Vol. 1. *Arts de faire*. Paris: Gallimard.

2 See in particular on working-class identity: P. Hudson (1992), *The Industrial Revolution*. London: Arnold and on bourgeoisie identity: M. Charpy (2010), 'Le théâtre des objets. Espaces privés, culture matérielle et identité bourgeoise. Paris, 1830–1914', Unpublished PhD thesis, Université François-Rabelais de Tours.

3 D. Edgerton (2006), *Shock of The Old: Technology and Global History since 1900*. London: Profile Books; and F. Jarrige and M. Charpy (2012), 'La technique au quotidien', *Revue d'histoire du XIXe siècle* 45 (2), pp. 7–32.

4 A. Corbin (1991), *Le Temps, le Désir et l'horreur. Essais sur le XIXe Siècle*. Paris: Aubier; and K. Pomian (1984), *L'ordre du Temps*. Paris: Gallimard.

5 M.-A. Dequidt (2010), 'Temps et société: les horlogers parisiens (1750–1850)', Unpublished PhD dissertation, Université Paris Est.

6 On photography, see A. Gunthert (1999), 'La conquête de l'instantané. archéologie de l'imaginaire photographique en France, 1841–1895', Unpublished PhD thesis, EHESS; and on musical time: A. Barbuscia (2012), 'La pratique musicale, entre l'art et la mécanique. Les effets du métronome sur le champ musical au XIXe siècle', *Revue d'Histoire du XIXe siècle* 45 (2), pp. 53–68.

7 S. Delattre (2000), *Les Douze Heures Noires: la Nuit à Paris au XIXe Siècle*. Paris: Albin Michel; and W. Schivelbusch (1986), *The Railway Journey: The Industrialization and Perception of Time and Space in the Nineteenth Century*. Berkeley: University of California Press.

8 C. Studeny (1995), *L'invention de la Vitesse. France, XVIIIe–XXe Siècle*. Paris: Gallimard; Schivelbusch, *The Railway Journey*.

9 B. Latour (1993), *La Clé de Berlin et autres Leçons d'un Amateur de Sciences*. Paris: Éditions de La Découverte.

10 J. Crary (1990), *Techniques of the Observer: On Vision and Modernity in the Nineteenth Century*. Cambridge, MA: MIT Press.

11 Honoré de Balzac (1833), 'Théorie de la demarche', *L'Europe Littéraire*.

12 T. Veblen (1899), *The Theory of the Leisure Class*. New York: Macmillan; and P. Perrot (1981), *Les Dessus et les Dessous de la Bourgeoisie, une Histoire du Vêtement au XIX^e Siècle*. Paris: Librairie Arthème Fayard.

13 C. Rabier (ed.) (2013), *Fitting for Health*, special issue of *Technology and Culture* 54 (3).

14 M. Charpy (2012), 'Craze and shame: rubber clothing during the 19th-century in Paris, London and New York City', *Fashion Theory* 16 (4), pp. 433–60.

15 On the 'medium or average man' see: P. Broca (1871), *Mémoires d'anthropologie*. Paris: Reinwald et Cie.

16 See Perrot, *Les Dessus*, and C. Bard (2012), *Une Histoire Politique du Pantalon*. Paris: Le Seuil.

17 E. Alain (1920), *Le Système des Beaux-Arts*. Paris: Nouvelle Revue Française, chapters on 'Des meubles' and 'Des arts en mouvement et des arts en repos'.

18 S. Giedion (1948), *Mechanization Takes Command*. Oxford: Oxford University Press.

19 See C. Hacks (1892), *Le Geste. Tout Dire sans Parler*. Paris: Flammarion; and D. Poulot (1889), *Méthode d'enseignement Manuel pour Former un Apprenti Mécanicien*. Paris: Monrocq; and the more recent work by J. Bremmer and H. Roodenburg (1992), *A Cultural History of Gesture*. Ithaca: Cornell University Press.

20 Charpy, 'Le théâtre des objets'.

21 G. Adamson and V. Kelley (eds) (2013), *Surface Tensions: Surface, Finish and the Meaning of Objects*. Manchester: Manchester University Press.

22 W. Benjamin (1989), 'L'intérieur, la trace', in *Paris, Capitale du XIX^e Siècle: le Livre des Passages*. Paris: Éditions du Cerf.

23 See V. Kelley (2010), *Soap and Water: Cleanliness, Dirt and the Working Classes in Victorian and Edwardian Britain*. London: Tauris.

24 A. Corbin (1986), 'Le grand siècle du linge', *Ethnologie française*, 16 (3), pp. 299–310; and Kelley, *Soap and Water*.

25 G. Perec (1989), *L'infra-ordinaire*. Paris: Le Seuil.

26 See catalogues of Au Bûcheron, La Samaritaine, Le Tapis rouge, etc. in Série actualités, Bibliothèque historique de la Ville de Paris and catalogues of Sears and Harrods.

27 One can see suspect disorders in criminal photographs in Archives de la Préfecture de Police de Paris.

28 M. Charpy (2014), 'Pour portrait. Sur les usages sociaux des figurations de soi au XIXe siècle', in S. Raux and D. Debuisson (eds), *À perte de vue: Les nouveaux paradigmes du visuel*. Dijon: Presses du Réel.

29 D. Goodman (2007), 'The secrétaire and the integration of the eighteenth-century self', in D. Goodman and K. Norberg (eds), *Furnishing the Eighteenth Century*. New York and London: Routledge, pp. 183–203.

30 See the recent work by P. Lejeune (2013), *Autogenèses. Brouillons de Soi 2*. Paris: Le Seuil.

31 See G. Freund (1974), *Photographie et Société*. Paris: Le Seuil; and G. Mazeau (2012), 'Portraits de peu', *Revue d'histoire du XIXᵉ Siècle* 45 (2), pp. 35–52. Physionotrace was a device that allowed to draw the silhouette of a profile on a copper plate thus facilitating the making of copies.

32 Many photographers produced micro-photographs on buttons, cufflinks and pendants. See S. Michaud, J.-Y. Mollier and N. Savy (1992), *Usages de l'image au XIXᵉ Siècle*. Paris: Creaphis.

33 M. Jasanoff (2004), 'Collectors of Empire: objects, conquests and imperial self-fashioning', *Past & Present* 184, pp. 109–35; (2005), *Edge of Empire: Lives, Culture, and Conquest in the East, 1750–1850*. New York: Alfred A. Knopf.

34 See J. Baudrillard (1968), *Le Système des Objets. La Consommation des Signes*. Paris: Gallimard, pp. 101–50; and R.W. Belk (1995), *Collecting in a Consumer Society*. London and New York: Routledge.

35 D. Cohen (2006), *Household Gods: The British And Their Possessions*. New Haven: Yale University Press; Charpy, 'Le théâtre des objets'.

36 G. Tarde (1890), *Les Lois de l'imitation*. Paris: Félix Alcan; Veblen, *Theory*; E. Goblot (1925), *La Barrière et le Niveau, étude Sociologique sur la Bourgeoisie Française Moderne*. Paris: Félix Alcan; and P. Bourdieu (1979), *La Distinction, Critique Sociale du Jugement*. Paris: Éditions de Minuit.

37 R. Barthes (1957), 'Histoire et sociologie du vêtement', *Annales. Économies, Sociétés, Civilisations* 12 (3), pp. 430–41.

38 N. Heinich (2005), *L'élite Artiste, Excellence et Singularité en Régime Démocratique*. Paris: Gallimard; and one of the first, C. Grana (1964), *Bohemian versus Bourgeois: French Society and the French Men of Letters in the Nineteenth Century*. New York: Basic Books.

39 On workers, see: P. Hudson (1992), *The Industrial Revolution*. London: Arnold; and M. Charpy (2008), 'Forms and scales of second-hand market in the nineteenth-century: case-study of clothes in Paris', in L. Fontaine (ed.), *Alternative Exchanges: Second-Hand Circulations from the Sixteenth Century to the Present*. Oxford and New York: Berghahn.

40 It is difficult to trace these artefacts because these 'personal things' are kept 'out of inventories'. See Charpy, 'Le théâtre des Objets', ch. 3; and A. Corbin, M. Perrot, G. Duby and P. Ariès (eds) (1997), *Histoire de la Vie Privée. De la Révolution à la Grande Guerre*, vol. 4. Paris: Seuil.

41 L. Auslander (1996), *Taste and Power: Furnishing Modern France*. Berkeley and Los Angeles: University of California Press.

42 Mazeau, 'Portraits de peu'.

43 E. A. McCauley (1985), *Disderi and the Carte de Visite Portrait Photograph*. New Haven and London: Yale University Press; (1994), *Industrial Madness. Commercial Photography in Paris, 1848–1871*. New Haven and London: Yale University Press.

44 P. Ariès (1991), *The Hour of Our Death: The Classic History of Western Attitudes Toward Death over the Last One Thousand Years*. Oxford: Oxford University Press.

45 See A. Martin-Fugier (1983), *La bourgeoise*. Paris: Grasset; D. Hussey and M. Ponsonby (eds) (2013), *The Single Homemaker and Material Culture in the Long Eighteenth Century*. Aldershot: Ashgate.

46 V. Steele (1995), *Fetish: Fashion, Sex & Power*. Oxford: Oxford University Press; (2001), *Corset, A Cultural History*. New Haven and London: Yale University Press; and Charpy, 'Craze and shame'.

47 Bard, *Une histoire*.

48 G. Bartholeyns (2011), 'Les apparences de l'homme', *Civilisations. Revue Internationale d'Anthropologie et de Sciences Humaines* 59 (2), pp. 9–40; N. Wickramasinghe (2003), *Dressing the Colonised Body: Politics, Clothing and Identity in Colonial Sri Lanka*. New Delhi: Longman; H. Fischer-Tiné and S. Gehrmann (2008), *Empires and Boundaries: Race, Class, and Gender in Colonial Settings*. London: Routledge; and C. Taraud (2003), *La prostitution coloniale: Algérie, Tunisie, Maroc 1830–1962*. Paris: Payot.

49 C. A. Bayly (1986), 'The origins of Swadeshi (home industry): cloth and Indian society, 1700–1930', in A. Appadurai (ed.), *The Social Life of Things: Commodities in Cultural Perspectives*. Cambridge: Cambridge University Press, pp. 285–322.

50 Jasanoff, *Edge of Empire*.

51 F. Dikötter (2006), *Exotic Commodities. Modern Objects and Everyday Life in China*. New York: Columbia University Press.

52 F. Jarrige and M. Charpy (2012), 'La technique au quotidien', *Revue d'histoire du XIXe Siècle* 45 (2), pp. 7–32.

Further reading

Adamson, G. and V. Kelley (eds) (2013), *Surface Tensions. Surface, Finish and the Meaning of Objects*. Manchester: Manchester University Press.

Auslander, L. (1996), *Taste and Power: Furnishing Modern France*. Berkeley and Los Angeles: University of California Press.

Barbuscia, A. (2012), 'La pratique musicale, entre l'art et la mécanique. Les effets du métronome sur le champ musical au XIXe siècle', *Revue d'Histoire du XIXe siècle* 45 (2), pp. 53–68.

Bard, C. (2012), *Une histoire politique du pantalon*. Paris: Le Seuil.

Barthes, R. (1957), 'Histoire et sociologie du vêtement', *Annales. Économies, Sociétés, Civilisations* 12 (3), pp. 430–41.

Baudrillard, J. (1968), *Le Système des Objets. La Consommation des Signes*. Paris: Gallimard.

Bayly, C. A. (1986), 'The origins of Swadeshi (home industry): cloth and Indian society, 1700–1930', in A. Appadurai (ed.), *The Social Life of Things: Commodities in Cultural Perspectives*. Cambridge: Cambridge University Press, pp. 285–322.

Bourdieu, P. (1979), *La Distinction, Critique Sociale du Jugement*. Paris: Éditions de Minuit.

Bremmer, J. and H. Roodenburg (1992), *A Cultural History of Gesture*. Ithaca: Cornell University Press.

Charpy, M. (2012), 'Craze and shame: rubber clothing during the 19th-century in Paris, London and New York City', *Fashion Theory* 16 (4), pp. 433–60.

Cohen, D. (2006), *Household Gods: The British And Their Possessions*. New Haven: Yale University Press.

Crary, J. (1990), *Techniques of the Observer: On Vision and Modernity in the Nineteenth Century*. Cambridge, MA: MIT Press.

De Certeau, M. (1980), *L'invention du Quotidien*, Vol. 1. *Arts de faire*. Paris: Gallimard.

Dikötter, F. (2006), *Exotic Commodities: Modern Objects and Everyday Life in China*. New York: Columbia University Press.

Goodman, D. (2007), 'The Secrétaire and the integration of the eighteenth-century self', in D. Goodman and K. Norberg (eds), *Furnishing the Eighteenth Century*. New York and London: Routledge, pp. 183–203.

Jasanoff, M. (2005), *Edge of Empire: Lives, Culture, and Conquest in the East, 1750–1850*. New York: Alfred A. Knopf.

Kelley, V. (2010), *Soap and Water: Cleanliness, Dirt and the Working Classes in Victorian and Edwardian Britain*, London: Tauris.

McCauley, E. A. (1994), *Industrial Madness: Commercial Photography in Paris, 1848–1871*. New Haven and London: Yale University Press.

Perec, G. (1989), *L'infra-ordinaire*. Paris: Le Seuil.

Rabier, C. (ed.) (2013), *Fitting for Health*, special issue of *Technology and Culture* 54 (3).

Schivelbusch, W. (1986), *The Railway Journey: The Industrialization and Perception of Time and Space in the Nineteenth Century*. Berkeley: University of California Press.

Schivelbusch, W. (1995), *Disenchanted Night: The Industrialization of Light in the Nineteenth Century*. Berkeley and Los Angeles: University of California Press.

Steele, V. (1995), *Fetish: Fashion, Sex & Power*. Oxford: Oxford University Press.

Steele, V. (2001), *Corset, A Cultural History*. New Haven and London: Yale University Press.

Veblen, T. (1899), *The Theory of the Leisure Class*. New York: Macmillan.

The Presentation of Material Culture

The Return of the *Wunderkammer*:

Material Culture in the Museum

Ethan W. Lasser

Part storeroom and part classroom, art museums are a distinctive hybrid. Charged with preserving artefacts from the past, and with exhibiting these objects to the public, museums play two very different and sometimes conflicting roles. They are sites where material culture – the vast field of artefacts, objects, buildings and monuments that is the subject of this volume – is made available to historians, and, more importantly they are the primary sites where the history of material culture is written for and consumed by the general public. As the scholar Randolph Starn explains in a recent study of the relationship between museums and the practice of history: 'It is no stretch, except perhaps to our professional egos, to suppose that museums actually deliver more history, more effectively, more of the time, to more people than historians do'.[1]

This essay considers the art museum's role in authoring and delivering the history of material culture. Because this is a large topic that others have explored, I will focus specifically on a curious and as yet unaccounted for shift in the way this history is delivered in art museums across the United States. Here curators are reviving a centuries-old model of display and interpretation. The *Wunderkammer* – the 'cabinet of curiosities' – as the *New York Times* critic Roberta Smith recently noted, 'is very much a curatorial vogue'.[2]

A fixture of elite interiors in Renaissance Italy, the *Wunderkammer* was a single room devoted to the display of rare and unusual artefacts and natural specimens. Collected over the course of generations, these artefacts and specimens ranged from scientific instruments to ancient tools, from fossils and shells to taxidermied animals.[3] As images from the Renaissance attest, the *Wunderkammer* were extravagant, fanciful spaces. The cabinet depicted in the frontispiece to Ferrante Imperato's 1599 catalogue *Dell'historia naturale* (Figure 18.1) is a case in point: shells and crocodiles hang from the ceiling, reptiles surround the window, and works of art – books and ceramics, a painting or two – occupy the open cabinets.

Scholars have comprehensively charted the rise, evolution and gradual decline of these spaces. As the museologist Andrew McClellan has explained, the cabinets thrived until the advent of modern science pushed them underground: 'By the mid-eighteenth century, the early modern Wunderkammer had given way to collections . . . governed by a methodical order'.[4] Artefacts and natural specimens were separated into museums of natural history and museums of art, and the cabinets were dismissed as odd and unscientific.

In the last ten years, museums across the United States have thrown a wrench in this neat, historical narrative. Cabinets are starting to resurface. Curators from every department in US art museums are beginning to put

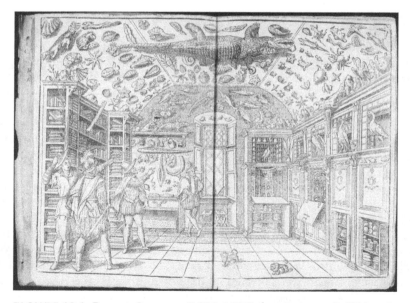

FIGURE 18.1 *Ferrante Imperato (1550–1625), frontispiece to* Dell'historia Naturale *(Naples, 1599). Courtesy of the Beinecke Rare Book and Manuscript Library, Yale University.*

together galleries that evoke *Wunderkammer* like Imperato's space. Stuffed alligators and other taxidermic beasts were thrust to the ceiling in the Chamber of Wonders at the Walters Art Museum in Baltimore in 2005 (Figure 18.2). Scientific instruments and mathematical treatises are displayed together with old master paintings in the Blaffer Foundation gallery at the Museum of Fine Arts, Houston. At the Metropolitan Museum's 2011 Alexander McQueen retrospective, the second room in the exhibition was advertised as a 'cabinet of curiosities', though in this case it was filled with 'sadomasochistic' clothing and headwear from McQueen's collections. And the list goes on: from the 'Promiscuous Assemblage' of natural history specimens and fine and decorative arts that the contemporary artist Jane Wildgoose assembled at the Yale Center for British Art to commemorate the eighteenth-century Portland Museum, to the displays of objects with 'unusual or curious technological qualities' at the Museum of Jurassic Technology, an institution whose blend of fact and fiction (some of the objects in the collection are real, historical artefacts while others are invented curiosities) has made it a cult favourite in Los Angeles.[5]

And yet, despite the growing presence of cabinets in museums today, these spaces have yet to be subject to any extended study. Though much has been written about the *Wunderkammer* of the past, the resurgence of the cabinet has yet to be examined, despite what one scholar describes as the

FIGURE 18.2 *Chamber of Wonders, The Walters Art Museum, Baltimore, 2005.*

recent 'flood of literature on the theory, practice and politics and history of museums'.[6] Important questions remain unanswered: How do these spaces differ from more conventional modes of display and interpretation? What sort of knowledge do they impart? How, to phrase it in the terms of this volume, do these spaces write the history of material culture? What do they ask of the visitor? Why, to quote the *New York Times* critic Karen Rosenberg, are the *Wunderkammer* such an 'excellent model for 21st century art and design museums'?[7]

This essay will take a preliminary look at these questions. In assessing the revival of the *Wunderkammer*, I have two readers in mind: students and scholars interested in the way that the history of material culture is written for the general public; and practitioners – art museum curators who are working on or thinking about assembling a cabinet of their own. In the pages that follow, I attempt to answer some of the questions that my colleagues and I faced as we assembled the *Loca Miraculi* or *Rooms of Wonder* at the Milwaukee Art Museum in 2008.

Two teapots

Let us begin by considering a pair of closely-related ceramic teapots (Figures 18.3 and 18.4). Crafted in mid-eighteenth-century Staffordshire, the historic centre of the British ceramics industry, these vessels share the same diminutive scale, naturalistic form and elaborate surface ornament. Each is decorated by a mix of blues and browns that swirl together to form an abstract, marbleized or, as ceramic historians term it, 'agate' pattern. Faintly visible beneath this pattern are the undulating ridges of a scallop shell: the sides of each pot have been press-moulded to resemble this naturalistic form.[8] Though it is not known where the teapots were produced, the vessels are so closely related that they may have been crafted at the same factory, and – it is reasonable to speculate – may have even been fabricated by the same hands.

The early history of the teapots has been lost. But after years, perhaps even after a century of service at a tea table in Britain, the vessels were packed up, shipped to an antique dealer, and acquired by collectors in the United States. After losing its ceramic lid and being refitted with a silver one, one of the teapots wound up in early-twentieth-century Boston in the collection of Mr Charles A. King; the other travelled all the way to Milwaukee, Wisconsin where in 1959 it was acquired by department store owners Stanley and Polly Stone. In 1939, King's widow donated her late husband's pot to the Museum of Fine Arts, Boston (MFA). In 1995, Mrs Stone bequeathed her pot to the Chipstone Foundation, a centre for the study of eighteenth-century British ceramics and American furniture.

Today, the two teapots are on view in public museums. And that is where our story begins: the King teapot stands on the left side of a large embedded

FIGURE 18.3 *Lead-glazed earthenware teapot, Staffordshire, c. 1740–60. Gift of Mrs Charles A. King, Museum of Fine Arts, Boston, 39.299.*

case in the Simone and Alan Hartman Gallery for European Decorative Arts at the MFA, a long corridor space filled with eighteenth-century British silver and ceramics (Figure 18.5). Here, the object stands in what, for the purposes of this essay, can be considered a conventional or established mode of display: similar cases, and similar installations can be found in the decorative arts galleries of many major US museums including the Metropolitan Museum of Art, the Art Institute of Chicago, the Detroit Art Institute and the St. Louis Art Museum.[9]

The vessel from the Stone collection is presented in the second room of the *Loca Miraculi* or *Rooms of Wonder* at the Milwaukee Art Museum (MAM) (Figure 18.6). Billed as a 'twenty-first century cabinet of curiosities' in the introductory wall-text, this suite of three rooms displays ceramics and furniture from the Chipstone Foundation collection. Like many of the

FIGURE 18.4 *Lead-glazed earthenware teapot, Staffordshire, 1755–75. Chipstone Foundation, 1959.1.*

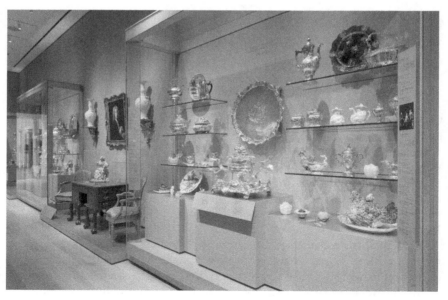

FIGURE 18.5 *Simone and Alan Hartman Gallery for European Decorative Arts. Museum of Fine Arts, Boston.*

FIGURE 18.6 Loca Miraculi *or* The Rooms of Wonder. *Milwaukee Art Museum.*

cabinet spaces installed in the last ten years, the *Rooms of Wonder* were assembled by a large team comprised of in-house curators and a visiting artist: Martha Glowacki.[10]

By comparing the way the teapots are presented in these two contexts, and by contrasting the type of information conveyed in the conventional display to the information conveyed in the recreated cabinet, it is possible to arrive at a set of preliminary responses to the questions outlined above, and to assess the way in which material culture history is being written and presented in the *Wunderkammer* spaces. To be clear: this essay is intended as an analysis rather than a critique. My objective is to understand what is distinctive about the twenty-first-century cabinets, and in doing so lay the groundwork for others who wish to debate and discuss the merits of the model of display.

As with any case study, it is important to end this introduction with the following disclaimer: the installations at the MFA and MAM are exemplary of the conventional and cabinet displays at other museums, but they are not carbon copies of other installations. The conclusions in this essay need to be tested – ideally on the basis of a first-hand visit and critique – before they are applied to the galleries in other museums.

The museum gallery

Museum curators and educators have two tools to convey information about the objects on view in their galleries to the visitor: the first tool is text, which is generally presented in the form of a wall label or brochure; the second tool is adjacency or juxtaposition. A great deal of information can be conveyed by placing an object next to related, or in some cases entirely unrelated, forms. As McClellan explains in his history of the museum, 'museums rely on classification and display to give their collections coherence and meaning'.[11] He adds that the assemblage of objects 'is the matrix within which individual objects are apprehended and given meaning'.[12] In all major museums these two tools are most often – and most effectively – deployed in combination.

Though the text that describes the teapots in Boston and Milwaukee is almost identical ('lead-glazed earthenware, Staffordshire, c. 1740' reads the label that captions each case), the two vessels are presented in an entirely different context in each museum. In Boston, the teapot stands in a case with a group of Staffordshire ceramics from the second half of the eighteenth century (Figure 18.7). This group includes a tea caddy, a milk pot and twenty-four different teapots. The King vessel is specifically positioned on the far left side of the second shelf next to a miniature version of itself, below a white teapot moulded to resemble a Georgian brick mansion; and above a green and yellow vessel shaped like a pineapple. Objects with equally singular forms and styles of decoration – from bulbous, Asian style vessels, to teapots with figurative imagery, to vessels with applied decoration – populate the other shelves in the case.

This display is a microcosm of the larger encyclopaedic museum: presented alongside related, but slightly dissimilar forms, each teapot is exhibited and at the same time classified. The installation invites the visitor to compare and contrast the vessels on display, and to parse and define the formal features – the specific forms and styles of ornamentation – that make each teapot unique. Arranged in a grid like the botanical specimens illustrated in a Linnaean taxonomy, each teapot is identified as a singular example of the larger family (or, to build on the natural history metaphor, the larger species) of related Staffordshire vessels. The label beneath the case tacitly acknowledges the scientific pedigree of this model of display. Harkening back to the classificatory systems that scholars locate at the foundation of the modern museum, the label notes that the case displays examples of the

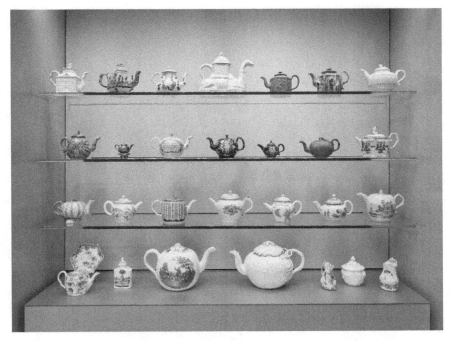

FIGURE 18.7 *Teapot Cabinet. Simone and Alan Hartman Gallery for European Decorative Arts, Museum of Fine Arts, Boston.*

'endless *variations* in the earthenware, stoneware and porcelain' produced in British ceramic factories.[13]

Upon first consideration, the display in Milwaukee looks similar (Figure 18.8). The Stone teapot is also presented in a large glass case with other ceramic forms. But closer inspection reveals a key difference: the objects in the *Loca Miraculi* display all share the same style of decoration. The Stone teapot is sandwiched between two vessels with almost identical marbleized surfaces. Filling out the case are a range of other, similarly-ornamented pieces, including a milk pot, a pair of sculpted ceramic birds, a large standing coffee pot, and, rather unexpectedly in the lower right corner, two mineral specimens which appear to have been spliced off of a larger rock.

What is the logic that underpins this unexpected coupling of natural specimens and decorative objects? The answer is certainly not, as in Boston, shared chronology (undated on the label, the age of the specimens can only be articulated in geologic time: the rocks are probably more than ten thousand years old). Rather, the answer is surface: the relationship between the rocks and the pots hinges on the similar colours and patterns that adorn each object. Beneath the case is a drawer whose contents explain the significance of this connection between natural and artificial (Figure 18.9).

FIGURE 18.8 *'Fossils and Agates' case,* Loca Miraculi *or* The Rooms of Wonder, *Milwaukee Art Museum.*

FIGURE 18.9 *Drawer display, 'Fossils and Agates' case,* Loca Miraculi *or* The Rooms of Wonder, *Milwaukee Art Museum.*

Opening the drawer reveals (beneath a protective layer of glass) a square paper card, upon which is printed a long quotation from Leonardo da Vinci's notebooks dated 1492:

> If you look at walls that are stained or made of different kind of stones and imagine some kind of scene, you begin to see them as creating a setting and you can think you see in them certain picturesque views of mountains, rivers, rocks, trees, plains, broad valleys and hills of different shapes. You can also find in them battles and rapidly moving figures, strange faces and costumes, as well as an infinite number of things you could reduce to a clear and complete form.

Presented alongside the square card that bears this quote are three mineral specimens that appear to depict the landscape da Vinci describes. The most striking example is a square block of slate whose figured surface resembles a mountainous landscape. The short pamphlet published to guide visitors through this display identifies these specimens as 'picture stones ... considered pieces of artwork made by nature', and then connects the objects assembled in the drawer to the objects displayed in the case. The latter reflect 'the public fascination with geology that caused images on rocks to decorate polite tewares' in the eighteenth century.[14]

The logic that underpins the display of ceramics and specimens is thus imitation: looking closely reveals that the ceramics in the case resemble the picture stones. The lines that wind around the surface of the stone teapot coalesce into miniature landscapes and abstract fragments of faces. Ghostly pairs of eyes and ears pop out from the marbleized background of the ceramics and take shape as 'strange faces', just as da Vinci describes.

Reading and writing history in the museum

Having looked closely at the displays in Boston and Milwaukee, we can now turn our attention back to the questions outlined at the beginning of this essay and begin to parse the distinctive features of the *Wunderkammer* displays. It is clear, to return to the terms of this volume, that the *Rooms of Wonder* at MAM 'write' the history of the teapot differently than the MFA case.

In Milwaukee, the curator's two tools, text and juxtaposition, are deployed to locate the teapot in what one might call a different arena of history than the more established mode of display. While the MFA case emphasizes the teapot's relationship to other ceramics, implicitly identifying the King vessel as one incarnation of the larger ceramic family or 'species', the display in Milwaukee emphasizes the vessel's relationship to a natural specimen, and by extension, to the larger culture of imitation in which it was produced. Provoking interdisciplinary questions about the relationship between natural and artificial, geology and ceramics, imitation and design,

this case locates the teapot at the intersection of decorative arts history and cultural history. By contrast, the display in Boston, where like-forms are arrayed next to like-forms, focuses more tightly on the teapot's formal qualities and its position within the history and development of Staffordshire ceramics.

In opening the teapot up for interdisciplinary inquiry, the *Rooms of Wonder* also ask something different of the museum visitor than the galleries in Boston. While the MFA case proposes an exercise in close looking, the display in Milwaukee presents the visitor with a mystery to be solved. Like a detective, one is invited to use a set of clues – the da Vinci quote, the guidebook – to make sense of an unexpected visual relationship between man-made artefact and natural specimen, and to assess the significance of this relationship. In other words, if the conventional display invites the visitor to look and describe, the cabinet invites the visitor to look and to discern the meaning of an unexpected relationship. Whenever objects are 'arranged in such a way as to defy obvious categories and hierarchies' writes the museologist Colleen Sheehy in an analysis of contemporary artist Mark Dion's recreated cabinets, the display will prompt 'questions about the logic of its order . . . [and] engage the viewer in an analysis and discernment of this order'.[15]

Placed in an active, discerning role, visitors are in turn more aware of the museum gallery as an authored space. In Boston, the objects are privileged over and above the authorial hand of the curator because the logic that underpins their display is self-evident. As McClellan writes in his analysis of the encyclopaedic museum, 'the air of permanence and universality that hovers over the displays disguises the degree to which what one encounters in the way of art and installation is the product of human judgment'.[16] By contrast the mystery and unexpectedness that pervades the cabinet points back to the authorial voice of the curator and contemporary artist, and the authored reality of the museum space more generally.

Conclusion

I want to conclude this essay by moving outward from Boston and Milwaukee to the broader landscape of the twenty-first-century museum. The distinctive features of the *Rooms of Wonder* are characteristic of the cabinet spaces that populate museums across the United States. Many of these spaces bring together *naturalia* and *artificialia*, art and science, and many raise interdisciplinary questions about the artefacts that they display. But what unites these revived spaces more than their contents is the active position they invite the visitor to assume. Whether one is standing in front of the case of ceramics in Milwaukee, beneath the crocodile and cabinet paintings at the Walters Art Museum in Baltimore, or in front of the shells and decorative arts in Jane Wildgoose's installation 'Promiscuous Assemblage', these

spaces and the unusual juxtapositions at their core push the visitor to work – to become an active reader and interpreter of the history they put forward.

The pressure that the cabinets place on the visitor helps to explicate their twenty-first-century appeal. Beyond their sheer wow factor, beyond the surprise and wonder of viewing a collection of taxidermy on the ceiling of an art museum, the *Wunderkammer* cater to what museum critic Nina Simon describes as the contemporary visitor's increasing interest in 'active engagement'. 'As more people enjoy and become accustomed to participatory learning and entertainment experiences', she writes, 'they want to do more than just "attend" cultural events and institutions'.[17] Today's museum visitors 'prefer to make and do rather than just watch'.[18] In inviting every visitor to parse the logic behind the artefacts on display, the *Wunderkammer* cater to just that inclination.

The position of the visitor in the revived *Wunderkammer* ultimately points to the deep relationship between today's cabinets and their Renaissance antecedents. As the art historian Bruce Robertson has explained, the early cabinets were filled with unexpected juxtapositions that prompted deduction and speculation. Their order and meaning 'lay waiting to be constructed by the active, engaged mind of the viewer' much like the spaces this essay has explored.[19] The seventeenth-century scientist Francis Bacon eloquently described the mode of inquiry that the cabinets set in motion: 'By rare and extraordinary works of nature, the understanding is excited and raised to investigation and discovery'.[20] Though these words were first published in 1620, they are increasingly applicable to the experience in today's museums. The *Wunderkammer* may be the latest thing – a cutting-edge, 'curatorial vogue' – but they also represent a return to the earliest chapter in the history of museums.

Notes

1 R. Starn (2005), 'A historian's brief guide to new museum studies', *American Historical Review* 110 (1), p. 68.

2 R. Smith (2013), 'A place to put all those curiosities: rooms of wonder at the *Grolier Club*', *New York Times*, 17 January: http://www.nytimes.com/2013/01/18/arts/design/rooms-of-wonder-at-the-grolier-club.html?pagewanted=all&_r=0_ [Accessed 4 June 2014].

3 The literature on the *Wunderkammer* is extensive. For the most comprehensive work, see: O. Impey and A. Macgregor (eds) (2001), *The Origins of Museums: The Cabinet of Curiosities in Sixteenth- and Seventeenth-Century Europe*. Oxford: Clarendon Press. For a lavishly illustrated volume, see P. Mauries (2002), *Cabinet of Curiosities*. London: Thames and Hudson. For a cultural history, see L. Daston and K. Park (2001), *Wonders and the Order of Nature 1150–1750*. New York: Zone Books.

4 A. McClellan (2008), *The Art Museum from Boullee to Bilbao*. Berkeley: University of California Press, p. 120.

5 For Baltimore, see http://art.thewalters.org/browse/location/chamber-of-wonders/ [accessed 27 July 2014]; for Houston see http://www.mfah.org/art/departments/Sarah-Campbell-Blaffer-Foundation/ [accessed 27 July 2014]; For McQueen, see: Bolton, 'Alexander McQueen: Savage Beauty', New York: Metropolitan Museum of Art, 2011; for Yale Center for British Art, see: Jane Wildgoose, 'Promiscuous Assemblage, Friendship and the Order of Things', New Haven: Yale Center for British Art, 2009; for the Museum of Jurassic Technology, see: L. Weschler (1995), *Mr Wilson's Cabinet of Curiosities*. New York: Pantheon Books.

6 Starn, 'A historian's brief guide', p. 68.

7 K. Rosenberg (2010), 'Dead or alive at the Museum of Arts and Design', *The New York Times*, 29 April. http://www.nytimes.com/2010/04/30/arts/design/30alive.html [Accessed 4 June 2014].

8 M. Erickson and R. Hunter (2003), 'Swirls and whirls: English agateware technology', in R. Hunter (ed.), *Ceramics in America*. Milwaukee: Chipstone Foundation, pp. 87–110.

9 For a discussion and critique of these conventions, see J. Prown and K. Hemple Prown (2002), 'The quiet canon: tradition and exclusion in American furniture scholarship', in L. Beckerdite (ed.), *American Furniture*. Milwaukee: Chipstone Foundation, pp. 207–27.

10 Wisconsin-based contemporary artist Martha Glowacki collaborated on the project with curators from the Chipstone Foundation. As noted above, I worked on this project with my colleagues Sarah Fayen and Jon Prown while serving as Curator of the Chipstone, a post I held from 2007 to 2012. For other examples of artist–curator collaborations, consider the work of contemporary artist Mark Dion, who is often credited with introducing the cabinet of curiosities to the art world. See: M. Dion et al. (1997), *Mark Dion*. London: Phaidon.

11 McClellan, *Art Museum*, p. 111.

12 McClellan, *Art Museum*, p. 111.

13 The emphasis is mine.

14 *Loca Miraculi* or *The Rooms of Wonder*, Milwaukee: Chipstone Foundation/ Milwaukee Art Museum, 2008, n.p.

15 C. Sheehy (2006), 'A walrus head in the Art Museum: Mark Dion digs into the University of Minnesota', in C. Sheehy (ed.), *Cabinet of Curiosities: Mark Dion and the University as Installation*. Minneapolis: University of Minnesota Press, p. 8.

16 McClellan, *Art Museum*, p. 114.

17 N. Simon (2010), *The Participatory Museum*, Santa Cruz, CA: Museums 2.0, preface.

18 Simon, *Participatory Museum*, preface.

19 B. Robertson (2006), 'Curiosity cabinets, museums and universities', in C. Sheehy (ed.), *Cabinet of Curiosities,* p. 48.

20 Quoted in Robertson, 'Curiosity cabinets', p. 48.

Further reading

Bell, W. (1967), *A Cabinet of Curiosities: Five Episodes in the Evolution of American Museums*. Charlottesville: University Press of Virginia.

Benedict, B. (2001), *Curiosity: A Cultural History of Early Modern Inquiry*. Chicago: University of Chicago Press.

Bleichmar, D. and P. Mancall (eds) (2011), *Collecting across Cultures: Material Exchanges in the Early Modern Atlantic World*. Philadelphia: University of Pennsylvania Press.

Findlen, P. (1994), *Possessing Nature: Museums, Collecting and Scientific Culture in Early Modern Italy*. Berkeley: University of California Press.

Laird, M. and A. Weisberg-Roberts (2009), *Mrs. Delany & Her Circle*. New Haven: Yale University Press.

MacGregor, A. (2007), *Curiosity and Enlightenment: Collectors and Collections from the Sixteenth to the Nineteenth Century*. New Haven: Yale University Press.

Wallach, A. (1998), *Exhibiting Contradiction: Essays on the Art Museum in the United States*. Boston: University of Massachusetts Press.

Wilson, D. (2002), *The British Museum: A History*. London: British Museum.

CHAPTER NINETEEN

Europe 1600–1800 in a Thousand Objects

Lesley Ellis Miller

In 1972 the new eighteenth-century Continental Primary Galleries, a suite devoted to the long-term display of the V&A's world-class collections of eighteenth-century European decorative arts were unveiled. Located in the south-east quadrant basement to the left of the Museum's main entrance, these galleries had been renovated under the curatorship of the pioneering interiors historian Peter Thornton (1925–2007). They were very much of their time – all windows were blocked out, the ceilings were lowered, bays along the walls were created for the open display of furniture and furnishings, both freestanding and built-in cases for other smaller or more delicate objects were installed, as was air-conditioning (Figure 19.1).[1]

The narrative and the labelling were in keeping with the Museum's then audience, assuming a certain educational background. Most obviously, an appetite for traditional art historical connoisseurship was expected, as was some knowledge of European history, the classical world and the Christian faith. The display content underlined what comprised 'Continental' in the decade that the UK joined the European Union. It was Western Europe – France dominated, Italy and the Netherlands were well-represented, Germany and Spain less so, and Britain was resolutely excluded.[2]

Forty years on, at the end of 2014, these same galleries will reopen as Europe 1600–1800 after a major renovation lasting four years. In line with the Museum's current mission to return its architectural spaces to their original glory, the restored 1909 interiors will frame the displays: the ceilings will be high; the windows revealed though shuttered, thus enabling visitors to orientate their position relative to the outside world. All fixtures and fittings, plinths and cases, will be in a modern idiom, designed by the gallery

FIGURE 19.1 *A gallery redisplayed in 1972. Note the height of ceilings relative to the visitor and the lack of windows. Courtesy of the V&A.*

architects ZMMA to meet current conservation, access and security requirements.[3] The displays and interpretation will cater for the needs of twenty-first-century visitors, responding to the Museum's mission to promote 'knowledge, understanding and enjoyment of the designed world'. Importantly, that ambition is predicated on providing 'optimum access to collections and services for diverse audiences' and on 'promoting, supporting and developing the UK creative economy by inspiring designers and makers.'[4] Here the historic and contemporary must walk hand-in-hand, as must scholarship and accessibility.

The renovation of Europe takes place under the aegis of FuturePlan, a strategic sequence of gallery restoration and reinterpretation, which entered its second ten-year phase in 2010. The gallery team, therefore, benefits from and builds on the experiences of previous projects, most relevantly the 'British Galleries 1500–1900' (opened in 2001) and 'Medieval and Renaissance 300–1600' (opened in 2009).[5] From the point of view of narrative, both projects have underlined visitors' liking for a chronological organization, within which particular themes form the subjects of individual displays and contribute to the overarching message of the whole suite. These themes delve into the context in which objects were created, the people who made, owned and used them. Both projects reveal how advances in conservation have enabled the safe and evocative display of light-sensitive

material even when allowing daylight in, and how conventional text-based interpretation may be enhanced by digital means.

The curators and educators responsible for determining the galleries' narrative content belong to a much larger project team, operating within certain material, cultural, spatial, and financial boundaries. Their initial brief from V&A senior management proposed that the story of design be told through about 1,000 objects, all of which were to come from the museum's own collections without relying on loans from other institutions. The narrative was to be organized chronologically through a series of thematic displays, and be valid for a predicted twenty-five-year lifespan. The chronology was to start at around 1600, the date at which the Medieval and Renaissance Galleries end and travel through to about 1800. Wi-Fi access was to be available throughout. The budget, which covers all curatorial, conservation and interpretation, as well as design and building costs, was fixed at £12.5 million, and the funding was to be sought from the Heritage Lottery Fund and other charitable and private sources.

Internal and external experts on the material culture and history of the period informed curatorial thinking on the content. Their specialist insight was complemented by the Learning department's audience research into non-specialists who might be attracted into these galleries, and their level of knowledge and expectations. The latter confirmed that few visitors have knowledge of this period, its personalities, or its major events (except for the French Revolution) – possibly a reflection of the absence of early modern European history from the English National Curriculum. On the other hand, young children responded enthusiastically to many of the objects, and the galleries are immediately accessible to families arriving at both Museum entrances. The target audiences – for narrative and interpretation – are families, students, independent adult-learners and European visitors, who constitute overlapping groups. Early on, the disposition of the space – four long galleries interspersed by three smaller galleries – suggested pacing that would allow different experiences, the long ones to carry the chronology, the small ones to offer a more immersive experience. Unlike in other galleries, 'activity areas' will be incorporated alongside displays in the latter, rather than isolated from them.

A two-pronged approach was adopted to creating the story, starting on one hand from 'textbook' history and on the other from objects in the collections. The former enabled us to consider the chronological partitioning of the galleries as well as what we meant by Europe. As with the British Galleries, the dates are fluid – the decision being made to end in 1815, rather than 1800, in recognition of the new world order heralded by Napoleon's defeat at the Battle of Waterloo. Although it was clearly impossible to cover every aspect of art and design for such a large geographical area in a space equivalent to that used for Britain 1500–1760 alone in the British Galleries above, the team were clear that they wanted the definition of Europe to be overtly wider than before: France would be at the centre, Portugal and

Russia, Greece and Sweden at the peripheries, and some reference would be made to the Ottoman Empire. Europeans also increasingly relied on ideas, imagery and craftspeople in and from Africa, the Americas and Asia, and that had to enter the narrative. Given that the Museum already boasted galleries devoted to Britain and to Asia, duplication was, however, to be avoided. Fortunately new technology will give the opportunity to direct visitors to other galleries containing comparable or complementary material.

The quest for objects started with the Museum's online catalogue which contained 95,362 objects (not all photographed or recently catalogued) apparently made (as opposed to used) in Europe in this period. Many of those objects were already displayed satisfactorily in other recently refurbished galleries.[6] This process also revealed certain weaknesses and strengths. The collections held virtually no architectural pieces, few eastern, northern or Ottoman European objects, and a heavy bias towards French holdings. The emphasis on France is partly the legacy of the significant bequest from the military tailor John Jones, whose collection of French eighteenth-century design formed the basis of the Continental galleries from 1882 onwards.[7] Refining the list and identifying the key objects relied on the efforts and knowledge of twenty-five curators in different departments. They met regularly for brainstorming meetings over a period of eighteen months, nominating 'A-list' objects, proposing and trying out themes for individual displays – initially with no reference to the amount of space, subsequently with indications from the architects of how the space might work.

'A-list' objects came in different shapes and sizes, some already well-known, others new discoveries in store, or new acquisitions made with these galleries in mind. Their status usually derived from their aesthetic and technical merit, their uniqueness and provenance, in other words, the qualities on which the V&A had traditionally collected. They might be large and spectacular, as in the case of Bernini's garden sculpture of Neptune and Triton, or small and intricate, as in the case of a German rosary. Some had been acquired on the understanding that they would be on permanent display, in acknowledgement of the generosity of the donor or the funding body. Other 'must-haves' were rather less tied to the connoisseurial model. They either have known popular appeal, as in the case of the three period rooms, or embody good human-interest stories. The 'A' list was not enough on its own to tell the story, but ensures that some 'stars' with great presence may be plotted into the gallery plan to draw visitors through – or ease the passage of visitors pressed for time.

From our brainstorming sessions it became clear that our collections (with no loans) would deliver three key messages relative to the history of early modern European material culture: first, France took over from Italy as the undisputed leader of fashionable art and design in Europe; second, European art and design systematically explored, exploited and collected resources from Africa, Asia and the Americas; and third, that ways of living came to resemble those we know today, in acknowledgement of changing

patterns of consumption in things and ideas. These messages will be conveyed by largely excluding France from the first two galleries (Europe and the World, 1600–1720 and The Cabinet), by an overt reference to France in the title of the third (The Rise of France, 1660–1720), and a consistent presence in the final galleries (The Salon; City and Commerce, 1720–1780; and Luxury, Liberty and Power, 1760–1815). We recognized that in order to capture wider Europe adequately and intimate the architectural context for the objects, we would have to use our interpretative devices astutely. As a result, our 'Style' films focus not on the place of origin, but on a place to which the style was disseminated, either immediately or some time after it originally became fashionable – for Baroque, Portugal; for Louis XIV, the Netherlands; for Rococo, Germany; for Neoclassicism, Russia.

While the architectural context has to be injected via film, the essential human presence will be incorporated via sculpture, paintings and dress. It is the first time that the latter has been on display in these galleries. In V&A records, the majority of items from this period date to the second half of the eighteenth century, and are catalogued as English – the default position for any outfit that arrived in the museum without documented provenance. Many are too fragile to be displayed, and many are incomplete, or altered substantially at a later date. The justification for new acquisitions in this area was therefore strong, and, since 2010, several items have been bought, including a three-piece suit of about 1780–90 from France.

Made of plain high-quality dark chocolate-brown broadcloth, lined in silk and linen, the suit fastens with faceted cut steel buttons, and its black satin wig bag is still attached to the back of the coat. It epitomizes the sombre fashions associated with Anglomania, thus contrasting with a lavish Court embroidered silk suit of the 1790s (Figure 19.2). Although poised to tell a good story, the suit had still to go through rigorous assessment and interventive treatment by textile conservators before being given a clean bill of health. Its structural state and the condition of the broadcloth were excellent, but the lining was in a fragile and poor condition requiring about 250 hours of conservation to ensure that the lining was stabilized and would not be damaged further through handling during and after mounting.[8] The mounting itself will support the suit fully on a custom-made torso in appropriate conservation-friendly materials.[9] Like many historic garments, the suit is very small, perhaps made for a young man who grew before subjecting it to the wear that might have threatened its survival. As a result a standard mannequin may need to be cut away to match its dimensions. Lighting levels of a maximum of 50 lux will further protect the suit, which will need to be rotated out of display to ensure it does not suffer long-term fatigue.

After conservation treatment was complete and safe environmental parameters established, the dialogue on mounting then involved conservators, curators and designers in what is an ongoing discussion. ZMMA propose

FIGURE 19.2 *Brown broadcloth suit on mannequin made for V&A's David Bowie exhibition in 2013. This stance would not, of course, be appropriate for an eighteenth-century gentleman. V&A T.10:1 to 3-2010.*

that each figure occupy its own case, that those cases be engineered into the floor in such a way that the figures appear to walk among museum visitors on the same surface. They are also keen that as little of the supporting mount as possible is visible, in line with the design language of the other displays (Figure 19.3). Their preference is therefore for torsos that are invisible. However, the design of the cases dictates that mannequins cannot be suspended and a more traditional and conspicuous fixing such as a pole will have to be used. Although this would not be an issue for female dress, where skirt and petticoat will hide the pole from view, using this style of fixing is problematic for men's suits of the eighteenth century. Breeches presuppose the existence of two legs, and may look extremely strange if displayed with a pole through just one leg, and, may eventually keel to one side – an unhappy occurrence both aesthetically and conservation-wise. Moreover,

FIGURE 19.3 *Architects' visualization of fashion display in Gallery 1, 2012. Courtesy of ZMMA.*

the eighteenth-century pride in finely turned calves, encased in smoothly fitting stockings, is entirely lost and seems more crucial to interpretation even than heads and hands. Whether realistic or abstracted, heads and limbs offer the opportunity to animate garments through a historically accurate pose and the suggestion of gesture. When complemented by original or reproduction accessories, the full silhouette may be conveyed – including contemporary vogues in hairdressing – often substantially transforming the impression gained from garments alone. These are particularly pertinent when revealing radical changes between the 1780s and 1800.

In a design museum such as the V&A, any history of early modern material culture is necessarily partial, dependent on accidents of survival, generations of collecting policies, the imperative to appeal to audiences beyond academe, and on the sensitivity of modern designers to historic objects and interiors. Inevitably, the story reflects elite culture.[10] It does not therefore reflect the contents of most textbooks for this period, either in seeking to be a comprehensive overview of European society or in advancing new hypotheses, as temporary exhibitions often do. It is hoped, however, that the galleries' visual impact, accessible and accurate interpretation will provide a compelling way into the subject, delighting whilst also instructing, not only our target audiences but also many other museum visitors.

Notes

1 J. Daniels (1972), 'Review of new eighteenth-century Continental primary galleries', *Connoisseur* 179 (720) February, pp. 150–51.

2 It was represented in the much larger English Primary Galleries (1952–87), subsequently called British Art and Design Galleries (1987–98), and after reopening in 2001 British Galleries 1550–1900.

3 Project architects' website, http://www.zmma.com [accessed 27 July 2014].

4 www.vam.ac.uk [accessed 27 July 2014].

5 C. Wilk and N. Humphrey (ed.) (2004), *Creating the British Galleries. A Study in Museology*. London: V&A Publications; P. Motture (2010), 'Inspire, engage, connect, transform . . .', *Museum Identity* 7, pp. 36–45. http://issuu.com/museumid/docs/museumid07 [accessed 27 July 2014].

6 For process, see the blog 'Creating the new Europe 1600–1800 Galleries', http://www.vam.ac.uk/b/blog/creating-new-europe-1600–1800-galleries (since September 2012).

7 L. Trench (2010), *V&A. The Victoria and Albert Museum*. London: V&A Publications, pp. 42–3.

8 V&A T.10:1 to 3-2010: textile conservation treatment = 249 hours; metal conservation treatment of cut steel buttons = 50 hours; costume mounting = 25 hours.

9 L. Flecker (2007), *A Practical Guide to Costume Mounting*. London: Butterworth Heinemann in association with Victoria & Albert Museum, p. xiii.

10 S. Medlam and L. E. Miller (ed.) (2011), *Princely Treasures. European Masterpieces 1600–1800*. London: V&A Publications; E. Miller and H. Young (ed.) (forthcoming 2015), *The Arts of Living in Europe, 1600–1815*. London, V&A Publications.

Objects of Empire:

Museums, Material Culture and Histories of Empire

John McAleer

In the early modern period, the transport and sale of a bewildering variety of trade goods helped to expand and consolidate European maritime and colonial empires. The collecting of objects and scientific specimens, and their subsequent public display in museums, was also one of the foremost ways in which Europeans explored non-European spaces and learned about their inhabitants. This short essay investigates the possibilities offered, as well as the challenges presented, by surviving material culture for displaying European imperial history in museum contexts.

The discussion focuses on two examples to explore some of the important themes that objects can help to elucidate for students of imperialism, anti-colonialism, post-colonialism, and their histories. The first artefact – a porcelain bowl produced in China for a British businessman in the eighteenth century – offers insights into global networks of commerce created by expanding maritime empires, and the ways in which these facilitated the exchange of goods, ideas and even design motifs. Many of the objects produced and exchanged as a result of imperial connections now reside in museums. The second example considers the changing interpretations attached to a single piece of ship's sculpture over the course of its museum career. In doing so, it demonstrates the relationship between museums and their collections, and the history of imperialism. Both examples highlight the ways in which objects embody key themes of empire: trade, exchange, representation (and misrepresentation). And, while the discussion focuses

mainly on the British experience, many of the points have applications in other contexts; indeed, the very nature of the subject brings transnational and global perspectives to bear on our understandings of these themes and contexts.[1]

At a basic level, the material evidence of the past – or the 'stuff' of history – can be used to tell various aspects of Europe's relations with the wider world. Objects offer visually arresting testaments to the impact and effect of the movement of people, goods and ideas around the globe in the early modern period. One of the most striking examples of this phenomenon is the Chinese porcelain produced for export during the heyday of the European East India companies in the eighteenth and nineteenth centuries. Combining Chinese technical and artistic skill with European imagery, such porcelain acts as a powerful material reminder of the commercial exchanges and patterns sustained by European long-distance trade with Asia. Over the course of the eighteenth century, porcelain comprised between 5 and 10 per cent of European imports from Asia.[2] The London-based East India Company alone may have imported one million pieces of porcelain per annum. With its translucent lustre, fine decoration and delicate finish, such porcelain was the height of fashion in Europe. Indeed, before 1780, there were over five hundred chinaware and porcelain dealers operating across Britain alone.[3]

The porcelain punch bowl commissioned by one of the Barnard family of shipbuilders, now in the collection of the National Maritime Museum at Greenwich in the United Kingdom, illustrates the point vividly. The entire scene is located in an imaginary Chinese landscape. But the exterior of the bowl depicts line drawings of ships under construction, probably copied from Fredrik Henrik af Chapman's *Architectura Navalis Mercantoria*, first

FIGURE 20.1 *Porcelain punch bowl, c. 1785. National Maritime Museum AAA4440. © National Maritime Museum, Greenwich, London.*

published in Stockholm in 1768 (Figure 20.1). The classical decorative motifs are also distinctly European, demonstrating the artist's ability to adapt the form, colouring and decoration of their work to European taste.[4] The trading relationships and cultural encounters with Asia evident in this one single example illustrate a wider point about the impact of the country's expanding global concerns on everyday life back in Britain.

In considering such material encounters, it is important to take account of the close connection between this phenomenon and the development of museums.[5] The British Empire yielded much material for British museums, particularly in terms of ethnographic collections. From the acquisition of 'Powhatan's mantle', the deerskin cloak believed to have belonged to the Native American chief and still part of the Tradescant collection at the Ashmolean Museum in Oxford, British museums have consistently relied on maritime and imperial endeavours for the acquisition of objects relating to different cultures from around the world.[6] Although it is now being exposed to more critical scholarly enquiry, this phenomenon has been recognized for some time. As early as the seventeenth century, for example, Thomas Sprat observed that 'there will be scarce a ship come up the Thames, that does not make some return of experiments [objects], as well as merchandise'.[7] When Mirza Abu Taleb Khan, an official at the courts of various Muslim rulers in India, travelled to Britain in the late eighteenth century, he remarked that 'the English are fond of making large collections of every thing that is rare or curious. The place where these articles are deposited is called a *Museum*.' In his view, 'all Nature has been ransacked to procure' these collections.[8] In assessing the impact of British imperial experiences on museums and their collections, Tim Barringer has argued that 'the acquisition of objects from areas of the world in which Britain had colonial or proto-colonial political and military interests, and the ordering and displaying of them by a museum' formed what amounted to a three-dimensional archive.[9] In many ways, the museums in which these objects are stored and displayed, and in which these encounters are interpreted for present-day audiences, have become 'contact zones' themselves.[10]

It is also important to remember that the history of an object does not end at the point of sale, or time of collecting, or even when it has entered European museum collections.[11] Much of the most exciting recent scholarship on global 'objects of empire' relates to the reconstruction of their subsequent careers, and the implications of their display and interpretation in radically different contexts from their original usage. The reconstruction of individual 'object biographies', as well as the multiple interpretations facilitated by new historiographical approaches, offers fruitful ways to present the nuances and complexities of imperial history for twenty-first-century audiences.[12] In other words, object biographies and provenance, collecting and display histories (i.e. the various phases of an object's career), offer important insights into historical changes and attitudes.

The complex relationship of objects to the histories of empire might be ascertained more fully by exploring a single object in more detail. Many of

the themes discussed above are encapsulated in a carving which once adorned HMS *Seringapatam*, a British naval ship (Figure 20.2). It illustrates the ways in which the multivalent nature of material culture might be harnessed to tell different histories of empire. Now in the collection of the National Maritime Museum, the object is catalogued as a figurehead and supposedly represents Tipu Sultan, the ruler of Mysore, a kingdom in southern India.[13] In attempting to expand and consolidate his own imperial ambitions, Tipu became one of the most intractable obstacles to the expansion of British commercial and political power in late-eighteenth-century India. After a series of conflicts, he was eventually defeated and killed in 1799 when British forces captured his capital city, Seringapatam. In doing so, the British East India Company consolidated its commercial and political control over large swathes of India.

The sculpture depicts a seated figure wearing a turban, who is riding a *roc*, a mythical bird of great strength. This, together with the umbrella he holds, symbolizes Tipu's regal status. It was carved in India in the early-nineteenth century, almost certainly by an Indian sculptor, in the decades immediately following Tipu's defeat at the hands of British troops. It was first on HMS *Seringapatam*, a 46-gun Royal Navy warship launched at Bombay Dockyard in 1819. But the object's interpretative richness extends further, reflecting encounters between cultures, unequal power balances in colonial India, the changing nature of the East India Company's relationship with the subcontinent, and the ways in which subsequent museum displays inflect and influence the interpretation of such objects.

In his lifetime, Tipu was represented (and represented himself) in all sorts of ways.[14] For some, Tipu was the 'Marcus Aurelius of the East'.[15] For others, however, he represented a 'bogeyman', stalking Britain's Asian empire.[16] And much of this representational work was achieved through objects. Tipu assumed the personal symbol of the tiger, conveying his authority, his majesty, and his right to rule through his association with this animal and its representation on various personal items and other objects found at his court. One of the most famous objects associated with him is the mechanical automaton known as 'Tipu's Tiger', now in the collection of the Victoria and Albert Museum, which represents the horrified fascination of the British public with the ruler of Mysore.[17]

This figurehead represents another stage in that process of representing empire. In the naming of the vessel on which it was placed, no less than the location in which it was constructed, the figurehead can be seen as evidence of British imperial expansion in India in the period.[18] The placement, in effigy, of a defeated rival on a British naval vessel illustrates how Tipu's story was deployed to convey a wider interpretation of the advance of British power in the region. Just as defeat diminished his reputation as a merciless and bloodthirsty rival, so Tipu's threat to British power was neutralized by the act of carving his likeness for use on a British vessel. As a piece of decorative art placed on the prow of a working ship, the carving was

FIGURE 20.2 *Figurehead of HMS* Seringapatam, *1819. National Maritime Museum FHD0102. © National Maritime Museum, Greenwich, London.*

designed to have an immediate visual impact on those who saw it.

By virtue of its status as a museum object, however, the carving offers other pathways for understanding subsequent relations between Britain and India. The meaning of the object has been transformed in its museum career, reflecting the changing approaches both to Tipu and the wider history of the British Empire in Asia. At first, the object was interpreted in the context of naval history. When *Seringapatam* was broken up in South Africa in the 1870s, the figurehead was preserved and then moved to the Fire Engine House in Devonport Dockyard where it remained until 1937. In that year, the Admiralty transferred the artefact, along with a number of other figureheads, to the newly opened National Maritime Museum. In 1999, it formed part of the Museum's 'Trade and Empire' gallery. That gallery was replaced in 2007 and the carving went into storage. In 2011, however, the figure embarked on a new chapter in its museum career, as part of a gallery telling the story of the East India Company and Asia. In this context, the figurehead illustrates the Company's struggle for power and territory in the Indian subcontinent. Depicting a local, 'Indian' empire-builder, the object is contextualized as part of a late-eighteenth-century contest for the upper hand in the subcontinent.

The figurehead encapsulates the European encounter with the rest of the world on a number of levels. It represents, in striking three-dimensional form, expanding British territorial power and imperial ambitions in the Indian subcontinent. Through its subsequent museum history, however, the figurehead also illustrates the fluid and shifting nature of material culture and its interpretation over time. In many ways, this example is typical of the possibilities offered by material culture for scholars of empire. Objects, exhibitions and museums reflect and, in many cases, shape perceptions of the imperial past. In the process, they offer powerful tools for understanding and interpreting that episode in global history.[19]

Notes

1 See, for example, D. Bleichmar and P. C. Mancall (eds) (2011), *Collecting across Cultures: Material Exchanges in the Early Modern Atlantic World.* Philadelphia: University of Pennsylvania Press, p. 4.

2 D. S. Howard (1997), *A Tale of Three Cities: Canton, Shanghai and Hong Kong. Three Centuries of Sino-British Trade in the Decorative Arts.* London: Sotheby's, p. iv.

3 M. Berg (2005), *Luxury and Pleasure in Eighteenth-Century Britain.* Oxford: Oxford University Press, pp. 56 and 77.

4 H. V. Bowen, J. McAleer and R. J. Blyth (2011), *Monsoon Traders: The Maritime World of the East India Company.* London: Scala, p. 113.

5 S. Longair and J. McAleer (eds) (2012), *Curating Empire: Museums and the British Imperial Experience.* Manchester: Manchester University Press,

pp. 1–16. See also J. M. MacKenzie (2009), *Museums and Empire: Natural History, Human Cultures and Colonial Identities*. Manchester: Manchester University Press.

6 See http://www.ashmolean.org/education/resources/resources2011/?id=478 (accessed 29 March 2013). See also: A. MacGregor (2007), *Curiosity and Enlightenment: Collectors and Collections from the Sixteenth to the Nineteenth Century*. London: Yale University Press, p. 30.

7 Quoted in Longair and McAleer (eds), *Curating Empire*, p. 2.

8 M. A. T. Khan (1814), *Travels of Mirza Abu Taleb Khan in Asia, Africa, and Europe, during the years 1799, 1800, 1801, 1802, and 1803*, trans. C. Steward, 3 vols. London: Longman, Hurst, Rees, Orme and Brown, vol. 1, p. 263.

9 T. Barringer (1998), 'South Kensington Museum and the colonial project', in T. Barringer and T. Flynn (eds), *Colonialism and the Object: Empire, Material Culture and the Museum*. London: Routledge, p. 11.

10 M. L. Pratt (1992), *Imperial Eyes: Travel Writing and Transculturation*. London: Routledge, pp. 6–7.

11 See S. J. M. M. Alberti (2005), 'Objects and the museum', *Isis* 96, pp. 559–71.

12 See I. Kopytoff (1986), 'Cultural biography of things: commoditization as process', in A. Appadurai (ed.), *The Social Life of Things: Commodities in Cultural Perspective*. Cambridge: Cambridge University Press, pp. 64–91. See also: C. Gosden and Y. Marshall (1999), 'The cultural biography of objects', *World Archaeology* 31 (2), pp. 169–78.

13 Bowen, McAleer and Blyth, *Monsoon Traders*, p. 155.

14 See R. Altick (1978), *The Shows of London*. Cambridge, MA: Harvard University Press, pp. 299–300.

15 Quoted in F. P. Lock (2006), *Edmund Burke: Volume II, 1784–1797*. Oxford: Clarendon Press, p. 362.

16 C. A. Bayly (1989), *Imperial Meridian: The British Empire and the World, 1780–1830*. London: Longman, pp. 113–14.

17 See S. Qureshi, 'Tipu's Tiger and images of India, 1799–2010', in Longair and McAleer (eds), *Curating Empire*, pp. 207–24.

18 A. Lambert (2002), 'Strategy, policy and shipbuilding: the Bombay Dockyard, the Indian Navy and imperial security in eastern seas, 1784–1869', in H. V. Bowen, M. Lincoln and N. Rigby (eds), *The Worlds of the East India Company*. Woodbridge: Boydell, pp. 137–51.

19 S. Longair and J. McAleer (2013), 'Introduction: shifting interpretations of empire', *Museum History Journal* 6 (1), p. 5.

CHAPTER TWENTY-ONE

Interwoven Knowledge:

Understanding and Conserving Three Islamic Carpets

Jessica Hallett and Raquel Santos

In September 2007 three 'Salting' carpets were identified in the Palace of the Dukes of Bragança, in Guimarães, in northern Portugal, by British carpet experts, Michael Franses and John Mills.[1] Their visit to the palace was inspired by a lead from a Parisian antiquarian who had prior knowledge of their existence. Refurbishment of the palace had began in 1937, and the Portuguese Department of Monuments began acquiring antique furnishings in the 1950s to decorate it, including the three carpets. Two are small prayer rugs with a large niche dominating the central field, framed by cartouches and medallions containing Koranic inscriptions, while the third has a large medallion occupying the centre and quarter medallions in the corners, surrounded by rectangular cartouches with poetic phrases in Persian (Figures 21.1 and 21.2). The carpets were purchased from the prominent London textile dealers, Mssrs. Perez, as historical objects but knowledge of their age and importance was later lost, as they were integrated into the interior decoration of a monument dedicated exclusively to Portuguese national history.

Since their acquisition, the three carpets were exhibited beneath a window, in direct sunlight and uncontrolled environmental conditions, resulting in extensive colour fading and degradation of the textile fibres. Their very poor condition spurred Franses to contact the Ministry of Culture, and a year later, the carpets were moved from the palace to Portugal's national conservation institute. Here, a major research project was mounted involving

FIGURE 21.1 *Benguiat niche carpet, Palace of the Dukes, Guimarães (PD77), before conservation. (Photography by Jorge Oliveira, DGPC, Portugal)*

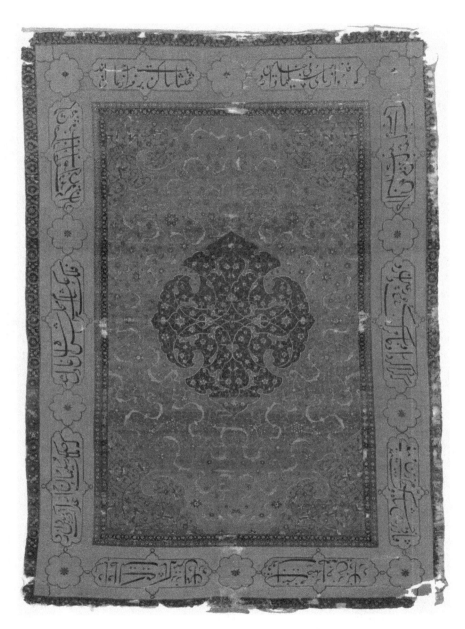

FIGURE 21.2 *Medallion carpet, Palace of the Dukes, Guimarães (PD77), before conservation. (Photography by Jorge Oliveira, DGPC Portugal)*

an interdisciplinary team comprising textile conservators, art historians and material scientists.[2] The team's work focused on resolving important historical questions surrounding the carpets' manufacture, as well as on developing a coherent strategy for preserving them. Working collaboratively resulted in an intense exchange of wide-ranging knowledge and information which in turn encouraged innovative approaches and unexpected results. Indeed, the results were so inspiring that in 2011 the carpets were formally classified as National Treasures by the Portuguese Ministry of Culture.

The so-called 'Salting' carpets are among the most highly sought-after carpets by collectors today and have been sold for astonishing sums.[3] They derive their name from the famous Australian-born British art collector, George Salting (1835–1909), who gave an important example to the Victoria and Albert Museum, London, in 1909. Since then, more than 100 'Salting' carpets (80 niche and 27 medallion) have been identified in public and private collections, from Tehran to New York. The group is characterized by the presence of a silk foundation (warp and weft), fine wool pile, high knot density, brilliant colours, wide palette and embellishments in precious metal thread. Their designs are distinguished by dense scrolling arabesques, Chinese cloud motifs, inscriptions and small dimensions. The newly-identified Guimarães carpets share these features and represent the largest, single collection of 'Saltings' outside of the Topkapi Palace Museum in Istanbul. The two prayer carpets almost certainly were part of a group of some 20 carpets which were sold by the Topkapi during the throes of the Russo–Turkish War of 1877–78.[4]

For more than a century, the origin and date of the 'Saltings' have been the source of considerable debate. At the end of the nineteenth century, they were ascribed to sixteenth-century Tabriz, in Iran, and then subsequently recognized to be related to the large group of well-preserved prayer rugs, with bright colours, in the Topkapi Palace in Istanbul.[5] As some of these had religious inscriptions which are Shi'ite in nature, it was proposed that the Topkapi rugs had survived in such good condition as they were not suitable for use by the Sunni Ottomans. However, their documented presence in Istanbul and brilliant colours encouraged subsequent scholars to claim they were eighteenth- or nineteenth-century Turkish rugs, and possibly even forgeries of classical Iranian carpets. Support for the latter supposition was drawn from their enigmatic combination of two very different artistic styles: on the one hand, the presence of poly-lobed cartouches and a rich colour palette of reds and blues consistent with the arts developed under the Safavid Shah Tahmasp (r. 1524–76), and on the other, the proliferation of large-format arabesque scrolls and metal thread usually associated with textiles produced under his grandson, Shah Abbas I (r. 1587–1629).

More recently, a new generation of carpet experts has returned to the subject and argued that the 'Saltings' are authentic sixteenth- or seventeenth-century carpets, and that the Topkapi rugs were sent from Safavid Iran as gifts to the Ottoman Court. Michael Franses proposed that

the carpets could have been sent by Shah Tahmasp to Suleyman the Magnificent in 1556, as suggested by a letter mentioning a gift of 'carpets spread on the floor of the mosque for the use of the congregation', or a decade later, to Sultan Selim II on the occasion of his accession in 1567.[6] Jon Thompson subsequently argued, on the basis of an inscription giving the date 1590–91 (Hijra 999), that they were a gift from Shah Abbas to Sultan Murad III, possibly on the occasion of the Treaty of Istanbul signed in 1590.[7]

Given this complex historiography, resolving the question of the origin and date of the 'Saltings' was timely. The materials used to make a carpet and how they are prepared can help identify groups of carpets and establish their origin and/or date. This type of data can also indicate whether these groups reflect a single, coherent production of short duration, or multiple workshops and a wide historical timeline. Only partial scientific information was available for the 'Saltings'[8] and hence, the rediscovery of the carpets in Guimarães offered an important opportunity to reflect upon their precise origin and date.

Characterization of the materials used to make the carpets (fibres, dyes, mordants and metal threads) was performed using a wide range of analytical methods.[9] Silk and wool fibres were identified in the foundation and pile using optical microscopy. The dyes were identified with High-Performance Liquid Chromatography with Diode Array Detector (HPLC-DAD) and Mass Spectrometry (LC-MS), while the mordants were analysed by Inductively Coupled Plasma with Atomic Emission Spectrometry (ICP-AES).

For tackling questions of provenance, yellow and red dyes are especially important, as the former are usually locally produced, while the latter in some cases have been shown to be culturally and temporally specific. In previous work on Islamic carpets the red dye obtained from the lac insect, harvested in South and East Asia and traded widely throughout the region, has been shown to be the main colouring agent for the red ground of sixteenth- and seventeenth-century Iranian carpets.[10] By contrast, the reds in Turkish carpets were usually obtained from the madder plant. All of the colours in the Guimarães carpets were shown to have been obtained with natural dyes typical of Iranian carpets. The blues reflect the use of indigo. A luteolin-based dye, possibly weld, was identified in the yellows, which also appears with indigo in the greens and with madder (probably *Rubia tinctorium*) in the oranges, something which has been shown to be a specific characteristic of Iranian carpets. The browns as well as the beige colours were obtained with natural wool, with the exception of the browns in the medallion carpet in which ellagic acid (indicating the presence of tannins) was identified. The reds and pinks were obtained with lac-dye, derived from insects belonging to the Kerridae family. In order to further narrow this identification, the first database for two important genera, *Kerria* and *Paratarchadina*, was developed in collaboration with the Royal Botanical Gardens at Kew.[11] The results of this innovative research revealed that the source for the lac-dye was probably located in or near Pakistan. All of the

colours were applied to the textile fibres using alum mordant, apart from the browns in the medallion carpet (iron), beiges (natural wool), and indigo (no mordant).

The metal threads were characterized by Energy Dispersive X-ray Fluorescence (μED-XRF) and Scanning Electron Microscopy (SEM-EDX).[12] They comprise a hand-cut silver metal lamina with a gold coating which is wound around a yellow silk thread. Microscopy revealed that the edges of the strip abut, but do not overlap, allowing the yellow colour of the silk to reflect off the metallic surface, enhancing the visual effect of the golden sheen of the thread. This technique is also consistent with Iranian production, and well documented in seventeenth-century 'Polonaise' carpets, known from historical sources to have been made exclusively in the city of Isfahan.[13]

As for the chronology of the carpets, all the analyses support an early date, such as the exclusive use of natural dyes and non-industrial metalworking techniques. An early date was also confirmed by AMS Radiocarbon and analysis of the medallion carpet pointed, with 95 per cent confidence, to a date between 1485 and 1604/1668, definitively excluding nineteenth- or twentieth-century production. Comparison of these results with other data published for Islamic carpets, confirms that this age is in line with those observed for other 'Salting' rugs.[14]

With this very detailed knowledge of the carpets' materials, offered by these diverse studies, it was now possible to develop a responsible and effective programme for their treatment and conservation. The very poor condition of the three Guimarães carpets, and their exceptional value, raised several conservation challenges. Achieving physical and chemical stability and increasing their visual aesthetic were the primary goals.[15] Given the advanced state of their degradation and main physical damage, all treatment phases took into account the ECCO Code of Ethics and were extensively debated by the interdisciplinary team. Two principles were considered of paramount importance: 'respecting the aesthetic, historic and spiritual significance and integrity of the cultural heritage' (Article 5) and 'limiting the treatment to only that which is necessary' (Article 8), as well as using 'materials and procedures which will not harm the cultural heritage, the environment or people'.

Cleaning was obviously an important step and essential for long-term preservation of the carpets, but it was also an irreversible process which could result in further damage and have negative environmental consequences. Both of these problems could be avoided by using supercritical carbon dioxide cleaning, a new 'green technology', which was tested for the first time on carpets. It was determined to be superior to traditional cleaning methods in all aspects, but, unfortunately, it was not possible to secure the substantial financing required to build an apparatus of sufficient size to accommodate the carpets.

Given these considerations, and after many tests, the team decided that treatment would involve removal of all previous interventions, mechanical cleaning, suction-table wet cleaning, and stitch consolidation involving a

new support made of compatible materials. This level of intervention was the minimum necessary to achieve an acceptable guarantee of stability, in compliance with horizontal display. With the conservation process complete, the carpets could now be returned to the exhibition gallery to take up their rightful place as objects of high artistic value, although many questions still remained to be answered about their fascinating history.

Two interesting observations emerged from the scientific study: namely, that the carpets can be dated with confidence to the sixteenth century, and secondly, that the two niche carpets are so identical in terms of their chemical composition that they must not only have been made in the same workshop, but also at precisely the same time (using probably the same dye batches). Support for this can also be found in their decoration, which reflects the repetitive use of stock design elements, something that characterizes the entire group. Such features would seem to imply that the 'Saltings' were part of at least one or more large orders or commissions, which, as Franses and Thompson suggested, could have made their way from Iran to Turkey as royal gifts from the Safavids to the Ottoman Court.

Interesting in this respect is the Persian poem around the medallion carpet which describes the rug itself as 'Fallen beneath the feet of a monarch [under] the foot of a Solomon' (Figure 21.2). It is tempting of course to associate this name with a historical personality, and two Solomons come to mind: the Safavid Shah Suleiman I (r. 1666–94), whose dates fall outside the parameters of the AMS Radiocarbon results, and the Ottoman Sultan, Suleyman the Magnificent (r. 1520–66). However, as the inscription refers to only 'a Solomon' and lacks honorifics, it is impossible to verify such an identification. Nevertheless, the presence of 35 niche carpets in the Topkapi collection today, which probably once also included the Guimarães prayer rugs, offers firm confirmation of the arrival of Iranian carpets in Istanbul which could have served as gifts to mediate a complex balance of power between the Safavids and the Ottomans. The inclusion of Shi'ite inscriptions in the rugs was not inappropriate or unsuitable, as some have argued, but a spectacularly clear affirmation of Safavid faith, power and lineage in this highly-charged political context.

Notes

1 J. Mills and M. Franses (1999), 'Salting carpets', in *Oriental Carpet and Textile Studies. Vol. 5*. Danville, CA: International Conference on Oriental Carpets.

2 The team comprised the authors (Centro de História de Além-Mar, Universidade Nova de Lisboa and Universidade dos Açores), M. Sousa, N. Leal, A. Aguiar-Ricardo and T. Casimiro (Faculdade de Ciência e Tecnologia, Universidade Nova de Lisboa), and P. Cruz, C. Frade and E. Lopes (Departamento de Conservação e Restauro, Instituto de Museus e Conservação, Lisbon).

3 A beautiful 'Salting' carpet (Karlsruhe) was sold at Sotheby's (London, 6 October 2010, Lot 394) for £1,161,250.

4 Mills and Franses, 'Salting carpets', p. 10.

5 Mills and Franses, 'Salting carpets', p. 2.

6 Mills and Franses, 'Salting carpets', p. 40.

7 Entry by Thompson, in S. R. Canby (2009), *Shah 'Abbas, The Remaking of Iran*. London: The British Museum Press.

8 Mills and Franses, 'Salting Carpets', pp. 25–32.

9 R. Santos (2010), 'The discovery of three lost "Salting" carpets: science as a tool for revealing their history', Master's Thesis, Universidade Nova de Lisboa.

10 M. Heitor, M. M. Sousa, M. J. Melo, J. Hallett and M. C. Oliveira (2007), 'The colour of the carpets', in J. Hallett and T. P. Pereira (eds), *The Oriental Carpet in Portugal: Carpets and Paintings, 15th to 18th Centuries*, exhibition catalogue. Lisbon: Museu Nacional de Arte Antiga; E. Armindo, M. M. Sousa, J. Hallett and M. J. Melo (2008), 'A Persian carpet's paradise garden: discovering historical and technical aspects through carpet conservation and restoration', in *ICOM-CC 15th Triennal Conference*. New Delhi, pp. 824–31; H. Böhmer and N. Enez (1988), 'A Topkapi prayer rug: arguments for a Persian origin', *Hali* 41, pp. 11–13.

11 R. Santos, M. M. Sousa, J. Hallett, J. Sarraguça, M. C. Oliveira, M. S. J. Simmonds and M. Nesbitt (forthcoming), *Analysis of Kerria and Paratarchadina Genera using HPLC-DAD, MS, and Multivariate Data Analysis for Identifying Lac-Dye Sources in Historical Textiles*.

12 This work was conducted in collaboration with M. Leal and presented at the 'International Conference on Oriental Carpets (ICOC XII)', Stockholm, 16–19 June 2011.

13 Mills and Franses, 'Salting carpets'.

14 Mills and Franses, 'Salting carpets'.

15 C. Frade, P. Cruz, E. Lopes, M. Sousa, J. Hallett, R. Santos, A. Aguiar-Ricardo and T. Casimiro (2011), 'Cleaning classical Persian carpets with silk and precious metal thread: conservation and ethical considerations', in *Cultural Heritage/Cultural Identity: The Role of Conservation, ICOM-CC 16th Triennial Conference*. Lisbon: International Council of Museums, pp. 283–92.

CHAPTER TWENTY-TWO

Reading and Writing the Restoration History of an Old French Bureau

Carolyn Sargentson

A bureau acquired in the nineteenth century by the Rothschild family for Mentmore Towers, Buckinghamshire, is typical of a type of Paris-made furniture used either as a desk or dressing table in the late seventeenth and early eighteenth centuries (Figure 22.1).[1] Such bureaux represent a new form of furniture designed at the end of the seventeenth century for writing, reading and dressing and are remarkable for their multiple lockable compartments as much as their potential for ornament. The curvilinear form of the legs and brackets, the complexities of the concave and convex shaping to the nine drawer fronts on its front face, and the highly ornate and carefully executed marquetry are the features that define its late 'baroque' style and date it to c.1700–10.

After a long life at Mentmore, the bureau was acquired by the Victoria and Albert Museum (V&A) in 1977. In that year a spectacular auction was held by Sotheby's, *in situ* at the house, of the Rothschild's collection of European art. A national outcry protesting the dispersal of the collection had failed to secure government protection for it, and the sale went ahead. Roy Strong, then Director of the V&A, was one of the leading voices in the three-year campaign, and, although the V&A's line was consistently one of pursuing the preservation of the entire collection in its magnificent Victorian Palace (built by Paxton in the 1850s), the Museum eventually led the move to acquire individual works of art for the national collections.[2] The Museum acquired pieces of French, German and Italian decorative arts, some of which were displayed in the V&A's Continental Primary Galleries completed in 1972.[3]

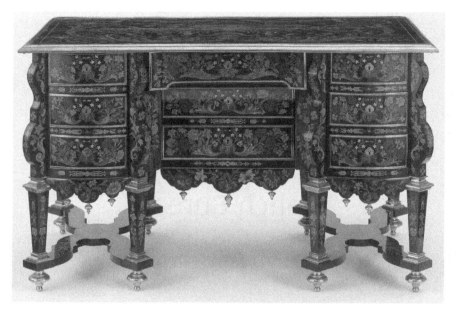

FIGURE 22.1 *Bureau, Paris, made 1700–10, restored in Paris 1850–60. Case of softwood and oak with drawers of walnut and softwood, veneered with ebony and inlaid with marquetry of domestic and imported hardwoods, clear horn backed with painted paper, bone, small pieces of sheet brass and mother-of-pearl; gilt brass mounts and escutcheons; brass and steel lock; steel key with a brass bow.* © Victoria *and Albert Museum inv. no. W.34-1977.*

While the German and Italian masterpieces from the Mentmore sale will be featured in the V&A's new galleries of European art and design 1600–1800 that are scheduled to open at the end of 2014, the bureau is destined to remain in long-term storage as part of the reserve collections.[4] Some of the reasons for the bureau's relatively swift change in status – from masterpiece saved for the nation in 1977 to a piece of uncertain origin and cultural value in 2014 – form the subject of this essay. Already in 1977 doubts were expressed about the condition of the V&A piece, when it was recorded as 'partially rebuilt'.[5] At that moment, when decisions about the V&A's acquisitions from Mentmore were made under pressure of time and in the context of the drama of the imminent break-up of a collection of national importance, the alterations to this individual piece were neither well-understood, nor seen as significantly diminishing of its cultural value. Since then, it has become clear that the case of the bureau has been substantially rebuilt and that much of the marquetry and all of the metalwork date from the mid-nineteenth century. Close examination, with the top removed to access the joinery, reveals a series of substantial structural alterations. These comprise a new case top, an extra reinforcing case back

and bottom, the replacement of all the substrates (solid wooden parts beneath the marquetry) to the nine drawers, and a set of eight brand new legs and brackets, three new aprons and new stretchers joining the legs towards the bottom. A set of new drawer locks, signed by a nineteenth-century French locksmith, Souchet (active c. 1850–70), and all the gilt brass decorations were also added.

In order for this structural work to have taken place, all the marquetry was completely removed, a practice by no means unusual in commercial restoration but no longer undertaken by museums. The marquetry on the top lies unusually flat on the substrate which is clearly machine-cut in oak and therefore of nineteenth-century date. This leaves of the original only the case sides, and – at first sight at least – the impressive decorative marquetry. However, by reading the marquetry not in terms of its design but its condition, two anomalies become clear. First, the marquetry on the drawer fronts was originally fitted with different metal escutcheons to protect the keyholes – this is indicated by fills in the marquetry. Second, some areas of the marquetry are riddled with insect damage (traditionally called worm holes but in fact the tracks of larvae that fed on the wood fibres) while other areas show no damage whatsoever. The legs, aprons and drawer fronts are undamaged; the drawer fronts and sides are perforated with holes that have been filled. The top comprises some areas that are damaged and restored in the same way, and others (the most elaborate areas) show no such damage at all. The condition of the brass mounts suggests that they were newly-made for attachment to the new legs and aprons, as were the escutcheons as outlined above.

It is possible to conjecture the biography of the bureau through the close art historical examination (by eye) of its component parts alongside the contextualization of the piece at various moments in the workshop, on the market and in the spaces of French and British interiors, including latterly those of the museum. If the bureau was indeed made in around 1700, then the evidence of structural repair suggests a certain chronology of wear and tear that prompted much of its alteration. Let us propose that it was made in Paris around 1700 by an unidentified furniture-maker (*ébéniste*) for an unidentified purchaser and remained in a French house, probably in Paris, until it fell out of fashion and was removed to an attic or sold. It may have languished for some decades, but was still in France when Souchet's locks were fitted. Before that final intervention, however, the piece was very likely acquired by a dealer who saw the potential to make money from it, but not without restoration. By this point, the bureau must have been in poor condition. The fact that its legs and stretchers appear to be completely replaced is a clear indication that it had deteriorated to the point where its legs (and the stretchers that strengthened the legs) failed to support it. At this point these parts were presumably completely removed, leaving a box that was dovetailed at its bottom corners and topped with a large panel of marquetry. Such case tops were easily removable (they were traditionally

fixed to the case with floating tenons). The marquetry was lifted from the case top and from the drawer fronts but it may well have remained on the case sides – the original softwood sides show insect damage and so does the marquetry.

If the piece was so dismantled, this moment of opportunity is well worth our consideration for it was then that choices were made that shaped the way that we see and understand the bureau today. Working, we must presume, to the dealer who had commissioned the restoration work, this cabinet maker made new parts and restored old ones. We have no way of knowing, however, whether the new legs, stretchers and aprons were exact replicas of the old ones. The latter might have been much simpler in form and curvature. The drawer fronts, especially those in the central bank of drawers which do not fit the case especially well, may have had different contours in plan; if they were changed then their new contours were matched by the front edges of the dust boards and case bottom which were also newly added. The three aprons may or may not have existed – and even if they did they may not have had the glittering brass knops that now depend from their lower edges. Similarly, once the marquetry was removed from the substrate, an opportunity arose to enhance what had been destroyed. In this moment, a decision would have been made either to re lay the original marquetry flat on the new oak panel, or to replace some of it with new pieces. A close examination suggests (but with plenty of room for error), that part of the old marquetry was re laid, but that the central areas were newly composed. Whether or not this was because some of the original marquetry was, like the legs, badly damaged cannot be determined; what now remains appears to be a combination of insect-damaged veneers, new pieces of inlay and a new ebony ground (Figure 22.2).

If the marquetry on the V&A bureau has indeed been restored and embellished in this way, the new work is evidence of the kind of alteration that so fascinated William Morris (1834–96), British design reformer and preservationist. In his manifesto of 1877 for the Society for the Preservation of Ancient Buildings, he claimed that restoration work:

> was of necessity wrought in the unmistakable fashion of the time; a church of the eleventh century might be added to or altered in the twelfth, thirteenth, fourteenth, fifteenth, sixteenth, or even the seventeenth or eighteenth centuries; but every change, whatever history it destroyed, left history in the gap, and was alive with the spirit of the deeds done midst its fashioning.[6]

The 'history in the gap' on the bureau top is legible in the newly-made pieces of marquetry. They indeed have a very different appearance to all other areas of (insect-damaged) marquetry on the bureau. The flowers are considerably more detailed and composed of more small parts of veneer cut

FIGURE 22.2 *Bureau, Paris, made 1700–10, restored in Paris 1850–60: detail. The marquetry panel forming the top to the bureau, the likely additions of 1850–60 outlined; a daffodil inlaid in the wrong wood boxed. The marquetry is inlaid into a ground veneer of ebony. © Victoria and Albert Museum inv. no. W.34-1977.*

in more diverse types of wood than was customary in c.1700. In fact they relate more closely to work of the later eighteenth century, and may even be a record of the work of a Parisian restoration workshop that was accustomed to reproducing floral marquetry of the 1770s and 1780s.[7] Some of the small pieces of veneer are atypical of eighteenth-century marquetry. An example is the daffodil on the centre of the top (identified in Figure 22.2) which would in the eighteenth century have been cut and inlaid in *berberis* (barberry), a domestic wood that is bright yellow in colour when freshly cut. On the marquetry the daffodil is not inlaid in *berberis*; rather it is cut from a brown wood to match the faded eighteenth-century veneers around it. These faded woods, their original bright colours almost entirely lost by the mid-nineteenth century, would have guided the restorer to select veneers that matched the old ones rather than introducing bright new woods that would have stood out as new. Thus an understanding of both the typical workshop's use of materials and the way that such materials change when exposed to light over time, allow the daffodil to reveal a clue to the restorer's interventions to the marquetry, even though a cursory reading of the marquetry design and its present condition do not.

The eighteenth-century maker of this piece, and its nineteenth-century restorer, remain anonymous. Only Souchet's mark links this object with a particular maker, in this case that of the workshop that fashioned the replacement locks. Souchet's name – another example of a little history in the gap – indicates that the restoration work took place in Paris, probably

between 1850 and 1860, just before the bureau was acquired for Mentmore. Souchet's locks appear on a number of nineteenth-century pieces of furniture dated between 1860 and 1875, including a number stamped by Charles Winkelsen (1812–71) in the style of *ancien-régime* furniture dating from the early 1700s to the 1780s. Such a workshop might well have restored the bureau, its very ambition in adding new and better components to both case and marquetry revealing the work to be – in Morris's terms – 'alive with the spirit of the deeds done midst its fashioning'.[8] We might consider the results as an act of outright fakery; the fact that Souchet's locks are marked clearly with his name, however, suggests that we should not be too quick to understand the restorer's intervention in that way.

In conclusion, this kind of detailed biography of an individual object poses problems of description, interpretation and classification, especially when an object turns out to be something other than it was originally believed to be. This is not an unusual occurrence in museums, especially when objects are re-catalogued, as in the case of this bureau. However, museum taxonomies and galleries have long depended on objects fitting comfortably into chronological and geographical frameworks, and when an object becomes differently understood, its identity and usefulness in the collection is destabilized. Now, with its history of wear, tear and restoration and the possibility that it was 'improved' by the addition of more elaborate legs, mounts and marquetry, the bureau's value in the collection is uncertain.

Ironically, the alterations that so enhanced its cultural and financial value in the nineteenth century threaten to disrupt the bureau's present value. The fact that the bureau will not be displayed in the new galleries of European art and design 1600–1800 suggests that the new research findings have caused it to fall from grace. It may be more helpful, however, to see its current status as under negotiation and as yet unclear. No longer can this object be read as a reliable example of eighteenth-century craftsmanship and design, nor can it accurately reflect the cultural practices (including reading, writing and furnishing) of that period. The story that this object can tell has changed – the bureau now offers evidence of a series of different craft skills and activities at various dates, and of the cultural practices of restoration, market circulation and collecting over a much longer period of time and across a larger European geography. However, the abbreviated modes of interpretation in most art museums (notably the labels) demand a simple identification of an object, and do not easily accommodate complexities and ambiguities. For the moment, the bureau will perform a more useful role in storage where it can be accessed for research purposes, and eventually perhaps recruited for a display that addresses themes of taste and collecting, or of restoration and preservation, especially in the nineteenth century.

Meanwhile, the place of the bureau in scholarship is ever more interesting, as it demands a style of expert investigation that is more often located in

museum curatorial and conservation departments than academia. Such research complicates several art-historical categories. For example, while art historians are increasingly interested in concepts of the 'fake' and the related status of the 'original' (or the 'authentic'), on the bureau no clear distinction between the two is demonstrable. Indeed, the piece in its present condition could be argued to be simultaneously an original piece of furniture and a fake, each identification valid at a different moment in its history but the former never entirely negated by the latter. Furthermore, the heritage industry's tendency to seek to fix an object in a specific time and place limits an object's capacity to tell more complex stories about the past. This case study points towards a role for the research of changes in the material nature of an object over time, including the results of normal wear and tear, of environmental and biological (insect) damage, of restoration and conservation, and to relate these to concomitant shifts in that object's value, identity and integrity over its full history. The physical layers of evidence in the bureau, from its internal structure to its decorative veneers, combined with an understanding that certain original parts and materials are now absent, are telling of the way the piece has been made and remade over time, each intervention a record of craft practice and skill, attitudes to preservation and restoration, and of fluctuations in its financial and cultural value.

Notes

1 I thank Sarah Medlam, Max Donnelly and Christopher Wilk as well as the editors of this volume for their comments on a draft of this article. The bureau was probably acquired by Baron Meyer Amschel de Rothschild (1818–74) and his wife Juliana (née Cohen) for their collection at Mentmore Towers, Buckinghamshire; by descent on the death of her father in 1874 to Hannah de Rothschild (1851–90) who married in 1876 Archibald Philip Primrose, 5th Earl of Rosebery (1847–1929); by descent to Albert Edward Harry Meyer Archibald Primrose, 6th Earl of Rosebery (1892–1974), and thereafter to his son by a second marriage, Neil Archibald Rosebery, 7th Earl of Rosebery (b. 1929); Mentmore and its contents sold at auction by the 7th Earl (Sotheby's, May 1977); the bureau intended for sale as lot 403 but acquired in advance of it by the British government in lieu of inheritance tax and transferred to the V&A.

2 The documentation relating to the V&A's involvement in the campaign is conserved by the Museum in nominal file MA/1/R1601 Lord Rosebery (Mentmore Sale) (V&A Registry).

3 For a list of Mentmore pieces newly exhibited in the galleries see 'Mentmore and the V&A' (1978), *The Burlington Magazine* 120 (902), p. 316.

4 On the new V&A galleries of European art and design 1600–1800 see the essay by Lesley Miller in this book.

5 Acquisition file W.34-1977 (V&A Registry).

6 http://www.spab.org.uk/what-is-spab-/the-manifesto/ (accessed 4 June 2014).

7 I am grateful to Yannick Chastang (independent furniture conservator, see http://www.yannickchastang.com/) who first suggested this interpretation, and to Frédéric Dassas and Calin Demetresceu (Musée du Louvre, Paris) who also supported this view.

8 Morris, see note 6.

CHAPTER TWENTY-THREE

History by Design:

The UK Board of Trade Design Register[1]

Dinah Eastop

The 'Board of Trade Representations and Registers of Designs' is a large set of records (texts, images, samples and objects) including representations (e.g. drawings, cloth samples) of nearly three million designs registered between 1839 and 1991.[2] The BT Design Register, as it is usually known, manifests relationships between the British government and commerce, design and business, and history and material culture. The following analysis highlights the richness of this resource and its distinctive features, starting with an exemplary representation: a 'map glove' made of white kid leather, with dotted lines along the fingers marking routes from east London to the Crystal Palace in Hyde Park, depicted at the wrist, with the Thames flowing along the little finger (Figure 23.1). The corresponding written records report that this design was registered by a George Shrove on 14 January 1851, three months before the first international exhibition opened at Crystal Palace on May Day that year.

The BT Design Register is held at The National Archives in the form of 11,122 volumes or boxes of folders, some weighing more than 25kg. It is primary evidence for, and a tangible outcome of, the British government's support for commerce through copyright control of registered designs.[3] This registration scheme was instituted by the Design Copyright Act of 1839, following protracted lobbying by proprietors to protect original designs from commercial piracy. Their concern is reflected in a remark incorporated into a kerchief design, registered in 1843, 'Talk of copyright of Design [. . .]

FIGURE 23.1 *Design for a glove registered by George Shrove on 14 January 1851. Courtesy of The National Archives: BT/43/422/75741.*

why they fly away with our Ideas faster than we can invent them'.[4] The aim of the registration scheme was to foster design innovation: registration gave copyright protection and so encouraged investment in design. Both 'useful' and 'ornamental' designs were registered, for many classes of materials and products, including metal, wood, glass, earthenware, paper hangings (wallpaper), carpets, and many classes of textiles including shawls and lace. The representations of designs submitted for registration take many forms: drawings, tracings, photographs, samples of the products, as well as whole artefacts, e.g. straw bonnets, collars, as well as gloves and printed kerchiefs. The Design Register is international in containing designs registered not only by proprietors in the UK, but also by proprietors in continental Europe and elsewhere, and including products designed for African and Asian markets.

As an historical resource, the Design Register has several significant features. The registers are 'name-rich' in terms of proprietors, businesses and their addresses, and the representations of the designs can include text information, e.g. the names of the British Museum, Westminster Abbey and the 'Collosseum' recorded on the glove. Sometimes the names of agents who registered designs on behalf of proprietors, and the names given to designs are recorded, as well as sizes and colour ways. The registration process required submission of two representations of each design; each was labelled with the 'unique' number allocated to the design by registry staff. One representation was retained in the Design Office and one was returned to the proprietor (or agent) with a certificate of registration; some of these representations, with certificates, are preserved in museum collections.[5] Commercially successful designs would have been produced in great numbers, and some of the resulting products are preserved in museum and historic house collections.[6] The registration scheme was judged a success by the British government because it was self-funding: the registry's costs were covered by fees charged for both design registration and for inspecting

registered designs.[7] Fees varied according to the duration of registration and the class of material being registered.[8]

The BT Design Register is arranged in six series, corresponding to the acts of Parliament which initiated and amended the scheme. Each series, except the first, is made up of two main types of record: registers containing the text record of registration, and volumes or folders of representations of the registered designs. On the 24 July 1883, McBryde, Orr & Haswell of Dragon Yard in Nottingham, registered a design for a scarf.[9] The register records that this 'scarf' (a cravat in contemporary terms) was named *THE X.L.N.T.* ('excellent' when said aloud). The corresponding volume of representations[10] includes an ink and watercolour sketch of it. Another design for a scarf,[11] *The Suez*, was registered by the firm on the same day. Further scarf designs were registered in the following year, when the firm was recorded as Tie Manufacturers, at the new address of Jewin Crescent, Nottingham. The BT Design Register is clearly an important source for the history of dress.[12]

Online access to Series BT44 (1842–1883/4) was enhanced in 2012/13 because these registers were transcribed and catalogued, and presented on The National Archives' online catalogue *Discovery*.[13] They can now be searched at an item level (i.e. by each individual design registration). Cataloguing here refers to imposing consistency in the spelling of proper names and the addition of city names where none is given in the register (as was often the case for London). For designs not identified during registration, object classifications were added to facilitate searching. Terminology can be challenging, e.g. the use of the term scarf in 1883/4 for garments that would now be called cravats, or where place names have changed.

Language is not the only challenge. Although designs were allocated 'unique' design numbers, these numbers were not unique because new number sequences were started, each starting from 1. For example, searching 'BT Design Register 7185' will identify two designs numbered 7185: the kerchief registered in 1843 showing a flying machine and a design for textile piece goods registered on 20 May 1884 by Dollfus, Mieg and Company, Calico Printers of Dornach, Alsace. Remaining alert to such anomalies is important.

Two designs for printed textiles, registered on 15 May 1874 by Robert, Thomas & James Rowat of Paisley, Scotland, are not only name-rich but also portrait-rich. The first[14] shows the British Prime Minister Benjamin Disraeli greeting Alexander Macdonald, a newly elected working-class member of the House of Commons. One corner of the design is marked 'Registered' (presumably to declare its status as a registered design) and bears the words 'W.DONNELLY Designer'. This is unusual as designers are seldom recorded in the BT Design Register, because it was proprietors who were given copyright over the designs, not designers. Only when designers were also proprietors do they usually appear in these records, e.g. the name of William Morris appears in Morris & Company.

The second design commemorates Sir Garnet Wolseley, who razed the Ashanti stronghold of Coomassie (now Kumasi) in defence of the Gold Coast protectorate (now Ghana). The representation,[15] a print on paper, shows the quarter repeat of a kerchief. When printed on cloth, the portrait of Wolseley would have appeared at each corner, with Coomassie ablaze in the centre (Figure 23.2). Recent visitors from Ghana explained that this military expedition is referred to as the 'Carnian' wars, a locally resonant reference to Wolseley's first name Garnet. They also examined other designs with links to Ghana, including a printed imitation[16] of *kente* cloth, the narrow-strip weaving for which Ghana is famous, and cotton printed with scenes of Accra[17] and another[18] with a portrait of King Taki of Accra. Each was registered in March 1908 by 'Calico Printers' based in Manchester. Delight at finding these designs in a UK archive was mixed with shock that

FIGURE 23.2 *Design for a kerchief featuring Sir Garnet Wolseley and the razing of Coomassie in 1874. Courtesy of The National Archives: BT43/320/282367.*

colonial control had extended to exerting copyright over designs derived from *kente* cloth. It is clear that designs can have contemporary political, economic and cultural salience, as well as historical significance.

From the perspective of historical research, what kinds of questions can be addressed via the BT Design Register? One answer is to identify and exploit its special features. These include the precise dates recorded for each registration (day, month, year), providing primary evidence for dating.[19] Cloth and wallpaper representations preserved with unfaded colours and original finishes provide evidence of 'as new' handle and appearance. The large number of records means it is useful for statistical analysis, e.g. comparing France and UK in terms of the number of female proprietors[20] who registered designs for 'lace' between 1842 and 1883/4. The 'name-rich' records enable changes in company name, and the location of individuals and companies, to be plotted.

Another answer is to refer to specific research, as in the following comparative study. When assessing the impact of *The Textile Manufactures of India*, the eighteen-volume sets of textile samples assembled by John Forbes Watson and published by the Indian Office in 1866, two examples of direct copying were identified[21] by referring to the material evidence provided in the BT Design Register. Comparisons showed that the design of a multi-coloured weave labelled 'mushroo' was copied in printed cotton and registered by Lyons Lord and Co. of Manchester on 11 July 1879.[22] The zigzag design of a turban (described by Forbes Watson as 'cotton, fine texture') was copied in coarser cotton and registered by Archibald Orr Ewing and Co. of Glasgow on 10 September 1879.[23] The BT Design Register provides primary evidence for exploring the history of business (institutions and their taste for innovation), design, technology (e.g. dyeing; photography), intellectual property and international trade in materials, design and products. It is also an excellent resource for the study of family and local history.

Widening access to this resource, while ensuring its long-term preservation, is a key objective of current research. Online delivery of the records has been enhanced, notably via transcription of the registers for 1842–1883/4. Options for the online delivery of the representations are being considered because of their potential to interest historians and other user-groups.[24] Evaluation of image capture and delivery techniques is underway. Several representations were recorded as polynomial texture maps (PTM), enabling viewers to manipulate lighting. When combined with the zoom facility, this allows interactive examination of materials, techniques and textures; sometimes more information can be revealed than by examining the 'real thing'.[25] Online searching of the representations directly, via the designs themselves, is the focus of current investigation, together with promoting greater interconnectivity between these records and related collections.

The BT Design Register is an extraordinary resource for history-making, manifesting the collection, organization and presentation of information in

the past and more recently. It has excellent provenance and contains name-rich, precisely dated records; it is also incomplete, inconsistent and not impartial. As an 'object of history', the BT Design Register can be explored as 'material culture',[26] understood as the interaction between things, subjects and language.[27] Exploring the BT Design Register is a process of interaction between questions asked, and its text, image and material resources. The 'map glove' can be used to generate histories of the (female) body and its social covering, glove/leather manufacture, the Great Exhibition, and of travel, map-making and souvenirs. An interactive model of 'material culture' ensures that text sources are not privileged over other sources (images and artefacts in this case). The BT Design Register is exemplary as material culture in combining text-based evidence (mainly in the registers) and material and image-based evidence (mainly the design representations) as equal, complementary and mutually dependant records.

Notes

1 I am pleased to acknowledge the support of Nancy Bell, Head of Collection Care, The National Archives; The Clothworkers' Foundation; and the Arts and Humanities Research Council.

2 For the Guide Reference to the BT Design Register: http://www.nationalarchives.gov.uk/documents/research-guides/reg-design-trademark.pdf [accessed 27 July 2014].

3 R. Prouty (1957), *The Transformation of the Board of Trade 1830–1855*. London: William Heinemann; D. Greysmith (1983), 'Patterns, piracy and protection in the textile printing industry, 1787–1860', *Textile History* 14 (2), pp. 165–94.

4 This design of 'The Flying Steam Company To China in Twenty-Four Hours Certain' was registered on 15 May 1843 by George Faulkener & Co. of Parker Street, Manchester. The National Archives (henceforth TNA): BT43/191/7185.

5 S. Tuckett and S. Nenadic (2012), 'Colouring the Nation: a new in-depth study of the Turkey Red pattern books in the National Museums Scotland', *Textile History* 43 (2), pp. 161–82.

6 For example, a kerchief featuring the flying machine design, BT43/191/7185, is preserved at the Science Museum, inv. 1938–0295. See G. Riello (2009), 'Things that shape history: material culture and historical narratives', in K. Harvey (ed.), *History and Material Culture*. London: Routledge, pp. 24–46.

7 H. L. Smith (1928), *The Board of Trade*. London: G. P. Putnam's Sons.

8 D. Eastop (in preparation for submission to *Textile History*), '"Original Designs for Ornamenting any Article of Manufacture or Substance": directions for registering and searching the Board of Trade Design Register'.

9 TNA: BT44/32/401224.

10 TNA: BT43/432.

11 TNA: BT43/432/401223.

12 See S. Levitt (1986), *Victorians Unbuttoned*. London: George Allen & Unwin.

13 http://discovery.nationalarchives.gov.uk/SearchUI/s/res?_q=BT+Design+register&_sd=yyyy&_ed=yyyy [accessed 27 July 2014].

14 TNA: BT43/320/282366.

15 TNA: BT43/320/282367.

16 TNA: BT52/60/1227.

17 TNA: BT52/60/1360.

18 TNA: BT52/60/1362.

19 See J. Halls (2013), 'Questions of attribution: registered designs at The National Archives', *Journal of Design History* 26 (4), pp. 416–32.

20 The category 'female proprietor' was added to the records during the cataloguing of 2012.

21 By Dr Sonia Ashmore, Research Department, V&A; personal communication, 30 May 2013.

22 TNA: BT43/333/337083; BT44/25/337083.

23 TNA: BT43/33/339344; BT44/25/339344.

24 For an online exhibition of 300 Victorian-era ceramic and related designs from the BT Design Register: http://www.nationalarchives.gov.uk/designregisters/aboutbt.htm [accessed 27 July 2014].

25 http://blog.nationalarchives.gov.uk/blog/capturing-and-exploring-texture/ [accessed 27 July 2014].

26 D. Eastop (2010), 'History-making and the conservation of garments concealed within buildings', in T. Hamling and C. Richardson (eds), *Everyday Objects*. Aldershot: Ashgate, pp. 145–56.

27 See podcast of the author's presentation, 'Stuff Happens', at the Gerald Aylmer Seminar 2013: http://historyspot.org.uk/podcasts/gerald-aylmer-seminar-2013-why-material-culture [accessed 27 July 2014].

Handle with Care:

The Future of Curatorial Expertise[1]

Glenn Adamson

Taking students backstage at the Victoria and Albert Museum, as I do now and again, I have many opportunities to run what we call 'handling sessions'.[2] These are much like any other classroom seminar, but with a crucial added ingredient: objects. They might be chosen to illustrate the historical development of a certain technology (ceramics) or type-form (spoons), or perhaps to pick out moments along a chronological chain – the history of drinking, for example, or gender relations. Each object is like a prop for a story, except that the object and the story it illustrates are real.

I generally sit the students around a large table, assigning an object to each of them in order to give them a sense of personal encounter, but so that each student can see the full array. Then I give them their instructions. Handle the object by all means, I say, but with a few provisos. First, hold it over the table, not over your lap, and keep it at a low height. If it falls at least it will not go far (Figure 24.1). Keep the objects far apart, lest they collide. And here is a curious rule: this may be a 'handling session', but you should never pick up a cup or a teapot or anything else by its handle. Yes, that is what they were designed for; but the join in an old handle may be very fragile. So always use two hands. Cradle the body of the thing as you turn it, examining its every detail.

As these instructions suggest, what happens in a handling session is quite different to what happens in any other encounter with objects. It is, in its

FIGURE 24.1 *Objects ready for handling. Author's photo.*

way, as mediated an experience as looking into a glass-fronted display case, or even browsing through online databases. The mediation is simply of a different kind: behavioural and psychological, rather than physical and technological. When you ask a group of students to decode the signs of manufacture on centuries-old surfaces, you are putting them in a unique subject position, vastly different from any that existed in the historical moment nominally under discussion. This is not just a matter of a temporal gulf – the divide in time that all history aims to cross. Indeed, the great advantage of handling any artefact with your hands is that it brings the past into the present in immediate and (in some cases) quite unaltered form. Rather, I am referring to the process of inspection itself. Even neophytes may attend to the details of an object's physicality much more closely than its historical owners – and in many cases, even its makers – ever did. Historical artefacts are saturated with subjectivity. In our rush to achieve an objective relation to them, we necessarily distance ourselves from that experiential dimension.

It may be controversial to say so within academic circles, but material culture simply does not demand active viewership in the way that fine art does. The very definition of the 'everyday' artefact is that it does not seem to require interpretation.[3] Whether its cultural role is oriented to use, decor, or

mere entertainment, that role is taken to be self-evident. Design history, anthropology and material culture studies, as disciplines, are in turn defined by their refusal of that presumption. They therefore employ various modes of deconstructive analysis. Where a 'typical' user simply drinks out of a much-loved teacup, taking care not to break it, the design historian tries to crack its code.

Collection management

If curators are lucky, and not consumed in the myriad tasks of administration and communication, they spend their days in constant interaction with objects. Yet they almost never touch, use, or even look at these things in such a way as to reconstruct historical *mentalité*. The same is true for dealers, collectors and auction house specialists. Think of the stereotypical postures adopted by all these various connoisseurs: peering through a magnifying glass to read a silversmith's hallmark; crouching down indecorously beneath a cabinet, so as to shine a flashlight on its underside; or simply turning a garment inside-out and examining its seams (Figure 24.2). In all of these situations, the examiner departs radically from what we might cautiously call 'everyday' ways of seeing.[4]

Recent technological advances have made possible ever more extreme forms of such active looking. Conservators now avail themselves not only of magnifying glasses, X-rays, and ultraviolet and infrared lighting, but also high-resolution photographs that can be enlarged to reveal more detail than the human eye can normally perceive. Images can also be altered in order to create an impression of an artefact's original state – so that, oxymoronically, they are closer to the truth than reality itself.[5] The National Archives in London is set to launch a new online interface that provides the further enhancement of digitally-simulated raking light, which gives the user the sense of a document, textile, coin, wax seal, or garment's surface texture.[6]

A particularly striking example of enhanced vision, which far outstrips the view of an object that any period user could have had, is the recent set of interpretive films produced by the Metropolitan Museum of Art on the occasion of an exhibition on the eighteenth-century French cabinetmaker Abraham Roentgens and his son David.[7] These animated clips, each about two minutes long, show the construction methods, secret compartments, moving parts, and other features of the Roentgens' complex and exquisite objects. The production values are astonishingly high, and the experience of watching the films (even online on a home computer) is both edifying and mesmerizing – comparable to a special effects sequence in a Hollywood film. Perhaps they are to our own day what the furniture of Roentgens *père et fils* was to theirs: a box of tricks meant to inspire wonder. But here's the thing: if you spend any time in the Metropolitan's show, you'll immediately notice that visitors spend a lot more time watching the moving screens than the

FIGURE 24.2 *Chair, c. 1780–90, attributed to George Jacob and Jean-Baptiste-Claude Sené, viewed from below to show original upholstery substructure. V&A 1086-1882.*

objects that they are intended to interpret. It is a fact every curator knows: a static artefact, no matter how beautifully made, stands no chance against a moving image.

So for all the obvious merit of these interpretive videos, they do erode the priority of the artefact within museum experience. Like the eyepiece-wearing, floor-scuttling behaviour of curators, they present material culture from an entirely artificial, and exterior, position. In such cases, the 'screen' of a television or computer lives up to its name. It pretends to the status of a transparent window, through which neutral and objective inspection takes place, putting the viewer at an indeterminate but lofty Archimedean point from which art and history can be surveyed. In actual fact, however, the screen is a tightly constructed filter through which only certain information will pass. Information and images are catapulted from the museum into the digital sphere only when they have been deemed sufficiently coherent, digestible, or entertaining, worthy of delivery through an increasingly elaborate and costly production system.

We cannot understand museums without realizing the deep-seated motivations at work here. So strong is our association of professional expertise with these optical transformations that we might hazard a hypothesis: it is the very artificiality of the way curators look at objects, the difference between the way they treat objects and the way objects are treated in everyday life, that underpins claims of expertise over material culture. As a profession, curation is premised upon a presumption of extraordinariness.

Further suggestive indications on this point are to be found in *unauthorized* ways of relating to historical objects, which seem invariably to involve using a thing more or less as it was intended to be used. The simplest and most obvious example is just touching an object, which is enough to get you chastised sharply in most museums. A favourite story of mine was related to me by a student interpreter at Winterthur, the great repository of early American decorative arts in Wilmington, Delaware. On one occasion, in a room devoted to seventeenth-century furnishings, the guide had launched into an explanation of some ceramic and silver objects. She spoke for some time, facing away from her audience, then turned around in order to point out a unique (and therefore extremely precious) survival within the collection: a so-called 'form' or joined bench made of oak, probably dating to the 1630s. Imagine her surprise when she saw that the members of her tour group were already sitting on it like a row of ducklings, waiting politely for her explanation. Of course she asked them to stand up and not to touch, which prompts the question of who was using the bench properly – them or her?

As it happens there are examples of museums allowing visitors to use the furniture in their collections. The project 'Please Be Seated', pioneered by curator Jonathan Fairbanks at the Museum of Fine Arts Boston (MFA) beginning in 1975, involved the commissioning of benches and chairs from prominent contemporary craft makers, such as Sam Maloof and Wendell

Castle. According to Fairbanks, his colleagues at the MFA were initially horrified at this idea, fearing that it would seem an open invitation to visitors to physically interact with everything else in the museum too, with disastrous consequences in conservation terms. In fact the opposite occurred. As if their itch to touch had been scratched, incidences of visitor-induced damage actually decreased.

Fairbanks's 'Please Be Seated' programme has been widely imitated at other decorative art museums, with equally positive results. Somewhat less commonplace, but by no means rare, are instances in which artists or members of the public are permitted to 'handle' collection objects as part of an installation or performance. These range from tours arranged for blind visitors, who are encouraged to touch the surfaces of sculpture or decorative art objects under supervision, to instances in which curators stage concerts using the historic instruments under their care so that audiences can hear them. Interestingly, some stringed instruments are more difficult to preserve when they are *not* used – as they were designed to be held constantly at a certain tension.[8]

Then there is the tradition of putting objects to use as a form of institutional critique, a strategy that builds on Fred Wilson's much-cited (though entirely non-interactive) exhibition 'Mining the Museum,' staged at the Maryland Historical Society in 1992, by including a 'live' element. In 2012, for example, the applied arts curator at the National Museum of Wales, Andrew Renton, sat down to tea with the artist David Cushway – using an early-nineteenth-century ceramic service in the museum's collection (Figure 24.3).[9] Renton has spoken of his initial visceral discomfort with the experience, and indeed the ingenuity of the project was its play on tea drinking's historical associations with relaxed conviviality.[10] A museum may be welcoming, but it is not hospitable in this domestic sense, and Cushway exposed this fact in no uncertain terms. In this sense his project did constitute a gentle form of institutional critique; but it was a rather controlled experiment. One might say that rather than eroding the museum's usual moratorium on use, he simply directed momentary attention to that condition, staging a single exception that did not challenge the rule.

For a more thorough shattering of the fourth wall between a museum collection and everyday use, one must turn farther afield, and to a situation that verged on outright pillaging: Sergei Bondarchuk's epic film version of Tolstoy's *War and Peace*, released serially in the Soviet Union in 1967. Though little remembered today, at the time the movie was the most expensive ever realized. The heavily propagandistic production was made in direct response to an American version of the novel, starring Audrey Hepburn, which had been dismayingly popular in Russia. The Soviet state considered their own version to be of such importance that hundreds of thousands of military personnel were set to work as prop-makers and extras. A defunct cavalry regiment, complete with replica saddles and harnesses,

FIGURE 24.3 *David Cushway,* Tea at the Museum, *National Museum of Wales, 2012. With curator Andrew Renton.*

was reinstated for the battle scenes. Every scene was shot on location, sometimes in the very palaces where Tolstoy had set his action. And the furniture? Requisitioned, along with the china, crystal chandeliers, and innumerable other items from the national collections at the Hermitage and other museums.

Public affairs

It is difficult to imagine any curator today countenancing such goings-on. The V&A does routinely field inquiries from art directors interested in borrowing a particular historic dress or chair for a shoot, and the answer is always no. The restrictions on the use of museum objects are not just exclusionary for the sake of it: the primary motivation is to protect. No curators wish to imperil the collection under their care. Yet twenty-first-century museums do balance the costs and benefits of preserving and using their collections. Curators know much more about the impact of light, dust and other forms of environmental damage than their predecessors did; at the same time, a global industry of touring exhibitions and high-profile loans, pressure to keep 'star objects' on view, and a desire to put things on open display rather than behind glass, are all strong inducements to run risks (Figure 24.4).

FIGURE 24.4 *Michael Elmgreen and Ingar Dragset, 'Tomorrow', 2013. V&A.*

To some degree, the dynamic that I am describing is familiar from debates about urban heritage. Should cities prioritize the extant architectural remains of the past, or change with the times?[11] Yet there is a different sort of imperative at work in the contemporary museum, in that curators increasingly are encouraged to promote their collections, through any and every means available. It has become almost a cliché to observe that museums worldwide are becoming more like other fixtures in the culture industry – such as shopping malls, theme parks, entertainment complexes and hotels.[12] This gradual 'spectacularization' has been a dictating factor in recent museum practice, and the V&A is by no means immune to the phenomenon. 'Hollywood Costume' is perhaps the most conspicuous recent example. This wildly popular exhibition was the brainchild of guest curator Deborah Nadoolman Landis, an experienced costume designer in her own right who brought to the project a rare combination of deep research and showmanship.[13] It presented the audience with a potent combination: the authenticity of original artefacts, and the manufactured artificiality of celebrity culture. As part of the rollout for the show the museum came close to breaking its own rules, commissioning a photographer to create a panoramic view of several garments much as a commercial art director might do. The image, which irresistibly recalled group shots of celebrities by Annie Liebowitz, was used not only on the cover of the *V&A Magazine*, but also ran in *Vanity Fair* (Figure 24.5).

FIGURE 24.5 *Garments from the V&A exhibition 'Hollywood Costume'. © V&A Magazine / Michael Roberts. Appeared on the cover of the Autumn/Winter 2012 issue of V&A Magazine: The Hollywood Issue.*

'Hollywood Costume' was hardly the V&A's first venture into the display of celebrity culture. In addition to monographic exhibitions on Kylie Minogue, Grace Kelly, and The Supremes, there was 'Postmodernism: Style and Subversion 1970 to 1990', which I co-curated in 2011 with Jane Pavitt. For reasons both theoretical and tactical, we chose to re-centre our story away from historicist architecture and avant-garde fine art, which had normally been treated as the core of postmodernism, and instead place pop music, graphics and performance at the heart of the show. Thus we chose, for our lead image for the project, a 1978 shot of Grace Jones, regal in an extraordinary neo-Constructivist maternity dress designed for her by Jean-Paul Goude (Figure 24.6). (Her partner and style guru at the time, Goude was also father of her soon-to-be-born child.) The ensemble was ephemeral, worn at a single performance by Jones at a nightclub in New York City. In fact 'worn' is probably not the right term – the construction was more like a podium, which Jones stood inside. It was fabricated of cardboard and felt, and open at the back so that she could slip out immediately after singing her number, and retreat backstage for a costume change. Thus the image that we used was already, from the beginning, a piece of stagecraft. That false-front mentality was completely consistent with postmodernism (a movement that prioritized surface effects over traditional conceptions of depth and substance) and also with the demands of a museum press campaign. For the exhibition, we recreated Goude and Jones' bodily façade using more permanent materials – felt-lined aluminium panels – and placed it high above the audience.

The reconstructed Jones ensemble was exhibited in the largest and most expensively produced space in 'Postmodernism', alongside costumes and video of other postmodern performers such as David Byrne, Laurie

FIGURE 24.6 *Grace Jones in a 'maternity dress' designed by Jean-Paul Goude,*
1978.

FIGURE 24.7 *'Strike A Pose' gallery in* 'Postmodernism: Style and Subversion 1970 to 1990', *at the V&A, 2011. Designed by APFEL (2D) and Carmody Groarke (3D).*

Anderson, Grandmaster Flash and Devo (Figure 24.7). Jane and I were very aware of presenting material that had been of obsessive interest to ourselves as teenagers, and of course the same goes for the audience. I imagine that many visitors to the exhibition knew a great deal more about the pop material we included than we did ourselves, and this dynamic is being repeated again and again at the V&A.

Access, inclusion and diversity

As museums have begun to take on pop culture, we are indeed presenting design in a manner analogous to its original purposes – but with much greater consequences than allowing visitors to sit on a bench. A teapot in a museum display case is displaced, put out of commission. Grace Jones' stage costume on a platform under hot lights, on the contrary, is right at home. In 'museumifying' Jones, we have not so much decontextualized her performance as amplified its effects, lending our cultural capital to hers – and gaining a great deal in return. Jones certainly did not require a platform like the V&A to validate her work. The music industry and its many derivatives dwarf the museum sector, and she has always been an expert in navigating that terrain. As far as I know, she never did come to see 'Postmodernism'.

Thus far I may sound dubious about the incursion of pop material into the museum, but that is not the case. I believe firmly in the benefits this move

brings to institutions such as the V&A, not least because of the healthy challenge this encounter poses to the traditional detachment of curatorial authority. As I mentioned above, one often-unnoticed corollary of museum forays into pop culture is that visitors may well know as much about the material on display, or perhaps even more, than curators do. Alongside this tendency, several other trends are similarly introducing parity into the traditionally asymmetrical relationship between curators and their audiences. Detailed factual knowledge can no longer be considered the province of the museum professional. Anyone with access to the internet is already able to call up more information about what is on show than can practicably be included in wall texts. This new world of knowledge-on-demand has prompted large museums in particular to make collections available online.[14]

As massive as this effort has been, there can be little doubt that it is only a first step. As we know from the example of Wikipedia, crowdsourcing can be (though is not necessarily) superior in both quantity and quality to sole authorship. If museums were more willing to cede partial authorship to their audiences, moderated 'wiki' structures could allow online readers to add content to catalogue records, and construct aggregated search engines that would hyperlink different museum collections to one another. In the future, these initiatives (and others currently unimaginable) will certainly be put in place, and they will have the cumulative effect of further relativizing curatorial expertise. In years to come, the museum's privileged relationship to the original artefacts under its care may well evaporate. Our objects may even come to seem like gateways, rather than endpoints – doorways into an increasingly rich, beguiling, and thoroughly mediated experience of access.

Lost and found

I have been arguing that even the most direct forms of museum access already involve displacement and distortion, and that these effects are becoming more multivalent and powerful with every passing year. But it is also important to stress that this is no bad thing. Once we acknowledge that museums are as much about mediation as they are about authenticity, we are able in turn to abandon the fantasy that they afford an 'immediate' experience. Instead, we can see the museum clearly as a site of cultural production, which is anything but neutral.

This leads me to the more explicit question of the politics that inevitably attend object display. One of the most important divergences in twentieth-century museology is the deep divide that has existed between the tradition of the Readymade, initiated by Marcel Duchamp, and standard gallery displays of decorative art. It is a startling and little noticed fact that the two situations are more or less identical: someone (artist or curator) selects an object from the field of everyday things, and displaces it into a display

environment. What differs is the way the object is mediated. In the case of the Readymade, it is presented as a 'work,' authored by an artist (whether or not it has been altered, or to use Duchamp's term, 'assisted'). In the case of a decorative art object, the museum may or may not attribute it to a specific maker; but the act of displaying it will certainly not be presented as a form of authorship. This simple difference has profound consequences. Indeed, the neo-Duchampian artist and the decorative art curator occupy the far extremities of art world politics. The Readymade occupies a central role in the reflexive critique that is crucial to avant-garde practice.[15] The *objet d'art*, by contrast, acts as the locus for the most conservative aspects of museum practice: connoisseurship, provenance and elite patronage. Practically speaking, the two curatorial strategies are identical. Ideologically, they could not be more opposed.

Against this backdrop of stark division, it is salutary to recall that when Duchamp scandalized the art world with his *Fountain* – a found urinal upended and set on a plinth as if it were a sculpture – the progressive director of the Newark Museum, John Cotton Dana, had recently exhibited a range of locally made sanitary porcelains (including toilets) in his galleries. For Dana, this was a way to continue the affirmative project of industrial art education that had begun in South Kensington half a century earlier, under the leadership of Henry Cole. This is not the place to review the extensive literature on Duchamp, but as John Roberts has recently written, one of his intentions was to direct attention to the same field of productive labour that Dana was trying to explore.[16] By exhibiting a work of 'industrial art', Roberts argues, Duchamp was dissolving the illusory boundary that is traditionally drawn between art-making and other forms of work.

It is fair to say that the parallel projects undertaken by Dana and Duchamp – both of which drew attention to the world of everyday production – have yet to be fully realized. In 1917 Dana wrote a pamphlet entitled *The Gloom of the Museum, With Suggestions For Removing It*, in which he argued that museums should be seen alongside other places, like department stores, commercial galleries, cinemas and factories, all of which offered equally valid ways of learning about objects. In this context, the museum was valuable to its audience primarily because it could 'broaden their sympathies and multiply their interests'.[17] This continuity with other cultural sectors is exactly what museums like the V&A are experiencing today.

Technical services

I do not mean to suggest that celebrating celebrities is the only (or even the best) route forward for the progressive-minded curator. Another model is the recent V&A exhibition, 'Power of Making', curated by Daniel Charny and organized in collaboration with the Crafts Council. The premise of the

show was simple: to build a contemporary cabinet of curiosities showcasing skilful, innovative and ingenious making. Charny packed 108 objects into a gallery normally used to show 40 or 50; and though few of the things on view had significant name-recognition (there was no celebrity factor here), the exhibition was one of the most popular in the museum's history (Figure 24.8). What accounted for this enthusiasm? Doubtless, there was an element of good timing. Economic downturns tend to prompt a return to the autonomy and security that people associate with craft. The ever-encroaching world of the digital, similarly, inspires an equal and opposite attraction to solid materiality. Yet I think there was another reason for the success of 'Power of Making': it was a thoroughly egalitarian space. Objects were shown without any sense of hierarchy. 3D printers were shown alongside traditional dry-stone wall construction, without any implication that one of those technologies was superior to the other. The work of amateur hobbyists mixed freely with that of highly-trained professionals.

Charny's approach in 'Power of Making' was a real lesson for me. I have long been suspicious of purely celebratory attitudes to craft, so I did have some misgivings about the simplicity of Charny's message, which might be summarized as making is good for you, so why not give it a try? That clarity was clearly a big part of the project's success. But even as I have absorbed that message, for me it was the 'super flat' structure of 'Power of Making' that was most influential.[18]

In a recent curatorial side project I attempted a response. Entitled 'Fix Fix Fix', the show investigated the art of repair, pursuing that theme through an associative chain of thinking.[19] Some of the objects on display were by artists, who had been asked to respond to a brief. The challenge I set was to repair an existing object, prioritizing respect for that thing rather than the expressive opportunity that found objects normally offers an artist. On my part, this was a conscious variation on the 'assisted readymade' – I wanted to adhere to a professional standard of repair, which one might call 'anti-expressive' (just as Duchamp's objects were). The perfect fix, after all, would restore the broken object to its original state, erasing the evidence of the repair in the process. That is only ever an ideal – even the most skilled restorer cannot turn back time – so fixing is always a matter of approximation. But even so, repair tends to erase itself, all the more so when it is done well.

With these thoughts in mind, alongside the commissioned art works in 'Fix Fix Fix' I introduced several everyday artefacts that marked out positions in the world of repair. This was a direct application of Charny's method of levelling the playing field. To drive the point home, I decided to withhold identification of the objects from the audience. When viewers encountered a Jeep motor in the middle of the gallery, or a set of nineteenth-century mounts that could be used to repair a piece of French court furniture, or a Japanese porcelain box skilfully mended with lacquer and gold, or the

FIGURE 24.8 *'Power of Making', at the V&A, 2011. Designed by Oscar & Ewan (2D) and Caroline Sjoholm (3D).*

frame of a grand piano hanging in a custom-fabricated steel truss, they were not necessarily aware of the status of these objects (Figure 24.9). Were these things artworks, or not? I wanted to forestall an answer to that question, in the hope that the question itself would come to seem irrelevant.

Furthermore, I wanted to infuse the exhibition with a complex range of emotional tonalities. These were present in 'Power of Making' too, if you looked hard enough, but I think that the smaller scale and tighter focus of 'Fix Fix Fix' yielded a more intense (and possibly contradictory) psychological environment. There was certainly outright celebration in the show – not least in a video made under the aegis of Charny's new undertaking, Fixperts. Founded together with James Corrigan, and now involving a global team of contributors, Fixperts is a social project of sorts. It involves pairing up design professionals with people whose lives can be improved through some kind of fix. This could be as simple as a custom-made wheelchair cushion, or as elaborate as a completely redesigned kitchen. The point of the project is to illuminate the rich connections that are brought into being by such maker/client collaborations. But elsewhere in my show there were other notes struck. That bundle of furniture mounts I mentioned, displayed in a wrapping of paper and string just as I found them in storage at the restoration shop Arlington Conservation, resembled a Dada sculpture (Figure 24.10). While appropriated (by me, not by an artist) from a non-art context, it was the object in the show that most strongly suggested a Duchampian aesthetic.

FIGURE 24.9 *'Fix Fix Fix', at Gallery SO, London, 2013. Photo: Sipke Visser.*

The Jeep motor, by contrast, evoked the world of the working-class tradesman and also another historical exhibition context, the Museum of Modern Art's 1934 show 'Machine Art', which helped to introduce a taste for industrial forms that persists to this day (Figure 24.11).

The porcelain box indexed yet another well-established aesthetic – the reverence shown to precious ceramics in traditional Japanese culture. In that context, an object that has been broken and repaired may actually become more valuable, because a moment in its lifecycle has been enshrined. Hence the gold repair, known in Japan as *kintsugi*: an accident permanently fixed in a resplendent material. The piano frame, finally, I extracted from a repair project being undertaken by amateur craftsman Steven Probert. He had inherited the instrument, a grand piano made at the turn of the century by well-regarded Boston firm Mason and Hamlin, and over the course of many years has dismantled it and remade it to his own exacting specifications. The lengths to which he has gone to achieve the perfect sound are remarkable – not least, in building a steel A-frame to give himself access to all its surfaces, which he has reworked fastidiously, in-filling each nick, scrape or dent with a custom-fashioned inlay.

Walking around 'Fix Fix Fix' once it was finished, I realized that I much preferred these various 'non-art' objects over the works I had commissioned: they seemed to me more strange, more aesthetically intense, more provocative. This is not to say that artists cannot achieve all these qualities; just that the

FIGURE 24.10 *Furniture mounts included in 'Fix Fix Fix'. Lent by Arlington Conservation. Photo: Sipke Visser.*

world already offers them, if we know where to look. As modest as 'Fix Fix Fix' was in comparison to any V&A show, including 'Postmodernism', I feel that it was just as effective in outlining an ecumenical curatorial methodology, in which every object is handled equally. This methodology has become more and more common in recent years, though decorative art curators have certainly not been leading the way. It was specialists in African and Native American art who were among the first to embrace the idea that artefacts should not just be collected and explained, but rather should be given a second life through the mediating act of display.[20]

This idea of equivalence among objects, in which artworks are not prioritized over other forms of material culture, has been embraced by museums of all kinds. As mentioned above in relation to the V&A show 'Power of Making', the early modern cabinet of curiosities has become a common point of reference for curators. Objects are increasingly presented in a way that emphasizes their potential to enchant.[21] This does not necessarily mean doing away with explanation entirely (though it may entail something as radical as that), but it does mean that curators are thinking about the affect of their displays on other registers. Their own craft of exhibition-making is becoming more akin to the performance of a magician than the detailed report of an anthropologist.

Such currents in museology may be the latest thing but they are also a return to older ways of thinking, which tries to correct for some of the

FIGURE 24.11 *Jeep Motor included in 'Fix Fix Fix'. Lent by Park View Motors. Photo: Sipke Visser.*

weaknesses of twentieth-century display methods. For most of its history, the avant-garde has suffered from a degree of hypocrisy, in that it espouses radical politics while in practice establishing itself as an exclusive elite. Museums that collect and display material culture are equally guilty: they pretend to the values of progressive universal education, but in fact tend to re inscribe existing patterns of power and prestige. The problem that besets both of these approaches is their pretension to neutrality – as if one were gaining direct access to an artist's ideas or an object's history. A truly democratic approach to curating will, instead, clearly express its own status as a form of authorship. Curators must recognize that their trade always involves acts of appropriation, in which meaning is ascribed and produced, not merely communicated.

The possibilities afforded by digital technology will multiply and deepen the implications of this condition. Will museum-based expertise become ever more diluted, dispersing itself in the vast sea of networked culture? Or will the potency of digitized artefacts (and those that were born digital in the first place) help museums to expand their cultural influence to a degree previously unimaginable? What will decide this question, ultimately, is the degree to which curators are willing to reimagine the museum: not as an isolated tower, dedicated to objective knowledge and permanent preservation; but as a platform of informed and subjective exchange, ever-changing. The museum is not a refuge. It is a place to encounter the world in a state of heightened attention.

Notes

1 J. Berger (1972), *Ways of Seeing*. London: BBC/Penguin. This essay is based on a paper originally delivered at the Gerald Aylmer Seminar 'Why Material Culture?' on 22 February 2013. I would like to express my thanks to the other participants, especially Giorgio Riello and Mark Jones (former director of the V&A) for their contributions to the event, which in turn have influenced my approach here.

2 Until 2012, when I took up my present position as Head of Research at the V&A, I was Head of Graduate Studies. In this capacity I was the co-leader of a Course in the History of Design, collaboratively offered with the Royal College of Art. I continue to teach occasional sessions on the V&A/RCA Course.

3 B. Highmore (2001), *The Everyday Life Reader*. London: Routledge.

4 Berger, *Ways of Seeing*.

5 An example is the celebrated photographic project of the Unicorn Tapestries now at the Cloisters in New York City. See R. Preston (2005), 'Capturing the unicorn', *The New Yorker*, 11 April.

6 Personal communication with Dinah Eastop, The National Archives, 15 March 2013.

7 'Extravagant Inventions: The Furniture of the Roentgens'. See http://www.
 metmuseum.org/en/exhibitions/listings/2012/roentgen (accessed 10 March 2013).

8 The Art Institute of Chicago is unusual in having a permanent gallery
 dedicated to tactile exploration for the blind, the Elizabeth Morse Touch
 Gallery; an example of a 'performing' musical curator is Darcy Kuronen at the
 Museum of Fine Arts, Boston.

9 See M. Tooby (2012), 'Some relationships between ceramics, sculpture and
 museum taxonomies', *Interpreting Ceramics* 14, http://www.
 interpretingceramics.com/issue014/articles/04.htm [accessed 27 July 2014].

10 A. Renton (2013), 'Deposits and withdrawals at the "collective memory
 bank": ceramic artists and the National Museum of Wales', lecture at the
 symposium 'Interpreting Collections: Idea, Object, Site', Freud Museum,
 London, 26 January.

11 See the journal *Future Anterior*, edited by Jorge Otero-Pailos and published
 biannually by the University of Minnesota Press.

12 C. Duncan (1995), *Civilizing Rituals: Inside Public Art Museums*. London:
 Routledge.

13 See D. Nadoolman Landis (2013), *Hollywood Costume*. London: V&A
 Publishing.

14 In the V&A's case much effort has centred on the provision of a Search the
 Collections service, which provides (at the time of writing) about 1.1 million
 catalogue records, about 25 per cent of which include one or more images of
 the artefact.

15 On autonomous criticality as the core of avant-garde practice, see T. Adorno
 [1970], *Aesthetic Theory*. London: Routledge and Kegan Paul. See also P.
 Bürger [1974], *Theory of the Avant Garde*. Minneapolis: University of
 Minnesota Press.

16 J. Roberts (2007), *The Intangibilities of Form*. London: Verso. See also J. Roberts
 (2013), 'Temporality, critique and the vessel tradition: Bernard Leach and Marcel
 Duchamp', *Journal of Modern Craft* 6 (3), pp. 255–66, and the response by
 Shales in E. Shales (2013), 'Evacuating Duchampian conjecture in our age of
 digitally reproduced scholarship', *Journal of Modern Craft* 6 (3), pp. 267–74.
 For a contrasting approach, which presents Duchamp's Fountain in terms of
 theoretical nomination rather than as a commentary on labour, see: T. de Duve
 (1996), *Kant After Duchamp*. Cambridge, MA: MIT Press/October Books.

17 J. Cotton Dana (1917), *The Gloom of the Museum, With Suggestions For
 Removing It*. Woodstock, VT: Elmtree Press, p. 30.

18 I allude here to the artist Takashi Murakami's exhibition and book 'Super Flat'
 which exhibited a more gimlet-eyed, but equally capacious, curatorial attitude
 in relation to everyday visual culture. See *Super Flat* (2009). Tokyo: Madora
 Shuppan. Also worthy of note here is Constantin Grcic's exhibition at the
 Serpentine Gallery, 'Design Real' (2009), which claimed exemplary status for a
 diverse miscellany of everyday objects.

19 'Fix Fix Fix' was on view at Gallery SO, a small but beautiful brick-walled
 space (a former mercer's storehouse, as it happens) in the East End of London,

from 14 February to 24 March 2013. Here I would like to acknowledge the
contributions of Christopher Thompson Royds and Felix Flury in the
conception and execution of the project, and the many lenders to the
exhibition.

20 See A. Gell (1996), 'Vogel's net: traps as artworks and artworks as traps',
 Journal of Material Culture 1 (1), pp. 36 and 37.
21 Among the many other recent exhibitions that have been motivated by this
 way of thinking, which run right across disciplinary boundaries, are 'Curiosity'
 (Turner Contemporary, Margate, 2013), curated by Brian Dillon; 'Alexander
 McQueen: Savage Beauty' (Metropolitan Museum of Art, 2011), curated by
 Andrew Bolton; 'The Uncanny Room' (Pitzhanger Manor, 2002), curated by
 Tessa Peters and Janice West; and 'Devices of Wonder: From the World in a
 Box to Images on a Screen' (J. Paul Getty Museum, 2001), curated by Frances
 Terpak and Barbara Maria Stafford.

Further reading

Adamson, G. (2013), *Invention of Craft*. London: V&A/Bloomsbury.
During, S. (2002), *Modern Enchantments: The Cultural Power of Secular Magic*.
 Cambridge, MA: Harvard University Press.
Gell, A. (1992), 'The technology of enchantment and the enchantment of technology',
 in J. Coote and A. Shelton (eds), *Anthropology, Art and Aesthetics*. Oxford:
 Clarendon.
Landy, J. and M. Saler (eds) (2009), *The Re-enchantment of the World: Secular
 Magic in a Rational Age*. Palo Alto: Stanford University Press.
Preziosi, D. and C. Farago (2004), *Grasping the World: The Idea of the Museum*.
 Aldershot: Ashgate.
Shales, E. (2010), *Made in Newark*. New York: Rivergate.
Shales, E. (2011), ' "Decadent plumbers porcelain": craft and modernity in ceramic
 sanitary ware'. *Kunst Og Kultur* (*Norwegian Journal of Art and Culture*) 94 (3).

CHAPTER TWENTY-FIVE

As Seen on the Screen:

Material Culture, Historical Accuracy and the Costume Drama[1]

Hannah Greig

If anything puts 'period' into a period drama it is surely material culture. In film and television productions, costumes, sets and props make the past look suitably distant, whilst at the same time their visual cues help the audience establish precisely where in the past the drama is set. In this regard, the material culture of a period film has enormous persuasive and illusionary power; deployed on the one hand to generate a range of recognizable pasts with ease and rapidity, but on the other hand acting as a visual index of change, the token of the strangeness or exoticism of the bygone time into which we – as present-day viewers – are invited. It is often presumed by filmmakers, audiences and critics alike, that the essence of historical authenticity lies primarily (if not exclusively) in material detail.

When working as a historical adviser, I am regularly asked with great earnestness to consult on the 'appropriate' content of a patch box, the 'correct' fluttering of a fan or the most 'accurate' shade of powder for pre-1786 men's wigs. Although it is not unknown, it is certainly much rarer for specialist historical advisors to be consulted on questions of character, context and narrative. Indeed, such is the overarching emphasis on material realism that film consultancy is often presumed to demand a craft-based skill in re-creation or a 'curatorial' expertise in period-precise objects. But

how successful can a drama really be in recreating a past material environment? And what are the wider implications of elevating material culture as the principal measure of historical accuracy? This essay considers the place of material culture in historical costume drama, to explore the potential – as well as the pitfalls – of communicating information about a material past through visual media.

Film, visual and material culture

Although visual interpretations of history – whether through documentary or drama – are now a long-established and highly successful genre of film-making, many academic historians remain uncomfortable with them and unsure about film's analytical merit. It is over two decades since the *American Historical Review* published a special issue on film and history. The contributors explored the extent to which history could be appropriately or adequately conveyed on film, flagging problems of chronological compression and dramatic invention, while also calling for more substantial intellectual engagement with the benefits that visual interpretations of history might bring to the discipline.[2]

As Robert Rosenstone noted in his opening essay: 'the history that finally appears on the screen can never fully satisfy the historian as historian (although it may satisfy the historian as filmgoer). Inevitably, something happens on the way from the page to the screen that changes the meaning of the past as it is understood by those of us who work in words'.[3] Nonetheless, he argued, although history shown through film could never be the same as history written in books, many of the academic criticisms levelled at films could be levelled with equal certainty at text-based history. After all, both are representations rather than 'realities' of the past. Academic writers and film-makers are both forced to make choices and compromises in their narratives about which events to highlight, what information to condense, what to celebrate and what to critique. And both have to operate within the constraints of their respective media. In these areas, then, film is not uniquely impoverished in comparison to the written word. Of course, where film diverges significantly is in the treatment of uncertainty and debate. Film, as many scholars have repeatedly asserted, has no footnotes. Historians can layer books with caveats and references, with questions and argument, in a way that the celluloid narratives cannot.[4]

A key point that Rosenstone and others returned to in these early debates was whether the different way in which film presented history in comparison to how books presented history was necessarily 'bad'. To argue that written history was automatically 'better' or more 'accurate' overlooked the unavoidable compromises that had to be made to translate the past into words. No writer, for instance, could fully convey all the details of a battle scene or quote verbatim from every single primary source consulted.

Moreover, arguably film might be more suited to communicating certain aspects of history than books. And if there was any one area in which film could excel in its translation of history it was surely material history. Historic objects, many have argued, are better seen than described. As David Herlihy noted in the same special issue: 'films are superb in representing the visual styles and textures of the past – values almost impossible to convey in written words'. 'Let the visual serve the visual', he urged.[5]

If we accept that film might be a suitable vehicle to capture and interpret our material past in a meaningful way, then perhaps the emphasis that period productions place on 'accuracy' of material detail is to be encouraged and applauded. On film, things can be shown in motion. Period objects are depicted in use, quills in hand, letters being opened, guns being shot. Period dress is worn by moving bodies, where it becomes creased, dirtied, where it beautifies and attracts attention. Not least, films demand a thick description of the material environment that is arguably impossible to replicate through words. Stanley Kubrick said of his period epic *Barry Lyndon* that it 'offered the opportunity to do the things that movies can do better than any other art form, and that is to present historical subject matter. Description is not one of the things that novels do best, but it is something that movies do effortlessly'.[6]

Such a privileging of material culture is not without risk. In particular it risks equating history to surface detail and implying – whether intentionally or not – that what separates the past from the present is simply a matter of set dressing. In addition, it is necessary to keep in mind that the period 'look' of a film is informed not only – and sometimes not even nearly – by history, but rather by the conventions and preconceptions of period drama as a genre. Amongst costume makers and set designers, Christine Edzard's *Little Dorrit* (1988) is regarded as a landmark production due to its insistence on historical detail and carefully researched 'authenticity'. For historians, however, *Little Dorrit* foregrounds a highly sanitized and picturesque view of Victorian poverty.[7] In this regard, despite apparent attention to period details, it is often what modern society expects (or would like) the past to look like rather than what historical scholarship might suggest the past looked like which more often than not defines the visual conventions of film.

What makes a duchess? Architecture, interiors and interiority

A useful example of some of the competing agendas that inform a film's material culture is the feature film *The Duchess* (2008), for which I acted as historical adviser. Set in the late eighteenth century, *The Duchess* explores some aspects of the life of Georgiana, Duchess of Devonshire (1757–1806). Based on Amanda Foreman's best-selling and prize-winning biography, the

film was directed by Saul Dibb and starred Keira Knightley as Georgiana and Ralph Fiennes as her husband, William Cavendish, Duke of Devonshire. As Foreman's biography (and underlying PhD thesis) examined, the Duchess of Devonshire enjoyed titanic celebrity in Britain from the 1770s onwards due to her power as a leading political hostess for Charles James Fox's opposition Whig party, and her notoriety as a leader of fashion, member of the *beau monde* and high society *doyenne* (Figure 25.1).

The biography followed a traditional cradle to grave narrative arc, one that set out to understand and highlight the duchess's political role and power.[8] The film, in contrast, sampled only a part of the duchess's life and focused almost exclusively on her personal relationships, most particularly the notorious Devonshire House *ménage à trois* (in which the duchess shared her home with her husband and her husband's mistress, Lady Elizabeth Foster), and her affair with Whig politician Charles Grey (played in the film by Dominic Cooper). In Dibb's own account, the driving agenda of the film was more than a salacious story. With a background in documentary films, and *Bullet Boy* (a gritty exploration of gun culture in contemporary London) his only cinematic feature prior to *The Duchess*, Dibb was not so much interested in making 'just' a period drama but, rather, in using *The Duchess* as a way to explore the personal relationships of these eighteenth-century celebrities with a documentary eye (Figure 25.2).[9]

The focus of the film are therefore the private lives played out within the otherwise familiar setting of the Georgian elite's country houses, wealth and public notoriety. As a character-based narrative, *The Duchess* does not seek to explore a specific historical event. Indeed, although locations are sometimes specified on the screen (to help the viewer navigate their way from Chatsworth to London to Bath), no dates are ever cited. The majority of scenes, the characters' actions, conversations, motivations and movements are fictitious, an imagining of the complexities of the adult relationships the film tracks. Arguably in this regard this film, like other period films, does exactly what academic history cannot – it moves away from recorded evidence, it depicts emotional responses and infers what we might guess at but can never really know.

This emphasis on interiority and the emotional experiences of the main protagonists shapes much of the film's material culture and overarching aesthetic. *The Duchess* was purposefully shot at many 'real' interiors. Kedleston Hall in Derbyshire, in particular, with its Robert Adam-designed rooms was deemed suitably fashionable, opulent and appropriate in date to represent a range of locations including: Devonshire House, the Duke of Devonshire's palatial London home on Piccadilly (demolished in 1924); Althorp, the seat of Georgiana's father, Earl Spencer; and the Duchess of Devonshire's fictitious lodgings in Bath (Figure 25.3). Holkham's magnificent marble hall (built by the architect William Kent in Derbyshire marble on a Roman basilica model) was used to represent the entrance hall to Devonshire

FIGURE 25.1 *Portrait of the Duchess of Devonshire, print by Robert Graves, after a portrait by Thomas Gainsborough.* © *Trustees of the British Museum, London. Prints & Drawings 1875,0410.239.*

FIGURE 25.2 *Film poster for the film* The Duchess *showing Keira Knightley as Georgiana, Duchess of Devonshire.* © *Pathé UK.*

House (Figure 25.4), with Somerset House in London standing in as Devonshire House's exterior. Chatsworth – the ancestral home of the Dukes of Devonshire in Derbyshire – is also purposefully referenced. The marriage of Georgiana to the Duke was filmed in Chatsworth's chapel, and carefully posed exterior shots with the looming property in the background visually tie the film to the Duke's famous and recognizable estate in Derbyshire (Figure 25.5).

The Duchess is far from unusual in its selection of extant historic properties as key locations. As Andrew Higson has argued, the use of sweeping shots of country estates, landscapes and luxurious (often National Trust) interiors within period dramas contributes to a particular 'heritage' vision within 'heritage' films.[10] It is not uncommon for historic houses to foreground their role as locations, actively promoting their venue not only to film companies but also, subsequently, to their visiting public. Without exception, the properties used during the filming of The Duchess advertised the association on their websites, and also hosted exhibitions of costumes from the production. There is no escaping the fact that period films fill not only theatre seats but also National Trust car parks, contributing to the maintenance of a tourist heritage trail.

FIGURE 25.3 *A scene from* The Duchess *shot in the grounds of Kedleston Hall, here used to represent Althorp House.* © *Pathé UK.*

FIGURE 25.4 *The marble hall at Holkham Hall, used to represent Devonshire House, London, in the film* The Duchess.

FIGURE 25.5 *A scene from* The Duchess *shot in the grounds of Chatsworth House, the Devonshires' eighteenth-century Derbyshire residence. Chatsworth's distinctive architecture is carefully referenced in the film.*

The use of such properties could be interpreted as one way in which period films might be said to be striving towards a hallmark of material 'authenticity' (and it is noteworthy that, in the publicity run-up to a film's release, the use of surviving historic locations is routinely emphasized as a significant part of a production's claim to historical 'realism'). Yet it is rarely the case that a single historic property is used in its entirety. Instead the majority of period films use a montage of extant interiors from a range of properties to create a visual fiction. As Michael Carlin, production designer for *The Duchess*, discovered, few properties offered more than one room that was deemed spacious or grand enough for *The Duchess*'s aesthetic. 'Many of these large houses aren't all they're cracked up to be', explained Carlin in an interview with *The Telegraph*. 'Most of them have one big reception space, maybe a reception room. Some of their other spaces aren't particularly impressive'.[11] Of course, such a pronounced division between grand reception areas and more modest additional rooms, between public and private rooms, is an important architectural expression of the emphasis an eighteenth-century aristocracy placed on public display and sociability as a means of projecting their authority.[12] Yet, despite the film's central concern with the tensions between the public and private life of the Duchess of Devonshire, the marked distinctions between public and private spaces evident in extant period interiors did not suit the production's vision of the Devonshires' life. Instead, ostentatious grandeur was sought for every room

in which the duchess's story was shot. In so doing, the film created a fictitious interpretation of elite domesticity, one which was a far more opulent version than suggested by the historical record.

Historical objects and props

Although space was deemed to matter, the type of ostentation projected within *The Duchess*'s set design was also carefully moderated. As historical adviser on the production, I was especially surprised (and, initially, not a little unsettled) by the comparative sparseness of the sets: a glittering but empty opulence largely defined the film's visual style. To be sure, most of the selected interiors boasted impressive permanent decorative detail, such as the alabaster colonnades, statued niches and Pantheon-esque ceilings and marble hall. All other adornment, however, such as furniture and carpets were removed. Once emptied of accessories, generally speaking, the rooms were dressed primarily with flowers and candles. In this way, despite setting the drama in 'real' historic interiors, on screen there were few to none of the varied goods that historians would associate with the period's burgeoning consumer culture. It is important to note, however, that limiting the amount of surface clutter was a strategic design choice that articulated the character-driven focus of the drama. Too much ornament would distract from the exposition of eighteenth-century character that this frozen and gilded loneliness was intended to evoke.

Of course, it would be impossible to do without additional props entirely; and an impressive level of research and attention was given to the details of any props made new for *The Duchess*. Some of my longest conversations were with a London-based art team keen to check the smallest material detail, such as whether a pencil would slot into a pocket book and the exact wording for replica newspapers, cheques and bills. Hand-painted fans made for a scene intended to evoke the 1784 Westminster election hustings reveal the level of artistic skill and precision involved. Inspired by contemporary fans produced in support of the Whig political campaign, these replica pieces show a bust portrait of Keira Knightley as the Duchess of Devonshire surrounded by pro-Whig political text. Around ten such fans were painstakingly made for the Westminster election scene, which took one day to shoot but amounted to less than two minutes of footage in the film. These fans were not earmarked for use by the lead characters but distributed amongst the crowd of extras. Despite the care invested in their making, at no point is it possible to see these delicate accessories on the film (Figure 25.6). In this context, then, historical precision was prized as part of the craftsmanship involved, even though such items would rarely have been seen in any detail on camera and in the final cut of the film.

A similar commitment to what might be categorized as 'authenticity' was also much in evidence in *The Duchess*'s Oscar-winning costuming. Designed

FIGURE 25.6 *Fan depicting Keira Knightly as Georgiana, Duchess of Devonshire and made as part of the props used in the Westminster election scene.*

by Michael O'Connor, the costumes for the lead characters were drawn from historical sources, with Georgiana's dresses, in particular, closely mimicking gowns and accessories evident in Reynolds and Gainsborough portraits of the duchess, as well as in the plethora of contemporary caricatures (Figure 25.7). Yet such precision can never be extended to every

A certain Dutchess kissing
Old SWELTER-IN-GREASE the Butcher for his Vote
O' Times' O' Manners'
The Women Wear Breeches & the Men Petticoats

RAYFORD SCULP
12 Sep. 1784

FIGURE 25.7 'A certain Duchess kissing old swelter-in-grease the Butcher for his Vote' (1784). *One of many satirical prints produced of the Duchess of Devonshire during the 1784 Westminster election. Here she is shown wearing a hat adorned with fox tails, a style that was replicated in Keira Knightley's costumes for* The Duchess. © Trustees of the British Museum, London.

level of a film's costuming and *The Duchess*, like other films of its ilk, relied heavily on rented clothes for dressing the mass of supporting artists and extras who made up heavily populated scenes. Look closely and it is clear that such wardrobes are highly generic. While in the eighteenth century, commentators worried about the ability of a mill girl to dress like a duchess, and domestic maids spent their salaries on modish accessories and wore hand-me-down gowns from their mistresses, almost without exception in film Georgian servants are shown as down-at-heel, shabby and togged out in dreary fabrics. Far from being period precise, rented costumes are one of the key areas in a film's material culture where stereotypes and presumptions about historical eras are most in evidence.

Authenticity, material culture and narrative

By and large, critics decreed that *The Duchess* successfully and elegantly fulfilled the standard visual conventions of a British-made, big-budget period piece, and it was the film's design that garnered both critical praise and major awards.[13] The overall 'authenticity' of the film's character-based narrative, however, is open to debate. To assert its credentials, the film's trailers made much of the Duchess of Devonshire's historic celebrity, her family connections to Diana, Princess of Wales, and advertised the fact that the drama was 'based on a true story'. Yet, as historian Richard Gaunt commented in a letter to *The Times Higher*, the film orchestrated scenes that were chronologically impossible. Of particular annoyance to Gaunt was the opening scene where an unmarried Georgiana and her future love interest, Charles Grey, are shown carefree amongst a group of friends while, unbeknownst to her, the Duke of Devonshire (her future spouse) ties up details of their marriage contract in conference with her parents inside the house.[14] The producers and director of *The Duchess* had been very aware that such a scene was a dramatic and chronological fiction, but such manipulations in the name of scene setting were deemed permissible, even though in other areas 'accuracy' was asserted as paramount.

Notably, while meeting the visual iconography of its genre, in other areas *The Duchess* could be said to have diverged dramatically away from other norms of a period film. Though tethered with recognizable material tropes of bustling silk and opulent interiors, the film's narrative itself included scenes of marital rape (between the Duke and Georgiana), female masturbation (between Georgiana and Bess) and an overarching narrative of domestic tragedy.

There are perhaps two ways of looking at this potential disjuncture between set-dressing and narrative. One – the more critical – could be to suggest that by dressing *The Duchess* in period fabrics, the production then played fast and loose with characters, contexts and chronology. The other – the more generous – is that in paying respect to visual conventions, *The*

Duchess then emphasized a far grittier sense of the period in its narrative. Indeed, although certain chronological events are manipulated for the purposes of the film's storyline and many of the conversations and interactions between the protagonists are invented, the overarching narrative and relatively dark interpretation of the characters' loves and lives arguably does more justice to the historical record than might usually be expected from a period drama romance.

As with most period dramas that claim to draw inspiration from 'real' history, in *The Duchess* there is no clear way for a viewer to distinguish between what is based on the historical record and what is not. Yet some period productions appear to use material signals in order to flag fictitious content. A case in point is *Amadeus*, directed by Milos Forman and released in 1984. Although the costuming of the film's supporting artists and much of the scenery were researched to fit period conventions, Mozart's flamboyant clothes, pink wig and modern turns of phrase do not. On the one hand, Mozart's marked difference from his surrounding environment underscores his exceptionalism, providing a visual set of references to the modernity he manifested in his own age. On the other hand, however, it arguably serves as a visual reminder to the viewer that they may be witnessing a dramatized fiction rather than an 'accurate' biography.

Sofia Coppola's *Marie Antoinette* (2006) could be interpreted along similar lines. Despite using Versailles as its backdrop, and drawing on Antonia Fraser's acclaimed biography, the clashing colours of the costume and modern pop sound track remind us that the film is making little effort to period precision. Coppola freely acknowledged that she had taken liberties with the known history of Antoinette and described her film as a 'history of feelings' rather than a 'history of fact'.[15] Although it generated fierce censure in France, where Antoinette's history remains a controversial field, elsewhere few criticisms were leveled at the film's historical 'accuracy', for its highly stylized modernity made 'authenticity' a moot point. Moreover, given that the film jettisoned the privileging of period detail in favour of Manolo Blahnik shoes, and purposefully played up its technicoloured fictions, it would surely be unlikely that any audience would take it as a documentary reading of French history.

Much the same argument could be made for recent television series, such as the hugely popular *Tudors*, with its sexualized opulence and near pantomime plot devices. At the time of writing, the BBC series *The White Queen* was subject to debate in both newspapers and social media on account of its reputed material inaccuracies. An adaptation of Philippa Gregory's historical novels, *The White Queen* is a medieval drama loosely based on the War of the Roses. Critics deplored the appearance of zips in dresses, men in trousers and impeccably manicured nails in the series, citing such 'inaccuracies' as evidence that the series lacked 'real' authenticity.[16] Notably such criticisms were rebuffed by representatives of the production who denied the use of zips and defended the series' material accuracy.[17] But

such niggling over material detail perhaps misses a broader point. From a different perspective it could be suggested that the fairytale costumes and impossible glamour of *The White Queen* does a service rather than a disservice to history, reminding the viewer that the text from which it draws is fiction not fact. Although very broadly based on an important sequence of historical events, Gregory claims her work as a fiction rather than a history and, as with *Amadeus* and *Marie Antoinette*, *The White Queen*'s visual flamboyance (so far removed from a medieval 'reality') arguably serves to highlight the narrative's fictional status.

Though we tend to assess films as unified products, there is rarely an all-encompassing historical agenda defining the entirety of its materiality. In *The Duchess*, props, sets and costumes were effectively a palimpsest of old and new, consisting of objects made for the production, of generic pieces hired for background effect and of surviving historic infrastructure. There is, however, no way for the audience to distinguish between items that are rooted in historicized interpretations and those that are not. Arguably, this production – and others like it – could be criticized as purposefully dressing inaccuracies (not only inaccuracies of material detail but also inaccuracies of chronology, character and context) in a cloak of 'authenticity'.

A useful comparison can be made to a particular, more traditional, approach to conservation of historic objects, which sought to hide modern repairs and interventions in order not to disrupt the overarching aesthetic of the piece. In certain period productions, the old and the new, fictions and facts are blended so that the splits and joins are not easily seen. In contrast, productions such as *Amadeus* and *Marie Antoinette* could be compared to the alternative model of conservation, wherein the interventions of a modern hand are clearly shown so that they are not mistaken for the original.

Productions that focus on historical subjects are not uniform, and perhaps there is scope for us to see the deeper and richer involvement of historical advisors. A medium that has flourished in recent years, and which has succeeded in holding vast audiences rapt over weeks, months and even years is television drama. It is striking that hit series like *Downton Abbey* and *Mad Men* aim for a 'thick' description of period detail, with every element from lip balm to lingerie, speech to sets, and interiors to exteriors painstakingly researched to ensure as close as possible match to historical sources and extant period examples. By insisting that their characters display a nonchalent familiarity with the period details and projecting their material vision of the past over many, many hours of drama (a privilege that period film notably lacks) such series allow the viewer to develop their own familiarity with that interpretation of the past. As a result, rather than being a 'foreign' place, the past communicated in such dramas becomes recognizable to the viewer, indistinguishable from the characters and lives with whom the viewer becomes so deeply involved. In a similar vein, most viewers of *The Sopranos* would not have begun their acquaintance with its characters with anything more than a few Mafia stereotypes to keep them

company. The internal laws and intricacies of that world (clearly fully researched and understood) had to be learned, stored and reapplied to each fresh episode by people watching across the world, living lives utterly remote from its subject material. It may be set in the present, but a series such as this may be our recipe for the past. It will take perseverance, but it might catch the mood, and we could find a canvas sufficiently broad and generous to show us a history around which experts and the general public can rally.

Conclusion

When considering the role that period drama can play in communicating material histories, or other histories, we should not set up a false ambition. Historical drama – whether on television or in film – is intended to entertain. As the screenwriter for one of Hollywood's most recent period epics, *Lincoln*, explains, there is a fundamental difference between drama and documentary. 'Ask yourself', he wrote in an article in *The Wall Street Journal*, 'did this thing happen in precisely this way? If the answer is yes, then it's history; if the answer is no, not precisely this way, then it's historical drama'.[18]

Certain licence can surely be granted to a production that presents itself as drama rather than documentary, but which areas of history should we defend? It seems necessary to emphasize that the 'pastness' of the past does not rest solely in set-dressing, but in historical actors and their motivations, which can be as obscure and foreign to modern society as Georgian wigs and Tudor codpieces. After all, how much does it matter if a crown is painstakingly reproduced in all its historical detail if the King or Queen on whose head it sits is given fictitious motivations or an imagined context of power? How important is it to layer a room with period-precise props if the action that it bears witness to has no basis in the historical record? It often appears to be the case that even if historical accuracy of material detail is ostensibly prioritized in a film's material form, precision in the depiction of character, context and chronology is all too often compromised. As a result, there is a risk that the material evidence of the past that so often confronts us in the media habitually abuses the difference it purports to represent.

Notes

1 I would like to thank Anne Gerritsen, Giorgio Riello and Quintin Colville for critical readings and helpful suggestions. Particular thanks to *Pathé* for the generous provision of images for this chapter.

2 'AHR forum [on film and history]' (1988), *American Historical Review* 93 (5), pp. 1173–227.

3 R. A. Rosenstone (1988), 'History in images/history in words: reflections on possibility of really putting history onto film', *American Historical Review* 93 (5), p. 1173.

4 Rosenstone, 'History in images'. See also H. White (1988), 'Historiography and historiophoty', *American Historical Review* 93 (5), pp. 1193–99. N. Zemon Davis (1987), 'Any resemblance to persons "living or dead": film and the challenge of authenticity', *Yale Review* 86, pp. 457–82.

5 D. Herlihy (1988), 'Am I a camera? Other reflections on film and history', *American Historical Review* 93 (5), p. 1191.

6 Quote cited by P. Cosgrove (2003), 'The cinema of attractions and the novel in Barry Lyndon and Tom Jones', in R. Mayer (ed.), *Eighteenth-Century Fiction on Screen*. Cambridge: Cambridge University Press, p. 21.

7 R. Samuel (1994), *Theatres of Memory: Past and Present in Contemporary Culture*. London: Verso, pp. 283–84. Also discussed in A. Higson (1993), 'Re-presenting the national past: nostalgia and pastiche in the heritage film', in L. D. Friedman (ed.), *Fires Were Started: British Cinema and Thatcherism*. London: UCL Press, pp. 91–109.

8 A. Foreman (1998), *Georgiana, Duchess of Devonshire*. London: Harper Collins.

9 Interviews for *The Independent*, 22 August 2008 and *Time Out*, 23 October 2008.

10 A. Higson (2003), *English Heritage, English Cinema: Costume Drama since 1980*. Oxford: Oxford University Press.

11 Interview for *The Telegraph*, October 2008. Published online: http://www. telegraph.co.uk/culture/3558644/.html?image=5 [accessed 30 May 2014].

12 M. Girouard (1978), *Life in the English Country House: A Social and Architectural History*. New Haven and London: Yale University Press.

13 Michael O'Connor won an Oscar and a BAFTA for his costume design. The set designer, Michael Carlin, and set decorator, Rebecca Alleway, also received Oscar nominations. The film's hair and make-up designers, Jan Archibald and Daniel Phillips were nominated for a BAFTA.

14 Richard Gaunt in a letter to *The Times Higher*, 18 September 2008, in response to my article 'Let's get our dates straight' *The Times Higher*, 11 September 2008.

15 Quoted in an interview with *The Guardian*, 8 October 2006.

16 For a summary of the criticisms see *The Daily Mail*, 22 June 2013 and *The Telegraph*, 18 June 2013.

17 See, for example, a response by the costume designer Nic Ede in an interview with *The Telegraph*, 28 June 2013 and online interview with script writer, Emma Frost, for Indie Wire: http://www.indiewire.com/article/television/ emma-frost-interview-the-white-queen [accessed 30 May 2014].

18 Open letter by Tony Kushner published in *The Wall Street Journal*, 8 February 2013.

Further reading

Cosgrove, P. (2002), 'The cinema attractions in Barry Lyndon and Tom Jones', in Robert Mayer (ed.), *Eighteenth Century Fiction on Screen*. Cambridge: Cambridge University Press.

Foreman, A. (1998), *Georgiana, Duchess of Devonshire*. London: HarperCollins.

'Forum on film and history' (1988), *American Historical Review* 93 (5).

Higson, A. (1993), 'Re-presenting the national past: nostalgia and pastiche in the heritage film', in L. D. Friedman (ed.), *Fires Were Started: British Cinema and Thatcherism*. London: UCL Press, pp. 91–109.

Higson, A. (2003), *English Heritage, English Cinema: Costume Drama since 1980*. Oxford: Oxford University Press.

ONLINE RESOURCES

Compiled with the Help of Claire Tang

Major museums

The Ashmolean Museum of Art and Archaeology, Oxford
The Ashmolean was created in 1908 by combining two Oxford institutions: the University Art Collection and the original Ashmolean Museum. Its extensive collections include ranges from the Palaeolithic to Victorian times.
www.ashmolean.org/

Asian Civilisations Museum, Singapore
One of the pioneering museums in the region, it specializes in pan-Asian cultures and civilizations with extensive collections in the material history of China, Southeast Asia, South Asia and West Asia.
www.acm.org.sg

Bavarian National Museum, Munich
It is one of the most important museums of decorative arts in Europe. Its collections include art historical and folklore collections.
http://www.bayerisches-nationalmuseum.de/

Boston Museum of Fine Arts
It contains more than 450,000 works of art, making it one of the most comprehensive collections in the Americas.
http://www.mfa.org/

The British Museum, London
One of the largest museums in the world, its collections cover all continents, illustrating and documenting the story of human culture from its beginnings to the present.
http://www.britishmuseum.org/

The Fitzwilliam Museum, Cambridge, UK
With over half a million artworks in its collection, the Fitzwilliam Museum presents world history and art from 2500 BCE to the present day.
http://www.fitzmuseum.cam.ac.uk/

Fowler Museum at UCLA
The Fowler Museum includes several collections of non-Western art and material culture at the University of California, Los Angeles. The museum also promotes research, exhibitions and publications.
www.fowler.ucla.edu

Freer Gallery of Art and Arthur M. Sackler Gallery
The Freer and Sackler are the largest collections of Asian art in the world, covering China, Korea, Japan, South and Southeast Asia and the Islamic World. Several artefacts in the collection can be viewed online.
www.asia.si.edu

Gardiner Museum, Toronto, Canada
It is the only museum in Canada devoted exclusively to ceramic art.
www.gardinermuseum.on.ca

German National Museum (Germanisches Nationalmuseum, Nürnberg)
The Germanisches Nationalmuseum is the largest museum of cultural history in the German-speaking region.
http://www.gnm.de/

Gothenburg Museum of Art, Sweden
The Gothenburg Museum of Art houses collections from the fifteenth century to today. The museum has a Nordic emphasis.
http://konstmuseum.goteborg.se/wps/portal/konstm/english

Harvard Art Museums
The Harvard Art Museums are part of Harvard University and comprises three museums: the Fogg Museum, the Busch-Reisinger Museum and the Arthur M. Sackler Museum.
http://www.harvardartmuseums.org/

Hong Kong Museum of History
The collections of the museum encompass natural history, archaeology, ethnography and local history.
http://www.lcsd.gov.hk/CE/Museum/History/index.html

Hunterian Museum, Glasgow
The oldest public museum in Scotland, its exhibits include materials since Roman times.
http://www.gla.ac.uk/hunterian/

Japan Ukiyo-e Museum, Matsumoto
One of the best woodblock-print museums in Japan, this museum displays the largest collection of prints in the world on a rotating basis.
http://www.japan-ukiyoe-museum.com/

Kyoto National Museum, Kyoto
One of the major art museums in Japan. The collections of the Kyoto National Museum focus on pre-modern Japanese and Asian art.
http://www.kyohaku.go.jp/eng/index_top.html

Los Angeles County Museum of Art (LACMA)
It holds more than 150,000 works spanning the history of art from ancient times to the present.
http://www.lacma.org/

The Louvre Museum, Paris
One of the world's largest museums and a historic monument.
http://www.louvre.fr/

Mehrangarh Museum, Jodhpur, India
One of the most important museums in Rajasthan, it hosts a collection of royal palanquins, costumes, paintings and decorated period rooms.
http://mehrangarh.org/

Metropolitan Museum of Art, New York
The Metropolitan Museum of Art is one of the world's largest art museums. Its collections include more than two million works.
www.metmuseum.org

Museum of Archaeology and Anthropology, Cambridge, UK
Cambridge University's Museum of Archaeology and Anthropology houses world-class collections of Oceanic, Asian, African and Native American art. It supports a wide range of research projects, with a focus on cross-cultural and interdisciplinary studies.
maa.cam.ac.uk

Museum Nasional Indonesia
The National Museum of Indonesia has a total collection of more than 240,000 items spread across a wide range of subjects.
www.museumnasional.org

The Museum of Chinese University Hong Kong
The University Museum and Art Gallery was established in 1953. It is the oldest museum in Hong Kong and houses Chinese antiquities.
http://www.cuhk.edu.hk/ics/amm/index.html

Museum of London
It documents the history of London from prehistoric to modern times.
http://www.museum-london.org.uk/

Nanjing Museum, Nanjing
The museum currently has over 400,000 items in its permanent collection, making it one of the largest in China. Especially notable is the museum's large collections of Ming and Qing imperial porcelain.
http://www.njmuseum.com/html/default.html

National Gallery of Victoria, Melbourne
Its collections cover both Eastern and Western hemispheres, ancient and modern, the fine arts and the applied decorative ones.
http://www.ngv.vic.gov.au/

National Museum, New Delhi
Established in 1949, the museum has 200,000 works of art, both of Indian and foreign origin, covering over 5,000 years.
http://www.nationalmuseumindia.gov.in/

National Museum of China, Beijing
Established in 2003, it has a permanent collection of over one million objects.
http://www.chnmuseum.cn/

National Palace Museum (Taipei)
The National Palace Museum exhibits a fine collection of Asian art including bronzes, lacquer ware, textiles and religious artefacts.
http://www.npm.gov.tw/en/

National Palace Museum of Korea, Seoul
National Palace Museum of Korea in Gyeongbokgung Palace, Seoul, houses over 40,000 artefacts and royal treasures, from the palaces of the Joseon Dynasty and the Korean Empire.
http://www.gogung.go.kr/fgn/jsp/en/html/index.jsp

The Palace Museum, Beijing
It is located in the Forbidden City which was the Chinese imperial palace from the Ming dynasty to the end of the Qing dynasty.
http://www.dpm.org.cn/index1024768.html

Peabody Essex Museum
The Peabody Essex is located in Salem, Massachusetts and was founded in 1799. It holds collections of American, Asian, Indian, Oceanic, Chinese, Japanese, Korean, African and Native American art and decorative arts.
www.pem.org

Philadelphia Museum of Art
One of the largest museums in the United States. The collections include world-class holdings of European and American paintings, prints, drawings and decorative arts.
http://www.philamuseum.org/

Pitt Rivers Museum, Oxford, UK
The Pitt Rivers Museum was founded in 1884 when Lt.-General Pitt Rivers gave his collection to Oxford University. The Museum displays archaeological and ethnographic objects from all parts of the world. The General's founding gift contained more than 18,000 objects but there are now over half a million. Many were donated by early anthropologists and explorers.
www.prm.ox.ac.uk

Rijksmuseum, Amsterdam
The recently reopened Rijskmuseum displays 8,000 objects of art and history, from their total collection of one million objects from the years 1200–2000. It also has a world-renowned Asian collection.
www.rijksmuseum.nl

Royal Ontario Museum, Toronto, Canada
It is one of the largest museums in North America. It is a museum of world culture and natural history.
http://www.rom.on.ca

Shaanxi History Museum, Xi'an, China
Shaanxi History Museum, located to the northwest of the Giant Wild Goose Pagoda in the ancient city Xi'an, in the Shaanxi, has a collection of over 370,000 items, including murals, paintings, pottery, coins, as well as bronze, gold and silver objects.
http://www.sxhm.com/

Shanghai Museum, Shanghai
The museum includes collections of ancient Chinese especially Chinese bronzes, sculpture, ceramics, calligraphy, jades, paintings, coins, seals, China's national minorities and Ming-Qing dynasty furniture.
http://www.shanghaimuseum.net/cn/index.jsp

Tokugawa Art Museum, Nagoya
It shows the collections of the wealthy Owari, a branch of the powerful Tokugawa family, which ruled in the Edo Period, from 1603 to 1868.
http://www.tokugawa-art-museum.jp/

Tokyo National Museum, Tokyo
Established in 1872, this is the oldest Japanese national museum and the largest art museum in Japan.
http://www.tnm.jp/?lang=en

Victoria and Albert Museum, London
The V&A in South Kensington is a major British museum of art and design, with collections that include ceramics, furniture, fashion, glass, jewellery, metalwork, photographs, sculpture, textiles and paintings.
http://collections.vam.ac.uk

Yale Centre for British Art
It has a collection of British art from the Elizabethan period to the present day, including paintings, sculpture, drawings, prints, rare books and manuscripts.
http://britishart.yale.edu/

Yale Museums
It houses a collection that has grown to rank with those of the major public art museums in the United States.
http://www.yale.edu/museums/

Online resources and libraries

Bodleian Library, Oxford
The Bodleian is the research library of the University of Oxford.
www.bodley.oc.ac.uk

The Bridgeman Art Library
It provides one of the largest online archives for reproductions of works of art in the world.
http://www.bridgemanart.com/

The British Library, London
As a copyright library, the British Library receives a copy of every publication published in the UK and Ireland. Its collection includes 150 million items.
www.bl.uk

The British Museum Online Catalogue
The British Museum online collection includes artefacts from across the world.
http://www.britishmuseum.org/research/publications/online_research_catalogues.aspx

Digital Library for the Decorative Arts and Material Culture
Image database of the Chipstone Foundation, and a list of American decorative arts organizations and resources.
http:/decorativearts.library.wisc.edu

Getty Images
It is an American stock photo agency, based in the United States.
http://www.gettyimages.co.uk/website

Guildhall Library
The library is a public reference library and specializes in the history of London.
http://www.cityoflondon.gov.uk/things-to-do/visiting-the-city/archives-and-city-history/guildhall-library/Pages/default.aspx

Joconde
It is the central database created in 1975 and now available online, maintained by the French Ministry of Culture, for objects in the collections of the main French public and private museums.
http://www.culture.gouv.fr/documentation/joconde/fr/pres.htm

National Art Library, London
The National Art Library at the Victoria and Albert Museum is a major public reference library.
www.vam.ac.uk/nal

National Library of Australia Pictorial Collection
This catalogue contains descriptions of paintings, drawings, prints, photographs and three-dimensional objects held in the Pictures Collection of the National Library of Australia in Canberra.
www.nla.gov.au/catalogue/pictures

National Library of Congress
One of the two largest libraries in the world by shelf space and number of books. Its online sources include an image database.
http://www.loc.gov/index.html

New York Public Library Digital Gallery
The NYPL Digital Gallery includes over half a million images of primary and printed sources in its collections.
http:/digitalgallery.nypl.org

Scala Images
It is the most prestigious photo agency of fine art, history and travel images in the world.
http://www.scalarchives.com/web/index.asp

Warburg Institute Library
The Warburg Instutute's 350,000 volumes are searchable together with the microfiche edition of pre-1800 volumes in the Cicognara collection, Vatican library, and other rare-book libraries.
http://warburg.sas.ac.uk/library/

Winterthur Library
The most important US library for American decorative arts, design and the material culture of everyday life in the seventeenth through the early twentieth centuries.
http:/library.winterthur.org:8000/cgi-bin/webgw

INDEX

CPSIA information can be obtained
at www.ICGtesting.com
Printed in the USA
LVHW012058210119
604681LV00019B/767/P

9 781472 518569